CREATING OLD WORLD WISCONSIN

WISCONSIN LAND AND LIFE

Arnold Alanen
Series Editor

Creating Old World Wisconsin

THE STRUGGLE TO BUILD
AN OUTDOOR HISTORY MUSEUM
OF ETHNIC ARCHITECTURE

For Ilene & Ed
Marconnet

John D. Krugler

Fellow historians

John D Krugler

6/27/13

THE UNIVERSITY OF WISCONSIN PRESS

The University of Wisconsin Press
1930 Monroe Street, 3rd Floor
Madison, Wisconsin 53711-2059
uwpress.wisc.edu

3 Henrietta Street
London WC2E 8LU, England
eurospanbookstore.com

Printed in the United States of America

Library of Congress Cataloging-in-Publication Data

Krugler, John D., 1940–
Creating Old World Wisconsin: the struggle to build an outdoor history museum
of ethnic architecture / John D. Krugler.
p. cm. — (Wisconsin land and life)
Includes bibliographical references and index.
ISBN 978-0-299-29264-5 (pbk.: alk. paper)
ISBN 978-0-299-29263-8 (e-book)
1. Old World Wisconsin (Museum) — History.
2. Historical museums — Wisconsin — Eagle — History.
3. Agricultural museums — Wisconsin — Eagle — History.
4. Open-air museums — Wisconsin — Eagle — History.
5. Historic buildings — Conservation and restoration — Wisconsin.
6. Historic farms — Conservation and restoration — Wisconsin.
7. Ethnic architecture — Conservation and restoration — Wisconsin.
I. Title. II. Series: Wisconsin land and life.
F578.K78 2013
977.5 — dc23
2012035301

To my friend and colleague

MARTY PERKINS (1951–2012)

His unexpected death in November left a great void not only at OWW but also in the lives of all who knew this extraordinary museum professional. Marty exemplified the esprit de corps that allowed OWW to come alive.

For which one of you, when he wants to build a tower, does not first sit down and calculate the cost to see if he has enough to complete it?

Luke 14:28, *New American Standard Bible*

Contents

Acknowledgments

Writing a book is a collective effort. Recognizing those who provided critical assistance is both exhilarating and humbling. Marty Perkins, the curator of research at Old World Wisconsin, sat for numerous interviews, searched relentlessly for documents and photographs, never balked at my numerous requests for information, and served as my ultimate fact checker. William H. Tishler (professor emeritus, University of Wisconsin-Madison) encouraged me to tell this story, sat for a number of interviews, shared his files and knowledge on OWW, and answered my many questions. Alan C. Pape and Mark Knipping, Jack Winn's first OWW hires, also generously shared their memories and their papers. Tishler, Pape, Perkins, and Matt Blessing (now state archivist for the Wisconsin Historical Society) read relevant chapters and provided useful and critical commentary. No one knows the history of the Society better than Dr. Michael Stevens (state historic preservation officer). He read and critiqued the manuscript and made innumerable valuable contributions to the text. I also thank the two anonymous reviewers who read the manuscript for the University of Wisconsin Press and who pushed me to write an even better book. My son and colleague Dr. David F. Krugler (professor of history, University of Wisconsin-Platteville) and my wife, Dee, read various manifestations of this manuscript and made suggestions that greatly improved the readability of *Creating Old World Wisconsin*. Society archivists Harry Miller and Richard Pifer, among others, provided invaluable assistance by opening the vast treasures of the Society's archives to me. I am indebted to those who allowed me to interview them for the record (identified in the sources section). They graciously shared their insights and memories of this complex creation story.

I gratefully acknowledge the support of Marquette University for providing the time needed to research and write this book. I appreciate the encouragement of former chair Dr. Thomas E. Hachey (now at Boston College) and current chair Dr. James Marten. I remain indebted to my colleagues who encouraged my transition to a public historian. Numerous research assistants labored to make this book possible by transcribing interviews. Among them are Jose Blanco, James Bohl, Patricia Higgins, Laura Lindemann, Christina Makos, Jeffery Ramsey, Amanda Schmieder, and Craig Simpson. A special thanks to Marquette University photographer Dan Johnson, who photographed me at the Koepsell house for my author photo and who assisted in the selection and modification of the photos used for the photo galleries.

The author gratefully acknowledges William H. Tishler, Alan C. Pape, and Arnold R. Alanen for the assistance they provided by sharing their photos, identifying the persons and buildings in the photos, and for their permission to reproduce their photos. The photos from the OWW archives, mostly supplied by Martin C. Perkins, are also reproduced with permission.

I thank Patricia Nelson for vigorously recruiting me to serve as a trustee of the OWW Foundation. The experience gave me considerable insights into fund-raising. The Wisconsin Historical Society supported research through the John C. Geilfuss Fellowship. I gratefully acknowledge the support of the editorial staff at the University of Wisconsin Press—Gwen Walker, Sheila McMahon, and Matthew Cosby—as well as series editor Arnold Alanen and copyeditor Mary Magray. Their high standards made this a better book. Every effort has been made to avoid errors of fact. Despite the assistance of so many, I remain solely responsible for the text.

Writing a book is a solitary effort. For that reason, I am most appreciative of the support received from my family. My wife, Dee, lived with this book as long as I did and I deeply appreciate her support. My son, David, and his wife, Amy Lewis; my daughter, Katie Pospisil, and her husband, Mike; and my two granddaughters, Megan and Kayla, all contributed to making this long-term project possible. The encouragement and support received over a lifetime from my parents, Marge and Fred, sustained me from afar.

CREATING OLD WORLD WISCONSIN

Introduction

This is the story of a few individuals who struggled to fulfill a vision. The Wisconsin vision entailed salvaging fast disappearing artifacts by relocating them to a protected environment. Nothing surprising, except that in this case the artifacts were houses, shops, barns, and a variety of outbuildings. Individuals — State Historical Society of Wisconsin (SHSW) staff and volunteers who worked under the umbrella of state government — labored to save a small portion of Wisconsin's vanishing migrant and immigrant heritage.[1] These visionaries initiated a massive intervention that I describe as "salvage architecture." This term parallels salvage archaeology, where archaeologists rush to collect data and material in advance of the destruction of the site. Salvaging structures that were no longer viable on their original locations defined the vision.[2]

What did the word "heritage" mean to Wisconsin's visionaries? Although they never defined it or delved into its meaning, they were not sentimentalists seeking to glorify the past for a present-day illusion. Heritage, as Ned Kaufman noted, "is a slippery word." Heritage conservation, the term used throughout the world, equated to historic preservation in the United States. Kaufman's description of tangible heritage, that is, objects and buildings, seems to define the visionaries' immediate preservation goals. Indeed, if they gave little thought as to how the buildings they sought to save might be used (the intangible heritage),

they never wavered from their goal to preserve and celebrate the state's ethnic diversity.[3] They did not, as later critic David Lowenthal would, distinguish between heritage, a term he admitted "all but defies definition," and history. History "is the past that actually happened, heritage is partisan perversion, the past manipulated for some present aim." These visionaries saw saving a portion of the state's ethnic heritage as synonymous with preserving its past. Heritage for the Wisconsin visionaries was the tangible past, a past that would have been lost without a massive intervention.[4]

As they pondered their museum, the visionaries had three models to consider. The first model preserved buildings in their original location. Examples included Colonial Williamsburg and Old Salem in Winston-Salem, North Carolina. The second model preserved buildings by removing them from their original sites to a new setting. Examples of the open-air museum based on relocation included Greenfield Village, Old Sturbridge Village, and the Farmers' Museum in Cooperstown, New York. The third model relied exclusively on reconstructed buildings. These included sites such as Lincoln's New Salem and Historic St. Mary's City. Given the scattered nature of building survival in the state, Wisconsin visionaries had no choice but to adopt the relocation model.[5]

They embraced an increasingly popular post-World War II concept, that of the open-air museum. This was a place, as Candice Tangorra Matelic noted, where "buildings not only house the collections, but are the collection."[6] In contrast to many of its well-known predecessors — Mount Vernon, Monticello, Greenfield Village, and Colonial Williamsburg — Wisconsin's visionaries did not focus on great men who profoundly changed the course of American history. Wisconsin also lacked the "highly developed architecture forms" that populated the eastern regions of the United States. Wisconsin's nineteenth-century buildings seemed "old fashioned," and, with few exceptions, were buildings that would not necessarily attract tourist interest. Built and occupied by "foreigners" in the second half of the nineteenth century, these structures reflected no great architectural themes. In the face of "a frenzy of modernization"[7] in the late 1940s and throughout the 1950s, Wisconsin's visionaries planned to save a portion of the vernacular architecture of the state's inhabitants. As they did, they also embraced another emerging concept, namely, landscape preservation and landscape reconstruction.[8] Similar to the great European models and places like Greenfield Village, Old Sturbridge Village, and the Farmers' Museum, the Wisconsin vision called for buildings to be relocated. In

its most innovative form, the visionaries also imagined the buildings relocated on landscapes that approximated the original locations. This kind of daring thinking extended the scope of the project. This, in turn, raised the thorny issue as to whether SHSW had the requisite resources to accomplish its grand vision.[9]

Migrants and immigrants found the area now known as Wisconsin inviting, and they helped to define its history. Before the Europeans came, this area was home to diverse peoples. From the end of the sixteenth century to the beginning of the nineteenth century, displaced Native Americans—refugees—from the East migrated to Wisconsin. The Ojibwe, Potawatomi, Oneida, Stockbridge-Munsee, and the Brotherton were among the new migrants. They joined with the Menominee, Ho-Chunk, and the Dakota nations to create a remarkable cultural diversity in Wisconsin. Europeans, except for a few French traders and priests, had yet to make an impact on the land.[10]

After 1820, new migrants began to supplant the native peoples and changed the character of Wisconsin's landscape and population. Immigrants from Great Britain and Ireland joined American migrants from New England and New York to begin a profound transformation of Wisconsin's landscape. A steady flow of immigrants from Germany, Scandinavia, and other European countries furthered more change. All told, perhaps as many as forty immigrant groups found their way to Wisconsin by 1920. They cleared the land, built houses and barns, and founded small communities. Wisconsin's migrants and immigrants chose landscapes that "recalled the homeland," and their buildings generally reflected Old World techniques and styles.[11]

As these immigrants succeeded and Americanized, they or their descendants let the first buildings fall into disrepair or radically altered them. The continuing deterioration and destruction of the vernacular ethnic architecture of the nineteenth-century immigrants by the early 1930s agitated one observer, Milwaukee architect and preservationist Richard W. E. Perrin. By 1960 he concluded that more than individual efforts were needed to protect some of Wisconsin's ethnic heritage. He needed the collective support of the state. Perrin brought his concerns to Dr. Leslie H. Fishel Jr. and the State Historical Society of Wisconsin.[12] When Fishel asked landscape architect assistant professor William Tishler to create a plan for the vision, he brought in the third member of the team that would define the essence of Wisconsin's major open-air museum. This was the beginning of extraordinary private/public collaboration. Herein lies our tale.

Perrin envisioned an open-air museum similar to those he had visited in Scandinavia and Germany during the 1950s. During his travels, he amassed an extensive collection of photographs that he supplemented with museum literature. After returning, he corresponded with curators at these museums. Perrin's visits convinced him that Wisconsin had to have an outdoor ethnographic museum that embodied the best of the European models. He elaborated on his vision in 1965. Wisconsin has "a very unique opportunity to develop an outdoor museum along ethnic lines" because of the many ethnic and national groups that settled in the state during its formative years and contributed to its growth and prosperity. "The remaining visual bits of evidence of their lives are the old buildings in which they lived, worked, worshipped, and carried on their other activities of daily life." These buildings were "not necessarily great architecture nor monumental in any sense of the word." Still, they were important buildings deserving preservation. Here he invoked Frank Lloyd Wright: these "folk-structures" were intimately related "to environment and the heart-life of the people." Perrin added a proviso: he thought the Wisconsin museum could add a degree of spaciousness and natural beauty unparalleled in the European models. These clusters of ethnic buildings, Perrin envisioned, "would be connected by nature paths and the whole thing set against a backdrop of great natural beauty of the kind only Wisconsin can afford."[13]

Because of the pattern of survival of nineteenth-century buildings, the Wisconsin vision mimicked Greenfield Village and Old Sturbridge Village. Perrin wanted to rescue some of the most endangered immigrant buildings by relocating and restoring them at a common site. The Society had an emerging vision. It looked to find new ways to stimulate public interest in the state's history. In the fifteen years since the end of World War II, its traditional role as primarily an academic and scholarly institution (mainly for its library and archives) had been broadened to encompass what some derisively called "popular" history. Efforts to expand the Society's public role, however, brought new pressures to the Society's already tight budgets. Fishel, a scholar of African American history, realized that Perrin's vision matched the Society's initiatives but only cautiously embraced it. Sixteen years would pass before the site, known as Old World Wisconsin (OWW), opened in the state forest near Eagle in southwestern Waukesha County.[14]

OWW is the largest of the eleven sites supervised by the Society's Museums and Historic Sites Division. The museum is an artificial site; OWW never existed as a historic entity until the 1970s. It uses relocated

historic buildings to interpret the lifestyles of a variety of immigrant groups that came to the state between 1840 and 1915. Since the late 1960s, buildings from throughout the state have been rescued from destruction, dismantled, transported, and reerected on an attractive 576-acre landscape nestled in the Kettle Moraine State Forest in southwestern Waukesha County. OWW lies within a triangle of three large metropolitan areas: Chicago, Madison, and Milwaukee. Presently the museum consists of seven ethnic clusters (Norwegian, Danish, Finnish, German, Polish, African American, and Yankee), four historic buildings that house visitor amenities and educational facilities, and an Ethnic Crossroads Village populated with twelve buildings. Interpreters demonstrate nineteenth-century agricultural techniques at three of the ethnic units and in the Village. In addition, horses, cattle, oxen, sheep, and hogs, many of them historic breeds, populate the site. A permanent staff of ten manages an annual budget of approximately $1.9 million (FY 2012–13). During the season, the site employs another sixty-five to seventy people as interpreters, tram drivers, janitors, and store clerks in the museum store.[15]

My association with OWW did not begin until a decade after the 1976 grand opening. As I walked the site, one question in particular intrigued me: how did this magnificent site come to grace the landscape? Visits to historic sites, and even zoos, led me to believe that interpreters generally could not address that question for their sites. Museum literature rarely addressed the question. As I investigated, I found that many staff and former staff knew parts of the creation story, but no one seemed to know it in its entirety. Beginning in the mid-1990s (with many interruptions) I undertook to answer my basic question by systematically exploring the paper trail at the Society's archives and by interviewing many of those who participated in the museum's creation. As the story unfolded, it became clear that this effort to build a museum was a complex and complicated preservation movement, perhaps one of the largest undertaken by a state or national agency.[16]

Why write a history of one open-air museum? Material culture historian Thomas J. Schlereth provided the rationale for writing histories of history museums such as OWW, noting an inherent paradox: "Historical museums and many of the historians who work in them, while devoted to the cause of expanding the public's historical consciousness, are often curiously inattentive to their own histories." For understaffed museums, writing their own histories is extravagant. As a result, little attention has been "paid to the origins, development, and influences of

history museums as part of both the history of American museums and American cultural history." The Society's case validates Schlereth's generalization. As the 1976 opening approached, one of the staff started to compile a chronology/history of the museum's development. The press of other duties left little time for the project, which he never completed. This study fills that void. *Creating Old World Wisconsin* joins a growing genre of historical literature that investigates the origins and developments of open-air museums in the United States.[17]

The creation of this open-air museum raises issues that are not only important to this site but to museums in a more general sense. These issues include preservation, fund-raising, the integrity and accuracy of the restorations, and the educational value of the buildings. For example, to what extent did the Society maintain its own standards for integrity and accuracy for its relocated and restored buildings? With tight budgets, inexperienced construction crews that employed the "learn-as-you-go" method, and the rush to have some buildings on-site for the grand opening, this is a compelling question.[18]

As suggested, the Wisconsin vision was not unique as a concept. It fitted a much larger and still evolving pattern. If my quest focused on one site, another historian wrote a comprehensive study of open-air museums in Europe and America. Old World Wisconsin was part of a worldwide movement that dated to the late nineteenth century. Sten Rentzhog, a former open-air museum director in Sweden, traced the development of open-air museums from their Scandinavian origins in the 1880s to the present. He defined open-air museums as distinctly different from historic sites preserved in situ and reconstructed sites such as prehistoric villages. Open-air museums began as collections of relocated buildings that staff used to educate the public about preindustrial rural national origins. Rentzhog visited OWW and described it as "one of the most magnificently planned of the American outdoor museums." He saw that OWW had much in common with the great open-air museums he had studied in Europe. Rentzhog noted that the museum was "rather unusual" in one respect—it was a "multicultural open air museum." His brief analysis mentioned only visionary Richard Perrin, who brought an international dimension to the museum's creation. His study showed that the rich details of the museum's creation story remained largely unknown and that important distinguishing characteristics of OWW in the context of open-air museums remained unexplored.[19]

Creating Old World Wisconsin describes and analyzes the long, often detour-filled, course taken by the Society in its struggle to create the

museum. The museum project dwarfed previous sites projects. If we came in on the unfolding OWW story in 1968, we would see the Society committing to a master plan for its museum. Amazingly, the Society had ordered a Cadillac when it could not afford a Schwinn bicycle. In an oversimplified and truncated fashion, this metaphor exemplifies both the strengths and weaknesses of the museum-building approach taken by the Society. Why did the leadership take such a risk?

First and foremost, the Society had compelling reasons to make its move. It fitted nicely into the Society's emerging public history initiative. Equally important, saving some of the state's fast-shrinking architectural heritage complemented its continuing mission to save manuscripts, books, and cultural artifacts such as farm machinery and make them accessible to the public. Second, it allowed the state of Wisconsin to play an important role in the nascent preservation movement of the 1960s. Third, at least initially, Society leadership could employ an incremental approach that could minimize its lack of adequate financial resources and personnel. This, of course, rendered success less likely. It is remarkable that the Society accomplished something that knowledgeable observers might well have judged beyond its reach. Despite working with shoestring budgets, Society staff and allied amateurs, volunteers, and co-opted professionals bonded into a team to save a small part of the state's immigrant heritage.

This study starts with the post–World War II changes at the Society and concludes after the museum's first eighteen months of operation. OWW was far from the museum envisioned in the master plan in 1968, but the three decades covered in *Creating Old World Wisconsin* bring its creation story to an end. Readers should view it as neither a defense of the Society and its personnel nor an indictment of their work. Literature professor David Lodge's statement that writing "a biography of a living person is always a tricky undertaking" applies equally well to writing a history of a living institution. Authors can strive for no more than to do justice to the people who inhabit their story. An inquiry dealing with living subjects and their memories carries inherent risks. No one individual knew the entire creation story of this museum. Thus, this book should be viewed as no one's perspective but the author's. The narrative reflects my understanding of those who left paper trails or who sat for interviews and shared their perspectives of the roles they played in the creation of OWW.[20]

The story that unfolds provides insights that will help readers better understand the human dimensions of museum building as well as important public history issues. *Creating Old World Wisconsin* emphasizes

the process by which the staff at a state historical society created a major open-air museum. For the Society, the commitment put its financial future at risk. This story highlights the challenges staff faced. Beyond the creation story, these challenges included, among other things, the management of a three-dimensional collection (buildings and artifacts), historic preservation on a massive scale, and site preparation for the visiting public.

If museum creation carried high risks, it held the possibility of significant gains. The Society flirted with financial disaster as it tested its staff's stamina and ability to persevere under the most difficult conditions imaginable. Long before the Society embarked on its perilous path to Eagle, humorist Mark Twain (Samuel Clemens) provided a brilliant insight: "The lack of money is the root of all evil."[21] Many of the evils that befell the Society's efforts can be attributed to a lack of resources. If this study seems preoccupied with funding, it results from the intimate relation between creativity and the money available for fulfilling visions. Unlike better-known privately funded outdoor sites, no wealthy patrician called forth the Wisconsin site. That meant OWW would not be influenced by a wealthy patron's view of the past. It also meant no patron with deep pockets was there to carry the financial burden in the formative years. A recent critical study of Colonial Williamsburg noted the patron's influence in the early budgetary practices. A Colonial Williamsburg vice president remembered: "At the end of the year [top administrators] figured out how much money they needed, and they got it from the Rockefeller family." Without these rich (in both money and ideology) benefactors, Wisconsin planners employed a more democratic approach that relied on state tax dollars and citizen solicitations. Hardly a perfect model, but the Society's methods to finance its museum offer insights for other publicly funded museums.[22]

As a state agency, the Society made the state of Wisconsin a partner in the enterprise. State government, with complex bureaucracies that are neither easily maneuvered nor manipulated, both helped and hindered museum creation and development. In theory, procedures had to be followed; every move seemingly had to be justified. More important, those who controlled the state budgets did not easily yield their tax-gained treasures. Too many competing interests restricted state financial commitments. Museums and historic sites were small voices in a vast arena. To complicate the situation, the Society was a quasi-independent agency, governed by its own Board of Curators. This meant the museum project could be managed without penetrating the state bureaucracy *if* it

did not need special budget appropriations or legislation. For this reason, planning revolved around the belief that money from other sources — other state agencies, corporations, private individuals, foundations, and the national government — would finance the project. This eventually led to tensions between state budget managers and the museum builders. Understanding these tensions sheds light on the development of government-sponsored cultural institutions.

Compounding the lack of funds, staff had little experience in the management of historic sites, let alone creating one from whole cloth. Rentzhog noted his amazement that outdoor museums "did not try to learn more from each other." The Society, through Perrin, its unpaid consultant, had access to two prototypes: Skansen and Old Sturbridge Village. William Tishler, who developed the master plan, had his undergraduate students investigate other significant sites, and the graduate student who prepared the economic feasibility study visited three New England museums. Staff visits to selected outdoor museums in the United States and elsewhere provided some additional data to assist planning. Otherwise, OWW fits Rentzhog's generalization that museums in Europe and America developed independently of each other. In fairness, though, the literature on museum creation in the 1960s was rather sparse. The two directors who led the Society between 1960 and 1976 had no experience in museum building. Fishel, who was appointed the Society's seventh director in 1959, had earned a PhD in African American history from Harvard University. He had no interest in historic sites when he came to Madison. Distinguished scholar Dr. James Morton Smith, who became the eighth director in July 1970, had strong academic credentials and a deep interest in public programs but no experience in museum building. The only exception was Ray S. Sivesind, the director of the Division of Sites and Markers. Members of the Society's governing board had no experience in museum building; indeed, most had no historical training. They were volunteers who had an interest in the state's history. Some of the curators adopted the project with considerable passion. The first chair of the Outdoor Museum Committee was Norman FitzGerald, a Milwaukee insurance executive; his successor, Roger Axtell, was an executive with a Janesville pen company. Neither had any experience with outdoor museums.[23]

In relation to the ambitious programs launched in the post–World War II period, the Society was understaffed. The recently created historic sites division lacked the personnel needed to carry out the ambitious planning that began in the early 1950s. Within the Society, staff often

had multiple duties that spread them thin. Sivesind, the sites division director, had museum credentials but had never dealt with projects of the magnitude of OWW. John W. Winn, the site's first administrator, had curatorial training but no experience in outdoor museum building. William Applegate, the site's next administrator, had retired from the army as a colonel and had a master's degree in public relations. He brought no experience with historic sites. The designer of the master plan represented another category: the recently credentialed but rather inexperienced professional. Tishler had recently been appointed as an assistant professor in the University of Wisconsin landscape architecture department. To be sure, some of those involved brought valuable experience to the table. Architect and preservationist Perrin served as the Society's technical adviser. On the other hand, the first site supervisor, Alan C. Pape, had neither managerial experience nor expertise in site restoration but brought high enthusiasm and a willingness to learn.

For the inexperienced staff, the complexities and costs of museum building became obvious only as planners moved to the construction phase. Progress depended on financing. Perrin had noted the obvious truth in 1960: "The magic ingredient, of course, is money." An inadequate financial base plagued creation and planning and led to setbacks, compromises, and near collapse. Parsimonious state budgets and surging inflation in the 1970s put extreme pressure on the Society's budget as it began on-site development. This lack of funds precluded hiring professionals for such tasks as planning and fund-raising, and even a professional site director.[24]

Within this context, OWW exemplifies the challenges that state-sponsored museums founded in the 1960s faced. The endless number of crises faced by the visionaries and builders demonstrated the daunting nature of museum creation. It was a venture into a vast unknown. No exact models existed for the founders to follow. Perhaps it was for the best that the visionaries and planners saw the future shrouded in fog. The number of obstacles rendered the creation problematic. Finding and securing the right site proved daunting. A lack of funds to purchase a site in excess of 500 acres brought a new and vexing challenge. Working within a state bureaucracy complicated that process. A master plan had to be created. Its development proved equally daunting for the same reason—inadequate funds. The project had to overcome Fishel's 1969 resignation. This fostered crises of confidence among Society administrators, leading some to consider shutting down the operation. The project had to overcome internal opposition that impeded site development. The greatest obstacle the Society faced was finding massive infusions of

money to keep the idea afloat. Only when a major donor appeared in 1971 did the project gain new momentum. After resolution of these crises, crews had to identify still-standing historic buildings, determine their availability, and move them to the site for reerection. The Society began construction with raw crews who had to learn as they rebuilt the buildings. This led to a plethora of problems that included a lack of supervision on-site and costs that far exceeded the initial projections. The rampant inflation of the early 1970s that sent costs skyrocketing created unanticipated challenges. Site development costs far outstripped the Society's efforts to raise funds. Later, after the site opened, staff realized that the museum would never meet the projected attendance goals. The ultimate crisis came at the end of the first season when the Society considered closing OWW.

As staff faced the prospect of opening on June 30, 1976, OWW faced new issues and challenges that it shared with other public open-air museums. In a relatively short time, newly hired staff had to devise methods to present the buildings to the public. The development of an educational and interpretive program led, whether intentionally or not, to a remarkable transformation. The houses and barns became less important as preserved specimens of an age long past, becoming instead stages on which stories about that past could be told.

Creating Old World Wisconsin opens another window on the museum-building process. This study traces the evolution of OWW through three stages of development. First came the amorphous Perrin-Fishel vision. Tishler's interpretation gave form to the vision by creating a plan that conceptually relocated immigrant buildings in comparable settings within the state forest. Last came the construction phase, which physically located the buildings, brought them to Eagle, and positioned them. This became the foundation of the open-air museum. This is a tale of both despair and triumph. Perhaps Society directors should have heeded the counsel of cautionary voices who foresaw what others learned only through dear-bought experience. Having embraced the vision, Society leaders were willing to "go as far as we can." The Society took OWW as far as it could. The project eventually dwarfed the Society and caused considerable tension within the Madison headquarters. Fundraising fell far short of its mark. The museum had to be scaled back from its 1968 plan. The study shows that a major museum could be built if its creators willingly defied logic and persevered in spite of the obstacles and setbacks. OWW is a remarkable, if imperfect, creation. How the Society managed to fulfill a portion of the Perrin-Fishel-Tishler vision is worth learning.[25]

CHAPTER ONE

Visionaries

Several inspirations affected the creation of state-funded museums in the United States. The great outdoor history museums of the 1920s, 1930s, and 1940s, funded by private philanthropists, influenced state-sponsored museums. For example, the St. Mary's City Commission, which the state of Maryland Assembly had charged to create a site at the location of the first founding of the Maryland colony, looked to Colonial Williamsburg as its prototype. Some commissioners thought their site could become the "Williamsburg of the seventeenth century." In a similar fashion, some saw the reconstructed Fortress of Louisbourg in Nova Scotia as a "Williamsburg of the North." Wisconsin visionaries looked to Old Sturbridge Village in Massachusetts for a paradigm. Some Wisconsinites drew on an even older tradition, open-air museums such as Skansen, the first outdoor history museum in Stockholm, Sweden. A renewed national commitment to historic preservation that emerged after World War II also influenced public officials. Wisconsin's visionaries embraced historic preservation as their major goal. Salvaged ethnic buildings would enhance present-day understanding of the state's rich cultural heritage and encourage tourism and economic development.[1]

Most well-known outdoor museums had visionaries with money. If their pockets were not deep enough to fund the start-up costs entirely,

they had more than enough to finance the vision and set it in motion. Henry Ford (automotive) at Greenfield Village, John D. Rockefeller (oil) at Williamsburg, the Wells brothers (optics) at Old Sturbridge Village, and the Lilly Foundation (pharmaceutical) for Conner Prairie had their visions of what the past was like and had the money to make that past a reality. States lacked visionaries with the financial resources to fund new sites from scratch. The lack of an entrepreneur capable of bringing forth a major historic site profoundly influenced the creation and development of a major historic site in Wisconsin. The absence of a Rockefeller fortune freed museum planners from a strong-willed founder. It also left them adrift when it came to funding. Less affluent visionaries in Wisconsin looked to their state government. As will be seen, state funding came at a price.[2]

From the beginning, Old World Wisconsin represented a different paradigm, one better fitted to the 1960s. It was a corporate (community) enterprise that called on many individuals to turn an idea into a site. Certain men, Richard W. E. Perrin, Hans Kuether, and Leslie H. Fishel Jr., legitimately fit the description of visionaries. Collectively, they provided the idea for a major open-air museum where threatened immigrant buildings would be rescued and restored. If they did not speak with a common voice, when woven together their visions helped form the creation narrative for the site. Similar to their biblical counterparts, they prophesied doom and called on their contemporaries to change their destructive ways (neglect and encroachment). They called on their contemporaries to find creative solutions to prevent the destruction of valuable historic resources within their state (preservation). Their paradigm, seeking government-based solutions, frequently forced them to temper their passion and their sense of urgency to accommodate slow-moving bureaucracies.

The idea of an outdoor preservation museum in Wisconsin belongs to no one individual. Rather, it resulted from three preservation initiatives — one nationally generated, one state generated, and one generated by individuals — that came together in the 1960s. At the federal level, the National Park Service established the Historic American Buildings Survey (HABS) in 1933 and Congress passed the Historic Sites Act in 1935. Recognizing the impossibility of preserving all historic buildings, HABS sought to "record in a graphic manner" the exact "appearance of type structures" as a "form of insurance against loss through future destruction." In 1949 Congress chartered the National Trust for Historic Preservation. Federal action culminated with the National Historic

Preservation Act in 1966 that established preservation roles at the federal, state, and local levels.[3]

The State Historical Society of Wisconsin, under Edward Alexander, Clifford Lord, and Leslie H. Fishel Jr., who served as directors from 1941 to 1969, began to carve a niche in historic preservation and historic sites. Both Alexander and Lord brought ideas and experiences from the New York Historical Association and the Farmers' Museum. The first historic house museum dated to 1850. By 1960 more than one thousand historic houses and historic villages populated the American landscape. The Society had no role in this growth until the 1950s. The vision for a single site to preserve Wisconsin's ethic architectural heritage did not emerge until the late 1950s when two Wisconsin preservationists, German immigrant Hans Kuether and architect Richard W. E. Perrin, began to lobby the Society. As witnesses to the increasing destruction of the state's ethnic architecture, they brought an urgency that the Society had previously lacked. They knew that time was the great enemy of preservation.[4]

Before the Kuether/Perrin vision could be accepted, the Society had to undergo an eighteen-year preparation period. With the end of World War II and with the many war-imposed restrictions and shortages relaxed, the Society "mapped plans" for an ambitious effort to re-create itself. Wisconsin had a historical society that predated statehood (1848) by two years. Until 1949 the Society, located in Madison, the state capital, was a private not-for-profit organization that had limited public funding. In 1949 the Society became a state agency and received a greater infusion of state funds. During its first century, the Society, which remained inconspicuous even in Madison, concentrated on its library, its archives, and its small museum.[5]

Change came most notably with the appointment of Dr. Clifford Lord as the Society's sixth director in 1946. Alexander characterized his successor as "one of the most accomplished historical promoters of the entire country." In addition to bolstering its budget and publicizing its work, the Society intended to become a model for bringing history to the people "in a variety of ways." It moved to complement its traditional research and resource functions with new programs—"popular" history, as its critics styled it—that included the development of historic sites. At his first public meeting of the Society, Lord applauded the Society's commitment to the *scholarly* public and pointedly asked, "What of the *general* public?" After talking about the Society's goal to expand its role, he rhetorically asked if his vision was "too glowing." "Is it beyond our

reach?" This question would haunt the ambitious program initiated in 1964.[6]

Wisconsinites had not ignored historic preservation before 1946, but it was either a local responsibility or a private undertaking. The Green Bay Historical Society undertook in 1909 to restore the Tank Cottage, the oldest structure known in Wisconsin; a Norwegian American businessman from Chicago began restoration of some log farm structures near Mount Horeb that dated to the mid-nineteenth century; and two Mineral Point residents began a creative restoration and reconstruction of Welsh mining structures (Pendarvis) in the 1930s and ran it for many years as a private business. In 1938 the Society reported on a survey of some of the state's historic buildings. These examples suggest some interest in the preservation of heritage sites.[7]

The Society's traditional role was to encourage preservation by local agencies with the promise to assist with fund-raising whenever possible. Lord used the collapse of a historic house in Milton, Wisconsin, to alert "other communities" to care for their "historic shrines" before the ravages of time made preservation prohibitively expensive or impossible. Robert M. Neal, one of the restorers of Pendarvis and president of the Mineral Point Historical Society, fitted the Society's philosophy. At the Society's request, Neal wrote an account of the restoration, which Lord hoped would serve as a model for other communities. Lord positively noted the creation or revival of numerous local societies between 1946 and 1953. The Society had three "field men" to encourage initiatives at the local level but had no programs or personnel in Madison.[8]

Edward Alexander, director of the SHSW from 1941 to 1946, was the first to flirt with the creation of an open-air museum at the state level. In 1969 he recalled that he and the dean of agriculture discussed developing an outdoor museum at Picnic Point, a 129-acre site on Lake Mendota that the university had purchased in 1941. Alexander also "discussed it with the Society's trustees but got no further than the general concept though I did talk to a few architects about it. If I were to live my life over, I'd give it No. 1 priority for the Society and let some of the other innovations slide." This effort failed for a number of reasons. Planning never advanced beyond an informal discussion with the Society's governing board. More important, the proposal raised at least two thorny issues that, from the Society's perspective, never seemed to go away. The first was the lack of budget resources. This made the Society dependent on extraordinary appropriations from the legislature, fund-raising efforts, and interstate agency cooperation to acquire land.

In this case, the university, which had used its funds to purchase the land, would have to endorse the use of its land for an outdoor museum on the campus. Second, historic preservation of historic sites in the mid-1940s was in its infancy at the Society and had yet to reach a priority status.[9]

The legislature complicated the Society's situation in two ways. While the biennial budget covered a portion of regular expenses, extraordinary needs required special appropriations or aggressive fund-raising from private sources. New initiatives necessitated new money. This meant advocating for additional appropriations from the legislature and with private foundations. Second, making another agency, in this case the Wisconsin Conservation Department, the primary agent for the acquisition of state land necessitated close cooperation with that division. In moving forward, Lord acknowledged that Alexander "paved the way" for the Society's sites program.[10]

In 1947 Lord welcomed an alliance with Conservation. He believed it was "a matter of common knowledge" among those interested in "preserving historic buildings and sites in Wisconsin" that it lagged behind its sister states. Inaction left precious resources to "the wrecker's hand." At its 1946 annual meeting, the curators had appointed a Committee on Historic Sites. This move anticipated the partnership with Conservation, the agency responsible for administration and care of state properties, including historic sites. The Society would provide the "technical knowledge and resources" to judge the authenticity and merits of proposed sites and plan "restoration work" as well as furnishings for buildings and layout.[11]

Speaking at the Society's annual meeting in 1947, L. C. Harrington, superintendent of Forests and Parks, noted that prior to 1947 the state had acquired a few properties as state parks, most of which were historically significant, and that many other sites needed to be acquired and preserved. The challenge was that the state lacked a "well recognized and coordinated procedure for the acceptance and maintenance of these historic places." Representatives of Conservation (later the Department of Natural Resources), the Society, and the Wisconsin Archeological Society met to hammer out the procedures. This resulted in a law that broadened the authority of Conservation and gave it an annual fund to acquire and maintain sites for public recreation or public education. To facilitate collaboration, Harrington intended to employ a historian through a pooling of Conservation and Society funds.[12]

Lord was not content with a secondary role and introduced a number of initiatives that reflected a growing interest in historic preservation and sites. As early as 1947 he asked the Society's Committee on Historic Sites to give him suggestions for historic sites that should be acquired by the state. He accepted that Conservation, using its funds, would purchase historically significant areas for preservation and education. Lord recognized that this initiative would not support "an immediate large program." At the least, the money made it possible to visualize and formulate a long-range schedule of acquisitions. As Wisconsin became more systematic in its approach to preserving some of its heritage, the state joined a growing national trend.[13]

In April 1948 the Society (funded by Conservation) hired Ray Sivesind to carve out a niche in the related areas of historic preservation and historic sites. A year later, Sivesind spoke both enthusiastically and tentatively about the Society's interest in developing sites at two state parks, the First Capitol State Park (Old Belmont) and the Nelson Dewey Memorial State Park (Cassville), the estate of Wisconsin's first governor. In both examples he made visitor interest the stimulant for further development of the sites. He made no reference to paying for the conversion from a state park to a historic site. Conservation had "engaged" the Society to research the sites and make recommendations for the future development of the sites. By August the Society had submitted plans for refurbishing the "mansion," the rebuilt Dewey house at Cassville, which was known as Stonefield Plantation. Three years later in April 1952, when Villa Louis (Prairie du Chien) opened, "the Society was for the first time in the historic site business." In June 1953 the Society opened its second site, Wade House at Greenbush. The language Lord used to describe the acquisition of Wade House reflected two characteristics that informed the Old World Wisconsin project. He described the house as "rescued" and noted its "permanent preservation."[14]

Lord also noted that during the previous year the Society committed to the creation of a period Farm and Crafts Museum on the Dewey estate in Cassville. The legislature had taken a direct interest in this museum and in 1953 declared Stonefield to be "the state farm and craft museum." That year, as it waited for a fixed plan from the Society, the Conservation Department committed to grading the site, landscaping the grounds, and building a series of small exhibit sheds and buildings for the large machinery. The Society set out to create replicas of buildings typical of rural village and farmsteads or to secure extant buildings that

could be moved to the site. Interestingly enough, during 1959 Milwaukee architect Richard W. E. Perrin had assisted Sivesind in acquiring a "stone cottage at Platteville for Stonefield." These buildings, whatever their origins, would primarily serve as display cases for the many agricultural artifacts and farm implements acquired during the state's centennial celebrations (1945–48). When Perrin approached Fishel in June 1960 with a proposal for a park consisting of salvaged historic buildings, he would have been aware of development at Stonefield. By the time the Society began to explore new sites conveniently located near Milwaukee, the state's largest urban area (Perrin's objective), Stonefield had some thirty buildings on-site, and staff added new buildings during the 1970s. In 1969 the Society completed the Wisconsin Agricultural Museum, which featured agricultural equipment used by Wisconsin farmers.[15]

The new sites program raised a number of important concerns that the Society needed to confront as it planned new sites. First, the Society needed the cooperation of the other state agencies, mainly Conservation. Other concerns included fund-raising, administrative costs, and sufficient visitation and sales to make the sites self-sustaining, as well as internecine strife between contending interests within the Society.

Alexander described the Society's modus operandi in 1960. It would develop sites by using capital funds supplied by some other agency or private group to develop the site. When the sites were ready for the public, the Society would manage them. The sites, which were located near population centers or near to main highways, would be managed on a "self-supporting basis" with revenues derived from admission fees. In this way, the Society would develop "bit by bit, year by year" a network of significant sites that paid for themselves. Alexander listed a number of "bits" that the Society had under consideration for development. They included the Eleazar Williams cabin (De Pere), Wisconsin's Territorial Capital and Supreme Court building (Belmont), the Ancient Indian Village (Aztalan), Circus World Museum (Baraboo), the National Railroad Museum (Green Bay), and the Brisbois House and Methodist History Museum (Prairie du Chien). On the basis of its existing sites and its ambitious plans, Alexander judged the Society to be a leader in the historical museum field.[16]

Hopes aside, Lord and Fishel understood that their success in sites development hinged on tapping into outside funding sources. Finding private sources to fund ambitious planning remained a constant concern, and a largely unfulfilled goal. As a first step to soliciting outside support, associates of the Society established the Wisconsin Historical

Foundation in 1954 to fund programs that the state would not or could not fund. Extraordinary funding from the legislature was possible but hardly assured. In an unusual move, however, the assembly did appropriate modest funds for Stonefield's development. As Lord boasted, the Society created this site only with "remarkable cooperation from county, village, local historical Society, the Conservation, and a small state subsidy." Money sometimes brought complications. The Society, with plans to develop a farm museum on the university campus in Madison still under discussion, had to fight a proviso that would have barred state funds for any comparable museum.[17]

The three newly developed sites reflected that funding would always be a foremost concern. They also shed light on the Society's fund-raising strategy during the 1950s: target interested donors for specific projects. Renovation of a large sheep barn at Stonefield ($57,000) could not be undertaken without "private gifts." Always optimistic, staff reported that a Milwaukee advertising man believed that the sum "can be raised quickly and easily from the farm implement manufacturers." To facilitate the restoration of St. Augustine Church in New Diggings, Lord contacted a "prominent and wealthy Catholic" to seek funding support. The Society generally sought donations from individuals who had an identifiable connection to the projects.[18]

With three sites, Villa Louis, Wade House, and Stonefield, open by 1953, and with a sites supervisor, Society words had been transformed into deeds. Lord bragged of "record attendances at Wisconsin historic sites" while noting that these three sites resulted from the "rather liberal" availability of "outside funds for preservation." Still, he recognized the limitations of the Society's approach. After several weekends spent making a visual inventory of some historic buildings in the state, he recognized that something must be done promptly to save them. The problem, as he lamented, was where to get the money to attempt a restoration or preservation of these buildings. He further acknowledged that the state "is probably not in a position to do anything." He called on Perrin for suggestions of "civic minded or philanthropic organizations" that he might approach.[19]

This important assumption guided Society planning: new sites would quickly become self-sufficient. The Society could bear some of the administrative costs, but planning assumed that attendance and on-site sales would prevent the sites from financially drawing down the Society's limited revenue base. When, for example, the proprietor of Dawn Manor at Lake Delton offered it to the Society, Lord launched

an investigation to assure it would be self-sufficient. This concept—that sites could pay for their operating costs—permeated planning in the 1960s.[20]

Finally, the new sites program raised another concern. As Alexander noted in 1960, the principles on which the Society operated may have been correct in theory, but their application brought forth problems, not the least of which was the monetary shortfalls the sites generated. Could the Society support its excellent library and archives while launching ambitious popular history initiatives? Its budget process meant that existing funds had to be allocated among an increasing number of worthy projects. At least one staff member raised a cautionary flag about this approach. In November 1960 Chet Schmiedeke questioned whether the Society could achieve its goal of developing Stonefield into the state's "largest and most attractive" historic site while taking on the proposed Perrin-Fishel vision. The "timing on this project is unfortunate. The thing we need right now is backing for our village at Stonefield. If this park idea gets under way it will certainly be in competition with us from a fund raising standpoint."[21]

The Society's newly created but limited historic sites programs served a number of Society objectives. They made history more accessible to Wisconsin residents; they encouraged tourism; and they preserved a few historic buildings. The vision entailed developing a network of sites and museums as "major educational facilities and major tourist attractions." Such an ambitious program exposed the Society's financial limitations and its increasing dependency on private funding. After this initial burst, Sivesind concerned himself more with sites management and less with the creation of new sites or preservation issues. The Society, still focused on its archives and library, continued to plan for new site development. Lord also continued to monitor local initiatives in places throughout the state and to encourage local development."[22]

During the 1950s, the Society initiated another project that would eventually merge with the Perrin-Fishel vision. The initial moves by Society staff to develop ethnic programs initially had nothing to do with historic sites. Looking to expand its constituency in the early 1950s, staff named nine groups that had limited or no association with the Society and discussed strategies to develop closer relations. Ethnic groups, with their rich heritage, seemed an obvious choice to bring into the Society's growing constituency circle. Efforts to cultivate these groups highlighted the challenges that were endemic to planning and reaching larger public audiences. Specific projects developed by the Ethnic

Program Committee included publicity, oral histories, and the enrichment of the Society's collections of manuscripts and artifacts. Collecting additional manuscripts and artifacts raised two issues: staffing and space. Publicizing the Society's interest in ethnic manuscripts and museum artifacts raised staff fears that it might be promising too much. The Society did not have sufficient funds to cover its existing programs. Without new monies to fund new staff, collection of these materials had to be approached with caution.[23]

By the time Perrin approached the Society with his vision, the Society had laid out its basic approach to the development of historic sites. Lord based his vision for historic sites in part on the assertion of a prominent Wisconsin politician whom he quoted as saying, "Wisconsin does not have enough of this sort of thing." Lord thought the time had come "to launch a more vigorous program for the development of historic sites." Educating state citizens and creating tourist attractions pushed the idea. The period of experimentation, Lord argued, had passed. Conservation bore the costs of site acquisition. The Society's guiding principle "had long been" that its sites and specialty museums, once completed, "should be self supporting." Lord noted that it had declined involvement with sites that could not meet "this basic requirement." But he allowed exceptions. At sites such as the Indian site at Aztalan, which lacked any (wealthy) descendants, public support would carry the site. He then voiced his fund-raising principle. Specialized sites such as the Medical Museum would be supported "almost entirely through private donations." With these principles in place, he articulated a ten-year program costing in the neighborhood of three million dollars, with half coming from the state and half from private sources. It remained to be seen whether his successor shared Lord's vision and commitment.[24]

Perrin was like a fire bell in the night. He sounded the alarm and sought support for preservation. He proclaimed his message loudly and clearly. Wisconsinites had to act quickly or risk the destruction of their rich immigrant architectural heritage. From June 1960 to June 1964, he continually lobbied Society personnel to step up and launch the initiative. Even Associate Director Richard A. Erney confessed that he had become fascinated with preservation as a result of Perrin's articles in the *Wisconsin Magazine of History*.[25]

On the eve of Perrin's proposal for Wisconsin's open-air preservation museum, the Society's most critical problem was finding resources to fund its ambitious plans. Acting director Donald R. McNeil summarized the Society's problems in 1959: "The unholy triad consists of space, staff,

and money—and the greatest of these is money." The state legislature provided the bulk of the Society's funding, but its appropriations never covered the expansive Society's programs. McNeil stated the obvious: the Society cannot depend on the government. Rather, the Society's ability to carry out its mission will be proportional to the "amount of private moneys raised." It must depend on its "private enterprise" (fundraising) by developing a critical mass of regular contributors. Then there was the critical matter of the expansion and maintenance of the existing sites. "Villa Louis and Wade House are not profitable enough to allow for expansion, nor even to take care of such pressing problems as a new roof, repainting, or promotional expenses"—an ominous warning as the Society contemplated an exciting and ambitious sites program.[26]

Nothing had changed with Fishel's appointment. After his first encounter with the state budget process (budgets, bills, committee hearings, lobbyists, and legislators), Fishel "cast caution out" and exposed the Society's failures with its sponsor, the legislature. Simply put, the Society had not been able to establish its credibility with its funding agency, the state legislature. While he took responsibility for not attracting the requisite legislative support, the message was clear. First, the Society was not able to overcome the dismissive attitude of the legislators and their inability to recognize the importance of the Society's role. Second, the Society could not convince legislators of the importance of telling the stories of Wisconsin's past. They were too "present-minded." He asserted that the new and improved historic programs were essential for the state and he lamented that practically no money was available for these innovative programs. The failure to secure additional funds from the legislature highlighted the need to gain support from private donors. Here, too, Fishel accepted responsibility for the Society. The Society has not been convincing; staff had not made its case that "our programs in history" are central to making "this state and this country vigorous." This lack of support raised questions about the Society's ability to implement its growing commitment to preservation.[27]

Given these financial limitations, Acting Director McNeil had asked rhetorically in 1959, "Where do we stop?" He answered that we do not. "We go as far as we can." Within this context, preservationist Perrin approached Fishel in 1960. His conversation with the director would set in motion events that would test the Society's financial limits. Could it indeed create a major outdoor museum that would salvage historic structures and fulfill the mandate to bring history to ever-widening audiences?[28]

Perrin's notion to preserve some historically significant buildings at "safe" sites emerged in the years after 1953. He based his proposal on observations made during his European trip that year. The United States government had sent Perrin and seven other architects to evaluate how European governments were using money granted through the Marshall plan. While in Europe he had the opportunity to become acquainted with a number of outdoor museums in Germany and some Scandinavian countries. The Swedish open-air museum Skansen served as Perrin's prototype. Its founder, Artur Hazelius, was a very practical visionary who launched the open-air museum concept in 1891. To his site, he moved buildings from throughout his country and created "our *old* Sweden in miniature." As Perrin walked the streets and viewed the buildings, he envisioned that the model could be replicated in his home state. He must have also grasped that relocated buildings offered a wonderful opportunity to tell about the ordinary people who formed the bulk of Wisconsin's immigrants. Perrin echoed Wisconsin architect Frank Lloyd Wright's thoughts on vernacular architecture. "The true basis for any serious study of the art of architecture still lies in those indigenous, more humble buildings everywhere that are to architecture what folk-lore is to literature." He returned to Wisconsin with the open-air museum concept to preserve vernacular architecture firmly embedded in his mind. In effect, Perrin proposed that the Society collect historic buildings in a fashion similar to collecting historic manuscripts.[29]

Perrin first concentrated his efforts on two interrelated issues. More than twenty years of field investigations for HABS made him realize that many buildings would not survive much longer. His immediate concerns centered on developing a program "to preserve and restore old buildings of historic significance and architectural value" and to survey thoroughly the existing buildings scattered throughout the state. Since the 1930s Perrin had been documenting Wisconsin's rural architecture and had witnessed its steady physical deterioration. In 1953 the American Institute of Architects, a professional association of licensed architects, appointed him Wisconsin's preservation officer. Lord congratulated Perrin on his appointment and pledged his cooperation in future projects that would be of mutual interest. He lamented that he could not "suggest readily adequate sources of funds to carry on the program of the Historic Buildings Survey." Fundamental to any implementation was the creation of an accurate and reasonably thorough descriptive list of Wisconsin's historic buildings (inventory). The Society and individual efforts by Perrin and others failed to complete this task. The Society was not well

positioned to accept responsibility for the survey. Three years later Lord
sent Perrin a list of local and county historical societies and expressed
gratitude that Perrin was getting some help in his survey of historic
buildings.[30]

One individual, a private citizen and an associate of Perrin, tried
to stem the tide of deterioration. Hans Kuether, who emigrated from
Pomerania in Germany in 1923, joined many other Pomeranians who
especially found Wisconsin attractive. Since the mid-nineteenth century,
they had re-created their distinctive architecture (*fachwerk*) throughout
the state. As he traveled the state, Kuether increasingly worried about
their deteriorating condition. In 1956, and on his own, Kuether attempted
unsuccessfully to preserve examples of Pomeranian architecture by
re-creating a village near Lebanon, Wisconsin. A significant effort by a
dedicated but untrained individual who lacked outside funding had no
chance of succeeding. His lack of success did not dampen his ardor.
Kuether shared his "wonderful idea" with Perrin, telling him of his
desire to preserve half-timber buildings still standing by moving them
to "one designated location somewhere in Wisconsin where they would
be re-erected into a village similar to one in the old country." Perrin
endorsed the idea of creating an "old country Pomeranian village" but
lamented that he had "tried the National Trust for Historic Preservation
on far less ambitious projects" without success. More optimistically, he
added that something as unique as the proposed village "might stir up
interest, whereas the preservation of individual structures did not even
arouse much local interest. If you have any ideas as to where I might go
for assistance, I will most certainly pursue this idea." Kuether's next move
made sense. He needed a greater financial base and appealed to the state
through its historical society. The Society clearly had telegraphed its
intention to expand its role in historic sites. Kuether thought his proposal
fitted nicely into the Society's developing preservation commitment.
He was wrong, and his petition fell on deaf ears. Sivesind, who thought
the idea was a good one, rejected any role for the Society in the project.
It was not that the Society had neither the will nor the financial base to
make the commitment. Rather, the Society had an ambitious plan in
the wings, and a Pomeranian village was not part of it.[31]

"Wisconsin Historic Sites Project" summarized the Society's thinking
and possible actions under consideration as Lord's tenure neared an end
in 1958. The document made an assumption that the state should be
involved in and be supportive of historic sites as a means of educating
the public and increasing tourism. It also assumed that historic sites, if

carefully selected, well developed, and efficiently managed, *"can pay their own way."* Historic sites had become one of the prime tourist attractions since World War II. Wisconsin lagged far behind other states in developing sites that would have an educational appeal for both schoolchildren and adults. The report made a "modest" proposal for an effective long-range project (ten years) to develop historic shrines and specialty museums to close the gap. It assumed significant state financial assistance that would be supplemented by an equal portion of private funds.[32]

The report listed possible sites, which because of location and potential for public promotion gave "every promise of self-sufficiency." In addition to the existing sites, the report envisioned three others that the Society would create and operate: the Circus World Museum (Baraboo), the National Railroad Museum (Green Bay), and the Medical History Museum (Prairie du Chien). The report listed other restorations that could be developed as well: the Territorial Capital (Belmont), Black Hawk War Fort (Blue Mounds), the fortified prehistoric Indian village (Aztalan), Fort Winnebago (Portage) or Fort Howard (Green Bay), and a fur trade museum (Land O' Lakes area). As noted, this proposal carried a price tag of $3 million to be financed over ten years. In return for its half, the state would have "a fine chain of attractions well distributed geographically over the state" that would draw "hundreds of thousands of additional visitors each year." The report, which asked for eight new employees, assumed that the Society would be responsible for creating and maintaining the exhibits at the sites. Last, it assumed that adoption of the program would facilitate securing needed private donations.[33]

By the time Lord left as director, some patterns had emerged. In fast-changing post–World War II America, the Society had embraced a new responsibility of developing and managing historic sites. By the mid-1950s it had three sites open and continued to plan for new ones. Its leaders tempered this enthusiasm with recognition that the Society lacked the financial resources to carry out independent initiatives. The Society knew that success or failure of its enterprises depended on fund-raising on the one hand and cooperation with other state agencies and local societies on the other. Finally, the planners operated under the assumption that carefully selected locations, public promotion, and modest admission fees would make sites self-sufficient. Planning to this point targeted specific topics, such as circuses, railroads, or forts. Interest in developing "another huge tourist drawing card" that would allow

Wisconsin to "surpass its competitors" (other states) motivated planners. In 1960, fueled by Perrin's urgent pleas to salvage some of the state's ethnic architecture, priorities slowly shifted to include a major effort to preserve Wisconsin's ethnic architectural heritage.

The time was ripe to bring together tourism and preservation with another long-standing Society interest, the celebration of Wisconsin's diverse ethnic heritage. Perrin, the driving force for the ambitious new project, was not the first "outsider" to lobby the Society. Nor was he the first to suggest the idea. He did become the most vocal and tenacious advocate for historic preservation and site creation. With Perrin now as its primary proponent, the Wisconsin idea to preserve buildings by relocating them to safer environments began to take form in 1960. That year, he published a booklet, *Historic Wisconsin Architecture*, which he intended as the "guidebook on historic Wisconsin architecture." He wanted to "help develop interest in Wisconsin's historic buildings." Why did Perrin succeed where others had failed? His heritage, his education, and his professional activities, which included numerous scholarly articles on Wisconsin's architectural resources, fitted him well for the role he was to play. Beyond this, his personality suited him well for gatekeeper of the state's historic preservation conscience that he was destined to play. His ability to persevere in the face of complacency served him well. Other factors, namely, Fishel's appointment and a growing national interest in historic preservation, made Perrin's timing impeccable.[34]

Fishel became the second major player. In the year following Kuether's proposal, the curators appointed Fishel as the Society's seventh director. He could not recall anyone raising questions about historic sites during the interview process. He did not come to the director's job with the idea of creating a major outdoor museum. His education and his work experiences to 1959 included nothing related to historic sites. He recalled no interest in the subject while a graduate student at Harvard or as an assistant professor at MIT. His dissertation was in African American history and he sought an academic appointment upon graduating. Although he resided in Massachusetts, he admitted that he had not visited either Plimoth Plantation or Old Sturbridge Village; he did recall a visit to Colonial Williamsburg as a child. Fishel brought neither an interest nor a commitment to historic sites or, for that matter, historic preservation.[35]

Fishel did not remember when he made the commitment or even when he first met Perrin. His office logs indicated that Sivesind brought

Perrin to see Fishel in June 1960. Fishel had been on the job for less than a year and was still establishing his priorities. Perrin's passionate (almost obsessive) advocacy of historic preservation opened a new vista for the director. Well in advance of the new "social history" that would transform outdoor museums beginning in the early 1960s, Perrin was a devotee of "the more humble and ordinary things" of Wisconsin's rural population. His interest was not that of a social historian, although he was undoubtedly aware of the nineteenth-century *völkisch* movement; rather, his was the interest of the architect whose passion was folk architecture. His extensive travels through the state convinced him that Wisconsin's rich heritage of vernacular architecture was in critical condition. Every year, important and irreplaceable architectural artifacts — houses, barns, and privies — disappeared from the landscape at an ominous rate. Perrin was not the only person who grasped the magnitude of the destruction of the state's vernacular architecture, but he became one of the most vocal voices of its preservation. So frequently did he sound the alarm that he wore out his welcome with some staff.[36]

Perrin broached his idea for saving historically significant structures in Wisconsin. The architect usually noted that he intended to salvage buildings that had been seriously neglected and unwanted by their owners. He did not intend to take buildings that could be restored in situ. He wanted to save some barns and houses he thought were near *destruction*. His idea was to put some of them in a park or a series of parks. Fishel took some ownership of the idea when he coupled the buildings with their builders. This was the marriage of ideas that made Perrin's vision a possibility. Fishel recorded that "as we talked I proposed an Ethnic Park, with representative structures of various ethnic groups." He thought Perrin liked the idea and they talked about financing. The origins of the Society's involvement in the outdoor museum that would become Old World Wisconsin dated to what Fishel styled "an interesting hour and a half or so." Later the director described himself "as one of the rare persons in the Society who thought [Perrin's proposal] was a good one." The architect and the historian of African Americans found common ground by connecting buildings and people.[37]

Seemingly insurmountable barriers abounded. Funding topped the list of matters to be considered, and Perrin and Fishel discussed financing. Without a transcript of their conversation, the nature of the details cannot be known. Perrin discussed the pioneer park concept with the editor of *Let's See Magazine* some months after his meeting with Fishel. The editor asked: "What does it take to get such a park?"

Perrin established two standards that had to be met: a successful quest for outside funding and the involvement of Wisconsin residents. He stated: "The magic ingredient, of course, is money. Money might be available from the state, from private contributors, or from a large foundation, although it is not available from any of these sources at the moment." The editor opined that the solicitation of funds must be preceded by the enthusiasm and the spontaneous interest of citizens. He thought no one exceeded the enthusiasm of Perrin. "If these old houses are to be saved, something must be done about them in the near future. If nothing more, they should be taken over by an interested group, dismantled, and stored until the time they can be reassembled in the dreamed-of-outdoor museum."[38]

Perrin uncharacteristically counseled patience. A project such as he suggested would most likely not break even at first, which meant it would need to be supported. He took a long-range view that it would be cheaper to build the museum now than wait a hundred years to reconstruct the pioneer park. As it turned out, construction would have been much cheaper if it had started in the early 1960s rather than in the 1970s. He knew that the Society could not fund the entire project. "The Society does, however, hope to be able to act, even if it is a shoe-string operation, to save one or two of the state's cultural monuments, and to be able to draw up a proposal for an outdoor museum in which representative houses of the nineteenth century could be displayed in settings similar to the original. It would like to find a foundation interested in backing the proposal."[39]

From the very first conversations, financial considerations were on the table. They could be ignored only at peril. Fishel further knew that he had little or no discretionary funds to commit. The historic preservation movement was still in its infancy. Should the Society commit to the proposed preservation role, it would enter unchartered waters as far as costs. The lack of any ready resources, however, did not stop Fishel from pursuing the hybrid idea of an ethnic museum. Exploration of the vision, using existing staff and volunteers, came with minimum initial cost. The pace though was excruciatingly slow. Almost four years passed before Fishel was ready to take the proposal to his board.

Fishel thought the idea had merit, but, lacking funds and with no experience saving old buildings, he approached it with extreme caution. He reflected on the "problem" Perrin had outlined. "I don't want to get rutted in this idea of an Ethnic Park," he told Sivesind, "but if it has some merit, we ought to explore it a little more." He listed six points for

extended exploration. He thought that the Society had to have the cooperation of Conservation (which "owned" the land), that the park should be near Milwaukee, that the reerected antebellum buildings should be set in a proper environment, that the buildings should be furnished appropriately, that ethnic groups should be encouraged to use the park for celebrations, and that expanding the park to house buildings after 1865 should be considered later.[40]

He instructed Sivesind to "take off with those ideas so that they can be rejected, or when revised, made the basis of a proposal to a foundation for money." The director also noted that the Society had to have a good idea of which buildings it wanted to include in the museum. He told Sivesind that once they agreed on objectives they could take it to the curators and request permission to work with Conservation and financial foundations. Sivesind responded that this "idea needs quite a lot of study," a theme he reiterated over the next few months. After reading a prepublication copy of the *Let's See Magazine* article on Perrin's proposal, Sivesind opined that he hoped "this ethnic park does not become a Greenfield Village which falls under the classification of that much used term 'visible storage.' The idea is basically good but it needs better thinking than this article reflects."[41]

The first step for the Society had to be the commitment. Fishel made a first, tentative commitment. At some point, however, he would need the endorsement of the curators. That it took four years for Perrin's vision to reach the board and to receive its backing foretold the long road ahead for site advocates. In the meantime, Fishel and Sivesind investigated possible sites. At Fishel's request, Perrin addressed those gathered in Whitewater, Wisconsin, for the Society's annual meeting on June 20, 1964. Agitated about the destruction of resources that had taken place in the intervening four years, he assembled his slides for one more appeal for action. He told Tishler that he "more or less wound up the talk by saying 'I've done this so many times and I'm never going to do this again because I'm disgusted. Every year I go out to some of my old haunts and more and more things are gone. Something needs to be done.'" He urged the curators to take quick and decisive action by establishing a series of parks around the state where decaying buildings could be brought and restored.[42]

Perrin's words and his slides had a powerful impact on the curators. Dick Erney recalled the presentation. Perrin was a "scholar" and a "fascinating fellow" who "really knew his business." Nothing ever grabbed the imagination of the members of the board the way the

proposed museum did. Partly it was Perrin's passionate persuasiveness that motivated the curators to take action. But, in the final analysis, it was Fishel's influence that persuaded the board to endorse the *concept* of a single park to preserve some of the state's architectural heritage.[43]

The curators authorized planning to move forward. By its action, the board committed to studying a long-range project with no established timetable. Most important, perhaps, was Fishel's decision to request no budgetary commitment for the study or for the Society to carry out the directive. His approach made sense for two reasons. As a novice, Fishel had no idea how much the project might cost. Beyond that, by not attaching a dollar figure to the endorsement, Perrin's idea at least had a chance to succeed. Perrin gave the museum its reason for being, namely, to salvage and preserve Wisconsin's architectural heritage. Fishel added the other necessary ingredient, connecting the buildings with the ethnic groups that had built them. Another goal—greater involvement of Wisconsin's ethnic groups with the Society—could be achieved with the preservation of some of their buildings and by telling their stories. It was a necessary first step, but the dedication of the site was still a decade away. Four days after Perrin's plea, the curators authorized their newly elected president to appoint a committee. In September, Society president Scott Cutlip appointed the Outdoor Museum Committee (OMC) and named Milwaukee businessman Norman FitzGerald as chair. This was an important step in gaining curatorial ownership of the project. Indeed, this committee and its successor became the sustaining energy for the museum. Cutlip charged committee members to put together a program for the outdoor museum. Soon after, he referred to the museum as "one of the most exciting potential tourist attractions in the midwest." Interestingly enough, the Society never emphasized nor fully exploited the tourist angle after planning began in earnest.[44]

Fishel had his endorsement from the board. More important are the commitments he did not seek. He asked neither his board nor its executive committee for a financial commitment. He sought neither additional funds from the legislature nor an endorsement for the park. Nor did he seek a formal endorsement of the concept from his division heads. This left the issue of the ethnic park's possible impact on department budgets unresolved. It helps to explain the Erney October 6, 1969, memo that questioned the Society's ability to pay for the museum and its impact on other programs. Fishel based his commitment on six considerations beyond the curatorial endorsement. First, he did not want to invest any significant funds in the project. He intended to forge ahead using existing

staff and budget. The amount of money spent on planning was the barest minimum. Second, never during the time of Fishel's tenure (1959–69) was the commitment such that he and the Society could not have withdrawn from it without much public exposure. Third, he approached the project incrementally, "inch by inch," as he later characterized it. Fourth, the commitment brought no sense of "urgency or haste" to resolve the matter quickly. Fifth, if the commitment was not a high priority, it was also a relatively small one in the context of other Society activities. An outdoor museum for the purpose of preserving some architecturally significant buildings of the many ethnic groups who made Wisconsin their home was only one of many initiatives undertaken during Fishel's tenure. Other projects, such as the expansion of the Society's headquarters and the multivolume history of the state, demanded considerably more time and effort. Most important, this commitment existed only "if funds can be raised for this project."[45]

Limited experience in the development of historic sites and a dearth of discretionary funds for launching a major enterprise restricted the Society's options. Once the curators committed the Society, at least six other major obstacles or impediments had to be overcome if the Society was going to succeed in the effort to save some historically significant buildings. These included the selection and acquisition of a site, development of a master plan, an inventory of historic buildings that assessed availability and estimated moving costs, financing and fund-raising, publicity, and the acquisition, dismantling, moving, and reerection of buildings on the site. In this context, two things need to be noted. The first is that these six obstacles, while obviously interconnected, could be approached incrementally. The second consideration is that when it came to financing, most participants seemed willing to leave that concern on the back burner. In part, this can be explained by the fact that the first four or five obstacles had to be developed before financing became relevant. More important, though, was the general reluctance to face the consequences associated with still another major fund-raising campaign.[46]

CHAPTER TWO

Managers

Lexicographer Dr. Samuel Johnson (1709-84) once remarked: "Great works are performed not by strength but by perseverance." As will be demonstrated, perseverance was the key weapon in the Society's arsenal. Simply put, more than a decade after initiating its sites projects, the Society was not in a strong position to launch a new project of the magnitude envisioned by Perrin. Lack of personnel trained and experienced in museum building, multiple major projects that the directors managed concurrently, an inadequate financial base, and an embryonic fund-raising strategy presented serious managerial challenges. Between 1959 and 1977, three men, Leslie H. Fishel Jr., Richard A. Erney, and James Morton Smith, directed the Society. Their management skills were critical for the success or failure of the proposed innovative open-air museum. Lesser men might have quit the field, but they persisted by moving from a concept to a museum in the space of twelve years.

At the Society's annual meeting in June 1964, curators responded to Perrin's impassioned plea and endorsed the *concept* of developing an outdoor site to preserve some of the state's ethnic architectural heritage. The commitment came at the midpoint of Fishel's ten-year directorship. The next five years tested the director's ability to persevere in the face of mounting obstacles. Fishel and the curators would soon learn, as the director of Old Sturbridge Village had cautioned, that the problems of

establishing an outdoor museum of the magnitude contemplated would be complex and would involve the mastery of special details.[1]

Defining the *meaning* and *scope* of the concept and finding the means to pay for it fell to the Society's director, his small sites staff, and a group of volunteers who served on the OMC that the president of the Board of Curators appointed to assist with planning and development. As director, Fishel was a linchpin. He had to lead, encourage, and coordinate the activities of the other players, his staff, the curators, and at least three curatorial committees—executive, outdoor museum, and long-range sites planning. His management approach must be viewed through his success in achieving seven major goals (or, perhaps, in overcoming seven major obstacles) that the Society confronted as it entered the realm of museum creation.

Two other outdoor history museums started in the 1960s give a perspective on the managerial challenges Fishel faced. In the neighboring state of Iowa, William G. Murray, who had recently lost his run for governor, turned his attention to the creation of an open-air museum. The economics professor at Iowa State University wanted to showcase the "marvelous story" of midwestern agriculture from Native Americans to present-day farms. He envisioned a series of farms at a common site to show agricultural change through time. He began in 1967, and within three years he opened Living History Farms as a work in progress. Within a relatively short time span, he created a master plan, used his political and corporate contacts to raise funds, acquired a five-hundred-acre site in Urbandale, Iowa, and began moving buildings to the site.[2]

In 1965 the Maryland Assembly appointed a commission to investigate the possibility of creating an outdoor history museum at the site of Maryland's founding, St. Mary's City. On the basis of its committee's report, the assembly in 1966 created the St. Mary's City Commission and authorized it to research, plan, acquire the land, and develop the museum. The initiative was part of a much larger stimulus package for the three economically depressed southern Maryland counties. The enabling legislation created an independent agency that reported directly to the governor and provided a modest budget. Over the next decade, the commission struggled to define its objectives, hire staff, create a master plan, undertake extensive historical and archaeological research, and acquire the needed land in the face of considerable community opposition. The museum had little to show visitors after its first decade and would not open officially until 1984, more than twenty years after the assembly authorized the project.

Living History Farms and Historic St. Mary's City represent two extremes for museums launched in the 1960s. If Murray, as an individual creator, moved with fewer encumbrances, managers of state-sponsored Historic St. Mary's City did not. Unlike these two operations that focused on one task, the creation of the outdoor museum was not the Society's only objective. As it had for the St. Mary's City Commission, land acquisitions proved the greatest detriment to the Society in getting started.[3]

This chapter examines Fishel's leadership as he sought to achieve two foremost goals — selection and acquisition of the site. Both proved frustrating and time-consuming and tested his leadership. Fishel's modus operandi for the ethnic village was incremental and cautious. If he shared either Perrin's passion or his sense of urgency, he kept it well disguised. He managed a major historical society that was in an expansive mode. He had many projects underway simultaneously, and the projected outdoor museum was only one among many and certainly not his top priority.

Before considering issues of management of the projects, three questions must be posed. Did Fishel have the support necessary to carry out such an ambitious plan? Did Fishel consider the 1964 commitment a significant step for the Society? How did Fishel use his staff, the curatorial committee, and the volunteers?

As director, Fishel did not have unlimited discretionary powers. The Board of Curators that had hired him took an active role in management of the Society, and Fishel needed their support. At least one powerful curator raised issues about Fishel's leadership. About a month after the board embraced the outdoor museum concept, tensions surfaced within the curatorial ranks. Board president Cutlip reported on a long talk with curator Robert Murphy, who "detailed a number of criticisms of Les Fishel." Cutlip explained the board's position "that Les must be strengthened and guided" and not "pressured into quitting." Murphy, who had chaired the search committee and knew well "how scarce qualified candidates for this job are," appeared to accept fully "our position." To ease the tension, Cutlip moved Murphy off the Executive Committee. The disgruntled curator assured Cutlip "that he was willing to go along with our position for an indefinite time."[4]

Beyond this, division leaders offered less than enthusiastic support. Fishel recalled that his newly appointed associate director, Dick Erney, who had been in the archives division, "would've opposed it, and I'm sure he did oppose it, because he was not an historic sites person." He

felt the museum would unduly strain the Society's resources. Erney admitted that Fishel favored historic site development more than he did. But Erney saw himself as a "team player" who believed one of his roles was to "argue vigorously" with the director. He certainly did not publicly oppose the director. Fishel also recalled that tensions existed between the museum staff and the library archives staff. They did not see "Society objectives through the same eyes." The tension usually concerned allocations from budgets that had limited flexibility.[5]

Fishel deemed neither Perrin's presentation nor the curatorial commitment worthy of note in his narrative report and the summary review of the proceedings of the annual meeting. The absences indicated the museum's low profile as of 1964. A more public acknowledgment depended on having something more tangible to present than a concept. Moving forward depended more on curatorial support than on the staff's. Still, Fishel waited almost a year to announce the Society's intention of creating a "new type of historic site."[6]

Cutlip moved quickly to appoint the OMC as a first step. He had commitments in August from seven curators, including Milwaukee businessman Norman FitzGerald as chair. They accepted the call knowing they lacked knowledge and experience in museum building. Cutlip recruited Perrin to provide some expertise. He acknowledged the merit of Perrin's appeal and asked him to help the committee examine the possibilities and "show us the way to a workable solution" for preserving representative historic buildings. Perrin felt compelled to accept the appointment despite an extremely heavy personal work schedule. This committee of volunteers became a critical player in museum development. Fishel thought the curators had "loaded the Committee with people who had commitments to other historic sites." To staff the committee, Fishel appointed Erney and Sivesind. Committee members began their work in earnest but quickly realized that they labored under some limitations, not the least of which were their lack of training and experience in museum creation. Only Perrin and Sivesind had any experience with historic sites. FitzGerald, who was frequently away from Milwaukee, did bring business credentials and management skills but no museum credentials.[7]

In the four years between the approach and the commitment, Fishel enhanced his knowledge of historic sites. He offered some thoughts on site planning that obviously had the ethnic village in mind. A planning statement should convey that the Society acted on both "conviction and economic interest." Historic sites "are both educational and entertaining

(in varying degrees) and do fall within our mission to make historical information available to the general public." He further emphasized that implementation of a historic sites program "will be costly," but tourist spending and tourist appreciation "will return the investment many times over."[8]

His top priority was selection and acquisition of a site. Initially, this seemed a relatively manageable task. It was not. Securing the right site would take more than a decade. Between Perrin's June 1960 visit and the annual meeting in Whitewater in June 1964, Fishel and others visited a number of possible sites, including the Bong Air Force Base in Racine County. Fishel concluded that the "Air Base is not ideal for the Ethnic Park, but it will do in a pinch." Bong was not yet available (the state eventually acquired it in 1974), and no one seemed to be able to say when the state would get the partially constructed air base from the federal government. Bong's flat terrain and small area raised issues about the Society's ability to display the buildings in a setting that resembled the original locations. Staff visited a number of sites in the Milwaukee area before settling on the Kettle Moraine State Forest near Eagle.[9]

In 1962, after investigating possible sites, the Society initiated discussions with Conservation. The Society proposed using a portion of the state forest in southwestern Waukesha County that Conservation owned. Here was Fishel's dilemma: the cash-strapped Society could not buy it, and Conservation could not lease or give it to the Society. Fishel would either have to raise money from private sources or find an alternative way to secure cooperation from Conservation. Given their earlier collaborations, use of the land at no cost seemed feasible and was the most desired scenario. Conservation would provide the site and services, and the Society would contribute buildings and historical research and supervise the presentation and interpretation of the site to the public. There was, however, an important distinction. Unlike the first three collaborations between the Society and Conservation, Eagle was not a preexisting historic site. A way had to be found that would allow Conservation to give or sell land to the Society. This dependency led down a road littered with bureaucratic impediments that unduly prolonged the process. Negotiations between the two state agencies continued on and off for nearly a decade. With many false starts and blind alleys, dashed hopes and frustration littered the road to Eagle. It is ironic that the solution to the site acquisition hammered out by the two state agencies in 1971 very much resembled Fishel's proposal in 1962.

Conservation did not jump at this opportunity. Roman Koenings, the superintendent of Forests and Parks since 1957, rather adroitly called Fishel's bluff. The superintendent did not have adequate specific data to evaluate the project. He needed to know the nationality groups under consideration, the number of structures to be reerected, and costs for moving buildings as whole units or disassembled and then reassembled on site. Lacking a master plan or even a grand strategy, Fishel was in no position to supply such information. Despite the rebuff, he confidently assured Perrin soon after his conversation with Koenings that the park "is *feasible*" and that the Society remains "vitally interested in it."[10]

At the end of the year, Fishel reported the idea of the ethnic park to his governing board. The Society, he noted, was pursuing the idea of "drawing together in one large area, original buildings constructed by ethnic groups, delineating each group's buildings, and adjusting the buildings, the topography, landscaping, furnishing, etc. to the original." Then he admonished: "This is a costly plan, but it has some support and, with more time and attention, it could become a reality." Beyond the usual warnings about potential costs, however, no one at this point looked into how "the dreamed-of-outdoor museum," as Perrin described it in 1960, was to be financed. One thing was certain: the museum would not be financed in any large part from the Society's anemic budget.[11]

After the June 1964 commitment, the newly formed OMC made site selection and acquisition its top priority. Without a site, the museum remained illusory. Beyond location and cost, the committee had to consider the size of the site and its physical attractiveness. It took well over a year before the committee had a firm location for its site in its sights. Of equal importance, if only in Perrin's mind, was the creation of a list of possible buildings that included availability and the estimated cost of acquiring and moving them to the site.

The only committee member with preservation credentials took it upon himself to visit Old Sturbridge Village (OSV) in Massachusetts. Perrin's fact-finding trip in November 1964 helped shape Society thinking on the critical question of the number of acres needed and how the museum might eventually look. He reported on the history of OSV. Perrin delineated the role of the Wells family in the creation and financing of the museum. He discussed the nature of its incorporation and its management, the support of the Friends of OSV, and the willingness of OSV leaders to share with Wisconsin planners. This museum offered "many lessons for us in developing a Pioneer Park in

Wisconsin." He assumed "a similar pattern of development and of operations could be adopted." The principal difference would be the nature of the exhibits. "Instead of a homogenous historic entity such as Old Sturbridge Village represents, our Pioneer Park would be a collection of architecturally significant structures of various pioneer ethnic groups, and conceivably could embody activities of an arts and crafts nature which would represent these various cultures, so that in many ways our undertaking could offer a much more diversified exhibit of interest to as many or possibly more people than come to Sturbridge Village." His trip reinforced his conviction that "with the ingredients we have here in Wisconsin, an equally significant Pioneer Park could be developed," inspired by the example of OSV.[12]

Perrin did not convince everyone, and this reflected one of the problems inherent in working through committees: consensus. On the basis of his OSV visit as well as visits to other museums, Perrin thought the site had to be at least 500 acres, if "we are thinking of a significant outdoor museum." He warned that the Society must acquire enough land to buffer the site against outside encroachments. Milwaukee lawyer and committee member Fred Sammond thought OSV provided a prototype that was beyond the reach of the Society. He estimated that the cost of dismantling, moving, and reconstructing each building would be about $30,000. He concluded that it would take millions to develop the museum and added, ominously, "without foundation or private support, it would be impossible to effect." He urged consideration of a smaller, more affordable site. His counsel fell on deaf ears. Fishel's tactics included thinking big—well beyond the confines of the Society's budget.[13]

If the committee favored the Eagle site, the tentative state of the negotiations with Conservation forced consideration of other sites including Bong and Aztalan State Park. Personnel changes and realignment with Conservation meant that it would take time to "get negotiations back to where they were two years ago." Even FitzGerald grew frustrated at the slow pace and urged Fishel to give his sites director "a nudge" on the property issue. Fishel and Sivesind met with the director of Conservation and his top advisers but received no satisfaction. Conservation intended to use the land in the Kettle Moraine forest for hunting, fishing, camping, and boating. Not wanting to seem entirely uncooperative, Conservation hinted that it might be able to purchase 500 to 1,000 acres in the Town of Erin in Washington County, immediately north of Waukesha County. Erney inspected the general area and judged that it "seemed suitable for museum purposes." The OMC

agreed to seek federal or state funding to purchase land and to rely on private gifts for the purchase and restoration of buildings. It then voted that a museum of at least 500 acres be located in southeastern Wisconsin, preferably in the Kettle Moraine area.[14]

This decision did not make the Kettle Moraine site a sure bet. Conservation's cooperation remained critical. The committee never lacked for suggestions, and it continued to explore both known sites and new locations. Committee member Mrs. Howard Greene, a Waukesha County resident, understood that David Pabst might be willing to sell the Pabst farm at a reasonable price. According to one Society officer, the "Pabst farm is on I-94 and is a beauty, but lacks, I think, rolling land, woods, etc." As of March 1965, the Society had a list of possible sites: the Bong Air Force Base, other federal sites, the Kettle Moraine State Forest, county-owned lands, and two private properties (one in Waukesha County and the other in the Town of Erin in Washington County). Pruning the list proved easier than deciding between the two remaining contenders.[15]

This search for the ideal site for the outdoor museum was part of an ambitious historic sites program. If the Society came late to historic sites, it now sought to make up for lost ground. Fishel had delegated sites expansion to the Long-Range Sites Planning Committee (LRSPC). As the Society struggled with the outdoor museum project, Sivesind continued to seek new sites while he tried to manage the three existing sites. The long-range plans for historic sites are relevant for a number of reasons. The Society hired Professor Philip Lewis of the University of Wisconsin landscape architecture department as its consultant on future sites, and Sivesind instructed him to develop a long-range plan that evaluated the most significant sites in the state. He wanted to know the basic features of twenty-five to thirty sites. In contrast to the outdoor museum, these sites would resemble Villa Louis or Wade House. Soon after, Sivesind brought to the brain trust a map that identified fifty sites. Instead of pruning it, Fishel, Erney, and business manager John Jacques added other possible sites. The next goal was to rank them in terms of desirability.[16]

To complicate matters, the Society now revisited the question of one site or multiple sites located throughout the state for the Perrin preservation project. Lewis suggested the Society might want to consider a series of ethnic parks that would be scattered throughout the state and located near scenic highways. The possibilities for historic sites seemed unlimited. Sivesind worked with the LRSPC to develop lists of potential

sites. This ambitious expansion of the sites program seemed logical, even desirable, given the programs that Lord initiated in the late 1940s. Left unanswered was the persistent question of how the Society intended to pay for multiple sites.

Lewis suggested a possibility. He reported on a February meeting from which he had just returned. While in Washington, D.C., he learned that the administration of Lyndon B. Johnson intended "to out-do the Kennedys" in demonstrating support for "preservation and development of our cultural resources." He urged the Society to move quickly to shape up its proposal on the ethnic park that he thought was "a natural for federal aid."[17]

FitzGerald asked if Sivesind's student assistant could look into the "question of getting federal money" for land purchases. Quick action on the outdoor museum, however, was unlikely. The ever-impatient Perrin wryly commented, "Progress has been painfully slow." This was not entirely of Fishel's doing. He worked through a committee of volunteers that met at best once a month and needed the cooperation of state agencies over which he had no leverage. Cracking the shield Conservation had put in front of the Kettle Moraine area elongated the Society's response time. As a result, rather than closing any doors, Fishel, Erney, and Sivesind decided that the question of putting the ethnic park in one place or in separate locations should remain open. Fishel thought the Society could do both. Perrin acknowledged the possible utility of clusters of smaller ethnic parks throughout the state but strongly argued for a single park of 500 acres or more that would include the major ethnic groups as he had outlined in his presentation. His passion brought the focus back to a single site.[18]

In view of Conservation's intransigence, the investigation of Bong took on some urgency. The next step was to find the "right persons" with whom to discuss acquisition. Congressional representative Henry S. Reuss (Democrat, Fifth District) provided the answer: another state agency, the Department of Resource Development. A meeting with the planning consultant for the Bong Commission produced no new results. He expressed his enthusiasm for establishing the museum at Bong. The Society's landscape consultant, who mapped the site, pointed out that Bong was a good location for drawing visitors (in Kenosha County near Burlington) but lacked the topographical and natural features the Society desired.[19]

In August attention shifted again to the Kettle Moraine State Forest near Eagle. Discussions, which continued through the rest of the year,

finally seemed to be moving toward resolution. At its October 16 meeting, OMC chair FitzGerald stated that Conservation expressed its willingness to explore a lease agreement until a bill could be introduced in the legislature authorizing the transfer of the desired land. At the same time, Conservation made FitzGerald aware of its desire for Bong to be reconsidered. This led to a comparative tour of Bong and the Kettle Moraine site in late November with Conservation leaders. Fishel thought the tour "was time well spent for the Society," in large part because it gave Fishel the opportunity to talk with the new director of Conservation. That agency had changed its views and signaled Fishel it would favor locating the museum in the state forest. Conservation still wanted a sale, not a lease. Fishel was "pleasantly surprised" by the Bong tour. He seemed reluctant to abandon that site until the details of the Kettle Moraine site could be settled. But he hesitated to endorse Bong because its ultimate disposition was "somewhat up in the air." The Kettle Moraine site struck those who took the trip as the most appropriate site.[20]

As the Society inched toward its site, it received a boost in early 1966. Governor Warren P. Knowles endorsed the Society's historic sites program in general and the outdoor museum specifically when he addressed the membership at its annual Founder's Day banquet. Similar to Perrin, a trip to Europe informed the governor's perspective. Recently, he had traveled to Spain as part of a trade development mission. He visited the Spanish Village at Madrid, which he saw as a prototype of the Society's outdoor museum. The governor no doubt referred to the Poble Espanyol in Barcelona, a museum that displayed representative samples of Spanish architecture. A few months later, he challenged the Society to make its historic sites program attractive to both out-of-state tourists and in-state visitors. The governor might have invoked "Remember the Alamo!" at this point. He wanted Wisconsin to rival Texas in "tooting" its horn about its history. The governor strongly endorsed the Society's initiative to bring together small complexes of ethnic buildings at a single site. The buildings, now languishing unused and uncared for in out-of-the-way and inaccessible places, would be reerected on terrains that matched their original locations. They would be made accessible to the fifteen million people who lived within a radius of 250 miles of the new site. Knowles described the outdoor museum as "an exceptional project and an expensive one." He applauded the Society's plans to seek philanthropic assistance for completing the project and gave no assurances of state funds.[21]

This endorsement came with a price. The governor hesitated to endorse "a project of this magnitude" without some idea of the Society's planning. He requested the Society make an inventory of Wisconsin's potential historic sites (which he understood was already underway) and to establish priorities for developing future sites. More than a year earlier, Fishel had recognized the urgent need for an inventory of significant historic sites. Here again, his small staff prevented meaningful action. Above all, Knowles wanted the study to address ways in which sites could be funded. He hoped the report would become the basis for renewed cooperation between private and governmental groups in developing historic sites. By June the Society had compiled a detailed listing of twenty-six major sites and was in the process of compiling an inventory of less significant sites.[22]

The governor's remarks reflected the pervasive optimism that drove the state and the Society's interest in historic sites. These sites allowed the public "to know history by seeing it first hand." This, Knowles asserted, "makes for better citizens and better people." The economic value of historic sites gave another important rationale for the state's ambitious program. He cited statistics from the National Association of Travel Organizations to make his point and equated the impact of effective tourism in a community "to establishing a new manufacturing plant with an annual payroll of $100,000." His goal, and the Society's, was to make Wisconsin a leader "among those states who care for their cultural legacies." While historic sites were "a valuable resource for our State," he acknowledged that preservation is a complicated and major undertaking. Nowhere was the complicated process more evident than in the Society's effort to acquire a site for its museum. Sadly, the governor's endorsement did nothing to move that process along.[23]

By the time the curators met at the end of January 1966, OMC members had recommended, and the board had concurred, that a 500-acre tract in southern Kettle Moraine State Forest was ideal for the park. The board authorized the OMC to negotiate with Conservation. FitzGerald's tour and the ensuing discussions exhilarated him. "As a businessman of long standing in Wisconsin, I might add that I am proud that two state agencies can work as closely and as cooperatively as these two have done to date." Events in the next year tempered that judgment.[24]

This elation evaporated quickly as negotiations staggered through the next year. Did this reflect Conservation's reluctance to part with a

portion of the state forest? Did the endless delays result from internal dissension within Conservation? Was the proposal such a low priority that Conservation shunted it to the sidelines? Did the Society's committee system hinder negotiations? Don Mackie, who handled the negotiations and professed his support on a number of occasions, had internal issues (personnel and lack of support) at Conservation. The curators had assigned negotiations to a committee. FitzGerald was in Milwaukee and other members lived in various parts of the state. For critical negotiations with another agency, the committee system proved inefficient. FitzGerald admitted that he had not even met two members of his committee. Extended trips to Mexico took him away from Milwaukee at critical times. These impediments hindered the OMC's efforts to accomplish its goals of identifying the exact location for the museum, getting a legal description of the land, and writing and signing an agreement with Conservation.[25]

FitzGerald, in his frustration, frequently asked Fishel to intervene when he did not receive responses from Mackie. A meeting of the OMC had to be postponed because FitzGerald had not received critical data from Mackie. The OMC missed deadlines for reporting to two general meetings of the Society, one in January and another in June. Fishel had no leverage with Conservation. In response to FitzGerald's plea to start nudging Mackie, Fishel promised him he would—but he took no action for eleven days. Fishel's reluctance to intervene in a more forcible manner cannot be explained fully. It suggests that the salvage architecture intervention was not that high a priority and that, in the face of interagency intransigence, he let the matter drift.[26]

One key committee goal was to "tramp" the site to see what it offered. Not even Fishel's intervention could assure quick action. The hospitalization of Mackie's park manager prevented the first visit. When Fishel checked a week later, he learned the manager was out for two months and that Mackie would not go without him. Postponement followed postponement. Whether by phone or in person, the standard line from Conservation was: "It will be a couple of weeks." Fishel believed Mackie wanted to cooperate but characterized the news from Conservation as discouraging. When he called, he heard Mackie's litany of excuses. These ranged from personnel problems to the time it took to resolve land transactions within state government. Fishel could only promise his committee chair that he would continue "to needle him until we got somewhere." When he learned that Mackie put off the "tramping" until

late June or early July, Fishel met with his brain trust to consider how to put pressure on Mackie. Fishel, Erney, John Jacques, and Sivesind agreed that they would wait to see if Conservation kept the June date. If Mackie canceled, then they would try to bring pressure by lobbying some members of the Conservation Commission. The next day Sivesind reported rumors that Conservation's delays resulted from a lack of confidence that the Society could raise funds to pay for the land.[27]

"Tramp" day came on June 21, 1966. FitzGerald, two committee members, Sivesind and his assistant, and two representatives of Conservation (Mackie was not one of them), met in the forest. Conservation offered two sites. The committee rejected the smaller site but enthusiastically responded to the 320-acre site that Conservation would supplement with another 180 acres of purchased land. Sivesind took issue with Perrin's pushed-for 500-acre minimum for the site. Given the problems that did result from eventually gaining a 576-acre site, the sites director's prescience seems uncanny. "Frilandsmuseet at Lyngby, Denmark, which Perrin has seen, contains 33 complete farmsteads in less than 110 acres. At the same time that the trend is to pull structures into complexes not too far apart for convenience of visitors as well as less difficult administration, maintenance, operations and security, it seems rather ridiculous to even think in terms of using a half-section of land for this project." This memo reveals Fishel's management style. He welcomed venting from his staff, as long as it remained within his inner circle, but broached no public dissent. Interestingly, the two staff members he assigned to the OMC were at best lukewarm to the Perrin-Fishel vision. If their reservations differed, they found accord in resisting its overly ambitious nature. Fishel heard their reservations but was not deterred from pursuing his ambitious plans for the outdoor museum or the ever-expanding sites program.[28]

Interagency negotiations proved cumbersome. Fishel began crafting the final legal details with Karl Holzworth in the Park Planning Division and then moved up the ranks, first to Mackie, then to Director Voigt. FitzGerald warned Fishel that the process would take at least two months. The OMC did not have a rough draft of the agreement until October 22, more than four months later. The committee revised the document and returned it to Mackie. Six weeks later, Fishel sent the redraft to FitzGerald, who sent it on to the committee a week later. Finally, on December 30, Fishel had word that he and Mackie would appear before the appropriate Conservation Commission committee, probably in February 1967. Conservation owned 400 acres, which it was

willing to sell to the Society. In 1967 the Assembly passed a bill that authorized the sale of land.[29]

With the state forest nearly in its grasp, another state agency wanted to manipulate the Society's site choice to foster its goals. The chief of the education section of the Bureau of Budget and Management, Fred Hiestand, raised issues that Fishel saw as a threat. On January 3 Hiestand wrote to Fishel that he had attended a review session conducted by faculty from Landscape Architecture on December 19, 1967. Whether he attended by invitation or merely dropped in is not clear. Hiestand thought the meeting centered on site selection. He confessed that he had harbored reservations about the Old World Wisconsin concept from the beginning. Somehow he came away with the conclusion that Society had selected the Eagle site not because it was the "optimum location" but because Conservation had forced it on them. Moving from this erroneous assumption, he questioned the wisdom of placing it at a less than satisfactory location. Then he wondered whether "the present operational plans for Heritage Village are comprehensive enough to utilize all the topographical resources available at the site."[30]

These concerns, and others, reinforced Hiestand's goal to locate Heritage Village adjacent to an exposition center (fairgrounds) along I-94 between Milwaukee and Madison that the Bureau of State Planning had under consideration. An article in a Madison newspaper in December revealed the vision harbored by Hiestand. The project, estimated to cost between $45 and $55 million, would have buildings, a racetrack, a grandstand, parking, and a farm, camping, and conservation areas. More relevant, a "project to be called 'Heritage Village' could be located nearby the exposition site." Hiestand predicted that if the Building Commission approved the fairgrounds relocation, then "it appears that the Eagle site matter will become a dead issue." He concluded by declaring his intention to scrutinize thoroughly the sites program during the forthcoming biennial budget process.[31]

This attack from within state government demonstrated management challenges Fishel faced as he moved to launch the museum. The attack clearly caught him by surprise. Threatened, he fought back. He found Hiestand's memo disturbing for several reasons. While he acknowledged that Hiestand raised some legitimate questions (ones the Society had considered but not answered), he found his "undercurrent of threat" most disturbing. He interpreted Hiestand's veiled threat as follows: the Society cannot risk an attempt to outflank the Department of Administration. Fishel knew he had to have that department on

board with the museum or it would "torpedo the works." He objected to
the implication that the only way to proceed was to "come up with
answers that are satisfactory to Fred and his superiors."[32]

In his memo to Erney, Fishel prepared the Society's defense. First,
Hiestand's commitment to the development of the Exposition business
distorted his view on site selection. Fishel was confident that the Society
had made the strongest possible case for the Eagle site. Fishel, Sivesind,
and the Old World Wisconsin Committee (OWWC) "seemed over-
joyed (too strong a word) to get a site with as much potential" as Eagle
had. The board reacted very negatively to the idea of linking the Society's
site to the Exposition Center. Second, he wanted to bolster the Society's
case by gathering the relevant data on plans for the I-system and four-
lane highway construction that would put the Eagle site in the middle of
the Chicago-Milwaukee-Madison corridor. Third, he labeled Hiestand's
doubts about the exploitation of nonhistorical features as "second
rate." They needed "little rebuttal." According to Perrin and Sivesind,
whom he considered the Society's chief authorities, "ethnic groups did
choose special topographical features" for their homes and outbuildings.
He hoped Perrin could develop a rationale that satisfied Hiestand's
concerns.[33]

But as Fishel had to acknowledge, Hiestand's training as a planning
analyst necessitated careful consideration of his comments on cost
estimates. Here the Society director's confidence waned. Three points
frustrated him. One, "Fred wants a response of one sentence to a report
of over 100 pages," which he thought excessive. Second, he did not
know how the Society could provide cost estimates until the inventory
of historic structures and the master plan had been completed. That
said, he now knew the Society must provide estimates of capital expen-
ditures and operational costs for the museum on an annual basis. Third,
he did not want to get into "a parry-and-thrust relationship" with Fred
or the department. Having convinced Hiestand that the Society had no
interest in associating with the Exposition project and that Eagle was
indeed the site of choice, acquisition moved forward.[34]

Perrin's advocacy drove the location and the size of the site. His
awareness of the rapid disappearance of valuable specimens led him to
push hard for the purchase of some of the forest to "stockpile" buildings.
This made gaining title to a small portion of the land imperative. The
protracted nature of accomplishing the purchase of a relatively small
piece of land again illustrates why it took so long to create the museum.
More important, the Eagle site introduced another potential obstacle:

rising land values in the Eagle area. In April Fishel set a priority: obtain an appraisal for forty acres in the northwest corner of the reserved land, purchase it from Conservation, and then begin stockpiling buildings on-site. In May the DNR administrator, John A. Beale, wrote that his agency had reviewed the long-range proposal of the Society to develop the ethnic park in the Kettle Moraine State Forest. It "appears to be a unique and thrilling concept and you can be assured of my fullest cooperation in carrying out the intent of the agreement supplement." He noted that while the DNR owned about 400 acres of the proposed 560 acres, there were some privately owned parcels scattered throughout the area. He suggested meeting to discuss the location of the initial 40-acre tract. Once a tract for initial development was selected, the DNR could then obtain an appraisal and secure approval to convey the land. At the end of June, OWWC still awaited a recommendation on the land purchase from its planning consultant, landscape architecture professor William Tishler. Two months later, FitzGerald inquired whether Fishel had contacted Tishler about identifying the land for appraisal.[35]

The more than 150 acres still privately held complicated site acquisition. First, this land could be purchased only as it became available. Second, intricate state procedures for purchasing the land had to be followed. Third, the state lacked the flexibility needed to match market-dominated escalations in land values. As a result, the Society missed opportunities to acquire valuable land contiguous to the state forest.

To this point, committee members had shown remarkable forbearance. An incident in Milwaukee in September 1968 showed the chair's frustrations. These delays, perhaps the recent announcement of Fishel's intended departure, the missed deadlines on the final copy of the master plan, and a simmering controversy over the amount of land (a small parcel or the entire site) put FitzGerald in a foul mood. He directed his anger at the two Tishler graduate students who accompanied the Society staff. Perrin eventually interceded on their behalf and restored civility to the discussion. FitzGerald saw four years of effort ground to a halt — "stymied" — by the Society's inability to get the needed land. He wanted to know where Fishel planned to get the money needed to buy the first ten to fifteen acres. Erney's response that "we were thinking of going to the Building Commission this fall for funds for land" probably did not satisfy him, especially when he noted the Society would not know the outcome until January.[36]

Another setback came in the wake of this acrimonious meeting. Michael Buchholz, a graduate student preparing the economic feasibility

portion of the OWW plan, received the bad news that land prices since 1962 had been rising exponentially in the Eagle area. He had asked the DNR for assistance on calculating land values. The response cited a number of examples to indicate that accurate estimates were not easily obtained because the Eagle area was in transition. Rough land not suitable for farming commanded a higher value as home sites and subdivisions. For example, in April Conservation appraised an unimproved forty-acre parcel at $350 an acre. The owner claimed that she had an offer of $1,000 an acre. The DNR projected prices in the range of $600 to $700 an acre and concluded that few owners are willing to sell at fair market value. The "animosity towards the State on the part of many landowners" rendered new purchases problematic. The DNR campaign to repair its negative public opinion had some success, but Voigt could only offer the assistance of his staff to the Society for negotiating the requisite purchases.[37]

Here again, Fishel did not control key elements of the process. He had to rely on the already discredited DNR when it came to community relations. Without the authority to purchase the needed land, the Society had to wait on the cumbersome land appraisal process of the state. Rising land costs, seller reluctance, even hostility to the state, budget restraints, and the deficits at the existing sites forced Fishel to shift the focus of the negotiations between the DNR and the Society from the outright purchase that Chapter 84 of the Laws of Wisconsin had authorized in 1967. Fishel proposed three options: first, the DNR would keep the title but let the Society use the land; second, the DNR would lease the land on a long-term basis with a reversionary clause for a dollar a year; or third, the DNR would transfer the title for a dollar and "other considerations." Voigt agreed to discuss Fishel's new proposal and its implications with his staff. His concern was not to set a precedent for other state agencies to raid the DNR for cheap land.[38]

The storm clouds that had gathered in 1968 intensified with the approach of the new year. Fishel, who had sought legal advice from Warren H. Resh, the Society's legal counsel, received the bad news as the year ended. The lawyer's interpretation of the 1967 law authorizing Conservation to sell land to the Society left no wiggle room. Sell meant sell, not lease. Fishel still held out hope that the DNR and the Society could seek a definitive opinion from the attorney general that would allow the Society to use the land without purchasing it. Again personnel changes at the DNR intervened. Don Mackie, the Society's staunchest supporter at the DNR, left his position in January. This meant Fishel

had to establish a working relationship with Al Ehly, the new director of parks and recreation.[39]

With negotiations for the forest at another impasse, Ehly suggested an alternative site when he met with Fishel in February. The DNR already managed a site at Aztalan and was "quite enthusiastic" about joining OWW and Aztalan. He wanted to bolster poor attendance at Aztalan State Park. A month later, with some of their staff in tow, Ehly and Fishel toured the "Aztalan option," a site near Lake Mills. Fishel found a number of reasons to favor the new site. First, the DNR owned about forty acres with adjoining land zoned as conservancy or agricultural. The lower appraisals made land in the Aztalan area about 50 percent cheaper than land in Eagle. With land prices escalating beyond the Society's fiscal capabilities, he hoped this land might be acquired with no out-of-pocket costs. Second, he considered the Aztalan Indian as an ethnic group that would fit "in nicely with an ethnic emphasis." Third, the site was near the interstate, which would make moving buildings and the requisite supplies to the site easier. Fourth, Lake Mills, with 2,400 inhabitants, could better handle tourists than Eagle, a village of about 650. Finally, his staff "was pleasantly surprised" and concluded: "OWW would fit and fit well." On the downside, Aztalan lacked the varied topography of the Eagle site. Fishel wanted to know Tishler's reaction. He thought the site was manageable for OWW but wanted a more detailed topographic study to see how this site compared with Eagle. This would, of course, take time, and Fishel hoped that Tishler could report by the end of summer. Specifically, Tishler needed to know how the master plan approved in October would have to be altered.[40]

Two published reports indicated that Tishler still favored the Kettle Moraine site. On April 30, Tishler agreed to do an Aztalan study, which the Wisconsin History Foundation (WHF) funded, at a cost of no more than $2,000. He committed to providing a three-dimensional model of the site and an illustrated site evaluation report that analyzed the physical and environmental characteristics of the site and presented diagrammatic concepts for the development of the Old World Wisconsin project. His conclusion would compare the development potential of the Aztalan and Eagle sites.[41]

The OWWC dutifully visited Aztalan in May. The ever-critical Perrin thought it "a good cow pasture" that was inferior to Eagle. Perrin was aware of the cost factors but wanted other sites considered if Eagle was no longer available. FitzGerald, "impatient to get a site," criticized its location after he had trouble finding it. Although Fishel dismissed

FitzGerald's carping as frivolous, Tishler's report confirmed the need to create better interstate access. After discussing the site with the committee and staff, OWWC agreed that Eagle was more interesting "but Aztalan was well worth consideration," mainly because it offered a better financial situation. FitzGerald, "in his usual ingratiating way," posed a number of questions that needed answers before the board meeting in June. How much would the DNR contribute to the development? Would the highway department put an exit off I-94? How do land prices in Eagle and Aztalan compare? Are other sites available? The committee instructed Fishel to examine two areas near state parks, Baraboo and Shot Tower State Park near Spring Green, as possible sites. Fishel's response reflected his frustration. "We can go looking for sites from now until the end of the century, and this will only complicate the decision. We will never find a site without some drawbacks and measuring drawbacks is a speculative exercise that never really ends."[42]

The questions and the lukewarm endorsement aside, Fishel still thought the Aztalan site "can be made to work out nicely." Two days later, FitzGerald called to tell him that he and three members of the committee were "negative" on Aztalan and that Tishler told him it would cost more in the long run to purchase the site, reconstruct a more interesting landscape, and plan for the museum than to buy Eagle. Fishel told him he did not agree with him or the other committee members and was not prepared to admit it would cost more to develop Aztalan. They reluctantly agreed that Tishler should continue with his study.[43]

For the moment the site's fate hinged on continued DNR cooperation (more likely with Aztalan but hardly assured) and Tishler's assessment. Tishler submitted his report in July. He studied a parcel of gently rolling land of 1,093 acres, of which the state owned 132 acres. The remaining sixteen lots remained in private hands. While the land was largely agricultural (73 percent), he feared that residential growth patterns would be more intense in the Aztalan area than in the Eagle area. Aztalan offered no unusual or insurmountable problems, but it was an "average" site that lacked many of the outstanding natural features of Eagle. While he gave Aztalan a less than enthusiastic evaluation, he recognized that site selection came down to two important and conflicting issues: economics versus quality. As a caveat he added that initial costs at Aztalan may be less but the costs of creating an acceptable site may be considerable.[44]

After sending a copy of Tishler's evaluation, Erney had the unpleasant task of meeting with Ehly, who was "very irate." He was "most unhappy"

with the report and characterized it as error filled and superficial. The report did not address how the site might be adapted to the plans for OWW. Erney, who could see cooperation vaporizing before his eyes, pressed Ehly on whether the DNR would help purchase lands at either Eagle or Aztalan. Would the DNR let the Society use the land under terms similar to agreements for Wade House or Stonefield? Ehly said his agency did not have the funds available to make any immediate purchases. The land would be purchased as soon as possible, perhaps in five or six years. Again, Ehly made it abundantly clear that the Society should expect no favors from the DNR if it chose Eagle over Aztalan.[45]

Erney reported the results to the OWWC. He did not recommend one site over the other but sternly warned that private land in Eagle made it difficult to buy. In a worst case scenario, it might cost four to five times more than Aztalan. After Tishler reported on his Aztalan site evaluation, the committee discussed the merits of the two sites. Committee members clearly favored the Eagle site, a site it could not afford. Rather than endorsing Aztalan, it equivocated and only stated it would be "much less expensive" and more easily acquired. Significantly, the committee did not state which site should be pursued. It only suggested that negotiations with the DNR should continue. Members of the OMC and their consultant Bill Tishler favored the Eagle site. Their support came in the face of seemingly overwhelming evidence that it was beyond the Society's reach. After nine years of struggle, the site issue remained unresolved. With Fishel's departure in 1969, the site issue nearly dragged down the project. Erney, who was at best a reluctant supporter of OWW, assumed the role as acting director. He inherited many problems, not the least of which was finding funding for the OWW site. But before concluding the story of the protracted struggle to acquire its site, the Society's quest for a master plan must be considered.[46]

Undergraduate students in Professor William Tishler's landscape architecture class familiarize themselves with topography of the Southern Unit of the Kettle Moraine State Forest in March 1967. (William H. Tishler)

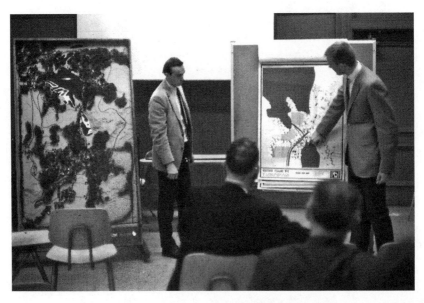

Students present four plans to the Old World Wisconsin Committee and members of the landscape architecture faculty in June 1967. (William H. Tishler)

John W. Winn (*left*), OWW administrator, gives Congressional Representative Henry S. Reuss (whose $100,000 gift revived the moribund Old World Wisconsin project) a tour of the site in 1972. (William H. Tishler)

To call attention to the Old World Wisconsin project, the Society dedicates the site on June 8, 1974. *Left to right*: At the groundbreaking ceremony Society director James Morton Smith, Joachim Peters (cultural representative, Pomeranian Society of Schleswig-Holstein), Richard W. E. Perrin, and Hans Kuether man the shovels. (William H. Tishler)

Dancers at the dedication entertain visitors and highlight the museum's ethnic connections. (Arnold R. Alanen)

Old World Wisconsin's principal architects, Richard W. E. Perrin (*left*) and William H. Tishler, attend the grand opening ceremony on June 30, 1976. (William H. Tishler)

Governor Patrick Lucey, honorary chair of the fund-raising campaign, delivers the opening remarks at the ceremony. (William H. Tishler)

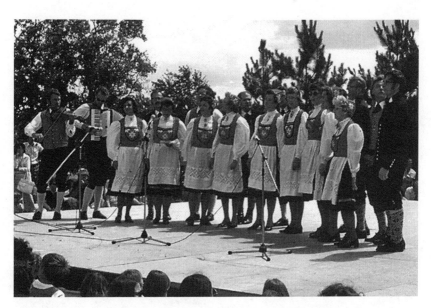

Norwegian dancers entertain visitors at the grand opening. (William H. Tishler)

Master Planners

As the acquisition of the site bogged down in protracted negotiations, Fishel moved to accomplish another major incremental goal. He knew the vision had to be transformed into a plan that would guide the acquisition and relocation of buildings on the anticipated site. Planning, even without the site, was indispensable for moving forward. Lacking a ready cash reserve, Fishel had to secure the services of a planner at minimal or no cost. This chapter considers the process by which the Society acquired its plan at no substantial expense. It focuses on college professor William H. Tishler and his students—sixteen undergraduates and three master's students—the team that crafted the first formal master plan.

Associate Director Dick Erney feared the impact of the projected museum on the Society and he especially disliked Fishel's willingness to ignore established procedures. He characterized Fishel's incremental method as a "nose under the tent" tactic. He elaborated: "The camel gets his nose under the tent, and then pretty soon you have the hump under, too." He did recognize two advantages: cultural agencies, the Society included, "could only succeed by such means," and OWW "would not exist if we had . . . followed procedure" and sought state approval. Erney allowed that financial exigencies drove the acquisition of a master plan. When asked about hiring a professional, Erney said

that it "never occurred to us to hire one, because we had no way of getting the funds to hire a professional planner. We didn't even know how to find one." He conceded the utilitarian value of an approach that assured Tishler's students a valuable educational experience while still keeping the project alive and yielding the possibility of a plan.[1]

Conservation forced the Society to offer at least an outline of a plan when the two agencies discussed a land deal in 1962. If Conservation was to serve as the Society's land agent, it needed a better idea of how its land *might* be used. Developing a detailed plan would take time. "I realize that the planning will involve a detailed study of topography and soil, of access routes, and historical information relating to ethnic groups," FitzGerald wrote almost four years later, "and we are prepared to take whatever time is necessary to make these studies or to have them made for us." A master plan was the next step. Still, two more years passed before the Society contracted for a formal plan.[2]

Fishel first turned to Perrin. He wanted advice on the location and size of the site, the number of ethnic groups to be represented, the number of structures available, the costs for moving them, the estimated cost for site preparation and operation, and a basic outline for the "story we want the buildings to tell." Perrin, not intimidated by the scope of his charge, reported by the end of May. This first (very tentative) plan called for six or seven clusters of ethnic buildings with some space between them. It recommended starting with seven restored German half-timber buildings. With furnishings, he estimated $30,000 per building would have them operational. The interpretational focus would be on "ethnic appearance and activities" and not on the chronological approach employed at Stonefield. The site should be in excess of 500 acres and within a radius of fifty miles from the Milwaukee County boundary. A necessary first step, but little more than a working outline.[3]

The OMC, while focused on the important task of finding a suitable site, realized that the outline needed embellishment. At its first meeting in October 1964, the committee discussed its need to better understand the proposed museum and the potential problems that the Society might encounter. The usual route was to contract a professional planner. In the context of numerous board and staff discussions about the inadequate funding for existing historic sites, the committee undoubtedly understood planning would have to be accomplished internally. Indeed, Fishel saw no need to ask for a budget allocation for the committee's work. The proposed park was part of the larger and increasingly expensive historic sites operation. Fishel argued that it was time for the Society

and its committees to assess expectations and costs as they considered the historic sites program's future.[4]

The OMC agreed on three guidelines that needed further investigation: (1) "the purpose of the outdoor museum should be the preservation and interpretation of buildings illustrative of different types of architecture in Wisconsin and any ethnic groups with which these architectural styles were associated"; (2) the buildings should be moved to one general area with units grouped closely enough together to be administered efficiently but not so close as to interfere with each other; (3) the museum should be located near a center of population and in an area frequented by tourists. The site should be located in a state park or other land owned by the state. In addition the committee asked FitzGerald and Perrin to work with staff to accomplish three tasks: (1) Identify a suitable site and the cost of acquiring it; (2) draw up a plan for the museum that lists specific buildings needed for acquisition, suggest how these buildings might be relocated, and make recommendations for interpreting buildings to the public; (3) secure estimates of the costs of purchasing and moving buildings and costs for preparing them for exhibition to the public.[5]

If Fishel considered employing a professional planner, he quickly rejected it because he did not have funds to hire one. The Society's generally impecunious status limited his options. As he wrote to board president Scott Cutlip in capital letters: THE EXECUTIVE COMMITTEE BELIEVED THAT THE SOCIETY SHOULD UNDERTAKE MORE STUDY AND PLANNING, WITHOUT ADDITIONAL COST TO THE STATE, OF THIS PROJECT." The OMC added little to the planning process beyond the general suggestions already put forward by Perrin and Fishel.[6]

Another consideration that drove Fishel's decision to plan using existing resources, mainly Perrin, the OMC, and Tishler, was more strategic. Not contracting for a professional planner kept open his option to withdraw from the commitment to the outdoor museum, which still existed only as an idea. Fishel's ambitious historic sites vision always had to be tempered by funding considerations. Lacking funds to make a major planning push, the committee took a hiatus from planning. It made little sense to plan without a site. Rather, the OMC focused on the size and location of the site. When Fishel revisited the need to create a master plan, his lack of funds forced a unique and creative solution. Why not utilize an existing university resource? Seeking the assistance of the landscape architecture department would keep planning within

"the family" and open the possibility of a master plan without significant cost.[7]

The landscape architecture department was an invaluable ally. Fishel had already employed one member of the department as a historic sites consultant. The department was in the process of reinventing itself. It had hired a number of new faculty members and wanted to establish a stronger research mission. Tishler, a recent graduate from Harvard University, had been hired in 1964 and looked to establish his career on a firm basis. One student recalled that these new "people created an excitement and a significant atmosphere of change." They had "a lot of energy," were young, and brought Harvard standards to the department.[8]

Fishel contacted G. William Longenecker, the head of the landscape architecture department. Longenecker knew that one of the young assistant professors had a "fascination for history" and a love of old buildings. He asked Tishler if he wanted to get involved. Tishler recalled that the idea "seemed to be something I'd be interested in and I, of course, jumped at the opportunity." He met with Fishel to learn his intentions. After several meetings, Tishler saw the possibility of using an undergraduate Design Studio class to develop the plan. These classes often involved students "working on real projects." Beyond his interest in old buildings, Tishler saw the teaching possibilities of the project. Designing a plan for an outdoor museum would give the students a practical, "real world," experience.[9]

Employing Tishler met three important Fishel goals. It fit nicely with his charge to develop a better working relationship with the university professors. More important, it entailed only a minimum financial commitment. For example, Tishler received no compensation over and above his university salary. The students worked for the learning experience. Finally, the arrangement permitted Fishel to assure Perrin, who felt the Society moved at a glacial pace, that the class was "tangible evidence that we are moving along."[10]

Was it risky to turn something as important as a master plan over to an undergraduate class? Fishel did not see it that way. "Okay, we spent a semester having undergraduates draw up a plan. They come in, and it looks awful, or it's far off base. . . . We'll go somewhere else. . . . So it wasn't that much of a gamble, and all we were going to lose was one semester. And at that point, we didn't feel much pressure." The last statement provides some insight into Fishel's incremental approach. The museum did not have a large constituency. Few outside the Society knew about it. Fishel's "with all deliberate speed" approach to museum

development exasperated only a few preservationists like Perrin and Hans Kuether.[11]

Neither Fishel nor the OMC offered their new and inexperienced planner any definitive guidelines or specific instructions. The Society and the professor worked with no formal agreement. They worked, as Tishler recalled, on the basis of a "gentlemanly understanding." Tishler did not even receive written instructions. He concluded after his discussions with Fishel and Sivesind that "they didn't really have a clear perception of what the outdoor museum was to be." At this point it was only an "idea in Mr. Perrin's mind," and no one "had any vision of what this could be." He understood that the Society wanted him to take Perrin's idea, as modified by Fishel, and give form to that concept of an outdoor museum that preserved examples of the rapidly disappearing buildings and emphasized the ethnicity of Wisconsin inhabitants. Fishel and Sivesind gave Tishler free hand to accomplish his mission and, more important, the time he needed. Tishler "felt it would take an entire semester to really come up with something that would be usable and presentable." They thought that was reasonable. Tishler kept Fishel and Sivesind posted, copied them on the materials he used in class, and met with the OMC. In return, Longenecker assured Fishel that the department had an interest in the project. It was standard for department faculty to "provide periodic reviews and guidance" for classes such as Tishler's.[12]

What a unique opportunity! For what seemed to be good and sufficient reasons, in the summer of 1966, the Society cast its lot with a young assistant professor and a class of sixteen undergraduate students. The class, Landscape Architecture 352, was part of the regular sequence of courses for majors and was offered in the second semester of 1966–67. The students were juniors who had already taken some courses in basic design, construction, surveying, and graphics. LA 352, which met for four hours twice a week, was a studio design course that allowed considerable flexibility in terms of what types of projects could be assigned to students.[13]

Tishler's previously scheduled trip to Africa in January and part of February necessitated contacting the sixteen students in December, well in advance of the beginning of the new semester. Tishler's initial letter to the students revealed his early thinking about the projected museum and the high expectations he had for the students. He told them that they would be working on the preliminary design of an ethnic village park and that a logical method of grouping the structures that the

Society intended to move to the site "is in the form of ethnic clusters or villages."[14]

The project presented the students and professor with an incredible challenge. If Fishel's scheme carried a risk, it stemmed from the discipline-based approach. Neither the professor nor the students had strong backgrounds in history or museum planning. Nor did they have a clear idea which buildings might be available. Still, the Society had offered a unique and exciting challenge. Tishler recalled his confidence that the class could do a good job and that they could come up with a plan that would fit the site. He also thought he was fortunate to have students who were "very enthusiastic and got very involved."[15]

Enthusiasm and commitment were essential for success. Not only did the students have to think about issues that concerned landscape architects, but they also had to immerse themselves in Wisconsin history and major outdoor museums. Four major goals had to be accomplished in the course of one semester. Students had to investigate and report on the ethnic groups that came to Wisconsin in the nineteenth century. They had to research and then describe how comparable outdoor museums dealt with a variety of problems. They had to get to know the site and then figure out how it could be developed to accomplish the Society's intention of preserving the structures associated with the immigrant groups. Finally, the results of their work had to be analyzed and summarized in graphic and written reports.

The first part of the course included background research. Tishler used a case study approach to acquire needed knowledge of the history and lifestyles of Wisconsin's ethnic groups and basic information on major outdoor museums. Tishler assigned students to investigate eleven immigrant groups (the Germans, Swiss, Irish and English, Danish and Icelandic, Polish, Belgian and Danish, Swedes and Finns, Italians and French, Slovaks, Norwegians, and Welsh). He asked those students not working on an immigrant group to research five existing museums (Greenfield Village, Mystic Seaport, Old Sturbridge Village, The Farmers' Museum at Cooperstown, and Colonial Williamsburg). As background, students heard lectures such as "The Ethnic Village Park Idea," "Historical Architecture in Wisconsin," and "Ethnic Groups in Wisconsin." They also viewed movies on Colonial Williamsburg, Greenfield Village, and the Henry Ford Museum and a slide tour of Old Sturbridge Village.[16]

Heritage Village, the name selected by the students for the museum, coincided with an idea germinating at the Smithsonian Institution, the

development of a series of living history farm museums across the country. At the time the Society considered developing a master plan, however, neither Fishel nor Tishler was aware of John T. Schlebecker and his proposal. Tishler did envision the planned site "as a place where there would be animals, people plowing and people explaining things and making things and whatever." Initially, though, the Wisconsin plan moved forward as an architectural preservation museum, not a farm museum. The Society's farm museum was at Stonefield, which Fishel considered "a very minuscule effort, unhappily."[17]

That site had little influence on the planning and development of the new historic site. Ray Sivesind took the lead in creating the Stonefield site in the 1950s and served as the Society's liaison with Tishler as he and his students created the new site's master plan in the 1960s. Tishler's undergraduate class did not use Stonefield as one of the models they studied to develop their plans. The closest model for Old World Wisconsin was Old Sturbridge Village, an open-air museum created in Massachusetts in the post–World War II period. Wisconsin's museum would use nineteenth-century buildings as OSV had used New England historic buildings brought to a common site. Tishler could not recall discussing Stonefield with Les Fishel when they began their planning discussions. While he recalled discussions with Ray Sivesind regarding Stonefield, he stated, "Stonefield was not suggested as a model for planning for OWW." He did add that he felt "Ray was somewhat chagrined about the idea" of a new agricultural village initially called Heritage Village. Tishler thought the sites director saw the museum as competition for "his baby," but added Ray was always a perfect gentleman about the matter.[18]

Tishler set high expectations for his undergraduate students. He asked those assigned to the ethnic groups to investigate nine points that included ascertaining geographic settlement patterns, dates of major migrations into Wisconsin, landscape characteristics of the homeland, landscape characteristics of the areas settled in Wisconsin, their reasons for migrating to America, the architectural styles in their native countries at the time of migration, adaption of native architectural styles to American conditions, the location of existing structures of architectural and historic significance for the ethnic group, and finally, the habits and customs of the immigrant groups.[19]

The second set of students received an equally ambitious assignment to research museums similar in scope to the projected one. The students "knew nothing about the museum business, frankly. These were a bunch

of undergraduates." But then, as Tishler admitted, "I didn't either." He asked them to investigate comparable institutions for their design plan and their rationale, cost factors, design features, ownership and method of financing, operational and management procedures, and location rationale.[20]

He required students on both projects to present their findings as written text and as graphic displays on 22" by 28" display boards. The student who worked on Cooperstown recalled spending an inordinate amount of time preparing the display board. Robert Gutzman had to research that museum, write up his findings, and then present them in graphic form. For text, he used quarter-inch press-on letters and realized that he was too verbose. It seemed to take forever to press "all those little letters" on the board. Tishler held the students to tight deadlines, and in this instance, students rushed to be ready for a jury presentation to the landscape architecture faculty. Gutzman had mixed feelings about the effort. He realized that it was valuable to have "a little insight" about projects similar to Heritage Village, but he felt it took too much time to complete. Still, he thought it worth the effort. The "boards were pretty impressive when they were all lined up in front of the class and the jury for presentation. It was quite a show."[21]

As the students researched their case studies on ethnic groups and museums, they moved into the next phase, site analysis. Tishler assumed the selected site of the ethnic park would be the state forest near Eagle. The site impressed him as having many advantages. "Sometimes we thought of it as being a miniature representation of what the rest of the Wisconsin landscape was like. Of course that's not completely true but it was possible, we felt, to actually locate certain ethnic farmsteads in a setting similar to where those groups had settled, whether it was northern Wisconsin, or the Coolee Country, or wherever." He also realized that it was "a fairly large chunk of land, and we wanted to understand it well, so that we wouldn't ruin it, with development, by putting things in the wrong place, or by overdeveloping certain areas and so forth."[22]

Tishler and his students also walked the site to get a feel for it. "Like all landscape architects, we wanted to become very familiar with the terrain." The class took several field trips to the site. The students had to inventory and evaluate relevant site criteria "to determine the influences that the site could have upon the development" of the project. As they walked the site, Tishler called attention to the different features of the Kettle Moraine area and talked about the many opportunities the landscape offered for future development. Gutzman confessed that at first it

was bewildering. It was not until after he and his colleagues completed the research on the ethnic groups and site analysis that they began to see the possibilities of the site.[23]

For the second part, site analysis, Tishler assigned twelve students to specific investigations. These included the regional context, transportation, geology, vegetation, slopes, water and drainage problems, climate factors, wildlife, esthetic qualities, soils, existing land use, and land elevations. He assigned the remaining four students responsibility for developing the topographical model and writing the site summary report.[24]

Armed with information about the ethnic groups, comparable museums, and detailed site analysis, the class moved into the third phase. Tishler divided the class into four teams of four students. He instructed each team to develop a list of buildings, spaces, features, and facilities that could serve as models for Heritage Village, Wisconsin. The objective was to have four possible plans that could serve as potential models for a master plan for the museum.[25]

Following one team provides a glimpse of the final phase—design plans and recommendations. Team 2 included Philip Chapados, Robert Gutzman, Michael McCarthy, and John Tietz. Their design concept included three basic units—an ethnic industry unit, an urban unit, and an agricultural unit that would portray important aspects of life among Wisconsin's ethnic groups. Their report described the three units and the natural area, which emphasized wildlife and geological features. It analyzed practical matters such as entry to the site and parking. For example, their plan called for a "tall windmill of historical significance" to serve as a vertical "locator" element to pull people to the administration or entry building. Beyond having offices, the functions of the administration building included dispensing information, admission tickets, and first aid. The building would also have an area for showing an introductory movie. The plan addressed visitor circulation. People would move through the site on foot or on horse-drawn wagons. An appendix to the report suggested the types of structures needed for their design. The planners hoped that the Society would be able to determine which buildings it could acquire in order "to provide a comprehensive visual experience of historic Wisconsin." Finally, the design concept laid out a phased plan of construction. Team 2 presented a graphic of its design showing how the three units looked on the Kettle Moraine landscape.[26]

Gutzman recalled the experience: he thought they grew into "a good team." They "developed a real friendship before we even got into this

class project, and I think we worked" well together. McCarthy spoke for the team and "he did real well for us. He was the kind of guy who had a certain charisma that you would like to have as a team leader. I think it was important to have a good representative because I think it spoke for the design and our capabilities as a team." Design classes "take a lot more time than you usually have to give them." He recalled that "we put in a lot of late hours, but it was a real team effort and I think that by now we had a good enough relationship that if somebody wasn't pulling [his] own weight that everyone else let [him] know."[27]

Gutzman was not the only one pleased with the results. As early as April 19, Sivesind had a copy of the design concept from Teams 1 and 2. Team 1 formulated a linear development pattern of ethnic farms located between two urban areas. "This concept," team members wrote, "resembles that of many shopping centers where two large Department stores are placed at opposite ends of a pedestrian mall." Sivesind offered some commentary on the two designs and concluded with a commendation to the class "for its achievement on this project." We "were not only impressed but amazed at their grasp of the totality of the project and the thoroughness with which they have attacked its separate aspects from every angle." Tishler promised that the class would be ready to make its presentation to the OMC on May 5.[28]

The only controversy generated was over the name chosen by the class for their project. At the beginning of the class, the museum was known by its generic names, the Outdoor Museum Project or the Ethnic Village Museum. When Fishel introduced himself and the other speakers to the class, he noted that naming the museum is a problem. He joked that it might be called "Tishler's museum." Still, naming the project was more than a minor point. The name would help define the museum. Tishler reported on March 7 that the students, "after much thought and debate, have decided to call this project Heritage Village, Wisconsin." However, when asked about it in 1994, he could not remember in detail why the class selected Heritage Village. He thought that each team probably came up with a name, and the class discussed the matter until it reached a consensus. An undated note in Tishler's papers listed the names the class considered. They included "Homestead, Old Wisconsin, Old World Wisconsin, Old Heritage Village, Heritage Village, and Village of Nations."[29]

Two days after informing Fishel of the name, Sivesind wrote to Tishler that you "may get a reaction to the proposed name." He noted that the OMC "started to discuss possible names at one session, but

decided the content and objectives were too vague at that time." Sivesind thought the title of Fred Holmes's book, *Old World Wisconsin*, "would be quite apropos for the museum," while recognizing that "it doesn't convey the total concept" either. Fishel's response to the class's name indicated that it was a matter of "some discussion" at the Society. "Naming this enterprise will undoubtedly consume more effort than it is worth but we were glad to have your class's idea on the subject." He asked Tishler to "throw out for their consideration" Old World Wisconsin or Old World, Wisconsin. For the moment, Heritage Village, Wisconsin stuck.[30]

On May 16 Tishler alerted the class that the "time has come to refine your preliminary design proposals into an illustrative master plan for development." A jury from the landscape architecture faculty would assess the presentations on June 3. Members of the OMC also witnessed the demonstration. Gutzman remembered "sitting back in class during the presentation and looking at the graphics and the boards as they were presented—nice illustration boards with all the site plans and details on them—it was quite a nice presentation." The students had taken on a huge challenge, and as Gutzman reflected on the experience, he was amazed "that we accomplished so much in so little time." He was not alone in his thinking. The committee members in attendance "were unanimous" in commending Tishler for "the excellent job which has been done by your students. . . . We were all thrilled."[31]

Shortly thereafter, Tishler and his class journeyed to Eagle River for the Society's annual meeting, where on June 22 they presented their preliminary plans for the museum. Armed with both text and display boards, the presentations drew rave reviews from the curators. On June 23, the board expressed its "warm appreciation" to Tishler and his class "for the imaginative and constructive plans for Heritage Village." The curators noted that their "dedication and their enthusiasm was contagious and happily infected members of the board, the Society staff and Society members with a renewed desire to create and maintain a lively, authentic and appealing complex of historic centers for Wisconsin."[32]

Before he had introduced his students, Tishler told the curators that the Society has its eye on a spectacular site that offers a "unique and unusual scenic landscape" that "closely resembles many parts of our state where the pioneers settled." What was needed "is an imaginative plan to blend these two factors into an outstanding educational and recreational development." He told the curators "our study represents a fine start in this direction."[33]

The fifteen young men and one young woman from Tishler's class had done well. They excited Society staff and curators alike with their plans. The board's decision to forge boldly ahead made it easier for Fishel to get a commitment without considering financial considerations. The project remained under the budget radar. The curators authorized Fishel to proceed to the next phase, turning the preliminary studies into a master plan. But all was not well. In his annual report, Fishel noted three closely connected matters of importance that potentially cast a pall over the proceedings.

He first noted that the newly created Division of Historic Sites and Markers was still in the process of transition. Fishel noted that the division is "badly understaffed" for undertaking the "wider responsibilities" that reflected its new status. Without more staff, "progress will remain turtle-like and erratic." This division was in no position to take on a major task along the lines suggested by Tishler's students.

Second, Fishel addressed the agreement reached by the Society and Conservation. Tishler and his students had walked the site in Eagle. Their planning assumed it was the site for the museum. Fishel happily reported an agreement with Conservation by which the Society could purchase 550 acres of the southern Kettle Moraine State Park. After both parties signed the purchase agreement, Conservation attorneys said the legislature had to approve the deal. Contrary to expectations, this would delay the acquisition of a site for years and force an eleventh-hour consideration of another site.

Finally, he informed Society members that the board had warmly received the "four highly imaginative use plans" presented by the students. The Society expected to refine and elaborate them into one major program during the year ahead. Then he added an ominous warning: "here, as with other sites, financing is a foremost frustration."[34]

Tishler thought the student presentations and their enthusiasm had gone a long way toward convincing the curators to adopt "the pie-in-the-sky dream" that was offered. Board members must have realized that they had never "wrestled with anything quite like this before," and they must have wondered, among other things, "How are we going to get the money?" No curator pressed either Fishel or Tishler on possible costs. Still, behind the optimism lurked a large dose of apprehension as the Society moved forward on the projected museum in 1967 and 1968.[35]

The naming controversy persisted into 1968. In October FitzGerald noted that the OMC had to settle on a name. Perrin, the museum's

staunchest supporter and severest critic, questioned the advisability of the title Old World Wisconsin. Quite rightly, Perrin thought it anachronistic because Old World reflected a present-minded perspective and he preferred a name that captured the nineteenth-century immigrant view: "New World Wisconsin." Sivesind strongly opposed that name and stuck with OWW. Tishler thought that OWW left something to be desired, but worked with it assuming it could be changed in the future. Society staff, however, favored OWW, and by the time the board accepted the revised master plan in October 1968 that name was official.[36]

Planning continued apace. This time Fishel and Tishler decided to use graduate students to synthesize the undergraduate plans. As he awaited completion of a master plan in 1968, Fishel defended the use of the graduate students whom the "Society charged to come up with a feasible development plan for Old World Wisconsin." Was this a risky move? No, he explained. When they are done, the "Society will determine whether their final product is viable. Since we cannot afford high-priced planning talent, we have to accept on-the-job trainees. Our first experience with the major professor on preliminary plans was highly satisfactory, so that logic dictated that we back the same horse twice."[37]

Two members of the OMC unsuccessfully solicited a grant of $4,500 from the Allen-Bradley Foundation for the purposes of assisting in the research and for preparing and publishing the final report. In December 1966 Tishler successfully submitted a request for a research assistantship jointly funded by his department and the Society. Tishler recruited two graduate students, Phillip S. Tresch (landscape architecture) and Richard L. Meyer (architecture), to work on the project and to split the research assistantship. They understood that on the completion of the OWW project, they would receive credit for a jointly written master's essay.[38]

Tishler also secured the assistance of another graduate student, Michael R. Buchholz (business), to write the economic feasibility study. Buchholz, also a master's degree student, worked under the tutelage of Professor James Graaskamp, "who developed one of the top-rated real estate investment programs in the country." When Buchholz learned of the project, he volunteered for it, seeing an opportunity for a master's thesis. Initially, he spent "a reasonable amount of time" with Tresch and Meyer learning about the project and the site. After this, he worked on his own gathering data and venting his ideas for the economic feasibility study with Graaskamp.[39]

Tishler was the principal investigator and his three graduate students acted independently of each other. Tishler thought that Meyer, who

had a degree in architecture from the University of Illinois, could provide useful insights on the historic buildings, an area in which he and Tresch needed help. Tishler thought Meyer "never really jumped into it with the enthusiasm, with the vigor that Tresch did." He never finished his degree. This may have resulted from the landscape architecture department's change in its requirements for the master's degree. Tishler informed them at the end of their first academic year that the faculty decided that their work on OWW would not be accepted for master's theses. Not wishing to lose the work he had already done, Tresch coupled his work on OWW with an in-the-field inventory of historic buildings in Southwestern Wisconsin. The university awarded Tresch and Buchholz master's degrees in 1969.[40]

Tresch studied the undergraduate proposals but mainly relied on his own field observations. He made numerous visits to the state forest, sometimes with Tishler and Meyer but mostly on his own to better understand the landscape and how buildings might be resituated. Again, in committing the project to "on-the-job trainees," Fishel relied on Tishler to manage this effort. Near the end of September 1967, Fishel met with Tishler, Tresch, and Meyer. The graduate students told him of the questionnaire they intended to send to professional planners and to history museum administrators "to discover what kinds of problems" they have encountered and what solutions they have devised. Fishel told FitzGerald that he was "not sanguine that this will produce great results," but he did not try to talk them out of their plan. He did, however, establish the purpose of their project. He wanted two results. Their analysis had to permit the Society to move to the implementation stage. This included a complete layout of the site "and other factors" based on the reports from the undergraduates. This meant distilling the ideas from the various plans into a single workable design. He did not want detailed drawings for each proposed building. The Society would take the next steps. Fishel intended to contract with an engineering and architectural firm to make the plans from which the construction crews would work. For this part of the report, he wanted "economic projections and engineering studies of such things as soil drainage, the establishment of ponds, the feasibility of developing roadways as planned, etc." The second goal was fund-raising. They agreed that the report would not be a fund-raising document as such, but would supply information from which the Society could prepare a brochure for that purpose. The final report was also to project a schedule for the phased development of the site. The graduate students pressed Fishel for guidance on how long a

period of time the Society envisioned for development, but he avoided the question. The answer depended on their research. He asked for an interim report soon after January 1, 1968.[41]

One "big headache" planners confronted was that the state's architectural legacy had not been quantified nor described in detail. Tishler and Tresch operated with only a limited awareness of which particular buildings *might* be available someday for the site. By January 1968, the Society had made limited progress inspecting buildings and ascertaining moving costs. As part of their learning experience, Hans Kuether took Tishler and Tresch on a field trip to see potentially usable buildings. They visited a Pomeranian area in Dodge County that Kuether knew well. Tishler called the experience "an eye opener." When construction began in Eagle, on-site personnel soon learned that an eye for historic buildings (out-of-the-way locations, sided over, or concealed by later additions) was a must for identifying new acquisitions. The difficulty in agreeing on a list of potential buildings surfaced that same month. Perrin, who had just received a copy of *An Interim Report: Old World Wisconsin*, confessed puzzlement regarding the list of buildings. He found it neither comprehensive nor inclusive of historically significant buildings. More important, the list could not be construed as a source of buildings since many could not be acquired let alone moved to the site. Tishler and Tresch continued to refine their plan through the summer. Society staff continued to inventory possible buildings to provide critical information about the historic significance of buildings and their possible availability for the site. By July Robert Sherman had inspected forty-seven of the sixty-one buildings on the Society's list but considered only eight as available.[42]

Tresch, Meyer, and Buchholz met periodically with Tishler to discuss their progress, procedures, and findings. But as might be expected from graduate students, they worked independently. Tishler felt no need to be as specific as he been with the undergraduate class because "these guys were a little older, and seemed a little more responsible." Tishler did not work closely with Buchholz.[43]

As a preliminary step to presenting the Society with its master plan, the faculty of the landscape architecture department met on December 12, 1967, to hear Tishler's graduate students. Hiestand summarized what he heard. They reviewed the plans put forward by the undergraduate class and presented their thinking on future planning. The faculty served as critics of the original and the updated plans. Faculty "criticism ranged far beyond commenting on the planning techniques and presentation

methodology." Among other things, the landscape architects discussed the rationale for selecting the Eagle site, the reasonableness of removing old structures from present locations, and the impact of structure removal on existing towns and cities. Fishel, who had been in the hospital for more than three weeks, apparently did not know of the meeting and was caught off guard when a representative of another agency tried to use the faculty discussion regarding the site to force the Society to change its location.[44]

In January Tishler submitted an interim report to the Society. When Fishel read the OWW report, he thought it was "pretty good, I think for a starter." Tishler also let the Society know that he would be out of funds by February 1. Erney appealed to the WHF, which granted an additional $900 to continue the work. Tishler and his students continued to refine the master plan and the accompanying site models.[45]

Completion of the final plan took more than the agreed-upon one year. The delays in meeting promised deadlines angered FitzGerald and he took it out on Tresch and Meyer, who attended a meeting in his office along with three other committee members. Fishel had promised this report in May, then July, then August. Now on September 16 FitzGerald still had no report. He "roasted" the graduate students for these delays and for advocating purchase of the entire site as opposed to the previously agreed-upon ten to fifteen acres. Perrin, who Erney characterized as sharing "the God role" along with OSV's Charles Van Ravensway, quickly calmed the committee chair when he stated Tresch and Meyer had come up with exactly the kind of plan that had been expected for making the best possible use of the site. FitzGerald finally settled for an ironclad guarantee that the report would be ready for the October board meeting. Erney told the students to plan on attending the meeting on Friday, October 25, and to be prepared to stay overnight for the board meeting the next day. Erney suggested that the question of how much land the Society should purchase should be discussed at the next OWWC meeting.[46]

Tishler and his students met the deadline. They presented "Old World Wisconsin: A Study Prepared for the State Historical Society of Wisconsin" to OWWC members when they met in the town of Greenbush in Sheboygan County in October. Tishler wanted "to fire their imaginations." The presentation, which took a couple of hours, was met with "great enthusiasm." The landscape architects, who "did a very nice job," went first. Buchholz remembered that they described the Eagle site in detail and walked the committee members through the

report. Buchholz then presented the economic feasibility part of the plan. He described his model and the projections he made regarding attendance, site costs, and revenue generation. He judged that committee members "were generally well pleased with the overall presentation." With the plan now ready, he felt "they had something to put their arms around and a working plan to go from." The next day the board accepted the resolution from its committee and earnestly embraced the master plan. It instructed the Society to print copies for distribution, secure the Eagle site, initiate fund-raising, and acquire historic buildings. What had the curators wrought?[47]

The 1968 Plan envisioned two major historical components, an urban complex and rural settlements, as well as five ancillary elements, a parking lot, the "Entry-Awareness Center," the ecological-geographical area, and the restoration and work area. Phase 1 envisioned about forty-eight historic structures. The planners thought that the "urban area would be the heart of Old World Wisconsin." From its hilltop location, visitors would have "spectacular views of the rural ethnic settlements and the natural landscape of the area." The plan put forth by Tishler and his students called for a parking lot that initially would accommodate 200 cars but would be expandable to 750 as the museum grew. The Entry-Awareness Center, a complex of buildings, would include administrative offices, an auditorium, an exhibition center, a gift shop, storage, and limited maintenance facilities.[48]

In the urban complex, reerected structures would be situated around three types of open-space areas common to Wisconsin or the Midwest. The *urban market square* included a parish church as well as a number of tightly grouped buildings. In the square, visitors could inspect and buy the wares of local farmers. At the other end of the urban complex was the *village common*, a "green, park-like space, with a lawn and a formal arrangement of trees." It included a bandstand and a Victorian-style fountain. Adjacent to the park, visitors could relax in the village beer garden and enjoy food and drink in the German tradition. A *short main street* connected the green and the market square. Its narrow street was to be lined with buildings and historic "street furniture" such as board-walks, hitching posts, barber poles, and other like objects.[49]

The urban complex, as projected, brought many ethnic interests together in "one dynamic complex." The plan listed four general categories of buildings: service-related buildings that included a hotel, a barber shop, and a dance hall; professional buildings such as a lawyer's office and a mortician; public facilities buildings that included a

bandstand and a theater; and industrial buildings that included a wagon maker, a feed mill, and a cheese factory.[50]

The rural settlement, which was to be constructed in two phases, would include fifteen nationality groups brought together in nine ethnic units. Along with the farmhouse, each farmstead was to include relevant outbuildings such as barns, sheds, granaries, corncribs, and saunas. The 1968 plan also called for other rural elements of nineteenth-century life—windmills, haystacks, gardens, fences, and wells—to be placed on the Old World Wisconsin landscape.[51]

It was one thing to plan; it was another thing to fund. The 1968 plan paid special attention to the economic feasibility of the projected museum. Before the board could endorse the plan, it would have to know what it would cost to build the museum and what the museum might generate in the way of revenue. Tishler and his students provided the first answers—answers that experience showed to be faulty. The total cash cost for site development by 1974 would be $1,387,000. They estimated the total project cost including unrecovered opportunity costs (noncash) to be $1,571,000. Answering the rest of the economic questions fell to Buchholz, who developed a set of models for attendance, costs, and revenues.[52]

The feasibility study linked two important project objectives—preserving Wisconsin's architectural and cultural heritage and bolstering the state's economy by increasing its share of the burgeoning tourist market in the Midwest. The analysis assumed that the preservation objective would generate both direct and indirect income, and it set out to find a method to measure them. Buchholz had to estimate the number of tourists the site might attract in its formative years, its operating expenses, and the revenue it might generate. To determine these factors, Buchholz visited Stonefield Village, Villa Louis, and Wade House in Wisconsin and traveled to Old Sturbridge Village ("a grand place") and Mystic Seaport. At OSV, he spent more than two hours with the vice president of business operations and gathered data on attendance and site revenue. Because he assumed that "almost 100 per cent of all outdoor recreational activity is based on the use of the automobile," he carefully analyzed traffic patterns for southeastern Wisconsin. On the basis of his analysis, Buchholz projected high and low estimated attendance figures for the years between 1969 (start-up date) and 1974 (when he assumed the museum would be 100 percent complete). In light of what did happen with attendance, the figures now appear quixotic. He reckoned attendance in 1974 would fall between 235,900 and 288,390. On the basis

of these figures, he then calculated the total revenues for the museum to be between $670,000 and $819,000. He reckoned operating costs for 1974 to be in the approximate range of $550,000 to $650,000. Thus, the museum seemed likely to achieve the self-sustaining goal within a few years of opening.[53]

This perhaps explains why neither Fishel nor the curators entertained the notion of seeking state funding at this point. Substantial assistance from state legislatures was not unprecedented. Another state outdoor history museum created more than three decades earlier during the Great Depression had been partially funded by the state. The estimated cost for reconstructing Lincoln's New Salem was $260,000 in 1930. The Illinois Assembly appropriated $50,000, which was approximately 20 percent of the cost to build. More contemporaneously, the Maryland Assembly when it created the St. Mary's City Commission and charged it with building a museum on the site of the state's founding provided an annual operating budget. Fishel's own plan trapped him. The encouraging feasibility study undermined any attempt to have a state appropriation for 20 percent of the estimated cost.[54]

Buchholz's analysis was a good faith effort to predict the unpredictable. The budding economist did not have a crystal ball. As Tishler noted, one weakness of the master plan was "the economic feasibility study for which we were criticized later. Even though it was prepared by a good student working under the supervision of a top-notch professor, it woefully underestimated the cost of the project." Did Fishel know that the projections with regard to attendance and costs were overly optimistic? So far as "I can recall, we never questioned the attendance estimates. We were more concerned with building the site and getting everything going." However, in the same month that the board adopted *Old World Wisconsin*, he wrote: "Few, if any, historic sites are 'economically feasible' if one considers only the income taken at the gate and balances that against all the expenditures—capital, operational, promotional and upkeep—required by an historic site." The projections aside, Fishel seemed to acknowledge that historic sites do not pay for their own keep.[55]

Tishler and his students had created a masterful conceptual plan. Lacking specific data on which buildings the Society might acquire, the plan laid out possible ethnic sites and other amenities that maximized the bountiful and varied landscape of the state forest. Many complications followed in the wake of its adoption. One was the ambitious nature

of Tishler's interpretation of the vision. It fell to the ever-vigilant Perrin to tell the emperor he was wearing no clothes. After seeing the interim master plan statement, he wrote: "If there is a single misinterpretation of Committee intent running through the report, it is the impression that the proposed outdoor museum is to be the be-all and end-all of historic preservation in the State of Wisconsin." The projected museum was "of gargantuan proportions." Tishler cannot be faulted here. Fishel had instructed the landscape architect to think big and he had. Fishel had ordered a Cadillac for an organization that would have had trouble financing a Schwinn bicycle. No doubt—acquiring this plan in the manner Fishel did was another masterly stroke in his incremental approach. Moving forward to implement the conceptual plan fell to Fishel, and not to Tishler, who had more than fulfilled his assignment.

The other problems were not so much with this plan but with the failure of Society leadership to move forward boldly in three significant areas that would haunt the construction phase. First, Fishel did not follow through on his intention to secure a construction blueprint that would provide specific details for siting the acquired buildings. But there were other complications. His lack of staff and financial resources and the failure to pursue the needed research in a systematic and thorough manner also prevented any decisive moves. Compiling a blueprint depended on the completion of the historic building survey. Here again the lack of resources hampered the effort. Thus, the second problem was the failure to bolster the research staff. The Society relied too heavily on a student-researched effort. When construction began, the inadequacy of the research effort became all too apparent. The third step that needed to be taken was the implementation of a systematic approach to fund-raising. As with research, the Society had not taken the requisite steps to ensure sufficient funding.[56]

In "The Rainy Day," Henry Wadsworth Longfellow wrote: "Into each life some rain must fall / Some days must be dark and dreary." The sunshine (euphoria) of securing a dazzling master plan quickly gave way to thunderclouds that loomed large on the horizon. At about the same time Tishler's plan came to the board, Fishel let it be known that he would resign as director to become president of Heidelberg College in 1970. His decision nearly derailed the embryonic museum. He had been the key person for keeping the project alive in spite of the obstacles. His importance became apparent soon after he left the Society in mid-1969. Judging that appointing a successor would take some time, the curators

appointed Dick Erney to serve as acting director until Fishel's successor could be found. Erney was, by his own admission, not a strong supporter of historic sites. How would this transition affect museum planning?[57]

Fishel's pending departure apparently did not dampen curatorial support for the museum. The presentation by Tishler and his graduate students, and especially the optimistic economic analysis put forth in the 1968 plan, encouraged the board's continued support. Tishler and his students had overcome one major obstacle. The Society had its plan by October 1968. Still missing was the research, the full-scale inventory of available historic buildings, a site, a blueprint that detailed infrastructure needs for the site, and a fund-raising plan that would assure financial stability. Without resolution of these issues, the museum concept was in trouble. Not quite a year after the October meeting, the storms hit. Did the staff and the curators have the stamina to carry the concept forward and begin construction? This question would be answered by their responses to a series of potentially debilitating crises and conflicts and with their campaign to raise money from the private sector. That Acting Director Erney provoked the first crisis severely undermined the collective will to move forward.[58]

Conflict Management

The battle of Eagle took Society leaders by surprise. After the protracted struggle with the DNR to secure a lease for the state forest, they never imagined that an even more intense conflict awaited them. Fishel knew that implementation of the Perrin vision might face obstacles, and for that reason he moved slowly on the outdoor museum project. He and his colleagues could not have anticipated the number and severity of the conflicts that arose after the adoption of the master plan in October 1968. This chapter analyzes several clashes that nearly rendered the project stillborn. That the Society planned to start construction in the summer of 1973 testifies to the remarkable tenacity of a few dedicated staff and volunteers. But rather than concentrating on the acquisition and relocation of buildings, a number of conflicts with some members of the local community forced the Society to delay construction. The battle of Eagle became increasingly public and personal. At stake was the state's ability to control the use of local property and the museum's impact on local property values.

In the months after Fishel's departure, the situation looked increasingly bleak as national and state budgets suffered through a period of stagflation (increasing inflation, slow economic growth, and high unemployment). The budget process gave no cause for optimism that the legislature would provide any new funding. Earlier the Society's budget

had been cut. Reductions in "an already tight budget" meant the Society might not be able to accomplish key goals during the next biennium. The recommended salary for a new director had been slashed by more than 36 percent, from $27,000 to $20,000. This made the position so unattractive that the WHF struggled to find a way to supplement the salary without antagonizing the legislature. Existing sites ran deficits. With no aid from the state, austerity measures had to be introduced. Closing some historic house exhibits in mid-September angered visitors; ten temporary employees were laid off. Most ominous for OWW, the chair of the LRSPC questioned taking on new sites when there were so many problems with those now in operation. He urged OWWC to decide whether or not OWW "is a viable project." A crisis loomed large on the horizon. The future of the museum hung in the balance.[1]

If Fishel fostered ambitious and costly changes at the Society, restraint characterized his approach to the outdoor museum. He was careful not to cross his Rubicon. He kept open his option to stop the project if it became unmanageable. After nine years and no great expenditures of capital, the museum had yet to emerge from its planning cocoon. Could the project survive new leadership? Could it survive a rigorous scrutiny of moving from planning (manageable costs) to implementation (unmanageable expenses)?

Dick Erney became the acting director on June 1, 1969. As Fishel's second in command since 1964, his primary responsibility had been the Society's 80,000-square-foot addition, valued at $2,340,000, to its Madison headquarters. Erney was well aware of the planning process of the museum. Even though he was one of two staff serving the curatorial museum committees, he described his connection as "pretty peripheral." His support for the museum had been tepid and he had voiced his concerns on numerous occasions. His new appointment gave him the opportunity to confront the issues that swirled around the project.

On October 6 he sent a memo to the OWWC. In summary, he asked the question Fishel had not asked: has the time come to quit the field? His memo, which must be considered in full, touched off a crisis that dampened curatorial resolve and left the committee members stunned. This memo provoked the first of a series of crises that dogged planners between late 1969 and 1975. The second—the long-smoldering site-acquisition crisis—finally achieved resolution only to be engulfed by the third. This was a legal challenge from Town of Eagle residents. Town officials intended to prevent the state from locating the museum within its boundaries. These three crises delayed construction and

accelerated costs. The last crisis, considered in the next chapter, was the Society's inability to raise the funds required to build the site. The weight of these crises nearly crushed Old World Wisconsin before it came to life.[2]

The curators felt confident that Erney could lead the Society through a challenging transition period and keep it running smoothly as the search committee did its work. Erney was new to the role of leader. He began working for his Ph.D. in early American History with "visions of teaching" history at a small college. The academic job market was tight in the mid-1950s. His dissertation director, David Shannon, who was leaving Columbia University to return to the University of Wisconsin, recommended Erney as a person "who would be good for any job at the State Historical Society." In 1957 Erney accepted a position in the Office of Field Services, where he collected materials for the society's newspaper and manuscript collections. He soon moved to the archives division and later became the state archivist. His familiarity with historic sites came as an interested tourist. He and his wife had visited the major Eastern sites such as Mystic Seaport, Old Sturbridge Village, and Williamsburg. He found them interesting in part because they added another dimension to his work as a historian.[3]

Fishel's resignation obviously fostered change. Fishel and Erney contrasted in their leadership styles. Erney was incapable of living with Fishel's ambiguities and uncertainties. One of his first priorities was an assessment of the outdoor museum project. Fishel had achieved three enthusiastic commitments from the curators. Never, though, did he ask for a financial commitment, and the curators never pressed the issue. They had a master plan that beautifully described the concept of the museum and made it *seem* economically sustainable. Fishel and his OWWC colleagues had selected a site but failed (for a variety of reasons) to secure it. This failure threatened future developments of the museum. Under Fishel's leadership, the needed inventory of historic houses remained incomplete. More important, the Society had done little to publicize the project or to initiate a massive fund-raising initiative. Erney inherited a project that had failed to emerge from the starting gate. How would he handle the situation?

If nothing else, the search for a new director put the museum project on hold. That aside, the Society's old nemesis remained. It lacked the monetary resources to undertake a major enterprise such as OWW. This reality would plague the acting director and the new director as it had Fishel. OWWC member Robert Zigman wrote upon learning of

Fishel's resignation to express his disappointment that "our efforts" for OWW have not been more productive. Many of his colleagues on the board shared his distress at the lack of progress regarding site acquisition and fund-raising.[4]

The Fishel years may have been "good ones" for the Society, but they were a mixed bag for Old World Wisconsin. The LRSPC met a few months after Fishel's departure. They agreed that the question of OWW should be resolved. Cutlip's statement must have had a chilling effect on the OWWC. He said he felt there was strong support for the museum and that it would be a mistake to *drop* the idea. After nine years of toil, the LRSPC pondered the museum's fate. Had the time come to abandon the project?[5]

Erney, too, pondered the future of the museum. His concerns provided the context for the five-page, single-spaced staff memorandum he sent to the OWWC. He did not act precipitously. He sent the draft to his most trusted colleagues, Sivesind, William H. Applegate, and museum director Thurman O. Fox. Sivesind thought the draft "excellent," and Fox declared it a "good letter." Sivesind suggested some approaches to soften the blow to people like FitzGerald but judged the draft to be the "first sensible analysis" of the OWW idea. Erney, who recognized that no other proposal within his memory "has elicited comparable enthusiasm" among the curators, drafted a lengthy letter to board president Thomas H. Barland. Erney acknowledged that the OWWC had worked "steadily, diligently and intelligently" to this point and that the proposed museum was "unquestionably one of the most imaginative proposals" to come to the board's attention. He well understood the board's excitement for the project. But after a thorough review of the plans, the acting director felt the Society had to confront the economic issues the museum presented. Barland recommended (according to Erney) that he "simply put the statement in form of a staff memorandum" and send it to FitzGerald and the OWWC.[6]

Erney listed several questions and problems that had been raised on the staff level. These fundamental issues, he wrote, appear not to have been discussed thoroughly, if at all, by either the OWWC or the curators. He needed answers before the Society committed irrevocably to the project. He raised six issues that together formed a scathing critique of the labors of the past nine years. His most important concerns centered on the financial feasibility of the project and its impact on other Society programs and activities, which was the greatest concern of the staff. He also expressed his concerns about the availability of suitable buildings

for removal and reconstruction on the site, the duplication with existing sites, furnishing and equipping the buildings at OWW, and interpretation at the site. Erney fell short of delivering an ultimatum, but no one missed the implications. If the committee could not provide satisfactory answers, then the Society should deep six the project.[7]

His first question about suitable buildings confronted the Perrin proposal directly. How many of the ethnic groups who came to Wisconsin brought or developed a distinctive architecture? Many immigrants did not "leave any distinctive architectural style" that reflected their ethnic origins. He next asked whether the Society could acquire enough original buildings to give the site integrity. If a sufficient quantity were not available, then it would be necessary to reconstruct buildings. From this assumption, he concluded that OWW "would be a 'village' or 'grouping' which never existed." Finally, he raised a public relations issue. Unless the museum included meaningful representation of all ethnic groups, the Society risked angering the excluded groups.[8]

His second issue, the unneeded duplication of sites, led him to compare the proposed museum with Stonefield and Wade House. The OWW plan envisioned twenty-one different types of units. Of those, sixteen existed or were planned for the other two existing sites. Such duplication, he asserted, "will be difficult to justify, particularly in any requests for public funds." He believed some of these sites offered better ethnic presentations than anything contemplated by OWW planners.[9]

His third section questioned whether the furnishings—furniture, utensils, tools, and clothing—had distinctive characteristics to make the interiors of the various ethnic buildings distinguishable from each other. He then noted that the Society had a "very meager" collection of artifacts and wondered "where we will acquire the artifacts?" When it came to crafts, blacksmithing for example, were there differences among the ethnic groups?[10]

His fourth section laid bare an issue that the committee had not seriously considered: interpretation. Assuming that architectural and artifactual distinctions among the ethnic groups justified proceeding with the museum, he asked, "How many people will find these differences sufficiently interesting to visit the site?" He thought OWW would need activities that will make it distinctive and give the visitor an appreciation of the cultural variations and contributions of the immigrant groups. He had in mind activities that he termed folk art forms: dancing, handicrafts such as wood carving and inlaying, needlework, and cooking that would make OWW into something of a permanent holiday folk

fair. Finding the right personnel to demonstrate these activities on a daily basis would not be easy and certainly would be expensive.[11]

He next challenged the 1968 plan. He found it "difficult to accept" the conclusion that OWW would be able to generate sufficient revenue to cover the cost of operating the site. While he did not do a detailed analysis of the data, his opinion and "that of other professional staff" was that attendance projections were too high and income predictions were too low. The only way the Society could cover the sure-to-occur deficit was from a legislative appropriation. The Society's "failure to obtain relief for our current site deficits in this session of the legislature" offered little hope in this direction. The OWWC must do a more thorough analysis of the financing of OWW. He suggested two alternatives. Either submit the prospectus to the Bureau of Management or submit it to a private consultant (if a competent one could be found at a price the Society can afford).[12]

Finally, he came to his overarching concern—the potential (negative) impact of the museum on the Society. Here he raised three issues. OWW, if continued, would add considerably to the workloads of the staff. Existing staff could not absorb the increased demands on the business office, administrative services and general administration, research, historic sites, and field services. One of two things must happen. Staff would be increased or other activities would be curtailed. Next he pointed to fund-raising. The museum could be funded only through a major effort to reach out to private sources. It would require a fund-raising effort "far more successful than any the Society has ever mounted." How, he wondered, would this impact other projects? The museum's impact on legislative support concerned him. Would the successful completion of OWW mean less state money for the library and archives, development at other sites, and staffing needs in every other division?[13]

Erney recognized that some of his questions went beyond the responsibilities of the OWWC. Questions about the museum's impact on the Society fell to the Executive Committee or the LRSPC. The timing and urgency of the memo resulted from the LRSPC's January 1970 deadline to submit its report to the curators. Without answers to the questions posed, that committee would be flying blind.[14]

He concluded: "On the basis of the currently available evidence and the Society's experience with other sites, I do not believe that Old World Wisconsin is feasible, either technically or economically." He had taken a rapier to cut the Perrin-Fishel vision to pieces. The memo was sharp, and Erney made no effort to smooth the edges.[15]

What circumstances led to this memo to the OWWC and what consequences resulted from it? Erney could easily be cast in the role of a villain, but that would be unfair. More aptly, he saw himself as guardian of the Society's resources and reputation. While not of the same magnitude, Thomas Jefferson's description of slavery comes to mind: we "have the wolf by the ears, and we can neither hold him, nor safely let him go." Could Erney and the Society cut the museum loose? His fear that the Society stood at the edge of an economic abyss led him to say yes. With Fishel gone, long-simmering fears of the museum's impact on Society programs had an audience. Opponents saw the specter of a Society drained dry by a major project that had no prospect of certain funding. The Society had not received a sympathetic hearing in the recent legislative budget hearings. Against shrinking budget prospects, it faced a sites program that continued to run deficits while planning for a museum whose potential costs threatened worse consequences. Erney believed the Society could not afford the museum.[16]

Erney sent the memo in part as a response to the stifled expressions of discontent from some of the staff. It was not an open revolt, but he recalled that it was evident at the Society "that a lot of people on staff were sick and tired of hearing nothing but Old World Wisconsin." Besides Erney, those who questioned the wisdom of the project included a few curators such as Robert Murphy, who also headed the WHF, and a significant number of staff, including the sites director. Sivesind did not need to approach Erney about his misgivings, as he had expressed them at earlier meetings. Beyond this, the staff saw Erney speaking for them in ways Fishel had not. Fishel recalled that he "wasn't worrying about straining the staff." He conceded that sounded "rather callous to say." He "figured that if something had to be done the staff would do it and we could get the wherewithal to do it." Cronon, who served as board president from 1970 to 1973, thought the "staff saw [Erney] as a hero."[17]

Erney's personality certainly contributed to his decision to send the memo. Cronon characterized the reaction of the curators. They saw "him being Dick, doing what Dick should do." He thought it made sense for Erney to ask the questions he did. He added that "I have a different kind of personality than Dick's and I'm not the kind who always thinks the sky is falling, and so I wrote it off as partly Dick Erney and his view of the world." If Erney was pessimistic, Cronon was an optimist "about the Society and how this project could succeed if it got off the ground" and acquired the Eagle site from the DNR. "I figured we could make a go of it." Besides, all Society activities "are kind of

hand-in-mouth, and this would be another one." Erney's cautious, conservative, pay-as-you-go attitude certainly informed his decision to send the memo.[18]

Finally, Erney felt an obligation to act on behalf of the new director. He thought of OWW as a "leftover," as unfinished business from Fishel's directorship that needed resolution before the new director assumed his duties. Erney reasoned that the new director might have a "better chance of succeeding if he pushed OWWC to resolve the questions he posed." The inability to produce results frustrated Erney, and he wanted OWWC to confront the harsh realities of the OWW commitment. His bluntness could easily be viewed as hostility. Tishler recalled that Erney's memo "was like a slap in the face." Two curatorial responses offered very different tones. Zigman responded rationally and offered a solution. Perrin reacted viscerally.[19]

Zigman said that the Society "should NOT forget this project." He acknowledged the need to reevaluate but wanted to establish a definite plan for development. He reiterated his belief that the Society needed to find a donor who could contribute one million dollars. To put Zigman's suggested action in perspective, his one million dollars would be over six million in 2012 dollars. He took the opportunity to reiterate his position that the Society must get a "sound development program" underway for soliciting private money.[20]

Perrin showed no patience. He had shared his knowledge of the state's fastest-disappearing historic resource—immigrant architecture. He had made numerous trips, mostly between Milwaukee and Madison, to participate in meetings with Fishel and the committee. He had tramped the various sites with Society staff. Of all the museum's supporters, he was most annoyed and frustrated by the slow pace of development. He now read this memo with "utter amazement and disbelief." It was incredible that after five years of close contact with this project the "staff" should now find so many reasons to question the planning process. The "obvious negativism" of Society staff cast a pall on the committee's efforts to move the project forward.[21]

Perrin summarized the six points and then launched his assault. He questioned whether "the staff" understood outdoor ethnographical museums and their educational functions. He wondered if "the staff" had made any attempt to study in depth European and American counterparts of the proposed museum. Given the negative attitude expressed in the memo, Perrin thought it futile to dwell at length on the points raised. For the record though, he shared some specific responses for the committee and the board.[22]

Perrin first noted the continuing research role of the outdoor ethnographic museum. OWW was not intended as the definitive statement on immigrants to Wisconsin and their architecture. It was ridiculous to assume that not many of the ethnic groups brought or developed distinctive architecture. Perrin explained: "It is the responsibility of the researcher to establish these differences and for the museologist to exhibit and to interpret them." Bringing together architectural examples of the various ethnic groups of different time periods and interspersing them in areas similar to their original locations would create a museum unlike any other in the world. It would not be "a collection of mummified exhibits accumulating dust and of no interest to anyone." This outdoor ethnographic museum would be "essentially a workshop," a learning lab to investigate ethnic groups and their buildings.[23]

Yes, Perrin admitted, OWW would duplicate some elements of Stonefield and Wade House. Here he reverted to sarcasm. Would you not restore Mount Vernon because so much is duplication of Gunston Hall or other nearby plantation restorations? Would you say that having seen one Gothic cathedral you have seen them all? Asserting that Cornish, Swiss, and Norwegian sites were better developed than similar exhibits at OWW was "certainly a very shallow assessment."[24]

Yes, a dearth of ethnic artifacts for furnishing historic buildings existed. But should that stop the process? They would have to be "ferreted out" or reproduced. Perrin continued: "That the furnishings of different ethnic groups would all look alike is another amazing assumption." He commended the work of one staffer, John Winn, who had done an outstanding job with little assistance in researching, locating, identifying, and negotiating acquisitions for the museum. According to Perrin, Winn's "work has been crippled by a lack of administrative enthusiasm and support and, of course, a lack of money." He dismissed the notion that the Society could not interpret the subtle differences in artifacts and buildings. As far as the costs, no one ever said OWW would be cheap. If "cheapness" is the only criterion, then the project will be severely handicapped. If the Society now has qualms about the analysis in the master plan, then further review should be done, but not by another state bureau. Perrin recognized that finding reasons not to do things rather than reasons for doing them was the safer course. Yes, additional staff would be required. Yes, legislative support would have to be obtained. Yes, funds would have to be raised. To use them to argue that OWW is not feasible "does not reflect any great depth of understanding at the administrative level." He concluded his analysis with a harsh judgment: "I am inclined to agree that Old World Wisconsin is

not feasible, but not for the reasons given in the Erney report. It would be my conclusion that the project is not feasible because the State Historical Society of Wisconsin is not capable of carrying it out."[25]

What did Erney think about this response? "Perrin had really attacked me," he stated, rather than addressing "what I said in the memo." He recognized that Perrin was "far more knowledgeable about museums," especially the one under consideration. But, he thought, Perrin remained oblivious to the potential impact OWW might have on the Society. Perrin's response to his memo of October 6 disappointed Erney because it did not discuss the points that he had raised.[26]

Some OWWC members, Erney, and Sivesind met with the LRSPC to determine what should be said about OWW at the impending board meeting. Committee members were on the defensive. Erney regretted Perrin's reaction to his memo and decried that he was not present to discuss the six points. FitzGerald stated boldly that OWW "was dead as long as Mr. Erney was in charge." John Geilfuss, the chair of LRSPC, asked FitzGerald for an anticipated completion date for the museum. His lame reply that it would take "a long time" did not help the cause. Erney reiterated his conviction that the attendance projections were much higher than the actual experience at Circus World Museum. FitzGerald could only reply that OWW "could be made more exciting than CWM." Geilfuss picked up on the legislative hostility theme. He hoped that OWW would not hurt the Society's ongoing projects. Fred Risser, a member of the assembly, agreed that the legislative atmosphere this session was definitely "not favorable" and questioned the wisdom of more new projects. One of the OWWC members agreed with Erney that OWW operational costs, if properly analyzed, would be "extremely high." Erney reiterated that the needed inventory of historic buildings remained unfinished. The tone of the meeting sounded like a death knell for the museum.[27]

This meeting did not resolve the Erney crisis. New OWWC chair, curator Roger Axtell, desperately tried to salvage a modicum of hope. He suggested that the project should "continue as a dream" with a high place in long-range planning but second in priority to the needs of existing sites development. The two committee chairs agreed to prepare a "position paper" that would be used for the long-range planning report. Meanwhile, Society staff received instructions to continue to preserve and stockpile available buildings and to continue to collect artifacts. These compromises left the outdoor museum in a state of limbo. In April 1970 a reporter quoted Erney as saying: "The project is not dead

but the problem now is finding funds for the almost $1.5 million venture." OWW "remains 'up in the air' until funding is found." The fate of the project hinged on the appointment of a new director.[28]

OWWC did not give up in the face of Erney's challenge and its limited support among Society leaders. In June the concept received an endorsement of sorts from the curators. They adopted "The Report of the Long-Range Sites Planning Committee," which included the statement that the "Old World Wisconsin concept is still considered a valid and exciting project for the Society." Further development, however, must be secondary to the maintenance and improvement of the Society's other sites. As an editorial in the *Milwaukee Journal* on December 23, 1970, in support of Old World Wisconsin noted, "Its time is running out." Time may not have run out completely, but as Perrin frequently preached, time was the great enemy of the museum. Houses, barns, corncribs, privies, and the like had disappeared at a discouraging rate in the ten years since Perrin first approached Fishel.[29]

New leaders—David Cronon as president of the board, congressional representative Henry Reuss, and Roger Axtell as the chair of the OWWC—joined stalwarts like Dick Perrin to keep the dream alive. Most important, as of July 1, 1970, the Society had a new director, Dr. James Morton Smith. As a college professor with considerable administrative experience, Smith brought not only strong academic credentials but a "deep interest in and conviction to the need for popular presentation of history." Erney thought the curators hired him because he was "committed to the project." Cronon told the new director that "our first order of business must be either to get the OWW project underway or admit it was beyond the Society's capability and cancel it." Smith's willingness to resurrect the "dream" was a major first step in rejuvenating the project.[30]

Smith faced a number of long-standing unresolved tasks in July 1970. Most relevant to OWW was the lingering crisis over the acquisition of the site. Even as he waited for the appointment of a new director, FitzGerald continued to press Erney regarding negotiations with the DNR for land in the Kettle Moraine area. Again, Ehly reported no progress because of local hostility and skyrocketing prices. He asked Erney for a status report. OWW seemed to be held "in abeyance," and Erney listed five reasons: (1) problems at other historic sites; (2) the LRSPC's review of "certain aspects of the project"; (3) anticipation of hiring a new director; (4) questions about Aztalan versus Kettle Moraine; and (5) the hopes of "finding private funds to get us off the ground."

Erney's comments led Ehly to inquire about the Society's stored buildings. He thought, since the Society seemed to have no immediate need for them, the DNR could reerect them at other state parks as service buildings. Sivesind investigated and concluded that the stored buildings did not have an adaptive-use potential. In Cronon's mind the problem was twofold: Society staff was not pushing the DNR very hard and the negotiations were between staff members who did not have the authority to consummate a deal.[31]

The museum's future still remained unclear. In January 1971 United States Representative Henry Reuss asked Perrin for an update. The Milwaukee architect vented his frustrations: "I must tell you in all candor that I am increasingly disenchanted with the way this thing is going. We have been at it since 1964 and haven't accomplished a blessed thing except to get the legislation passed with which you are well acquainted. With each passing year the number of good specimens is being rapidly decimated by wind, weather, and fire. . . . I remain convinced that this Ethnic Village could have been the greatest thing Wisconsin ever accomplished, had it started in time and been diligently pursued, but at this point in time even I must question its feasibility, particularly in terms of the Society's obvious lack of capability to get it started, to say nothing of carrying it out." Perrin also let Smith know that he intended to resign from the OWWC "unless something happens, and pretty damned quick." He could see no reason to stay with what he character- ized as "increasingly a farcical performance." Perrin's outbursts troubled OWW supporters at the Society. Smith was sorry that Perrin "sounded off to Reuss, though I understand his exasperation." He assured Perrin that he had tried "so damned hard" to deal with "ancient and honorable projects" such as OWW, but problems as menial as trying to "round up" OWWC members for a meeting frustrated him. He assured Perrin that as far as the museum situation, it was a "fish-or-cut bait item." He vowed that the project would not be dragged out unnecessarily.[32]

Cronon called Perrin to tell him that if he "can't help us" at least don't hurt us. Perrin and Cronon, along with two legislative representatives, had traveled together to Europe and visited many outdoor museums. That Perrin "would fire-off this hot letter to Reuss criticizing the society when Reuss was expressing interest in learning about the project" was unnecessary and angered Cronon. He even called Reuss to ask him to ignore the Perrin outburst and offered a briefing on OWW. Cronon hoped Reuss might be able to make some federal money available to jump-start OWW. In the meantime, Cronon and others but not Smith

met with Voigt and Ehly on February 3. That same day, OWWC met. Ehly told Smith that the DNR was ready to sell either Aztalan or the Eagle site when the Society is "ready to buy one." Cronon then wrote Reuss to update him on meetings with the DNR. He noted that until the Society "can settle the site question, we cannot make meaningful progress on the further development of the Project." The next step was to convene a meeting with Voigt to determine whether the DNR would support the Society's idea of sponsoring enabling legislation that would allow the land to be deeded or leased "without payment."[33]

Then the unexpected happened. Society leaders were not certain why Reuss had summoned them to his Milwaukee office in February. He indicated his willingness to donate a substantial portion of his Marshall & Ilsely Bank (M&I) stock, provided the Society used none of his money to purchase the land. This was the catalyst the Society needed to resurrect the OWW project. OWWC chair Roger Axtell was euphoric: "Dave Cronon, the new Society president, believes strongly in OWW and under his leadership the project has gained strong impetus in recent months." He told Reuss that their visit with him was the "greatest boost and leap forward since the inception of the project." As a result of the gift, Axtell reported that curator interest and enthusiasm continued and that some of them visited the Eagle site. Seeing the site for the first time, he reported, "my own convictions are stronger than ever." After listing some important new developments, he concluded that this "$100,000 will allow us to develop a *platform* from which to launch other fund-raising efforts."[34]

Ah, the Eagle site: the Society still had no site and no money to buy it. Cronon remembered talking to Smith about the negotiations with the DNR. The prevailing word from the DNR was that the Society must purchase the site. Cronon questioned whether that was indeed the case. When Cronon learned that Society staff had only talked to the lower level people in the DNR, he decided that the time had come to talk directly to Lester Voigt.[35]

Cronon did not entirely count on the goodwill that might result from negotiations at the highest level. He figured that this was a good time to talk to the head of the DNR because of contemplated changes within state government. The new Democratic governor Patrick Lucey wanted to move to a cabinet form of government. The head of the DNR, for example, would be appointed by the governor and not the board and would be answerable to the governor. Although he did not favor the changes, Cronon was willing to take advantage of the possibility

they might be implemented. He knew that Voigt was closer to the previous Republican administration than to the present Democratic one. He suspected that Voigt probably was a Republican, and as such "must be nervous about his future" with the Lucey administration. Smith and Cronon told him that the Society had received a $100,000 donation "from a prominent Democratic state politician." Cronon reasoned that Voigt wanted to establish his credentials with the new Democratic administration and might conclude that finding a way to convey the Kettle Moraine land to the Society was in his best interest. Voigt wanted to know if the curators were "willing to invest a lot of money in land that you don't own?" Cronon replied that since the DNR owned two sites and the Society operated them as historic sites, he did not see the problem. Cronon remembered Voigt saying that he thought his board might be willing to let the Society have the site. If so, Voigt assured Cronon that the DNR would put "some money and labor into developing it for you. We'll put in the roads and the parking lot." What a reversal! Under the leadership of Reuss, Cronon, and Smith, and within a relatively short time, a decade-long struggle over the site neared resolution. Negotiating the precise language of the lease took time, but eventually the Society achieved what at the time had seemed impossible: acquiring the Kettle Moraine site at no appreciable cost. The DNR agreed to a memorandum of understanding that assured the Society's use of the Eagle site. Equally important, the DNR agreed to provide at no cost to the Society an access road and a 200-car parking lot and took responsibility for snowplowing, grass cutting along the roadway, and even helping create the lakes, "if such engineering is possible."[36]

The future looked brighter than it had in many years. After the OWWC presentation at the La Crosse meeting in June, one curator informed Axtell that another influential curator "had changed her view about OWW." For the next eighteen months the OWW project forged ahead with fund-raising, publicity, completion of the inventory of historic buildings, revisions to the master plan, establishing priorities, acquisition of buildings, and site preparation.[37]

Not everyone was caught up in the moment. Old worries and ancient uncertainties persisted. Sivesind and Erney remained skeptical. The rush by Smith and others to script legislation to allow the DNR to transfer the land worried Sivesind. "I have seen some rather weird things happen in our historic sites program during the last 20 years but I think this one has a good chance of becoming the weirdest of them all." To

initiate legislation before the board has stated it wants to undertake the project appeared premature. He saw the Society stumbling into it "far enough that we can't back up. The costs of long-range operation and maintenance on this one will make our present sites look like petty cash operations." Erney added that it was well known he shared Sivesind's sentiments. Both had the opportunity to share their views during a frank, and sometimes brutal, discussion of the issues and problems on March 22. The meeting adjourned with no resolution beyond a weak statement that Erney and Sivesind, representing staff, and Cronon and Axtell, representing the board, would have to use their imaginations and the resources of curators to find a way to overcome the delineated problems.[38]

The Society and the DNR rapprochement modeled the May 15, 1971, memorandum of agreement on the ones in place for Wade House (Old Wade House State Park) and Stonefield Village (Governor Nelson Dewey State Park). After so many years, the Society had achieved the agreement Fishel had first proposed. If the site came without any up-front expenditure, its costs in terms of time and energy spent had been considerable. In effect, the DNR leased the Kettle Moraine State Forest to the Society for nominal considerations and agreed to make the physical changes needed to convert forest into a historic museum. Was it a pyrrhic victory? Mystery writer James M. Cain once wrote: "I write of the wish that comes true—for some reason, a terrifying concept." The planners had explored many sites but wished for only one. The Society had its Eagle site. Perhaps not terrifying, but it was a wish that came with a bundle of problems, some foreseen and one particularly nasty unforeseen one, the battle with the Town of Eagle.

This unanticipated and unwanted confrontation lay deep in the past. It started innocently enough with a meeting in February 1973 over a zoning request that a property owner laid before Waukesha County and the Eagle Town Plan Commission. It focused on local autonomy and raised an equally significant issue: the rights of the local community to control or at least influence development through local regulatory powers. In this case, the Town of Eagle embraced local rights to fight state agencies that threatened to ride roughshod over community concerns. Zoning regulations and building codes became the *causes célèbres* that pitted the local community against the state.

The planners did not see this crisis coming. By mid-1973, the ethnic park had acquired another name, Bicentennial Park. The Society planned to make OWW the central feature of the state's observance of

the 200th anniversary of the American Revolution. In addition, the Society's director was a nationally known scholar of the revolutionary period. It was ironic that the Town of Eagle invoked the "Spirit of '76" in its battle against the Society. A "citizens committee," formed to consider the potential impact of OWW on the community, began meeting in April. Whether consciously or not, they invoked a prominent doctrine of those who protested against Great Britain, namely, the struggle for local autonomy against the arbitrary and insensitive hand of central authority, in this case the State of Wisconsin and its minions, the Society and the DNR. Beyond this, town leaders claimed, echoing their revolutionary forbearers, to speak in "the name of people."[39]

Another split emerged from the controversy. The projected museum divided the Town and the Village of Eagle. The Wisconsin legislature incorporates cities and villages, but not towns. Towns, which consist of those areas not in incorporated cities or villages, have their own governing boards. This division represented another classic theme—ancients versus moderns. The intellectual foundations of the debate between advocacy of traditional ways and emerging progressive views can be traced to late seventeenth-century France. The controversy migrated to England and culminated with Jonathan Swift's *A Tale of a Tub* (1704). The British exported the notion to the colonies, and it manifested itself in many struggles during the national period. In this instance, elected town officials, who represented more traditional values, spoke for only a portion of "the people." They represented the concerns of those who feared change and wanted to preserve their pastoral way of life. As one resident put it, the present population was mostly farmers and political conservatives and feared the newcomers may be "ultra liberal." He predicted that a museum "could upset the economic way our town government operates and the peace and tranquility enjoyed by the people of this community." The Village of Eagle represented a more progressive element that welcomed the museum. They saw opportunities for positive growth. Russell Chapman, who operated a gas station in the village, saw the project as a boon to local business. Mrs. John Daggett, a thirty-five-year resident whose husband was a real estate developer, characterized the museum as "a handsome addition to the community. It will add historical value and employ a lot of people." When the town sought to have the village pay for part of the legal battle against the Society, village officials refused.[40]

Another element in this crisis was rooted in the past. The wished-for site made it imperative that the Society partner with the DNR. One

rural Eagle resident, who generally favored the museum, warned that the Society needed to overcome the residual hostility generated by the DNR. In rural Waukesha County, Conservation/DNR used its condemnation powers to acquire land for state forests. While condemnation was legal, the DNR "made a lot of enemies in Eagle." This not only flamed passions, but it also raised the sensitive issue of the private use of land versus the public use of that land.[41]

Politics also motivated some. One town resident noted: "Suddenly, from within our ranks, a young whipper-snapper named Carl Seitz emerged as our leader." Seitz, who was thirty-three years old, had recently been elected as the town board chairman and he took the lead. Some Society staff saw him as "our problem." He "receives vocal support from people negative to OWW at public meetings and is trying to build his reelection on this." Seitz built a coalition that fought "to help save the property rights of the people of Eagle." As one resident recalled: "We talked, we worked, we raised funds, we published newsletters, and we went to Madison in bus loads to impress on our legislators the rights of the people." Seitz used populism to fight the DNR-Society coalition. He took the "various issues to the town people to marshal their support." His strategy included the possibility of a referendum—a public vote on the museum. If the majority voted against OWW, "Seitz intends to fight the project."[42]

The intensity of the animosity Seitz represented caught the Society off guard. At a public meeting in the midst of the struggle one attendee characterized the project as "a cancer, a monster." If left unchecked, it "will destroy a whole way of a life." The opposition stunned the Society's public information officer, Chet Schmiedeke. The Society, he stated, had never encountered such negativism at its other historic sites. He explained, "Usually local communities are just dying to get something like this."[43]

The battle with the Town of Eagle flowed from the convergence of four events that in one way or another related to the site. With the site secured and some working capital, the busy voice of preparation echoed through the halls of the Society. Representative Reuss, whose donation energized the project, pushed the Society hard. He wanted buildings, not plans. His measuring stick would be the reerection of historic buildings on the site. These activities at the site, in turn, exacerbated anxieties and tensions within the greater Eagle community. The second factor involved land contiguous to the site. The state did not move quickly enough to prevent Albert Gagliano from purchasing the land.

He wanted to expand operations on the land he owned and applied to the Town of Eagle Plan Commission for new zoning that would allow him to have, among other things, a riding stable. Next came the Environmental Impact Survey (EIS), a draft of which the Society made available to interested parties in March 1973. Finally, in a last-ditch attempt to stop construction on-site, the town building inspector posted a work-stop order at the site.

In early 1973 town officials explored stopping or slowing construction of the museum. Construction was the accelerant that set ablaze a long-simmering tension between state encroachments and local control. Were the legal attacks a futile gesture or did they threaten the Society's opportunity to transform the forest into Perrin's museum?

Both sides focused on the EIS. The opening salvo came on February 5, 1973. The Waukesha County Park and Planning Commission and the Town of Eagle Plan Commission met to consider the petition of Al Gagliano for a zoning change. Town officials ran the meeting and showed considerable hostility to the DNR, asking, for example: "Why is DNR against riding stables?" Smith presented the Society's plans and conveyed its opposition to granting Gagliano's zoning request. Town of Eagle building inspector Don Van Acker then asked: "Do you guys own the whole Kettle Moraine State Forest?" This tone aside, Smith wrote to one commission member, stating that the "hearing epitomized the democratic town meeting at its best, with a free exchange of viewpoints by all who wished to be heard."[44]

Support for local autonomy brought an outside group to the fray. Stephen Hauser, a student at Carroll College in Waukesha, chaired a newly created organization, the Progressive Non-Partisan League of Wisconsin. Speaking in the name of the people against the encroachments of the state resonated with Hauser and his group. The league looked to inform the public regarding tax and fiscal issues and to promote progressive educational policies. It supported local suburbs and towns against unwanted state encroachments. Hauser learned of the controversy between the Town of Eagle and the Society from an article in the *Waukesha Freeman*. He contacted Carl Seitz to learn more about his "advocacy of local control." Hauser characterized the struggle as between David and Goliath. The prospect, the fear, of the state, with its greater resources overwhelming local government, seemed all too real in 1973. Not even Waukesha County would help. Lloyd Owens, the county executive, saw the county as a "bystander." Hauser remembered him using a dueling metaphor: "We're here to hold their coats." This tepid

response offered little comfort to the embattled town officials. They were not, as Hauser recalled, "slick politicians." They were very much "people of their community" who represented, "in the truest sense of the word, the people around them." What did their constituents want from the confrontation?[45]

The larger issues that drove the town board and the league gave way to very mundane and practical concerns of town residents. They expressed their concerns to Alan Pape and Gary Payne, two Society staff members who had moved to Eagle to begin museum construction. They explained the Society's position at public hearings and through local news outlets. Three general areas of concern became evident: townspeople worried about OWW's impact on the environment, how the museum might change their community, and the impact the museum would have on their pocketbooks. One resident specifically mentioned restaurants and motels that would surely come in the wake of the museum's opening and which seemed incompatible with the rural character of the area. A less-friendly observer referred to the restaurants, motels, and gift shops as a "parasitic growth." Residents raised questions about sewage problems and solid waste disposal. They worried about water usage and water pollution. They wondered whether the projected new deep wells at the museum would draw down existing wells. Many of their questions reflected pocketbook issues. Who would pay for the needed fire protection and medical facilities? Who would pay for the added police force needed to control the crowds and the traffic? How many of the museum staff would live in the community? Would their children add a burden to the local school system? Would the Society reimburse the municipalities for their added burdens? Some reacted viscerally and raised issues of rowdyism and an influx of "riffraff." Our community, said one, "will be forced to face crime, vandalism and pollution." Through a variety of outlets between March and July 1973 Town of Eagle residents vented their anger. A response to a letter in the local paper indicated that emotions ran high. "You will notice that I didn't sign my name either. I don't want any crosses burnt on my lawn also." Could the Society find a way to mediate an increasingly volatile situation?[46]

The Society responded in two ways. At Pape's urging the Society set up an informational display in the village storefront. He and Payne had encountered many residents since moving into the community. Some seemed enthusiastic, some uninformed but interested, and some negative. Society staff met and greeted those residents who came to their display. It was a very rational approach: inform town and village residents

of what Seitz at one point labeled the Society's "beautiful concept." They hoped to diffuse some of the opposition with their enthusiasm. The opposition had not, however, questioned the museum's educational value; rather, the real fight centered on whether town leaders would have any say in how the land would be used. More important, they would not let the state agency steamroll the town. Seitz thought they had to "stand up and be counted."[47]

It became clear that the Society's main response in its attempt to defuse the situation—the required EIS—did not address the issue that most concerned the town. Seitz and others wanted the Society to involve them in the decision-making process regarding land use. The Wisconsin Environmental Policy Act, which became law on April 29, 1972, seemingly addressed environmental issues that concerned local communities. This act required the DNR and other state agencies to gather relevant environmental information on projects "significantly affecting the human environment." The EIS was meant to inform decision making as the projects developed. It also required public hearings that would allow affected communities to comment and perhaps modify planning. The Society did not begin to discuss writing the EIS until September 1972. Once again the Society turned to Tishler.[48]

"I'd never done an impact statement before," Tishler recalled. He found his new task to be an involved and intensive challenge. No one knew the topography of the site better than Tishler. The more difficult task was to measure the environmental impact of humans on the site and its larger community. He had "to measure visitor impacts." Not surprisingly, he turned to experts: naturalists from Waukesha County and the DNR, a biologist from the University of Wisconsin–Waukesha, a soil conservationist, a park planner, another landscape architect, a game manager, and SHSW personnel. If he sought counsel from specialists and experts, Tishler did not seek direct input from either residents or local politicians.[49]

After more than four months, Tishler gave Smith a draft statement, and the Society distributed it in March. It also submitted the draft to a public hearing, where interested parties would be able to comment on it. On the basis of this meeting and numerous solicitations from experts, Tishler appended this data to his Draft EIS. He submitted this as his final report in June. Rather than alleviating community anxieties, the EIS only exacerbated them.[50]

The war of words carried on in the press persisted through the summer. The EIS had neither calmed the emotions of town residents

nor the town board. During the frenzy, the town board and town officials moved from debate to action. At the board meeting on June 14, David Levy introduced a petition asking for a special meeting to consider legal action against the Society. Payne thought the move was a "carefully planned and rehearsed maneuver." The board accepted the petition and ordered the town clerk to make a public announcement of the meeting, noting: "On a project this big, the voice of the people must be heard." Seitz wanted a referendum. If a majority opposed the museum, he intended to lead the fight. At the June 29 meeting the assembled residents voted seventy-nine to fifty-six to explore legal ways to halt the museum. As the meeting drew to a close, a local lawyer offered some free advice. He took no stand on the OWW issue, but opined that "the town cannot legally succeed in any litigation." Had the leadership followed his counsel, the town could have saved its money and its leaders' time. A legal battle frightened many, and within a short time the board reversed its decision to sue the state. Two supervisors rescinded their votes. They did not know the costs and thought the burden was too much for a small community. The town vacillated. It "might oppose Old World Wisconsin. Then again, it might not."[51]

The town adopted a confrontational approach on Saturday morning, August 11. Its building inspector journeyed to the site to post a stop-work order. He reasoned that since the Society had not complied with town zoning and building codes for the work that began on July 19, the work could not continue.[52]

With gloves off, the Society asked a judge to nullify the order, which he did, and ordered a hearing for the next Monday. The town had to show why an order halting its interference with the project should not be issued. Because the stop-work order interrupted the "tight construction schedule" and left its "people standing around out there doing nothing," the Society asked for $50,000 in damages. On the advice of an attorney in the attorney general's office, site construction supervisor Alan Pape (and new Eagle resident) ignored an order to appear in town court on that night. After a number of postponements, the judge came down squarely on the side of the state. The state was not subject to local zoning ordinances. Period![53]

Eagle residents ignored friendly advice to drop their attempt to prevent the state from building its museum. The *Eagle Town Crier*, the voice of the opposition, quoted David Levy's estimate that the majority of town residents "are violently opposed" to OWW. The mimeographed newsletter proclaimed its support for spending a few dollars to stop the

museum rather than to suffer the consequences of big brother's frivolous squandering of hard-earned tax dollars. At a town meeting in early September, residents authorized spending up to ten thousand dollars for legal fees but refused to give Seitz a blank check for pursuing the legal fight. The state followed with a temporary restraining order that prohibited the town from any further interference with the site. The town retaliated with a five-million-dollar countersuit on the grounds that the Society failed to conform to state and federal guidelines.[54]

Smith's Executive Committee backed him. Members agreed that the Society should not ask the town for a zoning permit "since the law clearly does not require it." The judge hoped the two feuding parties could resolve the matter among themselves. The Society had the dominant position and would not back down on zoning. Circulation of a petition among town residents indicated "a majority of our people do not want the Historical Museum located here." A deposition given by Smith near the end of the year reflected the town's dissatisfaction with the EIS and its hostility to the museum.[55]

Deposing Smith served no useful purpose other than giving the town's lawyer the opportunity to put the director through the wringer. Three matters interested the town's lawyers: the selection of the Kettle Moraine forest for the museum, the history of the museum to 1973, and the EIS. Clark Dempsey questioned Smith about the credentials of those who assisted Tishler in preparing the EIS. Smith's testimony indicated that the Society had delegated the EIS to Tishler and that it had not interfered with the choice of experts. His responses also revealed planning was very much a work in progress. He could not, for example, answer questions about the location of public toilets, the digging of wells, the location of fire-fighting equipment, commercial establishments, and security. In response to how the museum was to be funded, Smith could not provide definitive answers to the barrage of questions fired at him. Finally, Dempsey turned to the attendance issue. Dempsey seized on a figure in the EIS that suggested visitation in excess of one million per year. Smith quickly distanced himself from that figure. He responded that the Society has "never estimated anything near that level of visitation figure." Dempsey wanted to know if anyone anticipated annual visitation in those numbers. Smith responded that no "reputable person knowledgeable about visitation figures at other outdoor museums in the United States" would make such an assertion. Dempsey asked incredulously whether Smith was familiar with the EIS, which mentioned visitation in excess of 1,600,000 people. Smith responded: "That is the

reason I chose my answer so carefully. I said by a reputable person knowledgeable about historical villages in the United States. My recollection is that figure came from the state park visitation figures at Devil's Lake which is not comparable to an outdoor museum." While roughed up, the director's responses provided no ammunition for the town's case against the state.[56]

The matter drifted into the next year's public agenda. A meeting of the Building Commission reflected that the town's suit had an impact. The meeting, at which Governor Patrick Lucey was present, had to vote on an appropriation of $58,000 to build trails and parking lots. Lucey thought the OWW project was the best of the state projects for the bicentennial and endorsed it "wholeheartedly." He did not want the litigation to prevent the Building Commission from approving the appropriation, fearing that it might delay OWW's opening by July 1976. With a positive vote and with an ever-increasing sense of urgency, the Society continued to build.[57]

Perhaps recognizing the cause was lost, Seitz finally contacted Smith in August to suggest they discuss the suit. Seitz suggested that if the Society withdrew its suit, the town would drop its suit against the Society. Smith agreed to explore this with his counsel and the Board of Curators, provided the town board agreed that it would take no actions to prevent OWW in the future. They agreed to discuss this and the other points Seitz raised with their attorneys. The board voted that Smith, with the advice of legal counsel, proceed with the negotiations. Smith met with the town board on September 24 to further clarify the issues. Seitz agreed to lay the points of discussion before a meeting of town residents in October or early November. Finally, resolution came. The *Milwaukee Journal* jumped the gun when it proclaimed: "After more than a year of regrettable battling in court over the construction of Old World Wisconsin—an outdoor ethnic museum—the Town of Eagle and the State Historical Society seemed to have agreed on a ceasefire." Its hope that the project could "be completed in a spirit of mutual amnesty" proved fanciful. Van Acker, who ignited the legal battles with his stop-work order, refused to stipulate to the dismissal of the suit.[58]

The legal battle dragged on into the new year. The Society refused to agree to a dismissal unless all parties (meaning Van Acker) agreed to withdraw from the suit against the Society. When Van Acker resigned as an employee of the town, the possibility of resolution loomed large. While this left him free to sue the Society as a private citizen, it left the

Society and the town with the opportunity to withdraw from their acrimonious legal battle. Still, the town balked. As long as Van Acker refused to agree to a settlement and as long as the town agreed to be responsible for his legal fees, the legal wrangling continued. A technicality, Dempsey's claim of a conflict of interest in representing Van Acker (now a private citizen) as well as the town moved the negotiations to resolution, namely a dismissal of the suits. Seitz thought the concessions to the town were "a window display thing," but he agreed to the settlement and acknowledged that at least the town and the Society "will be talking to each other." The Society was more enthusiastic. "For the first time since 1972, work on the State Historical Society's outdoor ethnic museum, Old World Wisconsin (OWW) near Eagle is proceeding free of any pending legal action."[59]

This crisis was over; it lasted too long, and in the end the town had nothing to show for its time and expense. Town leaders failed to gain any significant concessions, but they had responded to their constituents and taken on the state. This time David did not topple Goliath.

The concept, the Ethnic Village, Bicentennial Park, Old World Wisconsin—however it was styled—had survived three crises over a six-year period. Any one of them could have destroyed or significantly altered it. Slowly, if not steadily, the planners struggled toward their ultimate goal. Still, two daunting and closely aligned obstacles loomed: financing the "dreamed-of museum" and constructing it on the desired Eagle site. With the Reuss gift, and with a commitment to open by July 4, 1976, implementation (fund-raising and construction) took on a new urgency.

Many of the Finnish houses came from Bayfield County in northern Wisconsin. The decayed Ghetto/Ketola house represents the type of buildings that Perrin wanted to salvage. (William H. Tishler)

Ed Pudas, a second-generation farmer, carpenter, and skilled log builder from Bayfield County, was a valuable resource for the Finnish reerections. (William H. Tishler)

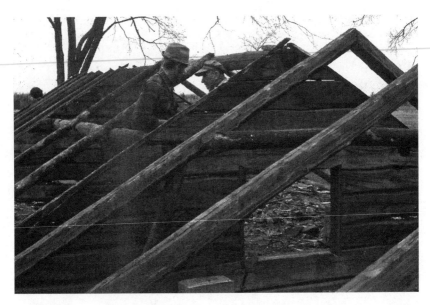

Construction supervisor Alan Pape (*left*) and Ed Pudas dismantle the Ghetto/Ketola house in 1972. (William H. Tishler)

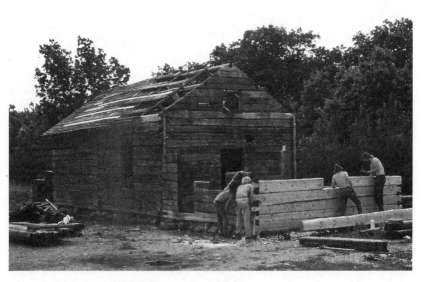

Site crews reerect the Ghetto/Ketola house in 1975 with a combination of original fabric and new lumber and logs. (William H. Tishler)

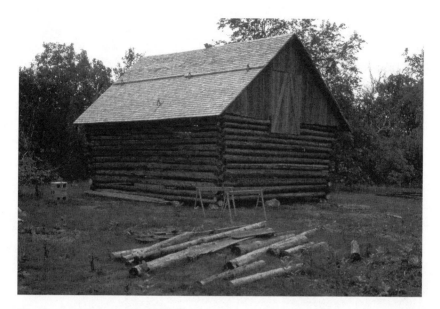

The Lanatta Finnish barn as it nears completion in 1973. This distinctive Finnish barn type (called a *lato* in Finnish) was only built by Finns in Wisconsin and was used for storing hay. (William H. Tishler)

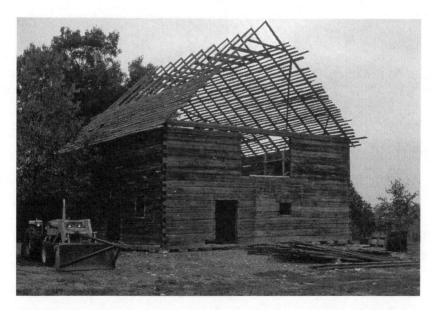

Reerection of the Kortsemaa dairy barn in 1973. Logs were closely fitted to maintain warmth during the winter. (William H. Tishler)

The Rankinen house in 1974. (William H. Tishler)

Pape examines the dismantled Rankinen outhouse in preparation for its reerection in 1974. (William H. Tishler)

CHAPTER FIVE

Fund-Raisers

If one phrase can capture the Society's struggles, it is Mark Twain's twist on a biblical concept: "The lack of money is the root of all evil." A lack of money thwarted the Society's efforts to build the museum in a number of ways. If, for example, the Society could have purchased its 500 acres in the mid-1960s, creation of the site would have taken a very different course. It did not, and this left the Society dependent on other agencies. The Society never intended to fund its museum from its budget or through extraordinary appropriations from the state legislature. From the beginning, the Society assumed that it (eventually) would be able to raise sufficient funds, a goal that proved fanciful. This chapter examines the ways that the Society approached funding and publicity in the context of its budgetary challenges and assesses the degree to which it succeeded. It analyzes efforts to recruit money from the private sector, state and federal grants, and in-kind contributions in forms other than money (e.g., equipment and labor).

Surviving three crises between late 1969 and late 1974 furthered, but did not assure, the 1976 opening. As the Society approached the construction stage, it faced its most severe crisis. This elephant in the room, the obvious element that had to be confronted, became more obvious: how would the Society fund its ambitious project? This question was ubiquitous and was much discussed in the decade before 1971. In

their first exploratory conversation, Fishel and Perrin discussed the need for outside funds to build the museum and sustain it through the difficult first years. The scope of the project was magnificent to behold. Curator Howard Mead "trembled at the size of the undertaking" and feared the "Society was talking about years of activity and millions of dollars." Curator Axtell felt that the Society's annual meeting in La Crosse in June 1971 was a critical turning point for the museum project, and he left with "a certain feeling of euphoria."[1]

At some point, though, words had to be converted to deeds. Decisive actions had to overcome fears and doubts. Intertwined with fund-raising was another issue that was critical for success. Planners had to fire the imaginations of the public and possible donors through a marketing and publicity campaign. Erney raised another important financial issue in his October 6, 1969, memo. How will the projected museum affect other Society divisions and programs? All roads led to funding.

Finding a method for funding its outdoor museum severely tested the Society and the curators. To build the site, they needed to find extraordinary revenue sources to supplement the budget and offset the ever-higher start-up costs that grew exponentially as the opening dead-line approached. Three potential sources of revenue existed. The first was public: the state, the federal government, and possibly foreign govern-ments that had ethnic ties to Wisconsin. Private resources, the second source, included contributions from corporations, large foundations, and private individuals. Finally, planners looked to revenue streams generated on-site from attendance and sales.[2]

The myth that money generated by attendance and sales of merchan-dise would make historic sites largely self-sufficient lingered far too long. Less than two weeks before the grand opening, the Executive Committee considered the already growing cash shortage for operations. Curators faced the stark reality of a $273,000 operating shortfall for 1976–77 and similar projections for the following two years. One member, Milwaukee businessman John Geilfuss, asked if the Society assumed the site would be self-sustaining. Smith responded that the 1968 feasibility study suggested that OWW would break even after five years. The report had been based on certain assumptions that were problematic. For example, it assumed fifty-three personnel, while the new site director estimated that he needed 110. More important, the report projected a yearly attendance of 350,000 (a daily average of 1,902). Later estimates vacillated between 150,000 and 250,000. Some questioned these attendance assumptions. One staff member opined that no outdoor museum can support itself

solely by admissions and sales. These museums are supported variously by state subsidies, gifts, or endowments. Regardless of the number, outside money was critical, and Smith noted that even the most stable history museum, Colonial Williamsburg, had recently resorted to a fund drive. Without an endowment, two relevant questions had to be answered. How much support should the Society request from the state? And how much would come from the private sector? Janesville business-man and OWWC chair Roger Axtell maintained that the objective had always been to create a self-sustaining museum, and he strongly opposed reliance on state money. The Society's other sites did little to reinforce the philosophical position expressed by Axtell. Attendance and sales did not prevent Wisconsin's three historic sites from routine annual deficits. Operational deficits at OWW would have to be squeezed from the Society's budget, covered by state grants, or supplemented by fund-raising (donors generally do not fund operational costs).[3]

The proposition that the Society could raise sufficient funds from the private sector was less a myth than a challenge. Successful fund-raising would negate any need for extraordinary state appropriations, reduce the threat to annual budgets, and lessen OWW's impact on existing programs. More important, it would allow the Society to build its museum on a firm financial foundation. Could the Society energize its staff and its curators to raise the requisite funds from outside sources? Could it provide the resources necessary to ensure stability and continued development of the museum? The short answer to these questions was no. Despite many discussions and numerous false starts, the Society never produced the requisite revenue flow. Neither fund-raising nor getting the public involved failed—but neither one succeeded to the extent necessary to meet projected costs. This left the project under-funded from the start, complicated the museum's continued develop-ment, and created considerable unease within Society ranks.

The financial obstacles the Society faced highlight both its strengths and its weaknesses. The Society was an anomaly in state government. Former board president Cronon reflected on its unique relationship within the government, describing it as "a corporate organization, a private organization, and a state-supported organization, and most legislators found that hard to understand." The Society was an indepen-dent state agency—a "very small entity" governed by an independent Board of Curators. In general, governors and legislators showed little interest in the Society unless they came from a district where the Society had programs, such as a historic site. In addition, curators needed to

remember that legislators tended "to think in the short term rather than the long term, which is difficult for a historical agency to do." Impatient legislators wanted results that they could point to for the next election. Funneling extraordinarily large sums to long-range projects with an indefinite completion date did not appeal to the politicians who formulated state budgets. To build its new museum on a firm financial foundation, Society leaders knew that private funding alone was the only way to fulfill its mission and maintain its programs.[4]

The fund-raising and financing story for OWW divides into two chronological periods, 1960–71 and 1971–78. A major (unsolicited) gift from Reuss in early 1971 separated the two periods. At first, fund-raising remained abstract as the Society timidly moved forward. During the second period, beginning in 1971, fund-raising became more concrete and more urgent. Initially, staff and curators sought federal and foreign government funding, grassroots campaigning, and solicitations from "friends." By late 1974 Smith and others recognized that their campaign needed better organization and professional assistance. In addition, staff and curators continually struggled to define the extent of the state's contributions. The fund-raising saga can be viewed through a series of vignettes that highlight staff and curatorial activities.

A number of factors emerged before the Reuss gift. First, soliciting money from private citizens, foundations, and public institutions seemingly struck terror in the hearts of mere mortals. Fishel, who had recently assumed the directorship, captured this feeling when he noted that curator George Banta "does not like fund-raising." Another curator noted later that fund-raising is not only "a very time consuming business," but it is "a very difficult business." Recognizing the need for aggressive curatorial fund-raising and enthusiastically embracing it never quite merged. The Society could not succeed unless the curators committed their time and financial resources to the drive; they were the key to opening doors to the private sector.[5]

Second, although the Society had demonstrated success in the past, it had never sought private funding on the scale OWW demanded. Cronon pointed to the Society's most successful campaign before the museum project. He touted the six-volume history of the state for which the Society raised "a couple of hundred thousand dollars." In general, the Society had developed a pattern of going to wealthy patrons to provide some of the amenities it needed to function properly. An incident from 1962 illustrates how the Society funded its special projects. In this instance, it wanted to produce 10,000 copies of two brochures for its

School Services programs at the cost of $500. Fishel appealed to one of the Society's friends, Neita Oviatt Friend. "The problem," Fishel confided to her, "is money." Could you, he implored, "see your way clear of adopting this project as your own?" Norman FitzGerald, the first OWWC chair, contacted two friends and fellow businessmen, Samuel Johnson from Racine and Edmund FitzGerald from Milwaukee, for possible assistance. While the Johnson solicitation eventually proved successful, individual contacts generally had been unproductive. As of 1967, Fishel focused on producing a fund-raising brochure based on the landscape architecture plan under development. He wanted to use the data to prepare a brochure, which could be mailed or given to potential donors. Would the usual laid-back style of fund-raising work for the new project?[6]

Third, solicitations for funds from the state and federal government, while potentially lucrative, came with bureaucratic entanglements. In 1965, for example, OMC decided its "best approach" would be to seek state or federal funds to assist with the site purchase while it sought private gifts for the purchase and restoration of buildings. While members suggested many potential sources, they could only request that staff explore them for funds. An effort for additional funds from the state quickly collapsed. In March the curators instructed the Society to withdraw its request for funds for sites development. The Outdoor Recreation Assistance Program (ORAP) incorporated the Society's request in its biennial plans, but this bill would not be considered until the legislature passed the budget. Indeed, the Society had financial problems and sought extraordinary money to make up a deficit caused by increasing the pay for student assistants. A consultant thought the ethnic park was "a natural for federal aid," but that remained to be seen. One OMC member thought Wisconsin Congressional Representative Henry S. Reuss might be helpful for seeking federal funds but suggested no strategy.[7]

Fourth, the Society consumed an inordinate amount of time creating its fund-raising model. It had many fund-raising projects underway at any given moment, and until 1969 it lacked a coordinator. Discussions about hiring professional fund-raisers or of designating the task to a single individual fell by the wayside. OWWC member Zigman judged Society efforts harshly. It wasted too much time and money "because no one sits down to coordinate all the activities." He felt that the Society contacted donors about membership, endowment, special projects, and programs that all too often left them bitter toward the organization. It

was a penny-wise, pound-foolish pursuit. Investing $25,000 to hire a director of development would reverse the situation in short order. In January 1969 the Society settled for an assistant director and assigned him responsibility for fund-raising for OWW. William Applegate, a retired army colonel who had recently graduated with a master's degree in public relations from the University of Wisconsin, had many other duties beyond fund-raising. He never evidenced a talent for acquiring big money.[8]

Fifth, and perhaps most important, Fishel's incremental approach meant that fund-raising and publicity had to wait until he had a master plan and a site in place. In April 1968 Zigman wanted Fishel to face the fact that funds would be needed soon. He felt that creating the fund-raising presentation was relatively easy; the difficulty was in the preliminary planning. He did not think the Society had done the necessary preparation for creating the OWW presentation. While he envisioned that the committee's role would be "strictly advisory," members would assist with fund-raising once the Society had created its list of potential donors and created its presentation. The Society had to be able to convince donors that it had a "well-thought-out plan" and a "well-administered concept." After laying out a strategy, he and Perrin agreed that the Society should not wait for the master plan before forging ahead. Fishel agreed with all of Zigman's points but one. He disliked waiting but he refused to create the presentation before he had the master plan. The presentation had to flow from Tishler's plan. Besides, he tersely noted, putting the presentation together was a staff responsibility.[9]

In April 1968 Fishel reported that the Executive Committee had given "an official blessing" to OWW. It agreed "wholeheartedly that the top priority in fund raising for historic sites should and would be Old World Wisconsin." At its January 1969 meeting, OWWC devised a plan that would divide the site into a specific number of complexes and the Awareness (Visitor) Center. A fund-raising plan should be developed for each one. The OWWC considered the concomitant issue of publicity, but members decided that OWW was "not yet ready for publicity." Premature publicity *might* lead to questions for which the Society did not have ready answers. As Fishel's departure loomed and without an assured site, the Society adopted a policy of watchful waiting.[10]

The transition period between directors and the continuing site crises have been considered in previous chapters. With the OWW project on hold, fund-raising and publicity remained a low priority. In

January 1971 another list of possible federal resources included the National Historic Preservation Act, the National Endowment for the Humanities, and the American Revolution Bicentennial Committee. Another list was generated, but no actions were assigned. The drift continued. A frustrated Perrin labeled the Society's operation as "farcical." But then the Society got lucky. At a very low point in the march to Eagle a new zealot emerged. The revival of the project was at once serendipitous and fortuitous. Indeed, it was a godsend.[11]

Henry S. Reuss was a successful Milwaukee lawyer and businessman with an abiding interest in environmental issues. He had several federal appointments before he won election to Congress in 1954. He served as one of Milwaukee's congressional representatives until his retirement in 1983. Midway through his tenure, as he was about to be named chair of the House Committee on Banking, Currency, and Housing, he began to divest his holdings in the Milwaukee-based Marshall & Ilsley Bank (M&I). One beneficiary was the OWW project.[12]

Representative Reuss, who had been consulted about the Bong acquisition and possible federal funds, summoned Society administrators Smith, Erney, and Appleby, curators Cronon, Axtell, and Geilfuss, and consultant Tishler to his Milwaukee office in February 1971. He did not indicate the precise reason, but they came prepared to talk about various facets of the OWW project. One by one they talked about their plan. The ever-focused Reuss kept asking: "What would it take for you to get started?" The OWW advocates agreed that Wisconsin needed the museum and that the state forest was the most suitable site. They further agreed that it was "ridiculous to consider purchase of land that is already owned by the state." Besides, that sum — in 1968 the state valued this land at $240,000 — was well beyond the reach of the Society. They noted a number of challenges including the lack of an inventory of historic buildings and a shortage of money. Tishler noted that at a minimum the Society needed $102,000 to get the museum up and running. Obstacles aside, their enthusiasm flowed forth.[13]

Reuss then summarized what he heard. He judged it a good project and said he would be glad to support it. He astonished his audience with an offer to donate Marshall & Ilsley bank stock worth $100,000 to get the museum project up and running. Reuss insisted that his gift remain anonymous, perhaps to avoid speculation about his net worth. Eventually, he donated about $175,000 to a variety of charitable projects. He said of his gifts, "I am not particularly interested in giving away large sums of money, but these [causes] seemed like good things."

Perhaps his status as the grandson of German immigrants attracted him to the ethnic village concept. In Congress, Reuss could be forceful, even demanding, but he eschewed confrontation. In offering his gift, he named five desiderata—matters he considered highly desirable actions. He counseled the Society to scale back on the size of the site, to seek a revision of the 1967 law to allow the DNR to lease land to the Society, and to get the DNR to build the access roads and parking lots. As cost-cutting measures, he suggested the Society seek "free" labor that might be available through federal programs and join ranks with the American Youth Hostels and Ice Age National Park and Trail Foundation. Most important, perhaps, he wanted the Society to establish a timetable for construction that will make it "visible." The time for talking had passed; he wanted buildings on the site.[14]

Cronon recalled that cold February day. Hearing the offer, "our jaws dropped, and we thanked him profusely." To say that Smith, Cronon, and the others were euphoric would be an understatement. On their return to Madison, they brainstormed, they laughed, and they delighted in their good fortune. Reuss had resurrected the project. According to Cronon, "Because of tight budgets and the very size of the Old World Wisconsin project, many people have been pessimistic about ever accomplishing anything." For the first time, and after more than a decade, someone was holding the Society's collective feet to the fire. No guarantees, but Reuss offered a flicker of hope.[15]

Reuss believed that the Society ignored many of his desiderata. They did not. The Society took them seriously and spent considerable time and effort investigating programs such as Operation Hard Hat (laborers paid for by the federal government), American Youth Hostels program, and the Ice Age Trail Foundation. On one point the Society stood firm. No one saw the 1968 master plan as cast in concrete, but no one supported the compact site (the rule for European museums) that Reuss pushed.[16]

Did the Society need this infusion of funds? Consider the financial condition of OWW six months later. With the Reuss gift, OWW had $102,810.46. Expenditures (personnel, supplies, rentals, consultants, and movers) amounted to $67,726.85. This left a projected balance by the end of 1972 (on the eve of site construction) of $35,083.61. A $20,000 gift from a curator offset some of the anticipated costs for the first six months. The projected balance from all sources on July 1 was slightly over $22,000. If the legislature approved its budget requests, OWW would have about $227,000 additional dollars for building the site. The Society recognized (again) that private funding would make or break its

effort. It set a modest goal of matching the state appropriation, that is, to raise $250,000. Were Colonel Applegate and the curators up to their monumental task?[17]

With construction pending, the Society was never better poised to forge ahead with fund-raising. The gift, Axtell proclaimed, would allow the OWWC "to develop a *platform* to launch other fund-raising efforts." Top Society administrators and curators alike can be faulted, as an analysis by the Department of Administration Management Analysis Unit did in 1976, "for its late hour planning for fundraising." Such a plan should have been developed at the time the Society acquired the site from the DNR. According to one report, "Successful completion of this major project is dependent on many factors, but first and foremost is money!" No one would have disagreed with this statement, but staff and curatorial defenders might well have pleaded their case on the basis of extenuating circumstances, such as the prolonged struggle for the site. That same report complimented the Society for its master plan and economic study. But the 1968 plan, despite the enthusiasm it generated, could not carry a major fund-raising campaign.[18]

For fund-raising, the Society faced three challenges that it never bested. The first was the senior staff's lack of experience and expertise for a major campaign. As with many aspects, it was learn as you go. The events that led to a gift of $20,000 from a curator illustrate this inexperience. A month before the board meeting in June 1971 the Financial Subcommittee met to consider possible donors. One member correctly noted that members had only considered "nickel and dime" possibilities. The project needed one or more large donors, and he noted that a fellow curator had the capability of donating half a million dollars. He asked Smith to contact another curator, Elsa Greene, for advice on an approach. Curator Neita Friend, the subject of the conversation, had been "generally lukewarm" toward the OWW project. The presentations she heard at the June board meeting impressed her with the progress the committee had made. Axtell concluded that it appeared that the committee's objective had been achieved. A month later, Greene reported that Friend had definitely warmed to OWW. By October the imaginary gift had grown to one million dollars. Erney, always lukewarm to OWW, intervened to argue that the gift (remember, Mrs. Friend had made no such offer) should be put in the Society's endowment and that OWW should get the income for five years (about $250,000). If OWW was not off the ground by that time, "it's never going to get off the ground." Applegate, the fund-raising coordinator,

countered that OWW required a donor with substantial impact, "and Mrs. Friend is the only one I know of." It all became moot. Smith did not contact her until February and then only by letter. After Applegate contacted her in May, he could not hide his dismay. By then she talked about a separate gift of $30,000. "Wow! Wouldn't this dash hopes?" It got worse. An indiscreet mention of curatorial plotting in the OWWC minutes nearly forfeited her support. The discussion had insulted her. She did not need a committee "to put the touch on her." She knew the need and planned to contribute. As it turned out, her gift of $20,000 fell far short of Erney's imagined "million" dollars. Smith could only suggest to his staff that they be more discreet in the future. Small wonder that Smith, Applegate, and Winn traveled to a historic site under restoration in Minnesota to learn more about fund-raising in December 1972.[19]

The second challenge was that staff coordination of fund-raising fell to Applegate, who had no experience in the field. He devoted at best only 30 percent of his time to it, which was not adequate for such a massive undertaking. After a poorly attended meeting of the Financial Subcommittee in April 1973, Axtell asked Smith if Applegate's many duties could be assigned to others, at least temporarily, so he could work full-time on OWW funding. In frustration he lamented, "I am at a loss to know how *better* to tackle this problem." Applegate told Smith that "even full-time effort on my part was not likely to produce desired results without more help from the board than I had so far." Zigman, a public relations specialist, later characterized fund-raising during these years as "at best pretty poor." According to Zigman, Applegate was not very effective. The curator objected to "paying a guy to do something, and he didn't do anything! He was always good at telling other people what to do but he was hired to do it, and he didn't do it!" True, Applegate was the face of the Society's fund-raising drive, but Zigman's harsh criticism hit the mark.[20]

The third problem was reliance on the volunteer curators. Initial planning for fund-raising began as the site negotiations with the DNR neared completion. This gave staff and curators approximately six years to provide a steady flow of money to ensure a successful opening. A major campaign would take time, and the ticking clock was the curators' implacable foe. William Penn's reflection, "Time is what we want most, but what, alas! we use worst," perhaps serves as the mantra for those six years. The curators evidenced no sense of urgency, no indication of the need to take aggressive action. In part, this stemmed from the nature of

the board, which was composed of prominent individuals, predominately male, from around the state. Most had jobs and other commitments but volunteered to serve on the governing board of the Society. The board, which met four times each year, functioned through a variety of committees and subcommittees that set policies for the Society. The Executive Committee worked most closely with the director. The most important curatorial contributions to date were endorsements in June 1964, June 1967, and October 1968 that allowed planning to move forward and led to the appointment of the OMC, which eventually morphed into the OWWC. The latter committee created two sub-committees, Technical Advisory and Financial. These subcommittees, in turn, reached out to experts in areas where staff was deficient. These volunteers were absolutely vital for planning and moving forward, but they functioned in a highly decentralized system that made quick action problematic.[21]

Initial plans in April 1971 included recruiting interested curators. Axtell suggested meeting within sixty days to "talk exclusively about fundraising." Despite the good intentions, fund-raising organization lagged and did not start in earnest until well into 1972. Over the next few years, various campaign goals and cost estimates emerged. Both escalated as the opening approached. Neither the Society nor the OWWC established a firm timeline for the needed cash flow. To provide the greatest chance for success, significant portions of the funds had to be ready for the construction phase. Discussions between Reuss and curators Zigman and Geilfuss suggested the magnitude of the task. Geilfuss, when told that OWW needed to collect $48,000 a month through December 1975, seemed incredulous. Applegate affirmed that figure was correct if the Society wanted the site ready even if it received no state or federal support. Zigman stated the obvious: the "fundraising effort is going to be a tough one." The curators had to raise major private funds between the fall of 1972 and the end of 1975.[22]

Axtell could only lament the low turnout for the Financial Sub-committee meeting at the end of April 1973. Only two of the six members attended an important meeting. Conflicts with other pressing matters and time constrains, while understandable, precluded effective action. Axtell thought these problems "are symbolic of where we seem to stand: we don't seem to have the time nor people to tackle the job. We're at a key juncture." The museum had only enough money to stumble ahead at a subsistence level. The museum needed at a minimum "a couple of hundred thousand dollars. This would give us a shot in the arm, cause

construction to spurt ahead, and give us a stronger base and spirit with which to seek even more funds." Axtell had not exaggerated: OWW had less than $20,000 at the end of April and needed an additional $225,000 to complete the first phase of construction.[23]

In an effort to succeed, the Society seemingly left no stone unturned. A fantastic opportunity emerged in 1972. The national American Revolution Bicentennial Commission (ARBC), which Congress created in 1966, planned celebrations for the nation and the states. One initiative interested Smith. The Society had since 1968 served as the state's informal coordinator for state bicentennial planning. Four years later, the governor appointed a forty-one-member commission to coordinate state celebrations and to assist with funding projects. Serving on the commission were three curators, a former curator, and Smith, who served as the secretary treasurer. In August 1972 the Wisconsin American Revolution Bicentennial Commission (WARBC) had endorsed OWW as the state's bicentennial park. Earlier that year, ARBC flirted with the concept of creating a network of cultural and recreational bicentennial parks in each of the fifty states. On February 24, 1972, the ARBC presented its idea to the National Governor's Council meeting, which was in session at the same Washington, D.C., hotel where the commission had met. The governors adopted a resolution in support of the park concept.[24]

The ARBC created a model for a park, but the plan lacked important specifics such as funding as well as how the plan would be carried out in each state. The ARBC asked the Department of Housing and Urban Development (HUD) to run the program. Still, planners had the allure of federal largess before them. Plugging into the national program might allow the Society, in Smith's words, "to get this thing going." As the script for the Society's publicity slideshow read: "Virginia has its Williamsburg; Massachusetts its Sturbridge; Michigan its Greenfield and Illinois its New Salem. Why not in Wisconsin an ethnic heritage preserve unique to America?"[25]

How much money was involved? Smith used the figure of $20 million on a number of occasions, but he could not state any figure with certainty. That sum and the circumstances under which money might be granted remained vague. This resulted because funding depended on the Nixon administration, Congress, and HUD. The Nixon administration had given every indication that it wanted to fund a spectacular celebration for the 200th anniversary of the American Revolution in 1976. Smith and R. Richard Wagner, the director of the WARBC, had good reason to believe that the nation might favor Wisconsin's project. A proposal

had been presented to the ARBC and to state governors to provide each state that had a valid plan with $20 million to establish a national park. The plan, as Smith described it, would create a series of new national bicentennial parks. Wisconsin was one of five states (with New Jersey, Oregon, South Carolina, and Texas) that had plans ready to implement. ARBC had secured funding from HUD to send consultants to study the plans of those five states. OWW seemed tailor-made for bicentennial money.

Two consultants from Booz, Allen & Hamilton (an international consulting firm), Wagner and Smith, met with Governor Lucey in September 1972. Previously the governor had given OWW his strong endorsement. All told, three sets of consultants had visited to examine OWW's economic feasibility and the political acceptability of Wisconsin taking over a federally funded park after 1976. The consultants gave every indication Wisconsin's proposed park impressed them and that OWW would receive a strong recommendation. If the proposal passed congressional scrutiny, Wisconsin stood to reap a windfall. Smith cautiously stated his understanding that the consultants had visited the five states and returned to Washington, D.C., to prepare the recommendations. He told Reuss that he had given his name to the consultants as the most knowledgeable person in Washington about OWW. The *Milwaukee Journal* endorsed OWW as a worthy candidate for the bicentennial parks program, but tempered its celebratory tone with "if that program is ever implemented."[26]

Federal money, at least under the ARBC/HUD proposal, proved to be a will-of-the-wisp. By mid-1973, hopes vanished. The enthusiasm of its Executive Committee notwithstanding, the ARBC voted not to recommend the plan for bicentennial parks in every state. It cited the economic downturn and unwillingness on the part of private investors and members of Congress to spend large amounts of money. Public information officer Chet Schmiedeke "shrugged aside" the news by saying the Society had not factored the Bicentennial grant into its planning and added that the site would open as scheduled. Mark Knipping recalled Smith touting a possible $20 million gift to fund OWW. Whether Smith or OWWC factored this money into planning cannot be known.[27]

It was obvious that the Society needed a solid and successful fundraising campaign to keep the project alive. That was not happening. By mid-1973, Smith judged that "fundraising efforts have not been too successful to date." This was not entirely from a lack of effort. Staff and curators enjoyed some success with their "grassroots" campaign. But

that effort, which mostly reached out to small donors, was ponderously slow and labor intensive.[28]

Staff developed two tools for publicity and lobbying donors and the public. The slideshow—the major medium for delivering the OWW pitch to donors—had been revised, and numerous presentations had been made. Smith, Winn, Applegate, and Knipping from Madison and Pape and Payne from Eagle spoke to the public on every conceivable occasion in an effort to raise public awareness. For the most part, talking to small groups brought small donations. One such presentation did offer some potential. The Wauwatosa Women's Club decided to create and sell an ethnic cookbook with all proceeds over production costs going to OWW. The project eventually yielded the hoped-for $10,000. Some talks produced a bigger lode. One talk that Applegate had given "a few years back aroused a great deal of interest." Wisconsin women through garden clubs had raised substantial amounts for landscaping: $100,000 for the Finnish farmstead; $150,000 pledged for the Norwegian farmstead, and $100,000 pledged for the Kvaale farmstead.[29]

A grant from the UW School of Natural Resources for $5,000 funded production of an informational booklet that also would be used for fund-raising. By design, it provided only general information to allow for changes in planning. It avoided attendance projections because they were now recognized as too conjectural. Other problems surfaced. One OWWC member criticized the draft he saw. It lacked enthusiasm. It should communicate "in a spirited manner the unique character of the museum and convey its outstanding value to the state." Beyond dropping anachronistic concepts that described Wisconsin as a "Mixing Bowl" and the frontier as "safety-valve," the brochure needed "a more fiery and enthusiastic introduction." The forty-five-page booklet, which featured a half-timber construction pattern on its cover, served both as an introduction to the projected site and an appeal to possible donors. Printed on cream paper with a multitude of sepia photos, the text was too wordy. It combined a revision of the master plan with a three-page appeal for support. The appeal emphasized high expenses and the Society's work. As a fund-raising appeal, it failed at the most fundamental level. It did not make explicit why a donor should invest big money into the project.[30]

The Society had some significant initiatives in process as well. The publicity booklet, which also contained a revision of the 1968 plan, estimated the cost of reconstructing the Koepsell house at $100,000.

This cost led to grant proposals to the federal government and the Pomeranian Society in Germany. OWWC turned to the National Park Service (NPS) in an effort to obtain preservation funds under the 1966 Historic Preservation Act. Federal law required compliance with procedures, and the Society had not taken one necessary step. The NPS did not accept applications for structures not on the National Register of Historic Places. OWWC scrambled to prepare nominations for the Turck (now Schottler) and Koepsell houses, but they could not be finished in time to qualify for 1972 applications. The Society engaged architect Perrin and his associate Ralph Schaefer to create formal cost estimates for reconstruction to bolster the National Register application. Erney met with NPS staff in May and October. Reuss called the NPS to check on the status of the Koepsell and Turck nominations. While "things looked good," the NPS wanted assurances that both had been included in the state historic preservation plan. Smith sent the confirmation. As the new year began, Smith reported no luck "in prying funds" from the NPS. The delay led to one of Perrin's patented outbursts. He could not comprehend why NPS might raise any questions about the eligibility of Koepsell for the National Register. He cited the "Old Synagogue" in Madison, which had been moved and was undergoing reerection. The alacrity with which the National Register accepted it and the speed with which federal funds were advanced to pay for moving and reerecting as well as the research work amazed him. Perrin demanded to know why the NPS did not move more quickly on the Wisconsin houses. After all, the Society's immediate objective was to save the buildings. By the fall, the National Register listed the houses and the Society received a federal grant for $41,250 for the Koepsell house, which the state matched with a similar grant from the state building trust. Staff prepared and sent a proposal for a DM100,000 (equivalent to about US$30,000) grant from the State of Schleswig-Holstein to fund Koepsell construction as well as proposals to the governments of Finland and Denmark. Eventually, the Society received $19,000 from the Germans and $15,000 from the Danes.[31]

One other facet of fund-raising needs to be considered before turning to the Society's effort to attract major donors. This might be called donations in kind—contributions of goods or services. Heavy manufacturers such as Allis-Chalmers offered the possibility of the loan of heavy equipment. So did the U.S. Army. Applegate sought equipment—trucks, backhoes, small cranes and wreckers, hand tools, and the men to

operate them. Both Allis-Chalmers and the Army politely declined. He also had no success with the Reserve Naval Mobile Construction Battalion commander.[32]

Other efforts produced better results. Elsa Green organized a campaign through the Society's Women's Auxiliary to collect artifacts for the site and to involve the local societies in the effort. Vivian Coletti, an antiques dealer who worked with OWW architectural consultant Schaefer, eagerly offered to share her knowledge and experience with staff. Interest in supporting OWW swept through many of the state's women's groups. They offered to sell cookbooks and flowers to raise money. Two area professors volunteered to work on-site and expressed interest in developing a work-study program for their students. Assistance of another kind came from the Model A Club from McFarland. This group camped on-site, put up a Finnish field hay barn on one day, and shingled it the next day. These were grassroots efforts at their best, but they could not overcome the need for major infusions of money.[33]

In February 1973 Applegate told OWWC members that the Society was about to launch a fund-raising campaign. He specifically identified large state corporations as targets. Axtell and Zigman had met twice to develop the Society's fund-raising strategies and to list possible donors. Axtell interjected that larger donors must be sought. He talked of the need to find donors who could contribute $100,000 to $500,000 for individual farmsteads or buildings.[34]

The Society did not contemplate fund-raising "in the formal sense." Rather, it relied on a series of low-key approaches. These included face-to-face meetings with potential donors and conferences with selected corporate and foundation representatives. The presentation included a "hard-hitting 15 minute film" and distribution of the informational brochure. The "ask" would be made by senior Society staff, but the groundwork would be done by OWWC members and certain curators.[35]

A glance at the April 30, 1973, meeting of the Financial Subcommittee reflects the shortcomings of the Society's approach. Members discussed various possible substantial contributors. Milwaukee-based Pabst Brewery seemed like a "natural" as a potential donor. The question was how to approach the company's new president. One curator, who was "a college chum of Augie Pabst," was a potential Society contact, and they assigned Applegate the responsibility to set up the ask. Members listed more potential corporate contacts. Again, Applegate received the nod for choreographing the contacts (having permission to use Zigman's name). Applegate reported he was preparing a list of prospective donors

for the board. Members understood the importance of personal contacts for initiating the pitch. The problem was that neither they nor their Society liaison had time to follow through properly. Toward the end of the meeting, one member mentioned employment of a professional fund-raiser, but it was not discussed.[36]

After listing the largest contributions to April 1974, Smith concluded, "it's not very impressive." Fund-raising needed to flush out more big givers. One such donor emerged later in the year. After careful cultivation, S. C. Johnson pledged $125,000 through the Johnson Wax Fund to reconstruct the first (Barrie-Vosburg, now Ramsay barn) of three buildings intended for a visitor's center complex. This was a major fund-raising coup, but a steady stream of similar gifts did not follow in its wake.[37]

The fund-raising day of reckoning came on Valentine's Day 1975. The significance of the curator's decision that day became evident only in retrospect as an accumulation of factors merged. The WARBC endorsement in 1972 had not produced significant funding. The Society, to make OWW more attractive to that committee, set a deadline to open OWW by July 4, 1976. That meant the clock was ticking. In soliciting funds from a long-time supporter, Applegate confided, "I am racing against time now and perhaps a bit desperate." Soon after, Smith echoed this sentiment: "1976 is fast upon us, and we have so much to do." On that February day, the curators had to decide whether to continue to fund-raise on their own or hire a professional firm to coordinate the drive. The answer would significantly influence the museum's development.[38]

As 1975 approached, fund-raising failed to establish momentum in a campaign that consisted mostly of sending brochures and letters and presenting slideshow lectures. Considerable time was spent developing lists of possible donors and compiling lists of those people who curators knew and who might serve as a (foot-in-the-door) contact. The Society did not have a development office; indeed, no one on the staff or the board served as a full-time fund-raiser.

At the end of the previous year, William Carlson, a professional fund-raiser, submitted a fund-raising proposal. It highlighted two elements: first, his firm would help the Society raise $3.2 million, and second, the campaign would be done in eighteen months (January 1975 to July 1976). Fund-raisers do not come cheaply, and Carlson asked for $5,800 a month plus $2,000 a month for expenses (travel, lodging, meals, telephone). Beyond this, the Society had to furnish his firm with

offices and secretarial assistance. Curators variously calculated the costs somewhere between $150,000 and $160,000. Smith brought the proposal to the Executive Committee. Before voting on the issue, one curator wanted to know if $3.2 million was indeed needed. Another questioned whether raising that amount was feasible. Still another suggested that bids for the contract should be offered. Dick Erney, perhaps somewhat sarcastically, asked how they would get a feasibility study if the fundraisers did not do it. The Executive Committee rejected the proposal but left the question open for further exploration. A few days later, Smith told Carlson that his proposal was too expensive for the Society's meager resources. Carlson seemed surprised, especially since time was so short. Beyond this, he suggested that the campaign would cover his fees and emphasized that his fee was "very low." He implored the director for a face-to-face meeting with the board, which occurred on February 13.[39]

As Carlson found out, the curators were not sympathetic. In advance, Zigman lobbied the president of the board. "Fundraisers don't raise one cent of money," he opined. They do organize and they "do crack the whip," but for the Society to commit to spending "this kind of money" is dangerous. Another wrote that while Carlson had a fine reputation, the price was too high, especially with no guaranteed results. Another worried that the Society might end up paying and getting nothing. He wondered if the curators could not raise the money "if we exercised discipline."[40]

Carlson gave the curators a fund-raising tutorial. He started with OWW, which he saw as having excellent fund-raising possibilities. He emphasized three basic factors. Although two months had already disappeared from his eighteen-month strategy laid out in December, he thought the $3.2 million goal was still possible. Second, the campaign would succeed because it would stretch people to give to a unique and worthy project. Third, the project would appeal to donors because they would see a long-range return for their philanthropic dollars. That said, he talked about what would be in place on July 4, 1976. More important, donors would become part of an ongoing project. He stressed the importance of the first two months of the campaign and the need for full curatorial support. This would be expressed in the form of a leadership gift of $500,000. The cash flow would come in the third month. For corporations, this happens through "peer coverage": presidents talk to presidents on a one-on-one basis. This meant the general chairman had to be an unusual person, one who "stands tall." He instructed that fund-raising has one basic principle: "People give to people." He said

fund-raising is a rifle shot campaign, not a shotgun approach. It is not done on the telephone or by picking up pledge cards at an office. What about the recession? When times are bad, "philanthropy always reaches new heights." Gifts will come if the project is worthwhile. The curators present listened to his presentation, discussed the matter, and then took the calculated risk that staff and curators together could raise the money without professional assistance.[41]

The obvious reason for the decision was the upfront cost. But there was more. The curators had previously orchestrated another campaign. They raised $311,000 from nineteen donors for the six-volume *History of Wisconsin*, the Society's other bicentennial project. Whether from hubris or frugality, they did not hire Carlson. Rather than securing the contract, Carlson had spurred the board members to inaugurate fund-raising on their own.

Where did Smith stand on this issue? He, better than the curators, knew the toll that fund-raising would take on his already stretched-thin staff. He understood the financial quandary as well as any curator. He did not push them to hire Carlson. With sentiment running strongly against Carlson, Smith only said the time had come to make a decision. Without committing himself, he offered a subtle warning that if they decided to use board members then "we do not have much time to gear up for a campaign."[42]

None of the curators seemed to notice that this campaign was twelve times larger than their first one. They appeared neither worried that they had no organization for raising funds nor a staff with time to commit fully to fund-raising. Staffing issues and a paucity of ready cash left the Society in a weakened position as it approached the biggest fund-raising campaign in its history. Hannah Swart, who was an ex officio member of the Women's Auxiliary and who had attended the February 14 meeting, called Axtell and said board members "cannot in good conscience put fundraising on the staff." Carlson made it clear that fund-raising was the board's responsibility but the curators seemed willing to leave fund-raising to Applegate and Smith. Ominously, she predicted that this would lead to shortfalls in fund-raising. Applegate was distraught enough to tell Smith that he felt like resigning. In Milwaukee, Fred Schmidt heard that the assistant director might be relieved of his position as of July 1. Perrin thought his colleague "would be well qualified to take over the OWW job if Applegate were terminated."[43]

Did the curators make the right decision in February 1975 when they rejected the concept of hiring a professional fund-raiser? The answer

came down to whether curators could put their "shoulder to the wheel and do it themselves." With the decision not to hire a professional fund-raising firm on February 14, curators by default took responsibility for the fund-raising campaign.[44]

At a board meeting a week later, Axtell, reporting for the OWWC, appealed to board members to get more active in fund-raising. The curators, he reiterated, "are the keys to opening doors." He asked for ten to fifteen curators to commit to calling five prospective donors over the next three to four months. He emphasized the need for a major "leadership" gift, now described as between $200,000 and $500,000. This was the number-one priority and would serve to prime the fund-raising pump. After securing this gift, the curators would aim for gifts in the $25,000 range. Interestingly enough, he received no formal commitment for either time or talent.[45]

Applegate, who now served as the OWW administrator, conceded in the aftermath of the February decision that he might have more time for fund-raising than in the past but could not be a full-time fund-raiser. The problem, of course, was the opening. In an effort to move forward with some direction and urgency, a few weeks later Smith initiated an effort to hire a consultant at a price more agreeable to the curators. He arranged for a meeting between the Financial Subcommittee and California-based consultant Chester L. Tolson. After a series of negotiations between Smith, Tolson, some curators, and the WHF, the Executive Committee agreed to hire the consultant for six months and to pay his $10,000 fee, plus up to $2,100 for travel and lodging and $6,000 for other expenses. Smith later conceded: "One of the most appealing aspects of our engaging his services was his unique fee setting. He charges clients only for the time they use him on a day-by-day basis." Tolson agreed to spend four days a month from May to August and two days a month during September and October advising the board and staff on how to make approaches. The WHF agreed to liquidate Neita Friend's gift of stock to underwrite costs of hiring Tolson. At this meeting, Applegate added urgency when he reported that construction of the farmsteads had not progressed as rapidly as expected "because of the lack of funds." He might have added that having to hire inexperienced workers (lowest wages) also slowed construction. More than a year earlier, Erney had noted the relation between fund-raising and construction: donations would determine the number of workers hired. On a more positive note, Applegate said that if the board worked with Tolson, the present goal of $5 million could be raised. He promised that on the days

Tolson was in Madison he would work exclusively on fund-raising. He also informed OWWC that he was updating cost estimates. He warned them that a number of items had been omitted from the original site plan (sewage treatment plant, perimeter fencing, publications, board-walks in the village, among other things). Board president Howard Mead reminded his colleagues that at the February meeting they heard about the importance of curator involvement in the fund-raising campaign. "Fundraisers do not raise the funds. The Board must do that, and there has been a good response from the Board members contacted."[46]

As of mid-1975, on-site construction had been paid for from the $900,000 raised from private, state, and federal funds. Much more was needed, and it was needed quickly. With the unanimous approval from two curatorial committees, Tolson presented the curators with his plans and his costs for advising the campaign at the annual meeting in June. In approving Tolson and his plan, the curators committed to raising $4 million from private sources, which would be added to the $1 million anticipated from state and federal governments. The campaign, dubbed "Out of One, Many (E pluribus Unum)," would establish a bona fide need, a system of evaluation, an organization for solicitation with a timetable, and a set of priorities. Tolson posited that 10 percent of the contributors would provide 89 percent of the needed funds; he wanted the curators to secure sixty-three gifts of $25,000 or above, with one gift that would be for 12 to 15 percent of the $4 million goal. While he set no dollar goal, he said the campaign needed 100 percent participation from the curators.[47]

Even with professional assistance, the curators spent an inordinate amount of time recruiting the business leaders to serve as the general chair and the area chairs. Time spent getting organized was time not spent recruiting money. Smith took a first step when he asked Governor Patrick Lucey, who on numerous occasions expressed his support for OWW, to serve as the campaign's honorary chair. Reflective of the campaign in general, it took months to finalize the governor's commitment.[48]

Tolson believed that the campaign "will really begin to roll when we get our leadership." Recruiting the general chair and the area chairs proved vexing and persisted well into the fall. One potential area chair declined, stating he was pushing eighty-five and did "not want to tackle this responsibility." Curator Robert Murphy declined for two reasons. He did not have the time and energy that would be needed to serve. Second, he admitted that he "had never been a strong supporter of the

OWW project." He thought the concept was excellent but believed that
capital and operating costs had not been adequately thought through.
Echoing the sentiments of Dick Erney, he did not wish to threaten the
Society's established interests or sites. The first choice for general chair
declined. Tolson suggested that Smith, who was on vacation in Maine,
call Herbert Kohler. He was sure Kohler would be impressed if the
director took time from his own vacation to encourage him to become
general chair of the campaign. Kohler did accept to co-chair the
campaign with his wife, Linda, but that was not until October. Even
then, the announcement that the Kohlers would head the fund-raising
campaign did not make the newspapers until December.[49]

Once recruited, finding times to meet as a "cabinet" proved prob-
lematic. Through November and into December, staff tried to get their
recruiters together with scheduled meetings postponed and then re-
scheduled. As a result, the campaign languished in the organization
phase. Smith sought to cover the fund-raising gap and cover operating
costs by requesting GPR (general purpose revenues) funding in the
budget. As recruiting area chairs continued, which it did through
November 1976, costs grew. The Society was hard pressed to meet the
demands for laborers and materials emanating from Eagle.

Applegate feared that the cash-strapped Society could not afford
to extend Tolson's contract. Campaign expenses had reached about
$19,000. The jaws of a vise seemed to be closing: "This sobering estimate
makes me wary about extending Chet's contract. As a matter of fact we
may not have enough to cover everything." The campaign had attracted
some money and pledges—$43,000 from the greater Milwaukee area
when the goal was $3 million. Applegate met with the Milwaukee-area
chair to develop a final list of prospects and discuss approaches. Business
executive Henry Harnischfeger wanted a projector for his desk that
would, with the push of a button, start the slide show. The projector
cost about $600. When informed the Society did not have money avail-
able for such a purchase, he called his company's publicity manager and
instructed him to order one. Another problem emerged that confirmed
the museum's financial plight. Vandals continued to cause damage at
the site, but the Society did not have funds to provide adequate security.
With less than four months to opening and the campaign running well
behind schedule, the Society faced the same problem it had in February
1975. Tolson, who would work full-time on the campaign, needed about
$100,000 for permanent staff for four months. That was about 2.5
percent of the campaign goal of $4 million. What choice did the board

have? It hired Tolson on a full-time basis. The Kohlers agreed to an aggressive campaign with the hope that the largest gifts could be negotiated, pledged, and at least partially paid during the next four months or so.[50]

With a month to the opening, the situation looked bleak. Despite having established two offices in Milwaukee, the campaign failed to pick up any steam. Since the last report, Smith said only $165,000 in pledges had been received. As troubling, he listed cutbacks the Society faced and talked of cutting personnel and programs. The "Society has been squeezed to a point where there is absolutely no 'give' in the Society's budget." In July, although newspaper articles touted that fund-raising had reached the $1 million mark, the news was hardly encouraging.[51]

Creation of the state's largest historic site was envisioned as a private/public endeavor. The campaign set a goal of $5 million. Of that figure, $1 million (20 percent) was to come from the state and $4 million (80 percent) from the private sector or federal grants. The Society did not envision private donors as partners. For that matter, the director did not see the state as a partner. Administration and decision making always remained in Madison at the Society (subject to procedures that the legislature imposed). The Society's great challenge was to find those in the private sector willing to fund its projects. Some donors found the disproportionate amount grating. They asked why "the State isn't paying as much as the private sector?"[52]

As fund-raising faltered, the state assistance became more important. The state was always involved. Since 1853, the state had provided financial assistance. After adopting the Society as a state agency, the legislature provided about 70 percent of its budget. By necessity, the Society sought outside funding to supplement the operating budget and fund new programs. Economic downturns, inflationary spirals, and political considerations negatively affected all state agencies. Between 1964 and 1976 budget reductions made it difficult for the Society to fund its many programs. Consider Dr. Smith's first address to the membership. He lamented that the Society had been in the grip of a barebones budget for the past four years and faced the prospect of an austerity budget for the next two years. The next year he informed members that gubernatorial directives ordered budget reductions of 2.5 percent for 1973–74 and 5 percent for 1974–75. The budget situation did not markedly improve over the next few years. State fiscal and efficiency experts implemented something called "productivity increases," which Smith described as a "high falutin'" term for austerity budget cuts. In early 1975, a sudden

economic downturn obliterated the predicted surplus. This led to draconian state cutbacks that left the Society's budget "shredded." Later that year, Smith noted that the governor had appointed him the state historic preservation officer to administer a cooperative federal-state program that brought $189,541 to Wisconsin. He complained to members of the Joint Finance Committee that the state had never appropriated a penny directly to the Society for state matching funds. To administer the program, he "had to rob Peter to pay Paul." When Mead reported on the latest budget negotiations, he merely said: "It could have been far worse." As the Society sought more from the governor and the legislature, they had less to give.[53]

Neither Fishel nor Smith nor the Board of Curators developed a comprehensive statement for the state's role. No governor or legislature had committed to pay for OWW. Governor Lucey based his support on the notion that OWW would be largely privately funded. Even though Smith bragged in late 1971 that there was no state money in the operation, OWW became increasingly dependent on state finances.[54]

The biggest state contribution came in the form of land from the DNR and funds from the Outdoor Recreation Assistance Program (ORAP) and the state's Building Commission, which funded capital improvements, through its trust fund. In September 1973 Smith and Erney solicited over $140,000 from the state building trust. By early 1974 the curators recognized that the Society could not operate an acceptable historic sites program without legislatively appropriated funds to supplement admissions and sales revenues. The Society received a grant from the building trust for nearly $850,000 to fund the restoration of twenty buildings at OWW. In addition, the building trust frequently wrote off deficits incurred for specific restorations. The DNR footed the bill for creating infrastructure needs such as roads, parking lots, and trails. Seeming inequities occurred within the system. The building trust appeared to pick up the entire cost for Heritage Hill, an outdoor museum in Green Bay, while the Society had "to beg for public money." The Society frequently called upon the legislature to fund new personnel, but the legislature never funded enough positions. Limited state budgets and a stalled fund drive put the Society and its museum in a difficult position.[55]

Lackluster results from the Society and the curators crippled their effort to create the "dreamed-of-museum." Why did fund-raising fall short of the Society's high expectations? It would be easy to blame Applegate. His limitations, coupled with the Society's inability to hire

sufficient assistance either in the form of additional development staff or a full-time fund-raiser, made his task unmanageable. He had too many duties to concentrate exclusively on a pursuit for which he had no formal training. The curators must accept a large share of the blame for the lack of success. They had time but spent far too much of it getting organized. More important, they never made the significant contributions that Tolson had projected. Other events, the many crises the Society faced between 1969 and 1975, budget cuts, and the rampant inflation of the early 1970s, certainly complicated the process. In the Milwaukee area, where the goal was $3 million, the OWW campaign came on the heels of the drive for the new medical college. That drive, which had just concluded, had drained most corporation community-support funds and left them in no mood to give to another drive. Some rejections came from circumstances beyond the Society's control. One foundation, when approached for a substantial gift, declined because its corporate sponsor was considering a move from Wisconsin "due to the unfavorable tax situation." Donors needed to identify with the project and feel that their money would make a difference. The bicentennial, Wisconsin's rich ethnic heritage, and preservation of a fast-disappearing historical resource did not excite the imaginations of enough potential supporters.[56]

Another reason was structural. Perhaps Applegate said it best: "Of course we are always in need of money. A project of this size has an insatiable appetite for cash." By the end of 1976, the estimated cost of building OWW had risen by another million dollars. Erney stated that the Society had only received cash or pledges totaling about $1.4 million. With a similar amount collected from government sources, the Society was less than halfway to its goal of $6 million. Small wonder that Applegate concluded, "We do have financial problems at Old World Wisconsin." Neither the state through the legislature nor through its wealthiest residents stepped up to take on the role of a John D. Rockefeller Jr. He had contributed an estimated $55 million for Colonial Williamsburg. A generation later, the state of Wisconsin through its historical society tried to draw on the wealth of residents. Lacking an effective fund-raising organization, the Society failed to garner sufficient citizen support to create and operate a museum on the scale envisioned for OWW. Financially speaking, staff limped into the construction phase without the requisite resources.[57]

Builders

To this point, the story has concentrated on the Society, the proposal for a site to relocate salvaged buildings, writing a master plan, acquisition of the site, legal entanglements with the Town of Eagle, and fund-raising. This chapter shifts the story to the construction of the site and its exhibits. Mark Knipping, who helped to build OWW and who would later become the director at another site, compared his experiences: "It is more fun building a site than operating one." Certainly an air of excitement—a sense of anticipation—pervaded the creation process. Knipping, though, may have damned the creation process with faint praise.[1]

Building a site from whole cloth presented daunting challenges. The staff in Eagle faced what seemed to be insurmountable obstacles as the opening date approached. Could they find and relocate representative buildings of Wisconsin's immigrants that fit their criteria? More important, could the relatively raw crews maintain the integrity of the buildings removed from the original locations?

Before 1971, exhausted budgets and bureaucratic squabbles held the process hostage. Fund-raising remained in an embryonic state. Once acquired, the state forest site needed an infrastructure to accommodate historic structures. While a handful of buildings from around the state

had been stockpiled on-site by the early 1970s, their condition rendered restoration problematic. More important, detailed information on other historic buildings and their availability remained elusive. Equally daunting, the Society had to assemble an effective team that could manage the complex details of construction.

Behind each reerected exhibit building lurked a story. All buildings went through six steps. The discovery process came first. For years, Perrin had located and described historic structures. Ongoing staff field excursions produced new candidates for consideration and inclusion. Next was acquisition. Did the building meet a need? Did it fit the Society's rescue and salvage mission? Was it a gift or did it have to be purchased? Was it movable? Could it be dismantled and stored at its original location? Was staff under a deadline to move it? The third step involved transportation to OWW. Depending on size and condition, a decision had to be made about dismantling the building or transporting it intact. The fourth step was to determine its location at the museum. The goal always was to re-create the original landscape to the extent possible within the master plan's designated areas. Staff also had to consider the building's relationship to other buildings that might make up the farmstead (not an easy task since in many cases those buildings had yet to be determined). Finally, the building had to be reerected. Did enough original fabric remain for an authentic reconstruction? Could quality replacement materials be found? Could staff conform to modern public safety standards without compromising the original house? Could inexperienced workers reerect the buildings without damaging their historical integrity? The ever-vigilant Perrin raised the issue of authenticity and necessary compromise when the Society considered the dismantling process, but the Society never adopted a formal policy. As it was, these tasks would have tried even the most experienced workers, which the OWW crews were not. As reerection ended, a sixth step emerged for each building: Research had to provide data on the buildings and their occupants in the context of European immigration to Wisconsin. Collections had to provide examples of the material culture associated with each building. Interpretation had to create storylines that would hold the attention of visitors.[2]

Beyond these considerations, two important questions about construction had to be answered from Madison, one regarding the decision-making process, and the other the persistent shortage of funds to regularize the construction process. Who was in charge, and could a

solid working relationship between the head (Madison) and the hands (Eagle) be established? Would enough funds become available to hire crews, support their work, and purchase needed equipment?

A number of problems delayed or complicated the construction of the site. Beyond those imposed by the EIS, the Eagle dispute, and funding, four additional impediments emerged. The first was a planning event that never happened; another was the inability to compile a full inventory of *available* historic buildings; a third was a land purchase that went bad; the fourth was the Society's tendency to set unrealistic or unachievable goals for its underfunded staff.

In October 1968 Fishel achieved one of his incremental steps when the curators enthusiastically endorsed Tishler's revised plan, which defined the museum as a *concept* from the perspective of the landscape. The plan was abstract. It designated locations for each ethnic unit, but lacking a complete inventory Tishler and his students did so "without any knowledge of what they might be." Fishel recognized that he had to take at least two steps to augment the 1968 conceptual plan. He wanted to hire an architectural/engineering firm to provide the requisite details that construction crews would need to site and reerect historic buildings. Fishel also wanted to secure economic projections and engineering studies for landscape features such as soil drainage and the establishment of ponds. For some of this, he planned to seek the assistance of an urban economic expert in the University of Wisconsin's School of Commerce. At the time, he knew full well that the Society had not done sufficient research on historic buildings and ethnic groups to move forward. His impending departure, a limited and rather inflexible budget, and, most important, his inability to secure the Society's chosen site rendered any effort to secure an operational plan, a "blueprint," for the site a moot point. The need for a blueprint became obvious once buildings began arriving on-site.[3]

Alan Pape, the first construction supervisor, needed detailed plans for siting houses and barns *before* they arrived at Eagle and specifics for the farmsteads and the village. Above all, the crews needed architectural data to guide the reerections. Madison administrators, the Technical Assistance Subcommittee (TASC), and consultants Tishler and Ralph Schaefer guided the crews with construction details about acquisitions, siting, and restorations that went beyond the master plan. Generally, the TASC and the consultants scrambled to provide timely data. Some matters needed extensive study to provide the crews with answers. Tishler, for example, secured a grant from the National Endowment for

the Arts to study and create a village plan. This allowed him to employ three graduate students to spend a year researching Wisconsin villages. Schaefer served as architectural consultant and provided the documentation that made it possible to restore buildings such as the Koepsell house.[4]

Knipping, who along with Pape made numerous excursions to rural Wisconsin, lamented: "Not only did we not have an inventory of what's out there, we didn't have an inventory of what ought to go into the museum." This meant planning was reactive, not proactive. This lack of information about the availability of historic buildings had plagued the Society from the start of planning, and it continued to do so after construction began. Salvaging historic buildings was the museum's raison d'être. The "discovery" process included finding the "right" historic buildings, describing them, and determining their availability. As with every aspect of this museum, the process was time consuming and labor intensive. If Fishel and Perrin understood that a complete survey of Wisconsin buildings was beyond their reach, they knew they had to compile a list of possible acquisitions. Without such a listing, Fishel wrote, "we are in a shaded rather than a lighted room." He added: "We urgently need an inventory of all significant historic sites in the state, but this cannot be developed with existing staff." Beyond this, discovery of specimens was not easy. Many of the houses built in the nineteenth century had been "remodeled" and could not easily be identified. Only a keen observer could ferret them out from their modern camouflage.[5]

The task should not be underrated. Fishel estimated that scattered throughout the state were over fifty ethnic communities. Of these, the museum needed but "a select few" examples. But which ones should be sought? When it came to knowledge of the state's architectural resources, Perrin stood unmatched. He took the lead in the Society's search for and acquisition of historic buildings. As early as December 1964, he had provided his list of twenty-one endangered German buildings from throughout the state. Initially, he argued for concentrating on German and Scandinavian architecture. He subdivided the German group into three architectural types: half-timber, log, and stovewood. He selected Finns and Norwegians to represent Scandinavian immigrants. He listed those buildings that should be designated as high-priority acquisitions. Some buildings were empty and in ruinous condition; others were still occupied. He marked seventeen that he considered the highest priority, "either because of the exceptionally outstanding character or because they are in danger of destruction." He did not include additional

supporting data but invited committee members to seek out his published evidence at their pleasure. Three months later, as Fishel concentrated on finding a site to house Perrin's buildings, OMC requested staff assistance for the time-consuming task of approaching some of the owners identified by Perrin. Were they willing to sell or give the buildings to the Society for preservation? Fishel assigned the task of compiling a list of possible historic buildings to his overworked sites director, who did not have sufficient staff to canvas the state.[6]

At the March OMC meeting, Perrin refined his thinking. Stressing his desire for a museum at a single site that was "dramatic and eye-catching," he identified six ethnic/national categories that the Society could represent in the museum: German, Scandinavian, Slavic, Benelux, United Kingdom, and United States. It was an ambitious plan that included six units organized into twenty-four groups or clusters that represented (at least) sixteen ethnic groups. The museum, when completed, would have one hundred or more structures. After examining Perrin's list, one curator inquired about the inclusion of a Swiss group, a significant immigrant group.[7]

Fishel, Sivesind, and the committee made little progress in identifying the historic buildings. Sivesind began to compile a map with the assistance of a student, who marked historic structures previously identified by Perrin. Over a year later Perrin met with Fishel to discuss some immediate concerns of the proposed museum. In discussing this meeting, Fishel asked about the acquisition of historic buildings. Perrin reminded the director that he had listed such structures and called for action on December 2, 1964. He reiterated his sense of urgency. The Society must consider their acquisition without further delay. He again sounded the alarm bell: They "may not be standing very much longer."[8]

To further complicate matters, Fishel faced dissension within the ranks. In April, Sivesind privately gave Fishel his evaluation of the planned new museum: not "my concept of what an ethnic park ought to be." He believed it was a plan for a museum of German and Scandinavian architecture, and he thought such a collection of buildings, based on their architectural excellence, "might attract perhaps 10 percent of the professional architects" but would have no appeal with the general public. Perrin, although not aware of Sivesind's harsh criticism, did think the exchange of ideas was useful for better defining the project. He promised to submit a further listing of buildings but tersely reminded them that the problems of acquisition and transportation remained unresolved.[9]

In time, Fishel assigned the survey to Robert Sherman in the Fields Services Division. With Perrin's list in hand, Sherman set out to ascertain whether the buildings still stood, assess their condition, take photos, and, if possible, measure the buildings. From May to mid-August 1967, he worked by himself and "was often frightened by unsuspecting snakes" or "chased by a hive of wild bees that had taken up homesteading in some abandoned structure which I was photographing or measuring." By the time he left for graduate studies at Cooperstown, he had inspected about thirty-four of the more than fifty historic buildings. As construction neared, the Society still did not have a list of available buildings. This meant that discovery, acquisition, siting, and reerection occurred virtually simultaneously. It was a classic "one step ahead of the posse" approach.[10]

The third matter also related to the master plan. The state did not own all the property envisioned in Tishler's plan. When the Society learned that the Buzz property, twenty acres of much-desired contiguous land, was about to be sold, it asked the DNR to purchase the land. State law required the DNR to purchase land at its appraised value, which in this case did not reflect ever-rising market values. The appraisal was $8,000 less than the asking price. The Society had three options: raise enough money quickly to supplement the DNR funds, ask that agency to condemn the property, or obtain an exception from the attorney general's office to permit purchase at market rate. Raising funds on short notice proved impossible. Condemnation under eminent domain in the highly charged atmosphere of the Eagle area was politically dangerous. Strong local opposition led the legislature to strip the DNR of condemnation as a means to acquire property for state forests but left it intact for state parks. The committee, fearing a public relations disaster, considered but rejected the suggestion to have the site redefined as a state park. The best option was to secure the exception, but that stalled when staff in the attorney general's office failed to move the request to the next level. Erney investigated why the request never reached the governor for approval. He learned that a law student who worked part-time had stopped the process. Erney's anger was palpable: "This sort of bureaucratic crap is too much." With no other bidder, the owner sold the land to Al Gagliano. Tishler labeled the fiasco a mess, one that adversely affected implementation of the master plan.[11]

Loss of the Buzz property was a vista buster. Rather than a pristine site unimpeded by obvious twentieth-century intrusions, OWW had gained a neighbor who built a campground and ranch on OWW's

border. More important, the site occupied the high ground and could not be screened from future visitors. This debacle highlighted both the Society's dependence on other agencies within the state bureaucracy and its lack of an independent financial base. Throughout the construction period, Smith and others sought support from the state that included funds for restorations, infrastructure, and personnel. While the Society enjoyed some success, at no time between 1972 and 1977 did it have sufficient funds to build the site. For example, periodic attempts through 1977 to buy Gagliano's land failed because the Society did not have sufficient funds to meet his inflated price.[12]

The fourth general problem related to goal setting. The Reuss gift in 1971 brought a contagious sense of urgency to the project. This led Smith to promise that "all possible efforts" would be made to have four houses, a church, a barn, a granary, a sauna, and three access buildings erected at Eagle by the end of June 1972. In 1968 and 1969 buildings that fit the rescue profile had been acquired. Jack Winn and a crew of maintenance workers disassembled at least five houses (Swiss, French Canadian, and German) for later reconstruction. The list presented to Reuss was ambitious, considering only four dismantled buildings were on-site. The Society needed to disassemble five other buildings, move another to the site, and negotiate for another. Once again, words did not match deeds. Impediments, such as slow negotiations for the DNR lease, the lack of an accurate inventory, the EIS, and the lack of a pool of ready cash, dampened the euphoria of February 1971. Smith offered Reuss an apology of sorts some eighteen months later: "The truth of the matter is that all of us were wildly wrong in our ambitious and optimistic schedule last January. It has been a long, sad tale of woe." Staff did not meet the June 30, 1972, deadline; indeed, construction would not start for another year.[13]

A meeting of consultants and staff in January 1974 laid out ambitious construction goals for the next thirty months. Based on four months of construction in 1973 with a crew of seven, they projected forty erected buildings by the opening. This meant reerecting at least one building each month. Two problems immediately emerged: the need for more workers and the acquisition of historic structures. The challenge for the impecunious Society was to bring the number of workers to sixteen. As the battle between the Society and the Town of Eagle raged outside (certainly a distraction for him), Pape supervised laying the foundation for the Society's first exhibit in July 1973.[14]

From mid-1973 to the completion of the Koepsell exhibit in the spring of 1977, the site took shape. Construction moved at a feverish pace. The Society acquired, and crews took down, at least thirty-five buildings (houses, a church, stables, barns, granaries, and outhouses). Staff visits to Bayfield and Sheboygan Counties initiated field research on Finnish and German buildings in Wisconsin. Meanwhile, Pape began hosting public tours. The first, on June 16, 1973, was a Girl Scout troop. Visitors proved a distraction as crews rushed to meet a variety of deadlines. The Society wanted something tangible for the dedication scheduled for June 8, 1974. The visit of Queen Margrethe II of Denmark on May 14, 1976, a visit of a German delegation on May 28 for the dedication of the incomplete Koepsell house, and finally the site's official opening on June 30 gave a sense of urgency to building.[15]

Rather than describing each building reerected through 1977, the remainder of this chapter focuses on one building: the house built by Joachim Friedrich Koepsell encapsulates the problems the Society faced to some degree or another with all of the early buildings. Early construction plans indicated that this house was the jewel in the crown for OWW. The Society committed the lion's share of the $116,000 budget for 1971 to this Pomeranian *fachwerk* (half-timber) house. Still, it did not open until spring 1977, nearly a year after the Grand Opening. What delayed completion? An examination of this exhibit provides a context for answering many of the questions that swirled around construction of OWW.[16]

Within the context of the previously noted hindrances, the Koepsell restoration began. This building demonstrated that exhibit reerection was a time-consuming (almost seventeen years, in this instance), expensive, and complex process. This house linked the "discovery" process— Perrin's long effort to identify significant historic houses; the present owner Elvin G. Butt, who wanted the house removed; and the Society, which wanted to preserve the house in its museum. What was Perrin's connection to the Koepsell house? How did he "discover" this house? Lacking many important documents to link the pieces together complicates reconstructing this part of the story. It means that important components must be deduced from Perrin's career and the architect's work patterns.

Perrin, a member of the SHSW, was an architect by training and a preservationist by avocation. He was born in Milwaukee in 1909, and after graduating from high school in 1927 he studied architecture and

engineering at the University of Wisconsin in Madison, the Layton School of Art, and Beaux-Arts Institute of Design. He had been a draftsman at two architectural firms before passing the board examinations to qualify as a certified architect in 1939. He worked in private practice for eight years before accepting a position in Milwaukee government. Before retiring in 1971, he had a variety of executive positions that included, variously, executive director and secretary of the Housing Authority, director of the Redevelopment Authority and the City Plan Commission, and commissioner of City Development. He was also Milwaukee's first Landmark Commission chairman. Perrin was a Fellow of the American Institute of Architects and Officer of Wisconsin Historic Buildings Preservation Office from 1953 to 1973.

Perrin dated his interest in historic architecture to the late 1920s, when he began to document Wisconsin's bountiful examples of vernacular architecture. In his 1967 presentation to Tishler's students, for example, he showed a slide of a Cedarburg windmill that he had photographed in 1929. Armed with his camera and tape measure, he had made numerous excursions into the Wisconsin countryside to document historic structures. His fellow architect Ralph Schaefer frequently accompanied him. Perrin personally intervened to help preserve the Mitchell-Rountree house in Platteville. The house, which dated to 1838, was probably "the finest example of old architecture in Wisconsin." During the late 1950s, he assisted the Society by making comprehensive inspections of historically significant houses.

If Perrin had a special interest, it was in preserving some of the more than twenty-five German half-timber houses that he had discovered by 1959. He did not limit his interests to vernacular German architecture. By 1976 he had visited virtually every European country from which Wisconsin immigrants had originated and had catalogued over six hundred pioneer structures. With the creation of the Historic American Buildings Survey (HABS) in 1933, Perrin found a national repository for his photos and measured drawings of historic Wisconsin buildings. He completed inventories and archival record documents on many of them for the Library of Congress. Working with the American Institute of Architects, the Milwaukee Public Museum, and the Society, he took the lead in encouraging an "interest in Wisconsin's historic buildings" among local residents.[17]

Beyond his interest in preserving historic buildings, Perrin had a personal connection to the Kirchhayn area west of Cedarburg. As a descendant of Gottlieb and Susanna Tischer, who settled in the

Kirchhayn area in the 1840s, Perrin certainly knew the area well. Perrin often spoke favorably of his maternal ancestors, who were among the first Pomeranians to migrate to Kirchhayn in 1843. OWW curator Marty Perkins thought these "solid Germanic genealogical associations" gave Perrin a "special personal and professional interest in the origin, preservation, and restoration of Wisconsin's *fachwerk* or half-timber architecture." The architect would have been familiar with the Koepsell house, at least in a general way, long before he measured it. *Historic Wisconsin Architecture*, which he published in 1959, included a photograph and a brief description of the Koepsell house.

The Tischers and Koepsells represented the thousands of immigrant families who migrated to Wisconsin from nearly every European nation. The Koepsell family had migrated from Prussia via Quebec in 1857 to the Town of Jackson in Washington County. As a "late-comer," Friedrich bought a forty-acre lot in 1859 in the Town of Jackson, a few miles north of Kirchhayn, where his brother had settled. Friedrich farmed land that was immediately east of Jackson marsh. That same year he built a traditional German (*deutscher Verband*) half-timber house where he and his wife raised their family. The house reflected the adaptation of old world skills and designs to a new world environment.[18]

The Koepsells left Wisconsin for South Dakota in 1886. The Butt family acquired the property and lived in the house until 1924. Once Elvin Butt built a new house nearby, he converted the once proud house to a storage building and allowed it to deteriorate. A gaping truck entrance had been cut into one side, its windows had been broken, and its damaged roof and sagging roofline had been left unrepaired.

At some point Perrin measured Koepsell to document it for the national Historic American Buildings Survey. The dates for his visits can only be surmised. He completed his measured drawings by February 1, 1960, which makes it possible to work back from that date. Measuring a building was an arduous task. In addition to the outside dimensions and elevations, individual rooms had to be measured precisely. Half-timber houses elongated the process, for each timber had to be measured as well as the spaces between timbers. It was a job that could not be done without assistance. To measure a house of two-and-a-half stories and multiple rooms would have taken a full day and perhaps part of another. Measuring the roofline was done from the attic. The architect measured the pitch of the roof and the distance between the rafters and noted the kind of roof boards. The outside cornices would be photographed with a telephoto lens for later analysis. Since Perrin had a

full-time job with the City of Milwaukee, it meant he worked on weekends and in the evenings on his historic architecture projects. He probably measured the Koepsell house in the summer or fall of 1959.[19]

Perrin would have left his Milwaukee home early on a Saturday morning for a journey of about an hour to the Butt property. Architect Ralph Schaefer, described by Tishler as "Mr. Perrin's silent partner," frequently accompanied Perrin on his excursions. Whether Schaefer assisted him on this day or not, Perrin needed an assistant to make the measurements. He would have approached the house, which was on a road that dead-ended at the Jackson marsh, from the north. Viewing the house must have kindled Perrin's anxieties about the destruction of another wonderful example of vernacular architecture. He saw a building that had been ravaged by the environment, usage, and neglect. Only the trained eye of an experienced architect could see the wonder of achievement behind the badly wounded structure. He simply described it as "in ruinous condition." Still, he had examined enough half-timber houses to appreciate its fine craftsmanship. The framing, he noted, had been done with great care. He admired the skill of the builder, whose house had two stories with a full loft above, a central hall, and a symmetrical arrangement of rooms on the first and second floors. Most of all, he appreciated the nogging (masonry used to fill in between the timbers), which he described as handmade with kiln-fired bricks of buff color. Despite its condition, he characterized Koepsell as perhaps "the most impressive Wisconsin half-timber house still in existence."[20]

If he had not previously done so, Perrin would have approached the owner for permission to photograph and measure the historic house. Perrin ascertained that Butt intended either to tear it down or give it away. He most likely shared his concern for the state's rapidly disappearing historic buildings and his vision for saving some of them. Perhaps he encouraged the farmer to think about the possibility that a preservationist group would take the building off his hands. The Koepsell house fit Perrin's developing notion of the preservation museum. He wanted buildings that represented a significant architectural style, were in a state of decay, were owned by those who no longer wanted them, and were located in areas inaccessible to the public.[21]

Perrin worked on his measured drawings in his Milwaukee home that had a desk and drawing board in the study. Given the nature of his task, he most likely spent a month or more working on weekends and evenings to complete the drawings. The submission of the five drawings to HABS brought the "discovery" phase to an end. Never one to rest on

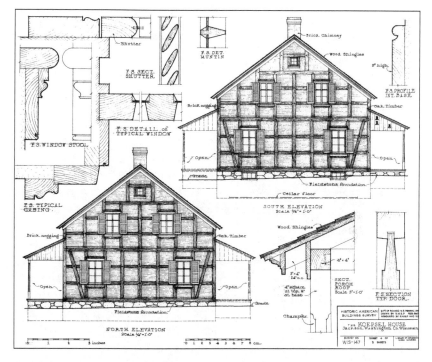

The fourth of Perrin's five drawings of the Koepsel house. (Historic American Buildings Survey, Library of Congress, HABS WIS, 66-JASCO, 1)

his laurels, Perrin moved to his next task. In June 1960 he convinced Fishel that the Society needed to take the lead in creating a preservation museum.

Acquisition, the next step, took time. More than a decade passed before the Society was ready to build the museum. During that time the Koepsell house continued to disintegrate. Between the submission of his drawings to HABS and October 1961, Perrin discussed his dream for a museum to preserve houses like Koepsell with Butt. The owner told him, "I've decided to donate the old house to Wis. Historical Society. Please move it soon, I don't think it will stay standing another winter. The walls are starting to give away." In January 1962 Perrin attended a meeting of the Ethnic Park Committee that included Conservation director Roman Koenings. Perrin again conveyed his sense of urgency. Some "of the early timber and frame structure survivals will be lost if not acquired within the next five years." Fishel, who emphasized that creation of the museum depended on the cooperation of Conservation, brought

up the "problem" of the Koepsell house. Koenings promised to have one of his staff look into dismantling, removing, and storing the house in some temporary location.[22]

The Society was in no position to move any houses. Conservation's investigation into moving Koepsell came to naught. Not until six years later did the staff again discuss Koepsell. On the basis of the data compiled by Perrin and Sherman by January 1968, the OWWC discussed the third step, moving costs for the Christian Turck (a log house in Germantown) and Koepsell houses. Before Koepsell could be moved, the Society had to acquire and dismantle the house. Sites director Sivesind noted that the Butt family had at one time given the house to the Society. He reported the family's irritation that the Society had not moved the house. Indeed, for all he knew the offer to donate it might have been withdrawn. Butt, who had been left with his eyesore, remarkably had not torn down Koepsell.[23]

Jack Winn, a Society curator, became the key player in the acquisition of the Koepsell house. The Society had sent him to Baraboo after it assumed responsibility for the Circus World Museum in 1958. As the first curator, he directed its restoration. In January 1968 Erney assigned Winn the task of completing Sherman's report as his other duties permitted. He not only evaluated structures as possible acquisitions but also located a number of ethnic structures that were not on Perrin's list. Erney further instructed him to get estimates from local movers and to ascertain whether the houses could be moved intact. The news was hardly encouraging. The mover investigated twelve buildings and deemed that six could be moved and gave estimates that varied between $5,000 and $10,000 per house. More discouraging, he deemed the Turck and Koepsell houses unmovable.[24]

Winn visited the Butt farm in the summer of 1968. He found that Mr. Butt had tired of waiting for the state and had unsuccessfully offered his house to two county historical societies. He thought it was a "safety hazard to his children" and had considered having the local fire department use it for a controlled burn. He hesitated only because of the large Norway spruce closely adjacent. Winn recommended "disassembly" so it could be moved "for reerection as the Koepsell House." If this was not feasible, the house should be "pirated for salvageable timbers, parts, adornments." How the mighty had fallen! The house was standing, but just barely.[25]

Winn became the Society's liaison with Perrin and worked with him during the summer. In advance of an August meeting, the architect

delineated some basic operational techniques for dismantling, transporting, and reerecting buildings: "Log and half-timber buildings cannot be moved intact." He had carefully studied the available literature and concluded that if the Society followed carefully "the scientific methods used elsewhere in selecting, transferring and reassembling old buildings," it would have the best opportunity "to keep unchanged the original aspect and documentary authenticity of our units." Once dismantled, the parts should be stored on-site in a temporary storage building. In addition, he advocated for a shop building where replacement parts would be fabricated to replace those that were destroyed in disassembly. As the Koepsell house demonstrated, Perrin established standards for dismantling, moving, and storing buildings that went beyond the Society's ability to meet.[26]

Just as the Society picked up some momentum on its museum project, Fishel let it be known in August 1968 that he would be resigning. His announcement was not publicized and seemed to have had no immediate impact on planning. The curators endorsed *The Old World Wisconsin Report* "with great enthusiasm" on October 25, 1968. With the negotiations for the land now making progress, Tishler optimistically projected that soon "construction can begin." Six weeks later Fishel wrote that the museum was "now in the beginning stages of implementation." It proved to be a long beginning.[27]

The boost that resulted from the curatorial endorsement quickly dissipated. Similar to the Koepsell house, the OWW project seemed on the road to disintegration. In January 1969 the Society publicly announced Fishel's departure. A January conference in Milwaukee between Fishel and curator Zigman indicated that fund-raising had not progressed beyond developing a strategy. Negotiations with the DNR for the Eagle site came unglued. That agency suddenly forced the Society to consider Aztalan State Park as an alternative to the state forest. Worse still were prospects for increased funding from the state. The Joint Finance Committee cut every increase recommended by Governor Knowles. It also reduced the projected salary of the new director. Curator Zigman characterized Fishel's departure as a "loss" for the Society and the state. The magnitude of the "loss" became apparent on October 6, 1969, when the OWWC received Erney's illusion-stripping memo. By year's end, the project had been mothballed.[28]

In the meantime, Perrin and Winn carried on in the face of adversity. In spring 1969 Perrin visited two of his favorite houses. The Turck house had stood empty since the death of its owner. Although vacant

for a year and a half, it had not been "excessively vandalized." Its preservation was most imperative. Soon after, he brought a group of Pomeranians to see the Koepsell house. Its condition troubled him. He implored Fishel to find some way to "temporarily store these buildings even if we can't reconstruct them immediately." They were irreplaceable! Fishel declared that the Society should save both the Koepsell and Turck houses, "even though we may not be able to pay the costs." This conundrum aptly summed up the Society's most serious problem. Fishel, who would leave the Society within months, was in no position to do this. He did announce that the Society had acquired a small federal grant that would allow a student to complete the much-needed survey. He also asked Winn to determine the next steps, estimate potential expenses, and find a storage place for the dismantled houses."[29]

In late April, Winn reopened negotiations with Butt. He described its condition as "sub-ruinous" but "still standing." With the central foundation support faltering, the house was in danger. Although not a trained architect, Winn made still another set of drawings of Koepsell in preparation for dismantling the house. He did a telephone interview with a Koepsell relative in search of details that were not evident in the much-decayed house. Butt again offered the building "as an unrestricted gift" to the Society. The agreement with Butt called for the Society to dismantle the house beginning in May and gave the Society three months to complete the work. The Society sent a crew of maintenance workers to dismantle the house. More than likely, Winn was there to supervise and photograph the operation. The crew stockpiled the salvageable materials — structural timbers, some bricks, trim and fittings, and some windows and doors — near the original site. Butt had agreed to allow storage on his property for up to one year (about September 1, 1970) with the stipulation that the piles be covered and securely tied. Winn and Butt signed the final agreement on August 12, and the Society officially owned the Koepsell house. If this was an important and necessary first step, it was a meaningless one until the Society gained the state forest site at Eagle and a mover brought the remains to that location. The inability of the Society to gain title to the state forest prevented it from moving Koepsell and other buildings until 1971.[30]

As construction neared, other problems or concerns beset the planners. A number of important questions had to be confronted formally. How many workers would be needed? What kinds of skills and experiences did they need? What tasks had to be accomplished? What equipment did they need? What kinds of restoration materials needed

to be stockpiled on-site? Would a workshop be erected? More important, perhaps, the Society left the lines of authority ill defined. Because of budget constraints, it did not appoint a museum-trained, on-site director until May 1976. With site administrators based in Madison, crews made decisions on the spot. It meant some important decisions were made "casually."[31]

Winn was the first of two de facto directors. He served from 1971 until early 1975 when Applegate assumed the role of "over-all director" of OWW. Both operated from Society headquarters. The choice of Winn reflected the decision-making process within the Society. How did Winn become the de facto director of the site? Erney, who was the associate director, recalled the process. He characterized Winn as "a knowledgeable guy in many ways," but he did not remember that Winn had any particular knowledge of architecture or old buildings. He did recall that Perrin was high on him, and indeed he was. In 1969 he had written that Winn had done an outstanding job, mostly on his own, in researching, locating, identifying, and negotiating acquisitions of specimens for the museum. Only a "lack of administrative enthusiasm and support and, of course, a lack of money" from Madison prevented him from doing more. In the final analysis, Erney remembered, "Jack was available, and he seemed to have the qualities and some interest in these buildings." After the Society had started to stockpile buildings, Erney "detached" Winn from the field services and named him site coordinator. He "was our choice," Erney said, "because we had no other choice."[32]

Winn had some problems. First, the Society had not planned well for the building process. He had to direct site operations from Society headquarters, about sixty miles away from Eagle. Second, he was uncertain of his role, his authority, and the reporting lines. He did not have a great deal of clout within the inner sanctum. Fishel remembered him as "a very difficult guy to decipher" and a person who never quite seemed to reach the peak of his abilities. Sivesind thought Winn was more comfortable with artifacts than people. His colleagues recognized that Winn's leadership style did not fit well with the demands of his new position. They saw him as a weak administrator who did not like to make quick decisions under pressure. Pape saw Winn as "a very cautious, calculating fellow." He believed that the best decision would be made only if you studied it long enough. Winn "didn't want to be pushed and he didn't want to push somebody else." Knipping, who worked for Winn at the Society, provided a different take. He was a true

"renaissance man," a man who loved the English language: "When he was in college he sat down with the unabridged Webster's Dictionary and read it from cover to cover. He had a better command of the English language than anybody I've ever known." Knipping characterized Winn as an intellectual who "liked to toss about this or that and cogitate on it." Winn was "an academic" who liked to think things over and be correct before announcing his decisions. However cast, Winn's leadership style too often prevented quick and decisive action.[33]

Two of Winn's first hires were Mark Knipping and Alan Pape. They were among a cadre of young and rather inexperienced men hired in the fall of 1971 to research and help construct OWW. On the basis of Winn's presentation of the project, both eagerly jumped at the opportunity and committed to working for at least five years. Both willingly forsook their intentions to earn advanced degrees: Knipping a doctorate in history and Pape a master's degree in landscape architecture. By the next spring, Winn employed Pape full-time, and he eventually became the site's first construction supervisor. The dismantled Koepsell house was still on the Butt farm when Pape arrived in Eagle. The Society had hired professional movers to bring the Koepsell remnants to the state forest by December 1971. The 1968 plan only designated the general location of the German farmsteads. The movers deposited the Koepsell remains in an area just north of the trees where the house now stands. This completed the third step and was the opening salvo in the siting process. Much remained to be done, including thorough research on Wisconsin German farms, the number of buildings in each farmstead, and the layout for the farmsteads.[34]

Reerection of buildings entailed far more than putting the pieces back together. It involved practical issues such as researching the ethnic group to determine its preferences, finding suitable replacement parts, and managing philosophic issues relating to historical accuracy and restoration. In practice, the 1968 plan left the number of buildings and their precise locations to others, namely, the TASC and construction crews.[35]

Start-up was hectic; each step forward brought new challenges. In addition to Koepsell, the movers delivered five other dismantled buildings to the site. Pape's inexperience led him to describe his first years as his "greenhorn period as site manager." He felt his role on-site was "ill defined." As one of the Society's representatives in Eagle, he served as the public contact person, the site security officer, the site planner, the personnel agent, and the building supervisor. Winn admitted in early 1974 that the crew functioned under a rather loose organizational pattern for

the first two-and-a-half years. Funding from the legislature finally formalized (made permanent) Pape's appointment as site manager and Karl Boeder as the buildings and grounds custodian.[36]

A lack of funds delayed construction of the German complex. A federal grant of $41,250 hinged on getting both the Koepsell and Turck houses listed on the National Register. After scrambling to assemble the support data, these two houses qualified and were listed on October 24, 1973. This allowed the release of federal funds during the next year, and the state matched the grant. With the money at hand, construction could begin. Pape decided to concentrate on the Finnish complex in advance of the June 8, 1974, dedication of OWW. Construction of the German complex would follow. As a necessary first step, Ralph Schaefer gathered and analyzed the data for a detailed architectural report that would guide the workers when construction began.[37]

The lack of certain funding affected what the crew could accomplish. Winn's directive to hire local minimum-wage high school students meant Pape had to continually train raw recruits. He called them a "rag-tag team" that lacked experience or training. Sometimes he relied on volunteers such as the Model A Club, whose members put up and roofed a barn in one weekend. As he approached the construction phase, Pape confessed that he was only a step or two ahead of his crews. He learned by doing, and as he mastered a skill or technique, he instructed his young crew members. Pape and his crew of high school kids were pretty much on their own. Professors Charlie Calkins from Carroll College and Marlin Johnson from the University of Wisconsin–Waukesha showed up that summer to provide some valuable assistance.[38]

Over the next three years, Pape's increasingly more experienced and skilled crews split their time between dismantling historic buildings around the state, laying new foundations, and reerecting houses and barns. As the construction supervisor, Pape felt "extreme pressure and responsibility to produce [as] many architectural exhibits of high quality with both structural soundness and historical authenticity" as possible. By the fall of 1975 he had more workers, but they came with "varying degrees of experience and talent." As the crews gained experience, Pape's micromanagement on issues such as authenticity chafed. This led to one of a number of labor crises. His "dictation even when the work has nothing to do with authenticity" led to a compromise brokered by Winn and Applegate and greater independence for the crews.[39]

Salvaging the Koepsell house raised questions about the restoration process and the issue of authenticity. No question is more important than this one: Is the historic integrity and significance of a building

compromised if it is moved from its original location? The only answer is "yes, but." As one authority noted, moving a historic building is appropriate if the only alternative is demolition. The Society salvaged buildings that, for whatever reason, could not be restored on their original site. Still, moving nineteenth-century buildings to a twentieth-century site entailed many changes that altered significantly the original building. When asked if the building that graces the OWW landscape should be called the Koepsell-Pape house, Pape thought the suggestion far-fetched and asked: "Why is that not the same building?" What else besides the obvious one of relocation made the building different from the original? Two issues, the amount of original fabric salvaged from the takedown by a state maintenance crew that had no particular training with restorations and compliance with public safety standards, fostered significant change.[40]

Perrin, the standard bearer for restoration, was emphatic: "We cannot throw buildings together without experts being present. Subtle differences are very important aspects." This meant hiring restoration architects. Neither Perrin nor Schaefer could be on-site to supervise every detail. That task fell to Pape, who admittedly learned on the job. Perrin did not favor reconstructed buildings. Too much was missing for accurate replicas. With the restorations, he was neither a perfectionist nor impracticable. He wanted the visible to be as accurate as possible. For the "non-visibles," he allowed more flexibility. He recognized the need to replace materials that had not been salvaged from the takedown. For example, new wood had to blend with the original either from staining, tinting, or by letting the logs weather naturally. In the rush to open the site, however, reerection forged ahead of research and forced the researchers to struggle to keep pace.[41]

Knipping and Pape never intended Koepsell to be an exact restoration. For one thing, Friedrich Koepsell posed a problem for them. He was primarily a builder and only secondarily a farmer. At the time the Society acquired his house in 1969, no other buildings associated with the house remained. In the absence of archaeological surveys, the number, type, and location of outbuildings remained problematic. The configuration of his farm came to light only after researcher Marty Perkins found an insurance document from 1875 that included one out building, a log barn. Researchers intended more than just the reerection of the house. They wanted to re-create a Pomeranian cultural pattern that emerged from the field investigations. The objective was to place the house in the context of a courtyard or *Vierkanthof*. In early 1972

Knipping and Pape visited twenty-six Pomeranian farmsteads, photographing and recording the relation of the outbuildings to the house. They also noted the presence of driveways, wells, gardens, orchards, and outhouses. They then analyzed the data to create a plan for a dual-purpose half-timber building complex that represented the "typical" Pomeranian farmstead and reflected the character of the Koepsell family. They intended the Pomeranian initiative to be the first data matrix, which they intended to be a model for each ethnic group. Their challenge was to imagine a traditional Pomeranian farm complex and then find the right buildings. The Society had to find the money to build it.[42]

From the beginning, they envisioned important changes that would alter the house's original condition. While the authenticity issue was always there, the builders looked at that issue from a more pragmatic or practical view. What must they do to reerect the building? In addition to creating a farmstead that never existed at the Koepsell site, Pape decided that the house would face west toward the courtyard instead toward the road as Koepsell had done. They further intended to situate the house on the highest point of the lot. Their research provided data that more than half of the *fachwerk* houses faced their barns. Pape decided that he would situate the house facing the courtyard, which in this case would be a prototype of a Pomeranian farmstead.[43]

Pape and Knipping made no effort to replicate the original foundation or cellar. Not intended as exact duplicates, the foundations raised questions about authenticity. The foundation of one of the Finnish buildings, for example, reflected a tension between Pape and Gary Payne that concerned getting the job done, necessary compromise, and authenticity. It also demonstrated one of the pitfalls of not having a director on-site. Pape had completed about half the foundation for a Finnish barn when Payne confronted him. Payne was the site's researcher and had spent considerable time researching the Finns. He asserted that the Finns would have never built a foundation with cement between the stones; rather they would have piled stones under the logs. The foundation, he contended, looked like a German one. The Society's public relations officer, who happened to be on-site and who witnessed the episode, thought two issues brought the matter to a head. One was a question of who reported to whom. Each thought he should be in charge. The more important issue was "a basic clash" regarding restorations. Payne took the long-term view that OWW was preserving the past for the future and asserted that every detail was important. Pape disparaged him as "a perfectionist" who wanted everything in a Finnish complex

done exactly as a Finn would have done it. Pape, as construction supervisor, took a short-term view and maintained that at times expediency was more important than perfectionism. According to John Harbour, Pape "marched to his own drummer, and was more interested in results than how he got there." This clash raised a fundamentally important question about the authenticity issue, and the Koepsell reerection provides the basis for exploring it.[44]

The original house sat on a foundation that covered a crawl space and a cellar accessible from the central hallway. Once he and Knipping sited the house, Pape arranged for a commercial excavator to do the digging. Knipping designed the new foundation without the cellar. The new crawlspace was a concession to modern safety standards and the need to have electricity at the house. For the walls, Pape had three choices: concrete block, stone and mortar, or poured concrete. Since the area was not visible to the public, he chose poured concrete but then had to train himself to do the framing. On this foundation, the crew laid I-beams to support the weight of many visitors and disguise the electric connections. The foundation, which was a twentieth-century construction, called attention to the many alterations done in the name of safety or the need for modern conveniences. Schaefer, who had reworked the existing architectural drawings (Perrin and Winn's) for Turck and Koepsell, prepared exacting specifications for the restorations. His April report for Koepsell required many additions that would not have been part of Mr. Koepsell's house. These included covering all wood that came in contact with concrete or masonry with a wood preservative, fireproofing the wood shingles, and adding insulation to the walls and underside of the joists.[45]

Next came the positioning issue—how the house would be seated in relation to other (unknown) farmstead buildings. Jack Winn made one critical decision relating to the final positioning of the house. Pape began the reerection working on the assumption that the house would face the courtyard (the *Vierkanthof*) in the traditional German manner. After getting the foundation in and about half of the first floor timbers up, Winn told Pape that he wanted the house to face the road. As Pape recalled, the crew disassembled the "damn thing," turned it around, and refitted the forms to the foundation. Fortunately, Mr. Koepsell had built a symmetrical house. Winn's explanation (at least Pape's recollection of it) was that after a weekend of deep thought, he decided it would be better if visitors approached the front entrance from the road.[46]

The salvaged logs posed a number of problems. After the Koepsell timbers arrived on-site, Pape had to cover them. Not knowing which material was best, he used black plastic. He knew neither how effective it would be nor how long they would need to be covered. If he received assurances from Winn that "we're going to get money to put it [Koepsell] up," he heard nothing about a timeline. Further, as he and his crew laid out the house, he realized that he did not know how to move the oak timbers safely. They were very heavy and the crew lacked the basic equipment to move them. The Society bought log carriers from a catalog but the crew needed a boom truck with a front-end loader. Winn listened to Pape's pleas but seemed in no hurry, perhaps because of the costs, to purchase a truck. Getting needed equipment remained a problem throughout construction.[47]

A close inspection of the salvaged timbers revealed a problem with decomposition or infestation that compromised them. Winn began a search for a solution in 1972. He wrote to numerous outdoor museums seeking advice for the best way to preserve heavy timbers. Some recommended chemical treatments, but all had drawbacks. One museum curator confessed that his site had tried different techniques: "We just 'experiment.' And still to this day we have not found any satisfactory solution." Winn looked to purchase a large concrete bath tank in which the timbers could be immersed in the dangerous chemicals used in the preservation process. The concrete tank proved too expensive, and Knipping recalled receiving orders for the crew to dig a hole in the ground and "line it with plastic sheets and pour this stuff in it." The "stuff" was pentachlorophenol, a carcinogen. The crew was supposed to put the timbers in the pit, soak them, and then lift them out. They lacked protective gear for handling the toxic chemicals and the equipment needed to move the logs effectively. Experiments to find an environmentally safe, effective preservative continued, but no immediate solution was available. Since the timbers weighed as much as fourteen hundred pounds, Knipping argued that they needed a tractor, protective gear, and spraying equipment in order to preserve the timbers with some degree of safety. The Society's inability to supply the requisite equipment put the crews in harm's way.[48]

Lack of funds hampered construction. Pape needed a restoration workshop where he and his crews could work on logs and other materials. This did not happen until the Society acquired the Palof barn in 1974 and renovated it. The crews needed trucks that would allow them to

get to remote locations on site. Despite numerous requests, vehicles (scrounged from other agencies) did not arrive until the end of 1975.[49]

New OWW on-site director John E. Harbour raised the authenticity issue formally after he arrived in May 1975. He discussed with his staff, in the context of the museum's current acquisitions, the difference between a reconstruction and a restoration. He recognized that OWW builders had intended to preserve the historic characteristics of buildings as workers dismantled, moved, and reerected them on-site. But how much of the original fabric had been sacrificed? He looked to establish a standard that would distinguish between a restoration and a reconstruction. Since each building presented unique problems, he and his staff concluded that a restoration must have a substantial amount of original fabric. The new director set a strict standard: "I have very serious reservations about the reconstruction of part or all of historic buildings. I think we are in the business of restoring houses here, which is generally accepted to mean replacement of not more than twenty-five percent of the original structure, roof excluded. If we are to maintain any architectural or historical integrity, I do not believe we should be in the business of reconstructing historical buildings." Allowing for the roof, which was generally not salvaged, the 70 percent of original fabric to 30 percent new material ratio seemed to be an acceptable standard. However, that goal was not always achievable, especially for the early takedowns. As the OWW crews gained experience, they became more adept at harvesting more of the original fabric. The Koepsell house takedown crew in 1969 salvaged the rafters and joists and many of the original timbers as well as some bricks, doors, window frames, and trim. Too much of the original fabric was lost. Finding suitable replacements caused delays in the restoration process. Some pieces during dismantling had not been identified in terms of use and location and could not be used. Koepsell required considerably more new material than the 30 percent ideal. The crews replaced these items with new materials from contractors or salvaged items, such as the door hardware, from other buildings. Interior walls, much of the trim (interior and exterior), shingles, roof boards, floorboards (basswood), and both porches had to be replaced with new materials.[50]

Here was Pape's challenge: find new materials that could be made to look like the old or find salvageable materials that could be intermingled with the original fabric. Finding and preparing replacement logs exemplified the need for new material, while the search for bricks demonstrated the value of finding salvageable materials elsewhere.

Finding replacement oak timbers for Koepsell proved easier than acquiring 40 cedar logs needed to reerect the Turck house. Site supervisor Bjarne Breilid found a company that promised to have the required logs available for pickup in January 1975. Once acquired, the logs had to be hand-fashioned, that is, hewn and shaped with mortise-and-tenon joints. Replacement bricks provided a more interesting story. The majority of the wall fabric was brick. Dismantling in 1969 was not approached in the same way it would be later. As a result, the crew salvaged only about 600 bricks and the restorers needed twice as many to complete their job. The resourceful Alan Pape found an abandoned farmhouse in another community, which the Society purchased for $800. In April 1975 Perkins and seven others went to the site with a tractor and a gooseneck trailer. They spent four days at this site salvaging what they could from the house. After pulling down the walls, they meticulously cleaned the bricks and loaded them on pallets for transportation to OWW. The crew recovered 3,600 bricks and used about 1,200 for the nogging between the timbers and the chimney. While not a perfect match, the cream city bricks when blended with the original bricks would have been noticeable to only the most critical observer. The timely infusion of new money from the Society allowed Breilid to hire a professional stonemason to assist the crew with bricklaying.[51]

The rush to open shunted Koepsell to the sideline. The inability to have Koepsell ready for the public on June 30 reflected the problems the Society faced. When the site opened, Koepsell was one of the buildings that visitors could view but not enter. Crews had been unable to finish the trim, stairs, floors, and doors. Problems with contractors installing electricity further delayed the effort. Interior paint (stripping and analyzing) research was ongoing, and nothing had been done to furnish the house. The site in June 1976 was no more ready for the public than this house. Yet Smith decided that OWW would open as scheduled.

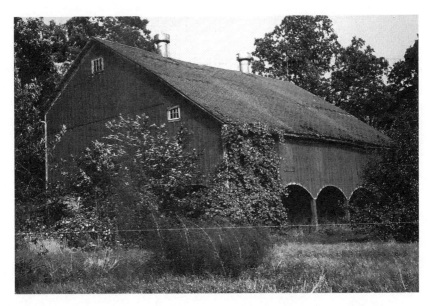

The Barrie/Ramsay barn in its original Fort Atkinson setting in 1973. Locating and acquiring buildings was an integral part of the creation story. (William H. Tishler)

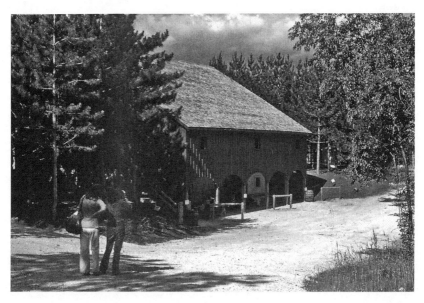

The Barrie/Ramsay barn, relocated from Fort Atkinson, in 1975. Staff adapted the preserved building for its visitor's center. (William H. Tishler)

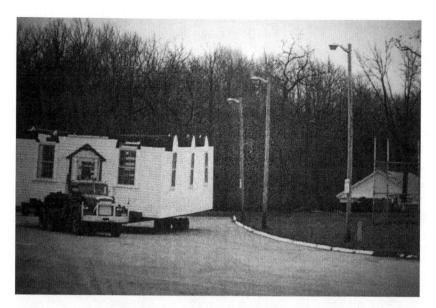

Staff move St. Peter's Church from Milwaukee to Eagle in 1975. Relocating buildings to Old World Wisconsin proved a daunting and expensive challenge. (Old World Wisconsin Archives, Wisconsin Historical Society)

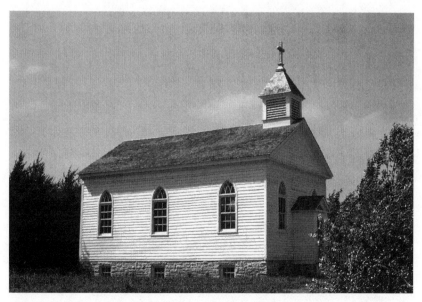

Situating and reerecting St. Peter's Church proved equally formidable. As of 1977, the church was the only building in the nascent Crossroads Village. (Arnold R. Alanen)

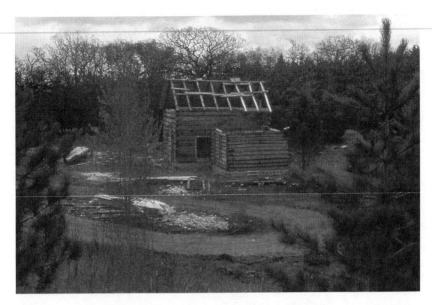

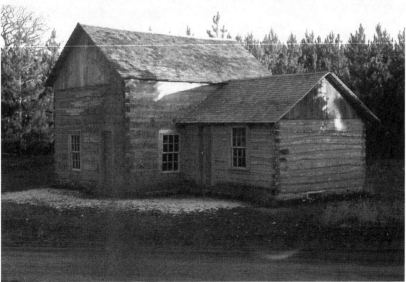

The anticipated visit of the queen of Denmark in May 1976 led to the frantic search for a suitable Danish house. Crews found, acquired, moved, and reerected the Pedersen house in less than six months. (William H. Tishler)

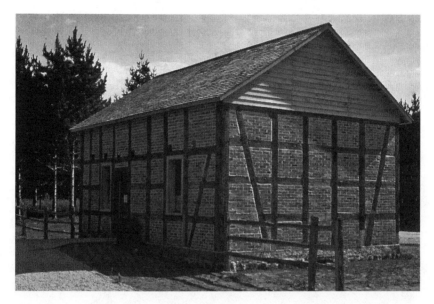

The relocated Lueskow/Mueller house represents another adaptive use of a salvaged building. This building served as the museum's entrance. (William H. Tishler)

Crews reerect the salvaged Turck/Schottler house in the German area using modern equipment. (William H. Tishler)

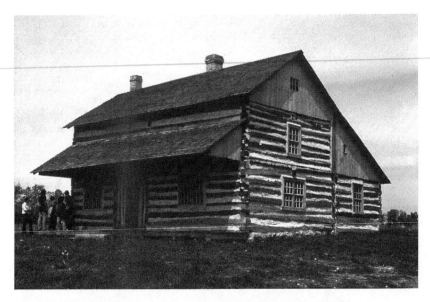

The Turck/Schottler house opened to visitors in 1977. (William H. Tishler)

An interpreter awaits the arrival of visitors to the Norwegian Frossebrekke house in 1977. It was the oldest building to be salvaged (1845). (William H. Tishler)

The completed Kvaale house and the partially completed Bosboen barn in 1977 were part of another Norwegian farm complex. (William H. Tishler)

Transporting visitors around the 576-acre site proved challenging. During the 1976–77 seasons, horse-drawn wagons proved both inadequate and expensive. (Arnold R. Alanen)

Toward an Insecure Future

Scientist Niels Bohr once observed, "Prediction is very difficult, especially about the future." No one claimed creating a museum would be easy. But then, no one foresaw the incredible struggles that the Society would encounter. By October 1975 the Society had confronted many of these challenges. Creating a site that met the standards imagined by the visionaries continued to present difficulties. Three interrelated problems emerged: Society leadership (or lack of it), fund-raising (or lack of it), and site development (or lack of it). Between October 1975 and the end of the second season two years later, many defining characteristics of OWW had emerged. This was a period of intense activity as staff raced to meet its opening deadline of June 30, 1976.[1]

This chapter considers the Society's successes, stumbles, and missteps as it struggled to open the site by its self-imposed deadline of July 4, 1976. In bringing the creation story to a close, this chapter continues the story of the acquisition and relocation of ethnic buildings that defined the museum. But an open-air museum can also be defined by failed efforts to acquire new buildings. In the case of OWW, five missed opportunities offer insights to the creation process. These included an African American complex, a nearly complete Norwegian farmstead, a *fachwerk* brewmaster's house, a railroad depot, and a Pomeranian dogtrot log house. This chapter also introduces a number of issues that took on

great urgency as the Grand Opening approached. These included planning for future exhibits, an enhanced research program, visitor amenities, the movement of visitors around the site, and the creation of an interpretive program.[2]

The rush to open for the bicentennial celebration brought heightened stress. Certainly the twenty-four months between October 31, 1975, and October 31, 1977, offered an abundance of highs and lows. Euphoria and despair vied for center stage. Much had been accomplished; much was left undone as the harried crews struggled to prepare for June 30. The winter that preceded the opening was the staff's "winter of our discontent." Wisconsin's winter and early spring thwarted efforts to bring the site to a state of readiness. Another winter of discontent followed for 1976–77. The multiplicity of problems encountered culminated with discussions to close the funds-starved museum for two years and regroup. At stake was the survival of OWW.[3]

Administering the site had been a problem from the beginning. Three issues intimately tied to the Society's status limited site development. The first was that the Society never achieved a balance between an ambitious array of desired programs and its resources. The second, closely related, was the chronic funding problem. To complicate that situation, between 1971 and 1977 the legislature frequently made cuts to the Society's modest appropriations. Fund-raising never closed the gap. The third was that the Society never had sufficient trained and experienced staff to fulfill its responsibilities. This was most obvious on the "popular" history side. Staff for a new project frequently had to be cobbled together from existing programs.

Rather than seek a site director with training and experience, the Society relied on its own staff. Jack Winn had gained valuable experience as a curator at Circus World but had no formal historic sites training. The Society assigned him to supervise and coordinate the museum project in mid-1971, and he served in this capacity until Smith reassigned him in early 1975. Rather than seek a professionally trained site director, Smith relieved Applegate of all his duties save fund-raising and made him the site administrator. Applegate, a retired Army colonel with an advanced degree in public relations, had no experience in historic site management. Both Winn and Applegate remained in Madison and only occasionally visited the site. If Winn exhibited a deliberative, academic leadership style, Applegate's reflected his military training. He gave orders and anticipated that site staff would follow them without hesitation. Neither went out of his way to consult with those on-site. Two

acquisition decisions demonstrated how fund-raising and publicity concerns affected construction. These decisions also showed the haphazard nature of acquisitions in the absence of a detailed inventory and site plan and, more important, raised the issue of historical accuracy for the reerections. Both acquisitions showed the pitfalls of planning based on expediency.[4]

The lure of financial assistance and significant publicity led Applegate to accept an urban church (St. Peter's) for a rural village. This forced planners to work around an anomaly when planning the village. The Catholic Church was a "gift" from the Knights of Columbus, who promised to raise $30,000 for its reerection. Knipping objected to the acquisition of a building that had little to distinguish it architecturally. The Milwaukee church had been moved a number of times and underwent numerous renovations since 1839. Much of the original fabric was missing including the back wall. Knipping estimated that reerection would cost $50,000. Applegate showed his displeasure at this negativism and told him he did not welcome carping and foot dragging after he had made a decision. St. Peter's Church arrived and had to be hastily sited. Its arrival presented an anomaly to planners, whose first building in the rural village was an urban church. Beyond this, it became the first building in the yet-to-be-planned nineteenth-century village, and it came without the requisite research. This presented a reerection nightmare for Alan Pape and led to a testy reprimand from Applegate for making construction decisions on his own. Too many questions had no ready answers. These included the back wall (much altered), the missing balcony, the false ceiling, stairs, windows, and trim. Pape could only make educated guesses as he proceeded with the reerection. Harbour, who had to deal with the urban church in the rural village when he arrived on-site, offered a perspective on this acquisition. After inspecting the already acquired Harmony Town Hall that was scheduled to be moved to OWW, he judged that the inadequate preparation for relocating the building "is reminiscent of St. Peter's and one is enough."[5]

A Danish house presented a different set of problems. After numerous trips to the Danish consulate in Chicago, Applegate arranged an invitation for the queen of Denmark to visit and dedicate a Danish farmstead (as yet undetermined). Locating and acquiring a suitable Danish house was the problem. Houses built by Danish immigrants did not replicate the housing they left behind. After a long search, Gary Payne found an available house built by a Danish immigrant. This left less than two months for dismantling, moving, and reerecting the

Pedersen house. The need to replace many ash logs complicated the restoration. The queen's dedication of the hastily reerected house garnered the much-desired publicity. But that publicity came with a cost: OWW now had a building whose historical integrity left much to be desired.[6]

From the beginning, the preservation project lacked an experienced outdoor museum management and planning staff. Budget cuts and lackluster fund-raising prevented the hiring of a professional site director until just before the opening. This appointment should have been made in 1972, not in 1976. On-site, Pape, who had no administrative experience, served as the de facto local administrator as well as construction supervisor. He and researcher Gary Payne frequently clashed over who was in charge on-site. The decision to hire Bjarne Breilid as the on-site administrator allowed Pape to concentrate on building acquisitions and construction. Winn and then Applegate still made the important decisions, which hampered Breilid's effectiveness. Increasing tension between Pape and his workers eventually led to another shift in responsibilities. With a new construction supervisor in the spring of 1976, Pape, now the restoration planner, devoted most of his time to preparing architectural reports on buildings already reerected and new possible acquisitions.[7]

Of the few candidates who applied, only John E. Harbour had the requisite qualifications to serve as director. He arrived in mid-May and had about six weeks to prepare for the opening. Harbour came with museum training and experience. From the seventh grade through his senior year in high school he lived "living history" at Colonial Williamsburg, where his father was a vice president. During his summers in college, he worked for the NPS in Jamestown, Yorktown, and St. Augustine. Harbour served in the army and then enrolled in museum studies at Cooperstown. After graduating, he spent the next eight years at Old Bethpage Village on Long Island, where he was site director. Leaving his pregnant wife behind to sell the house and pack, Harbour rushed to Eagle to familiarize himself with the site and prepare for the opening, now scheduled for June 30. Not surprisingly, given the challenges he faced, he recalled the first six weeks as "a great blur."[8]

The gap between what planners thought could be done and what construction crews could do was never quite closed. In January 1974 OWWC projected forty buildings on-site by the opening date. In addition to the farms, these included a visitor center complex and some village buildings. As the Koepsell restoration demonstrated, individual reerections took time, more time than allowed by the Madison staff. By

1975 the Society knew that it took an eight-man crew 246 working days (nearly a year) to dismantle and reerect a five-building farmstead. In addition to securing facsimile replacement pieces, having fewer workers than needed, and the constant struggle for funds, Winn complained of "the monumental obstructive delays occasioned by apparently necessary compliance with administrative rules (and, undoubtedly obligations) of the Bureau of Facilities Management." BFM enforcement of its rules led to a three-month delay in moving St. Peter's Church. The bureau imposed a 5 percent cost reduction for the visitor center, forcing OWW to seek reductions from its contractors. Everything, it seemed, had to be checked and approved by that agency before staff could move ahead.[9]

Even without an on-site director, planning had to move forward. Beyond acquisitions and reerections, other pressing matters loomed ever larger. One was organizational. In 1975 the Society had less than a year to develop three critical divisions. Research, always understaffed, needed to be more systematic, and it had to catch up and overtake acquisitions and construction. As the opening approached, staff had to build an artifact collection to furnish the reerected buildings. Finally, an interpretation program had to be built from scratch. This included developing a philosophy, objectives, and storylines based on research of the families and ethnic groups they represented, hiring and training a staff, and costuming them. Beyond the matter of organization, budget deficits left each division woefully understaffed. Another pressing matter was logistical. Moving visitors around the site, ticketing, parking, and numerous amenities such as water and restrooms had to be confronted. Added to this, a brush fire in fall 1975 threatened the site, necessitating sending every able-bodied man and "our antique, almost obsolete" fire equipment to fight it. As the end of 1975 approached, three workers quit in disgust and others considered leaving. Vandals struck twice. This made the hiring of a security force imperative and added new costs to the mix. If in September "everything has been so hectic lately," by the end of the year that seemed an understatement.[10]

New Year 1976 began with a series of ominous events. First came a rebuke from the governor. The Society had promised to raise $4 million in return for $1 million in state aid. Smith's inclusion of a substantial amount in the General Purpose Revenue (GPR) fund to cover startup costs for OWW in his budget request incurred Lucey's wrath. Despite his consistent advocacy for the museum, the honorary chair had become increasingly disenchanted with a fund-raising drive that had fallen well below expectations. He characterized the results to date as "quite

meager." Given the limited financial resources of the state, these items should have been financed by the fund drive. He advised the Society that the state could not possibly approve GPR funding for startup costs. He sent representatives to meet with Smith to ascertain the status of fund-raising and the Society's contingency plans. With the grand opening looming on the horizon, this was hardly a propitious beginning to the New Year. The Society could not afford to alienate its supporters, but its uninspiring fund-raising campaign had forfeited Society credibility with the governor, the Joint Finance Committee, and the legislature. Lucey's indignation highlighted the museum's most serious predicament: one budget crisis after another. Revising and cutting the budget became a way of life as the site struggled to establish a firm foundation.[11]

Other calamities followed on-site. Flu swept through the work force leading to many missed days in early January 1976. Weather-related incidents abounded. January was too cold and snowy to work outside on many days. This forced Pape to create make-work projects for the crews. A quick February thaw created a sea of mud that made much of the site largely inaccessible. March brought rains so heavy that the crews had to be sent home. Only in April did the weather relent and allow the crews to work full-time. Other actions impeded progress. A break-in at the construction shed exacerbated the perennial problem of not having proper equipment for the restoration. Thieves stole valuable tools and a generator. The rush to have a presentable site by May led to tensions between the workers and staff. The inability of the Society to provide promised raises to the crews in a timely fashion further deflated morale. Some workers thought the future looked so bleak that they considered quitting. In January three disgruntled workers who had quit in November returned in a hostile mood to confront their former supervisors. They came into the main office "drunk, loud, foul-mouthed, [and] spouting obscenities." They lambasted everyone in general and Pape in particular as they belittled the work underway and its lack of authenticity. Only Breilid's calm demeanor kept the situation from getting out of hand.[12]

Harbour frequently invoked "Murphy's Law" in his early reports. OWW's mantra seemed to be: if anything can go wrong, it will. The paradox for on-site staff was that no matter how much was accomplished during the first six months of 1976, it could never be enough. If time was the enemy of the fund-raisers, so, too, did it limit construction achievements. Between January and June, crews dismantled buildings (houses, barns, smokehouses) for transportation to Eagle. They laid at least eight foundations and erected a horse stable and three houses while continuing

to work on previously started projects that included putting in rest stops and pit toilets, erecting fences, and plowing and planting fields. Many of these tasks required clearing stands of red pines. The hurried reerection of the Danish house only added to the confusion.[13]

Harbour implemented many new procedures that necessitated a scramble to adjust to a new style of leadership. He set about to learn as much as he could about the site's history. For example, he dispatched one staff member to Madison to analyze fund-raising and expenditures. Winn set out to compile a compendium of documents to inform Harbour of the site's history, but that project fell by the wayside as other matters took precedence. As Harbour struggled to know the site and its history, he knew he had less than six weeks to ready the site. The best news was that the Society found funds to bring the construction staff to twenty-six. Still, the new men generally lacked restoration experience, and precious time had to be committed to training them. As in the past, newly assigned workers had to perform tasks that required more skills than they possessed. Overtime stretched the already thin budget as the crews worked fifteen hours a day on a seven-day-a-week pace.[14]

Other forces seemed to conspire against having the site ready. With two weeks to go, crews had to halt construction to prepare the site for visitors. Residue from the felled red pines—branches and other debris—littered the site and had to be cleared. Crews had to set up a stage and chairs for the anticipated crowd of 5,000 visitors. The contracted well driller took off for weeks at a time, leaving the site without a ready source of fresh water. The steamfitters working at the visitor center went on strike, rendering the Barrie barn unavailable for the opening. Soon after, the painters at St. Peter's church stopped working. A contractor who had been hired to create an introductory slide presentation delivered one that badly needed additional editing. Without the visitor center, Harbour decided to show it in the basement of the church. Lacking electricity, the crew set up a generator behind the building. The loud generator and the need to revise the show quickly ended that effort. The horses and wagons needed to transport visitors did not arrive on-site until the early morning of June 30.[15]

Ready or not the grand opening happened on the scheduled day. The anticipated crowd of visitors swelled to an estimated 8,000 to 12,000. Visitors literally overran the site. The visiting public was another constituency that the Society could not alienate. Six months before the opening, Smith stated that it was essential to "make a creditable showing at the site during its first year of operation." Did OWW make a credible

showing when it opened for its first season? The hectic opening both exceeded and fell far short of the "credible showing" mark.[16]

Opening day started on a modern note—with "a monumental traffic jam." Parking was only the first of many seemingly insurmountable problems. Eagle had the biggest traffic jam in its history. For many Town of Eagle residents it was a "worse fears realized moment," as excited visitors parked on the highway back to the village. The lack of amenities to say nothing of the dearth of historic buildings open to the public created frustration and anger. One important visitor that day offered a scathing critique. Former president of the Board of Curators Judge Thomas Barland apologetically began his letter with a critical and negative assessment of the first day. He conceded that the public was not aware of the enormous expenditure of energy and money that the Society had committed to the museum. He offered his comments from the perspective of prospective donors and interested visitors. June 30 was sunny, hot, and muggy. The overly long program, with many speeches that ran on and on, left some "ready to faint from heat stroke." Those around Barland grumbled and were angry. Reading a "long list of donors and legislators was the last straw for many." In short, the program became an ordeal. The audience sat on chairs that faced uphill and forced them to stare into an intense sun. By the time the Norwegian dancers and singers took the stage many had given up and departed. Those who remained could see the stage only by standing or rushing to get closer. Barland criticized the Society's lack of organization for a program that did not anticipate visitor needs. His site tour did nothing to alleviate his seething irritation. The few exhibits open were far from ready. Advance publicity led people to expect more. The four widely separated exhibit areas—German, Yankee, Norwegian, and Finnish— with only a few scattered buildings meant walking great distances on dusty roads. The absence of toilets at the few open sites and the absence of signage to help navigate the confusing network of roads left him fuming. He concluded that "customer amenities are so undeveloped at the present time that many people left Old World Wisconsin feeling let down." It was clear to Barland that the Society was not bringing in money fast enough to make the necessary and critical improvements that would allow the site to reach a level of interest, convenience, and safety expected of our state.[17]

Without quite saying so, Barland raised the ultimate question: had the Society opened its museum prematurely? His description raised another issue: had too many compromises been made in the rush to open?

Smith knew the site was not ready to open and agonized over the decision to open on schedule. His reluctance may have resulted from a sense that OWW's past was catching up with it. Since 1972, and against all odds, staff had diligently labored to meet the bicentennial deadline. Inadequate funding and a staff burdened with too many responsibilities made fulfilling the vision problematic. For too long, staff tried to create a museum on a shoestring (Smith's word). In 1975 Winn projected it would take fifteen years to acquire, move, and site the requisite buildings. Only then would the project reach "a mellowness of operation." Opening day fell far short of a state of mellowness.[18]

A number of factors made it impossible not to open. There was the long-standing and much-publicized promise made to the WARBC. Promises also had been made to state officials and to donors. Public awareness heightened as opening day neared. Most important, staff had worked too hard for this moment. After practically around-the-clock effort, one researcher recalled the "general feeling of elation" that it all came together on opening day. Then, too, Smith wanted to open the museum on his watch. Only three weeks later on July 23, he announced that he was leaving the Society as of October. Finally, Smith realized that the opening could not be postponed indefinitely.[19]

The limitations the Society faced were compounded and became obvious on June 30. The lack of a blueprint meant that acquisition, siting, and reerection proceeded without staff understanding of the overall plan. The meager fund-raising effort left OWW cash starved. Acquiring proper equipment and a sufficient number of construction workers always fell short. The research effort—the unit was not created until 1975—fell far behind the acquisition and reerection effort. The plan to build on more than 500 acres of rugged forestland, which maximized the effort to relocate buildings in similar environs to their original sites, created a transportation nightmare. Planning for interpretation of the buildings and their occupants—it too began in 1975—was barely in place by opening day. Needed visitor amenities fell victim to a variety of delays and left the site without water, adequate toilet facilities, a visitor center, or a place to show the orientation presentation. Small wonder that Smith had reservations about exposing the site to visitors on June 30.

Applegate planned and arranged the day "almost single-handedly." He felt badly about how the events played out on June 30. He had antici-pated most of the problems but lacked the resources to handle them. The expansive site and the hot weather were beyond his control but the program was not, and it was too long. Acknowledgment of donors was

necessary, but was a reading of their names the best way to do that? Applegate's planning did not consider crowds that were more than double the estimate. More important, his role demonstrated that the Society did not have adequate personnel resources in Madison and Eagle. The Society never had a staff adequate to carry out the many tasks it chose to undertake. Perhaps it is not surprising that the opening did not go well. Applegate was strung out with his duties as site administrator, fund-raising, and with publicity that included many speaking engagements. He epitomized the Society's generally impoverished condition. Too few staff had too many responsibilities. The Society would have needed three more effective Applegates to have had a chance to succeed.

Even though Smith witnessed the day, he told Barland that until he received his letter he was "unaware of the poor impression we made on the public." While the Society received some congratulatory letters and generally favorable press coverage, the public had every right to be irate. In the spirit of the approaching bicentennial, one reporter invoked Patriot Thomas Paine to remind readers of the need to persevere, and that better days were ahead. Things did go wrong. Contrary to all plans, fourteen buses converged at the Norwegian area at the same time, producing a monumental traffic jam and clouds of dust. A second group of buses emerged from the German area into the Yankee and saw two pickup trucks loaded with portable toilets charging into the reception area. Dust, delays, crowds, and insufficient facilities had not made a good impression. A headline the next day captured the scene: opening day had failed by succeeding too much. That day also showed the larger problem. OWW was more than the Society could handle. Implementation of the museum was neither carefully thought out nor skillfully executed.[20]

Once more, inadequate funding hurt. Smith admitted that the Society did not have cash on hand to bring OWW to the desired "minimally acceptable professional standard." Most of the money raised came in the form of pledges, many redeemable over a three- to five-year period. The director recognized that the Society had to make a massive effort to recruit money. It was an oversimplification, but it was undoubtedly true that the Society had few problems that money would not have solved. Getting that money required a herculean effort not only from the staff but from the leadership as well. The curators, although fully committed to the concept, fell short on the financial aspects. Beyond this, as late as mid-July, area campaign chairs were still being recruited.

With the campaign underway, and finally generating revenue, Smith's soon-to-be-announced departure did not help.[21]

Smith's goal of having a credible first season was on shaky ground. Harbour emphasized that public comment had been overwhelmingly complimentary of the staff. Still, many irate letters from visitors indicated considerable dissatisfaction with the site. One in particular opined that the Society "should be ashamed of itself" for the farce it perpetrated on the public. Many in his party were from out of state and were deeply disappointed. Somewhat disingenuously, Applegate lamely replied that preopening publicity and warnings at the gate advised patrons that the museum was not complete. Another visitor who drove over one hundred miles complained of the lack of water and the few toilets. Others complained about the irregular schedules for the horse and wagons and the few open buildings (five plus six outbuildings). Another observed that the site had opened too soon, and others demanded a refund of admission costs. Most telling were the comments from OWWC member Victor Greene, a professor of history at the University of Wisconsin–Milwaukee, who visited at the end of August. He started with his compliments: the quality of the reconstruction (superb), entrance area (appealing), and the restaurant (pleasant). Then came his significant and basic criticism. OWW was not sufficiently oriented to the public, which seemed "*to be more tolerated than welcomed*" (emphasis in original). His complaints included having to wait forty-five minutes to see the orientation film, problems navigating the site, a generally weak interpretation program (too brief, too academic, dry, and "really lifeless"), and a gift store that was poorly stocked and with most products inaccessible. To its great credit, OWW staff constantly monitored the situation and took steps to remedy the glaring deficiencies. Still, the question lingered: had the museum been ready for the public on June 30?[22]

Despite his spirited public defense, the site director harbored his own doubts about the advisability of opening on June 30. He called June "an exciting month," one that will not soon be forgotten. The future, he opined, "holds great promise for this museum, but it will not be gained cheaply. We have moved too far, too fast. In this business speed is no virtue." Harbour told the OWWC in September 1976 that the museum had opened too early. He compared OWW with his previous employer. Old Bethpage Village had eight years of construction, which was too short, before opening to the public. He used the word "incredible" to describe the much shorter construction phase for OWW. His superiors did not welcome Harbour's hints that the June 30 date was too early to

open. Years later, he still thought that the Society made a mistake by opening the museum in such an unfinished state.[23]

Harbour had good reason for his concern. One budget crisis after another welcomed him to the site. As the opening approached, Harbour reported that the costume budget was woefully small, a description that fitted all categories of the operations budget. The curatorial Executive Committee realized the risk and expressed its concern about the projected cash shortage for operations. It offered no solutions. Harbour's most used words, as reports on cash flow spiraled down, were "hope" and "reduction." After opening, daily attendance fell below the projected 453 visitors daily average. This, in turn, forced staff to make additional budget revisions (reductions). In August the numbers continued to decline. Simply put, OWW was not taking in as much as it was spending. Much was in doubt. Could the pace of construction meet development plans outlined by the board and staff? Would the state support construction in the next budget? How long would fund-raising sustain construction and operating costs? What of the increasing deficits? How could visitation be increased dramatically? Were additional staff reductions needed? Should the museum close, regroup, and reopen when it was better prepared?[24]

The creation story for OWW has been one major crisis after another. One final crisis must be considered: the closing crisis. Shutting down was hardly fanciful. January 1977 followed the pattern established the previous year. It started roughly. A report from the audit bureau gave the Society low marks for having "grossly underestimated" the cost of constructing and operating the museum. The audit estimated it would now take the Society ten to twelve years to complete the museum with a total cost of $8 million. An editorial in a local newspaper asserted the legislature must consider whether the museum is worth the price.[25]

The governor slashed the OWW biennium budget request from $538,300 to $239,800. Staff confronted three alternatives: close the museum to the public and catch up on research and construction, open with a drastically reduced staff and construction schedule, or reduce the days open from seven to six or five and raise admission fees. Acting director Erney rejected closing temporarily, fearing its impact on the fund drive and positing that OWW might never reopen. Erney even went so far as to return to the governor after he slashed the Society's budget to request money for OWW alone. Having committed to no new taxes, the governor rejected the plea and told Erney to make his case to the Joint Finance Committee. Erney contacted every member of

the legislative committee and succeeded in getting a small portion of the budget request restored. The restoration came grudgingly. Smith's promise not to seek additional state funding haunted the hearing and led members to question the state's commitment to the project. Harbour, who had described OWW's budget situation as "very grim," soon considered that an understatement. He characterized the situation as: "We can't open and we dare not close." The staff was now paying the price for years of inadequate planning. Harbour characterized OWW as "the most visible blunder made by Dr. Smith." Faced with budget cuts, staff reductions, and a fund drive that was merely adequate, season two would open on an ominous note. On the eve of its second season opening, Perrin provided a grim assessment: "I dislike saying it, but it seems to me quite obvious that Old World Wisconsin is floundering."[26]

The audit raised the issue of state support. Skansen in Sweden served as a model for both Perrin and Sivesind. Unlike their European counterparts, the governments of the United States and the individual states believed that museums and other cultural and heritage institutions had to support their own operations. This meant that they had to rely on private funding and site-generated revenues to keep the gates open. A Madison newspaper editorial lamented that the Society, which it described as "a gem, a national treasure," has to "live a hand-to-mouth existence, at the mercy of a legislature that pays only lip service to our rich and vital heritage." Dependency on the state subjected the Society's budget to the ebbs and flows of state politics and the state's declining economy. The question was: what percentage of the construction and operating costs should be state funded? OWW had always been seen as a private-public operation. While the numbers shifted, the goal as of 1976 (depending on the final figures) was a private to public ratio of four to one or five to one. Public dollars came from the federal government and the state. As of March, the federal government had contributed just over $200,000. The state had furnished just over $1.6 million. By March, private contributions and pledges began to show significant yields. A list of Leadership Gifts between $50,000 and $250,000 included fifty-eight corporations and individuals who had indicated a willingness to give or who had pledged to give over a three- to five-year period. The Society reported gifts of $1.4 million. This figure was well short of the needed $5 million and left OWW severely underfunded. This pace of fundraising made the Society more dependent on state monies. At a time of severe budget constraints, the Society sought to have the state cover 45 percent of the operating costs and 50 percent of construction costs. By

October, state budget analysts conceded that the state would have to pay for a greater part of the costs for OWW. By the end of the year, Erney admitted to a budget analyst that raising $4 million from the private sector was increasingly problematic. The time had come for the museum to wean itself from its dependency on private funds for operating expenses.[27]

The continuing and deepening budget crisis notwithstanding, the staff continued to make progress with site development. Similar to the previous winter, dreadful cold temperatures and staff shortages impeded progress as the second season opening on May 1 approached. The site had twenty-seven historic buildings but only seventeen, including the just completed Koepsell house, were ready for the public. That number was still well short of the 1974 goal to have forty buildings for the 1976 opening.[28]

Reerected buildings tell an important part of the OWW creation story. This story also encompasses buildings that did not come to grace the site. Together, buildings acquired and structures pursued but not secured reflected two important elements: the scope of the original master plan and the unsystematic and untidy nature of the acquisition process. Tishler worked without a reasonably accurate list of historic buildings available in 1967, and a decade later Harbour decried the Society's inability to provide inventory and availability data for planning purposes. Lack of an acquisitions plan based on accurate data regarding available buildings led to false starts that consumed staff time and energy.[29]

Some of the early acquisitions reflect the haphazard nature of the process. An anomaly occurred with the 1973 acquisition of the Rankinen house acquired by the Society. Pape's architectural review in 1976 revealed that the building was not a typical Finnish log building. Instead of closely fitted logs in this house, the original builder left gaps that had to be filled with chinking.[30]

The staff identified five buildings or sets of buildings that, if acquired, would bring needed additions to the site. In spite of considerable time and effort, the African American exhibit, an intact Norwegian farmstead, a brewmaster's house, a railroad depot, and a dogtrot Pomeranian log house did not become part of OWW. Each building or set of buildings represented an important facet of the immigrant/migrant experience or an important adaptive use. Taken together, these potential sites exposed a number of problems. These included funding deficiencies, the rush to open, the never-completed inventory of available buildings,

and, above all, the hobbled research effort that lagged far behind acqui-
sitions. They also illustrated the pressures under which the Society
functioned.

The black exhibit, after a series of false starts, had to be abandoned
and was not resurrected until 1993. The desire for an African American
exhibit reflected the strong multicultural forces of the late 1960s and
1970s. OWWC chair Roger Axtell first broached the issue of the lack of
a black exhibit at OWW. A black Kenosha plumber, he argued, should
be able to take his children to see a representation of the African
American past. He specifically referred to "a farm that was used to house
freed slaves." Such a building, if still standing, would offer the opportu-
nity to demonstrate that blacks, along with the Scots, Welsh, and Irish,
contributed to the development of Wisconsin. He suggested Perrin
should be asked to put such a building in his inventory. The architect
had consistently argued against representing every ethnic or national
group found in Wisconsin and was not terribly sympathetic. Staff
could not identify suitable buildings and let the matter drift. When the
WARBC weighed in on the matter in 1973, the Society paid attention. In
considering granting money to OWW, the WARBC took the Society
to task for not including minorities for the museum. That committee
made its money contingent on action. As a result, the Society hired a
researcher, Zachary Cooper, to research and write a short book on the
black experience in Wisconsin. In addition, he was to identify and secure
suitable buildings.[31]

Cooper, who eventually earned a Ph.D., was an academic historian
who had limited knowledge of historic buildings. He had the task of
finding the elusive black buildings. On the basis of his identification,
the Society acquired three buildings — a cemetery chapel, a smokehouse,
and a school — laid their foundations, and brought two of them to Eagle
as a first step toward reerection. Closer investigations revealed that the
buildings did not fit the museum's chronological profile. Calling it the
biggest disappointment to date, Harbour ordered all work on the African
American exhibit stopped. This false start pointed to the need of having
adequate research completed before purchasing and bringing buildings
to the site. More important, it highlighted that a group's representation
depended on finding suitable available architectural examples.[32]

Finding Norwegian historic buildings was not a problem. Readily
available German and Norwegian specimens seemed to dominate the
acquisitions. The Norwegian Breen farm buildings, constructed between
1875 and 1900, had been not been used since 1950. While deterioration

was evident, nine buildings were salvageable. This was perhaps the most remarkable nineteenth-century intact farm unit in Wisconsin. During a spell of subzero temperatures in the winter of 1975–76, a crew measured the buildings as a necessary first step for moving them. The Breen complex offered OWW a unique opportunity to acquire a complete farmstead (as opposed to the composite farmsteads under consideration) and site it with many of its original landscape features. After acquiring the nine buildings, crews dismantled and brought three of them to OWW but reerected only one. The 1977 estimated cost to complete the reerection was $180,000, an exorbitant sum when so many other ethnic groups remained unrepresented and so many other projects needed funds for completion. Eventually, the Society abandoned the project.[33]

The rejected Breen buildings reflected an "ethnic" tension that informed the decision process. Tishler's 1968 plan included nearly every ethnic group that came to Wisconsin. Implementation, because of costs and building availability, fell far short of inclusivity. Some groups both lobbied and rallied support for their ethnic group. One legislator brought sixty-five members of the Polish American community to the site to enlist their support and demonstrate their interest. Availability and financial considerations disappointed Polish American aspirations for a complex that OWW had scheduled for completion during the next biennium. Alan Pape recalled a visit of the new governor Lee Dreyfus (1979–83) to the site. When shown the space reserved for the Breen farm, he pointedly noted the absence of any Polish immigrant representation. Having representation at OWW attracted interest from many groups. A state official, as he concluded a meeting with Society director Erney, mentioned his Swedish and Irish heritage and expressed his hope to see both represented at the museum. The leaner and meaner museum projected by the end of 1977 neither aspired to represent every major immigrant/migrant group in Wisconsin nor to save every available historic building. In effect, this revision reflected Erney's prescience on at least one of the issues he raised in his October 6, 1969, memo to OWWC.[34]

Three other missed opportunities that reflected emerging problems merit brief mention. Staff targeted the brewmaster's house in Fillmore as a worthy addition to the visitor center–administration complex. The size of this building would have provided the space necessary to gather administrative offices in a central location. Siting it on the green near the Ramsay barn would provide a convenient location for site administration and storage. After measuring and photographing the building in preparation for relocation, the acquisition fell through. By the end of

1977, as a cost-saving move, staff decided to move administrative offices to a remote but on-site early twentieth-century farmhouse. These moves, perhaps as much as any others, reflected the unraveling of the original vision. The story for this brewmaster's house ended well. Local residents in Fillmore intervened to restore the house on its original location.[35]

Another near miss was the Kansasville depot, which would have filled in an important part of the original master plan. The Society acquired the 1883 depot as a donation in 1976 but could not afford to move it to the site immediately. Preservation of this building hinged on the definition given to the Crossroads Village. In the face of the continuing budget crisis, staff recognized that reduction in the size and scope of the village would cut projected costs dramatically, although a smaller village would have no place for the depot. As originally conceived, the village was deemed too ambitious, and the Kansasville depot fell victim to the need to bring ends in line with means. If the depot highlighted the pressing need to cut planning costs, the final missed opportunity highlighted the most pressing problem that resulted from the Eagle site: moving the public around the site. The 500-plus acre site, with its kettles, hills, and woods, provided ideal settings for the reerected buildings. The scattered farmsteads meant OWW could not be just a "walking" museum. The new director of interpretation thought bicycles might be an alternative. He eventually signed a contract to have bicycles available on a rental basis. Pape acquired the already dismantled Pomeranian dogtrot log house and had it delivered to OWW. The Gruel house, serving as a bike rental shop, would be another adaptive restoration for the visitor center complex. Even though the foundation was in place, one of Harbour's first acts was to cancel the contract with the bicycle supplier. Soon after, Harbour issued exacting procedures for the acquisition of historic buildings. He intended to do the research first to avoid needless expenditures of time and energy in fruitless pursuits.[36]

Harbour's dictum that "speed is no virtue" in the museum business was nowhere more true than in research. Staff needed field research to find ethnic buildings that might be available. Research included measuring and photographing each building to document relationships between farm buildings. Equally important, it had to document the families and communities associated with the buildings. More problematic was the need to produce general knowledge on each ethnic group that was to be represented. Of all his concerns—getting a handle on the budget, bringing order to the site, and preparing for the

opening—nothing bothered Harbour more than the incomplete state of research. After a month on site, Harbour realized that there were "a lot of holes in our data." Knipping laid out the challenge Harbour faced. Again, the research department had to initiate a "crash program" to compensate for a four-year lag in gathering the requisite data. For example, some buildings had been reerected on a "somewhat conjectural" basis; others had to be renamed or their appearance had to be altered to reflect new research.[37]

Research was the museum's badge of credibility. Without it, construction was "only guesswork." Research is not a highly visible commodity; it is expensive and its importance can be easily overlooked. It informed the reerections, but equally important, it enabled staff to defend and justify the decisions it made. A reorganization of the research effort in mid-1975 marked a significant step for OWW.[38]

A grant from WARBC had allowed Applegate to officially organize the research program. Prior to this, the construction crews did most of the research on a need-to-know basis. For the most part, researchers Knipping, Payne, or Pape and his crews diligently carried out these assignments, but the effort was far from systematic. Lacking a "coherent, methodical, on-going program" meant planning was haphazard. The inclusive nature of the museum and the need to research thoroughly each of the forty-plus immigrant groups and the buildings they erected put enormous pressure on the small research staff. Applegate charged Knipping and his two researchers, based in Madison, to research and write small monographs on specific immigrant groups (African Americans, Finns, Germans, and Norwegians). These booklets, however valuable, did little to alleviate the lack of research on the buildings at OWW.[39]

Research reflected the perennial problem of not having sufficient staff in either Madison or Eagle. Applegate pulled two members from the construction crew to do research. While the other researchers concentrated on the booklets, Marty Perkins was the only person able to do the necessary historical and biographical research on buildings owned or on-site. In addition, Knipping and Perkins did the field research on buildings under consideration in order to recommend acceptance or rejection. The sorry state of the research component was not from a lack of effort but a lack of staff as well as "crisis" assignments. Knipping and Perkins had to divide their time as new assignments demanded attention. An example of "crisis" research came when the Society had the opportunity to acquire the Harmony Town Hall in July 1975. Knipping had

three days to investigate and compile a report on Wisconsin town halls. He randomly selected thirty-nine town halls. The findings indicated that the Town Hall should be featured as part of the Yankee area. In addition to researching and revising the village plan, Knipping spent considerable time in the field seeking Norwegian and German outbuildings for the site. To compile data on groups intended for inclusion, the research department co-opted other staff. Breilid, a Norwegian by birth, researched the Norwegians. Knipping assigned the Yankee migrants to Perkins, who spent about six months gathering the data and writing his report. At the same time, along with Pape, he spent time in the field seeking German half-timber buildings. Budget constraints eventually severely limited the Yankee presence. Research, similar to house hunting, had its own blind alleys. More important, research struggled throughout 1976 to catch up with development. Buildings were on-site and the staff "knew practically nothing" about them. Equally important, staff knew very little about the families. In addition, gathering this data for reerections and interpretation and the search for new acquisitions occupied the small research staff between October 1975 and October 1977.[40]

On the opening day of the second season, May 1, 1977, the Koepsell house was ready for the public. A long journey had been completed. Staff had rushed to prepare the house for its visitors. Last-minute activities included retrieving eight doors from the Butt farm, hanging them, caulking, painting, adding trim, enclosing the stairs, and continuing research. Finding a house with all its furnishings was a "very rare prize," and staff had to scramble to furnish the empty Koepsell house. The nascent collections department had to locate and acquire period-piece furniture for the first-floor rooms. This was expensive and time consuming. This quest for representative artifacts also carried on through the season. Some "nice artifacts" came on permanent loan from another museum. Research on the Koepsell house and family also continued throughout 1976 and 1977. Not all questions were lofty: only research could answer whether the closets in the 1969 relocated Koepsell house were original. Research also informed the construction of the Pomeranian farmstead courtyard (*Vierkanthof*), which would be completed in the next years. An insurance policy for the Koepsell farm provided critical data on the outbuildings. The process of gathering historical data did not include an archaeological investigation of the Koepsell site (or any of the other acquisitions).[41]

What of the preservation and restoration effort? The Koepsell house again reflects and represents the site. The ever-critical Perrin examined the house in June 1975 and expressed his satisfaction with the quality of the work. Later that year, site supervisor Breilid examined the just completed brickwork and exclaimed, "It looks quite impressive." A few months before the grand opening, Henry Reuss visited OWW and toured the Koepsell house. He told Winn that the house impressed him. As part of the opening ceremonies, a visiting German delegation presented an award to Hans Kuether at the Koepsell house, which had been opened for them. Harbour reported that the house impressed them. Impressive? Yes, the Koepsell house was impressive. Amazing or incredible might equally apply. This had been a team effort from a team that did not always function smoothly under pressure. Some outside contractors proved undependable and held up the electrical work. This delayed concealment of all electric outlets that would have been otherwise visible to visitors. Other contractors produced the needed replacement windows and interior and exterior trim. The house had been twice vandalized. Crews had to divide their time between a number of re-erections taking place simultaneously as they hurriedly raced to be ready for another opening. That the new Koepsell house was ready for visitors on May 1, 1977, was a remarkable achievement.[42]

Saving the Koepsell house had not been a given. Its sadly deteriorated condition, the delay in acquiring it, its storage on-site, the lack of financial resources, the search for suitable replacement materials, and inexperienced restoration crews, among other things, rendered the process problematic. If Reuss had been successful, the house would have had an adaptive use as a youth hostel. Had Smith yielded to Reuss's compact plan, Koepsell would have been one of many houses that circled a parking lot. Ever persistent, Knipping and Pape imagined it as the centerpiece of a Pomeranian farmstead, and they carried the day. Three barns would eventually join the house to serve as the staff's vision of a courtyard that would have complemented a German farmhouse. With a garden and an outhouse adjacent to it, the Koepsell farmstead became one of three farms that represented the German immigrant experience in Wisconsin. This exhibit, along with the others in various stages of restoration, represented the work of many individuals, from Perrin to SHSW staff such as Fishel, Smith, Winn, and Applegate, curators such as FitzGerald and Axtell, outsiders such as Tishler and his students, on-site staff such as restorationist Pape and researchers Knipping and

Perkins, the largely anonymous crews who made the oak pegs and pounded the nails, and the donors who did contribute.

If Mr. Koepsell could have visited OWW in 1980, he would have recognized the house that bears his name. He would not have recognized the surrounding buildings, but they might have reminded him of similar settings he had seen in the old country. As a skilled carpenter, he would have quickly discerned that this was not the house he had built. Whether this "transplant" was a restoration or a reconstruction matters not: it is not the house Friedrich Koepsell built. Only about half of the original house had been salvaged. This house was the staff's representation of a bygone era. The house and its surrounding buildings are best understood as an interpretation—an explanation—of past events. The new Koepsell house and all the other new/old buildings at OWW became stages where costumed interpreters told stories about the family and other immigrant families. In no way does this sully or denigrate the staff's remarkable achievement. Koepsell became a piece of a bigger story, the story that tells of the diverse immigrants who ventured to Wisconsin. They changed the landscape and, in turn, transformed themselves into Americans in the raw, new world of Wisconsin that they now called home. These are stories worth hearing and make visiting OWW attractive. The new Koepsell house also represents a remarkable transition that occurred during the first two seasons. The preservation objective gave way to using the restored buildings as backdrops for telling stories about the immigrants. It and other OWW buildings represented the adaptive preservation of old buildings that visionaries had not necessarily envisioned.

After its first two seasons, it was clear that OWW had at once fulfilled the aspirations of its visionaries and had fallen far short of their original goals. But what of the visitors who came during the summer and autumn of 1977? What would they experience from the visit?

The site they would visit continued to feel the effects of its premature opening a year before. OWW remained understaffed and underfunded. Still, during the past six years, the Society had acquired sixty-two buildings. Not all had been moved to Eagle and many would never be reerected. Construction crews had reerected twenty-four of them. Of these, seventeen were open to the public on May 1. On arriving at OWW, visitors found the recently opened parking lot nestled among the red pines. Inside there was a road system of more than three miles. Staff recently completed an elaborate web of nature trails that allowed

visitors to take short cuts between the widely scattered ethnic clusters shaded by the dense forest.[43]

A "moderately successful" survey conducted by staff over the July 4 holiday period ascertained that nearly three-fourths of the visitors came from Wisconsin. The majority (91 percent) learned about OWW from newspaper stories and recommendations from friends. Newspaper stories, radio and television reports, and the untold number of slide presentations by staff wetted visitors' appetites to see Wisconsin's rural past. What impressions might these visitors have formed from their first encounter? Visitors entered the site through the small *fachwerk* Mueller (now Lueskow) house that faced the parking lot. What they saw might have been less than favorable. The rush to open and the pressure to re-erect new (old) buildings left the site in less than pristine condition. Weeds and clutter, construction debris, and garbage barrels with exposed black plastic bags irritated the director. On August 3 Harbour listed seventy items relating to the site's appearance that staff were to address. He especially wanted staff to pay particular attention to the Lueskow house (the ticket office). Without gutters, cascading water had eroded the soil. The front looked "quite unsightly with the depressions caused by the falling water." Weeds growing on either side of the front door gave an unkempt look. Indeed, the front of the ticket office looked like "a total disaster." He saw the view as a very poor statement for museum visitors.[44]

Once visitors purchased tickets, they moved to a large green. If they looked right after moving to the green, they would have seen the early stages of construction at the Clausing barn. Most would turn left and walk to the recently dedicated Ramsay barn (May 1977). Some visitors would have tarried to view the revised orientation film. Upon leaving the barn, visitors had the choice of walking the site or purchasing a ride in a horse-drawn wagon. Whether by foot or by wagon, visitors quickly would have become aware that traversing the site would not be easy, especially on hot and humid sunny days. The wagons were ponderously slow and frequently fell behind schedule. Walkers would also have learned of the many steep hills that led to sites such as the Koepsell farm complex. Following the internal paths from Ramsay to the German cluster and then on to the Norwegian area was a mile-and-a-half trek. Whether walking or riding, visitors could enjoy the scenic beauty of a site steeped in Wisconsin's natural history. Many of those who visited, however, might have agreed with Mr. Perrin, who, after two visits in

1977, characterized OWW as "a rather far flung empire with widely scattered development." Much of the site remained undeveloped, and some visitors even complained about the vast empty spaces between farmsteads.[45]

Visitors coming in late July were able to visit the most recent re-erection, the Rankinen house (Finnish). This was the third building (Koepsell and Harmony Hall had preceded it) opened during the 1977 season. Staff anticipated completion of four barns by the end of the season. One, the Clausing barn, had its concrete foundation poured and visitors might have watched crews adding the exterior stonework. Visitors might have glimpsed crews scrambling to finish construction of the Rankinen horse stable and laying the foundations for the Schulz house (German) and its two companion barns (Grube and Koepsel). They might even have questioned workers regarding the reerection process. In the slow-developing Crossroads Village, visitors saw only St. Peter's church. A *Milwaukee Journal* reporter, Bill Hibbard, noted the church's Milwaukee origins but suggested that, with its clapboard outside and its plain and simple interior, the church "could have been built in a rural community." St. Peter's Church stood a lonely vigil, a promise of what the village might become.[46]

Those who navigated the site saw representative ethnic buildings scattered some distance from one another. These included the Koepsell house (German), the Fossebrekke house (Norwegian), the Ketola house (Finnish), the Pederson house (Danish), and Harmony Hall (Yankee). At each of the stops, costumed interpreters greeted them, told stories about the houses and families who had inhabited them, and demon-strated some of the daily activities that members of a nineteenth-century household might have performed. Most likely, the interpreters would have called attention to the fine collection of period furnishings that enhanced the "yesteryear" appearance of the house. On any given day, visitors might have encountered the "delicious aromas of turnip soup and rutabaga stew," as interpreters demonstrated nineteenth-century meal-preparation techniques. At some locations such as the Koepsell house, visitors would have seen orchards and gardens. Not only did visitors see the remnants of rural life, but they were also able to feel, smell, and hear them. It was, in the words of Bill Applegate, "a living experience" for visitors.[47]

Visitors that summer found few amenities. The Orientation Map they received provided only barebones information. There was a small, understocked gift shop in the yet-to-be-finished Visitor Center in the

Ramsay Barn. Interested visitors would have found items directly related to the site and could purchase one of the booklets on Finns, Norwegians, blacks, or Germans that the research staff had written. Landscaping around the Ramsay Barn had yet to be completed. Some pit toilets had been added to the site, but this was, at best, a stopgap measure. The only modern facility was in the Ramsay barn, some distance from the far-flung Norwegian or Finnish clusters. The only food available to visitors was at the refreshment stand at the Norwegian rest stop.[48]

Even the most discerning newspaper readers would have been oblivious to the challenges the staff faced to keep the museum open. They could not know of the incredible amount of time devoted over the past year to organization, planning, and budget juggling. Nor could they know of the herculean effort made by the research staff to provide the interpreters with substantive data on the ethnic families, or the statewide effort by the collections staff to furnish the buildings, or the one-man effort to update the architectural data on the reerected buildings.[49]

Visitor satisfaction would have depended on their perceptions, on their interactions with interpreters on site, and their relative comfort level. Measuring that satisfaction cannot be ascertained with any certainty. In late June, Joan Nemitz led a group of people from Madison who ranged from ages eleven to fifty-five. On behalf of the group, she offered a litany of complaints ("suggestions for improvement") that many visitors may have shared. On a hot and humid day, the group found drinking water to be scarce. To their dismay, the only refreshment stand was not open. She listed as vexing the inadequate orientation map, the lack of signage or incorrect signage, the lack of benches in shady areas, the need for friendlier attendants (interpreters), and the additional costs to ride in one of the wagons. In an effort to be humorous, she added that the group decided the church should be more strategically located "so tourists could pray they survive the rest of their journey or to thank God that they did survive the journey." On the positive side, she found the slide show interesting and the attendants informative.[50]

Staff interpreted the available anecdotal evidence favorably even though some visitors had expressed concern over the quality of the interpretation that they had received from a very inexperienced costumed staff. In mid-October, Harbour noted that he had received only thirteen "complaint letters" (five about rain, five about transportation, and three "general complaining letters"). The director concluded "that people are enjoying themselves if no letters of complaint are received." One OWWC member reported on the visits of friends who had come to

OWW during the 1977 season. They were "moderately enthusiastic" and were pleased that OWW was under construction. Bill Hibbard assessed his visit as "a most satisfying experience." As a teaser, he noted: "there's more to come." Visitors that summer would have not only felt "the living experience" of rural life but would also have experienced a living institution struggling to gain a foothold as a "credible museum."[51]

The close of the second season on October 30 left OWW at another critical juncture. The time had come for the museum to reinvent itself. Almost a decade after the curators approved the master plan, Erney, Harbour, and the OWWC had to ask the hard question that the board, Les Fishel, and Jim Smith had not pursued: can the Society afford the museum? Tishler had produced the plan Fishel asked for: he thought big and brought in a "gargantuan" (Perrin's word) plan. In those ten years too many problems had emerged. The most significant was that neither private fund-raising nor state funding could adequately support the museum as envisioned. Inflation and rising costs overwhelmed planning. Transportation remained a problem with OWW. During the second season, those who rode the horse-drawn wagons paid $1.84 less than the cost. Attendance fell far short of budgeting, and collections, interpretation, and research scrambled to stay even. Visitor amenities never quite reached the standards imagined. When the brewmaster's house fell through, it left an adequate space for the on-site administrative staff in limbo.

The second factor was the ten-year plan that the legislature demanded for budgeting. That edict forced new thinking. Erney gave the Society continuity for its leadership. Two directors came and went but he stayed. After serving twice as the caretaker between appointments, the curators named him in August 1977 as the Society's ninth director. Despite his earlier apprehension, OWW was now his project—his problem. He had devised a new approach, which modified but did not entirely abandon the original plan, known as an "operable nucleus." In spite of his earlier critical concerns, in 1976–77 it was Erney who labored to salvage the project and present the public with a credible museum. Faced with crushing deficits, staff moved to develop OWW as "a credible museum" for the public and the legislature. The new plan projected that the first phase would consist of seventy-eight reerected buildings that included a smaller village (currently the site has sixty-seven reerected buildings and one reconstruction).

Toward the end of 1977, Richard Erney paid a visit to a state budget analyst. He understood that the Society and the budget officer had an

adversarial relationship and wanted to shift it to a more cooperative one. Erney said he was no "wild expansionist" (a subtle criticism of his predecessors?) but said he would do whatever it took to maintain a high-quality program. The analyst pulled no punches. For openers he asked, "How without assessing any blame in any way, did things go so far awry on Old World Wisconsin?" How indeed?[52]

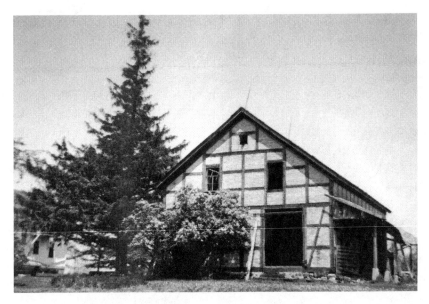

Owner Edwin Butt converted the once-proud Koepsell house to a barn and storage facility after he built a new home in 1923. (Old World Wisconsin Archives, Wisconsin Historical Society)

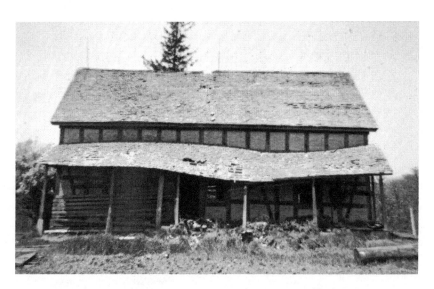

By the 1960s, the house had deteriorated. It was a prime example of Perrin's concept of salvage architecture. (Old World Wisconsin Archives, Wisconsin Historical Society)

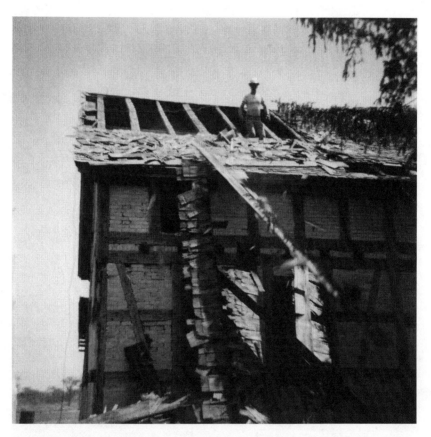

After acquiring the building, state maintenance crews with no restoration experience dismantled the house in 1969. Much of the original fabric could not be salvaged. (Old World Wisconsin Archives, Wisconsin Historical Society)

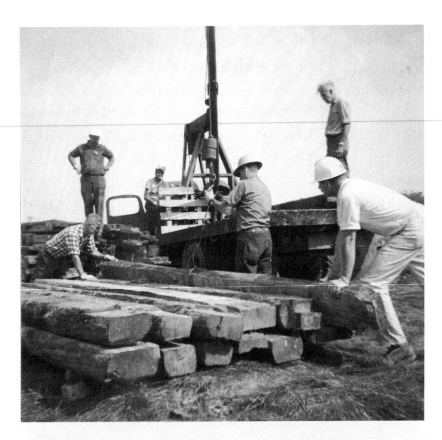

Crews stockpile timbers, windows, boards, and the like for future transportation to Old World Wisconsin in late 1971. (Old World Wisconsin Archives, Wisconsin Historical Society)

Reerections did not completely replicate the original houses. Public safety dictated modern additions such as these reinforced beams. (Old World Wisconsin Archives, Wisconsin Historical Society)

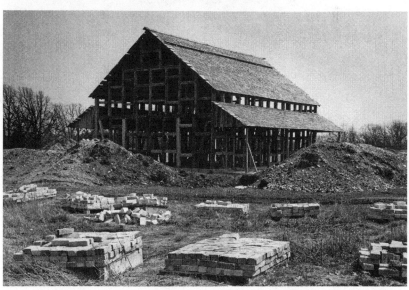

Not all of the original bricks could be salvaged. A dismantled *fachwerk* house in another county provided the needed cream city bricks. (Old World Wisconsin Archives, Wisconsin Historical Society)

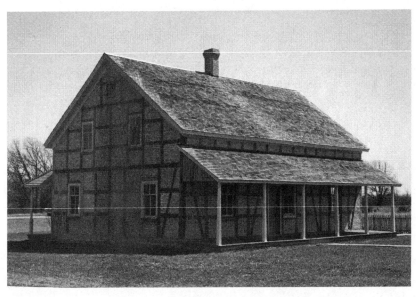

After many delays, the "new" Koepsell house opened to the public in May 1977. (Old World Wisconsin Archives, Wisconsin Historical Society)

Epilogue

In his analysis of American outdoor museums and living history sites, Sten Rentzhog concentrated his analysis on Vesterheim (a Norwegian American Museum in Decorah, Iowa), Greenfield Village, Colonial Williamsburg, Old Sturbridge Village, the Farmer's Museum in Cooperstown, Upper Canada Village, Plimoth Plantation, Mystic Seaport, Old World Wisconsin, and Living History Farms (in Urbandale, Iowa). While OWW shares many characteristics with these museums, it remains an anomaly. No other institution took the path that the Society did to create its museum. Its closest matches as open-air museums with relocated buildings are Greenfield Village, Old Sturbridge Village, and Conner Prairie. Rich patrons dominated their creation stories, and their fortunes sustained them through the difficult first years. The Wisconsin story of a state-sponsored museum on such a grand scale is unique. OWW's most analogous state-sponsored open-air museum might be Upper Canada Village. This 60-acre site situated on the banks of the Saint Lawrence River in eastern Ontario also consists of relocated buildings. It is, however, 500 acres smaller than OWW.[1]

The Society's vision was unique among American open-air museums to this extent: the size of the site, the magnitude of the plan, the attempt to integrate relocated buildings on similar landscapes, and the lack of any reliable source for funding the expensive project. Society leaders and

its staff and volunteers struggled to give shape to Dick Perrin's vision, but their museum fell far short of his mark. Simply put, the Society could not afford its "dreamed-of-outdoor museum." In moving to create Perrin's vision, the three directors (Les Fishel, Dick Erney, and Jim Smith) and the Board of Curators gambled that they could pay for a project that proved to be too encompassing and too expensive for the Society.

The answer to the question as to whether the Society should have taken on a project beyond its means was a relevant question in the 1960s and 1970s. The Society confronted this question at every juncture. Erney bluntly stated his concern in October 1969 when he concluded OWW was not economically feasible for the Society. He forced the project to be mothballed but did not derail it. His move showed that he was less willing than his predecessor to commit the Society to a course he considered dangerous. Did Fishel make the best decision for the Society when he committed to the museum? Was it a rational decision informed by a careful analysis of the data? Bernard Shaw addressed the issue of rational behavior and its consequences in his 1903 drama *Man and Superman: A Comedy and a Philosophy*: "The reasonable man adapts himself to the world; the unreasonable one persists in trying to adapt the world to himself. Therefore all progress depends on the unreasonable man." If Fishel had made a reasonable business decision in 1960, Perrin's proposal for a centrally located site to preserve examples of vernacular architecture would have been brushed aside. Fishel's incremental strategy (brilliant or imprudent depending on perspective) was the only feasible method for approaching the project. He refused to look too far down the road and to ask the most important question: how would the Society pay for the museum? This question he answered more on a hope than a realistic estimate. When he resigned in 1969, the only matter resolved was the acquisition (at minimal cost) of a daring and ambitious master plan whose economic feasibility data projected a misleading future. Fishel had funded the project internally. He did not seek budget increases or special appropriations from the Budget Finance Committee. Nor did he put in place needed fund-raising mechanisms. Fishel was comfortable letting events unfold and making hard decisions only as the need arose. Erney was a more cautious leader. He looked down the road and saw impending calamity. He asked the hard questions and found no one ready or able to answer them. He did create considerable resentment among OWWC members, who could not answer his questions but were unwilling to abandon the vision.

The Society had other opportunities to abort the museum project. Permission to move forward was a curatorial decision. Why the governing board did not exercise its responsibility by asking probing financial questions is more difficult to explain. The curators could have turned deaf ears to Perrin's heartfelt plea in 1964, but the architect was a passionate and persuasive preservationist. Perrin's proposal was both daring and exciting. Then, too, Fishel and Perrin approached the curators at a time of sweeping changes taking place in American culture. The 1960s became increasingly tumultuous and turbulent. The Beatles, the emergence of the Counterculture, increasingly violent responses to civil rights issues, an unpopular war in Vietnam, and political assassinations headlined the decade and challenged traditional values. Perhaps within the context of this rapid and unsettling change, some curators looked to the past to gain a sense of stability. Without a sense of nostalgia, the visionaries and managers sought to recapture a past worthy of celebration. The curators committed *in principle* to building an ethnic park that was inclusive of the Wisconsin immigrant experience. To create a museum that represented every immigrant or migrant group was well beyond the Society's means. Fishel, who had no idea of the total cost in 1964, warned the curators that the museum plan would be costly. No curator thought it necessary to ask for an estimate. Fishel helped the situation by asking for no funding at this point.

Another critical curatorial decision came in October 1968. Tishler and his students enthusiastically presented a remarkable conceptual plan that encompassed every immigrant or migrant group (except for Native Americans) that came to Wisconsin. It relocated immigrant buildings in ways that allowed their original landscapes to be recaptured. It was an exciting and grand concept, and the curators readily endorsed it. They saw no need to subject the economic feasibility plan to a critical analysis. Had they done so, the project might not have moved forward. Again, Fishel asked for no new funds. To some extent, Fishel and the curators engaged in a conspiracy of silence. It was the Society's version of "Don't ask, don't tell." Neither saw the need *at that time* to confront the issue of paying for the museum. This was because both accepted the economic feasibility analysis at face value.

One year later, the board could have agreed with the harsh assessment of acting director Erney that the museum project was not feasible for the Society. A few enthusiastic museum supporters on the board kept the project (just barely) alive. Another important juncture came with Smith's appointment in 1971. Sensing the enthusiasm of the OWWC

members and some staff, he decided to move forward with the project. With the emergence of a major donor and with the acquisition of the site at no cost, the financial issues could again be postponed.[2]

Society directors and its governing board could advance the outdoor museum initiative because they acted on a number of false assumptions. Optimistic suppositions made progress possible but rendered success problematic. One was the assumption that the understaffed Society could do everything internally or by relying on volunteers. Les Fishel never vetted the ethnic park with any specialists in the museum field. This had an internal logic. The Society could not afford outside experts so they had to rely on staff and volunteers. Equally important, with the exception of sites director Ray Sivesind, Fishel never formally discussed the proposed museum with his division heads. This meant he did not have to answer the hard questions that needed to be asked. Had he done so, the outcome might have been different. The vision was too big, too sweeping for the Society. After an unofficial review of the plans for OWW in 1974, folklore specialists at Cooperstown Graduate Program were both awed and dubious. They thought the scope of the plan was too grand. The Society did not have the staff or financial resources to build such a museum. With an almost cavalier spirit, reminiscent of Lord Tennyson's "The Charge of the Light Brigade," the Society had defied the odds, sometimes marching and sometimes stumbling forward. Measured steps might have made the project more feasible. Focusing on one or two groups, Germans and Scandinavians perhaps, might have been more manageable from a staff and funding standpoint. Here the paradox that is OWW emerges. Perrin had been in the field since the 1930s. Each year more and more examples of the vernacular architecture of Wisconsin's many immigrants groups vanished from the landscape. A more measured approach would have ignored at least in part Perrin's sense of urgency. Fishel and then Smith could have turned blind eyes to the destruction of valuable historic resources, but they did not. In moving forward with the project, Fishel ignored the counsel of two of his most trusted colleagues, Ray Sivesind—reputed to be one of the leading experts on historic sites in the country—and Dick Erney, and at least two influential curators, Fred Sammond and Robert Murphy.[3]

The Cooperstown people fretted over the fact that people represented on OWWC had no particular expertise as folklorists or museologists. The charge was valid. But it also ignored the genius of OWW's creation. Here was, arguably, the Society's greatest achievement in managing the project. Always cash strapped, the Society cobbled together untold

numbers of amateurs—untrained volunteers who worked for pleasure and commitment to an idea rather than monetary reward—and it co-opted professionals with advanced degrees who dared to learn as they proceeded. The approach came unglued as the Society faced funding the construction of the museum in the early 1970s.[4]

A second misconception was the belief that fund-raising would provide the means to build the museum. Fund-raising was a linchpin around which everything revolved. Here, too, the dream of raising enough money from the private sector proved overly ambitious. In large part, this resulted because Society leadership consistently underestimated the enormity of the task. Here again, the directors and the curators acted on a misassumption. The successful campaign to fund the six-volume history of Wisconsin apparently blinded them to the magnitude of an initiative that was more than ten times greater. The Society had neither the staff to conduct the campaign nor the money to hire professionals. The notion that it could be funded through private contributions was a will-o'-the-wisp, a ghostly image. In November 1977 Harbour informed his staff that fund-raising "continues to do not well." By year's end, Erney as much as admitted that reaching the $4 million goal from the private sector was unattainable. Again, financial exigencies forced the Society to rely on its staff and its board. The curators rejected hiring professional planners or seeking funds for its own development department as curator Zigman had implored. Rather, the Society trusted a part-time consultant to keep its staff and the curators on task. Delays in launching the campaign forfeited any chance of success. Waiting until 1976 only postponed the bad news that the fund-raising campaign would fall far short of its mark. This left the Society and its museum struggling to survive as they looked beyond the opening. Closely related to the misassumptions regarding funding was the belief that historic sites could be self-sustaining. Taken together these two misguided beliefs led to missteps that affected every stage of planning.[5]

Errant assumptions led to the selection of the state forest at Eagle. The lure of the site stirred the imagination of the landscape architect chosen to create the master plan. The excitement of Tishler and his students was palpable, as was that of the curators who enthusiastically endorsed their plans. The success of the plan depended on fund-raising, but the solicitation of money from the private sector never garnered the excitement generated by the site or the plan. Staff and curators alike planned and further planned the fund-raising campaign but failed to get organized until the months before the opening. The drive, while

enjoying limited success, never excited potential donors to the extent needed. Beyond this, delays caused by site acquisition and writing the Environmental Impact Statement pushed the project into the mid-1970s, a time of rapid inflation and rising land costs.

Another ill-advised assumption centered on planning and research. The Society, which adopted a "research and plan as you go" philosophy, risked advancing without adequate preparation. The Society placed too heavy a burden on the architectural research previously done by Perrin and the research done by the students for their 1967 plans. Tishler and his students had not done the comprehensive research that was needed. They created an excellent general conceptual plan for the museum. But Tishler and his students could not possibly have provided the systematic and thorough research needed. Fishel, who resigned soon after the curators accepted the master plan, never implemented the next steps. These included creating an effective and well-staffed research staff and hiring the experts needed to create a construction blueprint for the site.

This deficiency became more obvious after construction began in 1973. Some research did occur between 1969 and 1975. This included research reports on immigrant groups and trips to comparable museums such as Upper Canada Village. Left undone was the critically important survey or inventory of historic buildings. The Society lacked the financial and staff resources to do the needed research on prospective buildings. Research remained reactive, only doing the tasks that were absolutely essential. After 1973, all too frequently staff had to cobble together the critical architectural reports for rescued buildings after the building had been restored. Research for construction proved far from orderly as construction crews struggled to reerect buildings on-site to meet the Society's self-imposed deadline for opening on June 30, 1976.

Rather late in the process, the Society sent Knipping to Europe in the summer of 1975 to investigate the great outdoor history museums. He issued a clarion call for a more orderly process. The European outdoor museums made the process clear: first, the research had to be done, then the planning, and finally the acquisition and reerection of the buildings. In its haste to salvage buildings, the Society had virtually reversed the process by grabbing available structures, transplanting them at OWW, and then doing the research. Knipping's report did not receive serious consideration from Society leaders. In time, the Society came to realize that planning was a complicated and time-consuming business, especially for those who had never undertaken such a unique project. Planning and research only began to right themselves after Harbour's appointment in May 1976.[6]

Recognizing, as scientist Niels Bohr did, that prediction is difficult, should Society leaders be faulted for not planning and executing in a more effective manner? The Society had ventured into uncharted waters. Experience proved wrong regarding the construction and operations cost estimates as well as the revenue the site could generate. The economic feasibility study was the work of an economics graduate student. His effort need not be faulted. But what of the business leaders who served on the Board of Curators in October 1968? Apparently, they felt no need to subject the study to thorough analysis as they might have done in their own businesses. No one suggested having the state budget analysts look at it or hiring an outside firm to vet it. When Erney raised his red flags a year later, the curators made no move to reassess the project based on his concerns.

Many of the problems OWW experienced had been or should have been foreseen. Sivesind, the historic sites director, counseled Fishel that the planned site was too large. Henry Reuss, whose donation made OWW possible, questioned the wide geographical expanse of the museum. Much of the discussion in late 1977 focused on the problem of transporting people around the site. Reuss had advocated for a much more compact museum, one that would be easily accessible from a central parking lot. Smith firmly but politely (after all, Reuss had just contributed $100,000) rejected the idea and committed to the vision in all its fullness. The lure of the nearly 600-acre site, where relocated buildings could be situated on comparable landscapes, was too strong for the Society to think small. Problems moving visitors became all too evident at the opening, and these problems persist to the present.

The fund-raising misconception hampered the Society and its museum in at least one other significant manner. When Smith realized that the Society did not have the means to cover operating expenses for the first year, he included money to cover those costs in the budget submitted to the governor. As noted, this angered Governor Lucey. In January 1976 he rebuked the director, who had promised to ask for no new funding, and sent representatives to explore alternative funding with him. By now the Society had no alternative but to rely on state funding. This never sat well with legislators, especially during times of severe across-the-board budget reductions. Some legislators and their budget analysts worried about the size of the commitment. When they looked over the edge, they saw a bottomless pit. If they supported the museum, they worried it might be "something that will drain them forever." The "operable nucleus" put forth by Erney was a wise move made out of desperation. To have creditability with the state, the Society

had to demonstrate some discipline and reign in the projected costs. Leadership finally had to think small.[7]

Toward the end of the first season, OWWC chair Roger Axtell asserted that "Old World Wisconsin has entered a new era" and indeed it had, but not in ways he imagined. The creation story ended by October 31, 1977, with many parts of the museum incomplete or unfulfilled. OWW was underfunded and understaffed from the beginning and remains so today. The village became the museum's last hurrah. The much-redacted Crossroads Village that would be built reflected the pressure of continued budget problems. Polish and African American buildings, modest in comparison with the other represented groups, marked the end of the rural construction. What of the Society's effort? The museum that existed at the end of 1977 and the additions that came after fell far short of the vision, a vision that went far beyond anything the Society could afford. Thus, by default, the Society settled for something less and something remarkably different from the original Perrin-Fishel-Tishler vision.[8]

The visionaries saw their museum as a gigantic salvage project. They thought of it as a sanctuary for endangered architectural relics from another world—nineteenth-century Wisconsin. As the museum neared its opening, the Society had to confront the question that would transform the site. Who are our audiences and why would they visit? Today, hardly a word is spoken about the museum's mission to preserve immigrant architectural specimens from the nineteenth century. Those buildings have become props for telling stories about the immigrants who built the houses and barns. To tell the stories, the empty houses had to be filled with furnishings that reflected the nineteenth century. The farms needed authentic tools and equipment similar to those used by the farmers. The staff had to create gardens and fields for planting and cultivation. They had to populate the barns with cattle, horses, sheep, and pigs. These necessities of an outdoor museum received little or no attention in the rush to find, dismantle, transport, and reerect buildings for the scheduled museum opening. Confronting these needs transformed the site.[9]

Since its grand opening in 1976, OWW has grown and changed, though it never emerged from the shadow of its own past. Those charged with constructing the site found that the conceptual master plan was not a blueprint for building the site. Then, as the crews re-erected the preserved buildings, Sivesind's criticism came home to roost. Who, besides a few students of architecture, would visit a vernacular

architectural preservation site? Beginning late in 1975, as planners began to anticipate visitors, they shifted the emphasis from preservation to storytelling.

Perrin, the prescient architect, intuitively had anticipated the "new social history" that would transform academic history departments and outdoor history museums in the late 1960s and early 1970s. That genre emphasized telling the story of ordinary people and everyday events. What better place to tell these stories than in historic buildings Perrin helped to preserve? Here preservationist Kaufman's distinction between tangible and intangible heritage seems relevant. The Society did salvage nineteenth-century buildings, the state's tangible heritage, and continued to do so after its opening. A museum transformation took place as the museum moved toward its grand opening. The intangible heritage took center stage. Preservation of buildings gave way to telling stories about the people who built and occupied them. Wisconsin's inheritance from the nineteenth century was found less in buildings and more in those pioneers who confronted a new world in Wisconsin and helped to define the state in the twentieth century.[10]

Similar to the museum, research and interpretation remained works in progress. Indeed, OWW was far from a finished product at the end of its second season. It was a living-history museum that continually had to reinvent itself and find new methods and new exhibits for reaching its audiences. This is, of course, inherent in the history business, and as of June 30, 1976, OWW was part of that business.[11]

Perhaps the visionaries and builders of OWW could have profited from a paraphrase of a nineteenth-century historian. Lord Acton's "Advice to Persons About to Write History—Don't" might seem to apply to states considering the creation of historic sites. OWW offers insights to the pitfalls that the creation of a major site entailed, the obstacles that had to be overcome, and the success that came with the reerection of historic buildings such as the Koepsell house. "Don't," however, would negate a remarkable achievement and the testimonial OWW provides to human ingenuity. If the site provides visitors extraordinary opportunities to learn about Wisconsin's rich cultural heritage, it came at a high cost—not only in money but also in time and energy.[12]

Knowing OWW's story enhances our understanding of the struggles inherent in one state's museum creation. It is a story of a public institution that willingly pushed itself to the limit. Acting director Donald McNeil had asked rhetorically in 1959, "Where do we stop?" He answered that we do not: "We go as far as we can." The site in place at the end of

1977 was as far as the Society could go. But was it far enough to avoid an uncertain future? With state funds for new construction "uncertain" and without the needed nearly half-million dollars from private donors, the 1977–79 biennium looked bleak for OWW and those who labored to make the museum "credible." The lack of funding proved the great nemesis of creativity.[13]

One final question remains: has OWW achieved Erney's goal to become a "credible museum"? From the perspective of the early twenty-first century, the only answer can be a resounding Yes! Visitors can experience Wisconsin's frontier past in a much fuller sense than in 1977. The number of buildings has increased from eighteen in 1977 to sixty-eight. Motor-driven trams have replaced the antiquated horse-drawn wagons, although they are, of course, modern intrusions that detract from the attempt to create an illusion of a distant past. Visitor amenities have improved. The Clausing barn houses modern restaurant facilities. The gift shop in the Ramsay barn in its much-expanded space offers visitors a greater selection of Wisconsin-related materials than it did in 1977. Modern restrooms, water fountains, and even vending machines populate the site in sharp contrast to 1977. Staff has initiated a gradual implementation of the site's first comprehensive master interpretation plan. Its purpose is to enhance visitor experiences and make the site more attractive. Nearly every weekend has special programing such as Laura Ingalls Wilder days. Comprehensive research reports developed since 1977 provide the necessary historical data for the interpretive staff. Carefully maintained gardens and orchards abound near the houses, and "nineteenth-century" crops can be seen on the farmsteads. Visitors can see strategically placed nineteenth-century tractors and other equipment as they walk the site. A wide variety of farm animals now populates the site, some of which are back-bred varieties.

In common with most, if not all, open-air museums, the staff at OWW struggles to keep its doors open. The dedication of the barebones staff makes it possible for present-day visitors to have credible experiences. Cultural and historical state-sponsored sites across the country suffer from reduced support. Budget allocations for the site from the Society have grown since 1977, but continue to be, at best, minimal. Fund-raising is not appreciably better than 1976–77. Still, the Society bases future program planning on a successful new campaign. Marketing surveys and a variety of publicity campaigns based on them have failed to excite public interest in ways to attract the desired visitation or attract the breakthrough donations. It would be foolish to expect that

any open-air museum today would be void of the troubles that OWW has had and continues to experience. That the staff manages as well as it does testifies to its ingenuity and perseverance under the most trying and difficult circumstances.

In the final analysis, judgment should be rendered less on the process and more on the product. Anyone who has visited OWW should applaud the Society's doggedly incremental but flawed approach that defied conventional wisdom. The visionaries, the planners, and the builders struggled to beat the odds, and they did. The Society, its staff both in Madison and Eagle, and the amateurs and co-opted professionals who had joined the fray persisted under the toughest of conditions.[14]

Wisconsin had a museum that was unique in the country—an ethnic heritage museum built with salvaged architectural specimens. The Society had saved a portion of its state's past. If its creation was a pyrrhic victory—a victory at too great a cost, at least for the SHSW—OWW remains a magnificent, if tarnished, achievement. If the Society had not intervened to save the more than sixty historic buildings, most, if not all, would have been destroyed. The state had no financier with the wealth and interest to step forward to undertake the task of salvaging a few of the fast disappearing historic structures. The Society stepped into the breach at great risk to its own financial stability to create its museum. Yes, OWW is a work unfinished. Many migrant and immigrant groups are not represented. With costs far outstripping the Society's ability to recruit money, planners had to scale back significantly the 1968 plan, leaving it only partially fulfilled. Still, the state of Wisconsin has been enriched because the visionaries dared to take on a project of gargantuan proportions that produced one of the nation's "best outdoor history museums."[15]

The final word should go to Christina G. Rossetti. Unwittingly, she provided the best ending for the OWW creation story. "Can anything be sadder than work left unfinished?" Yes, she wrote, "work never begun."[16]

Abbreviations

Individuals

ACP	Alan C. Pape, first site construction supervisor
BOB	Bjarne O. Breilid, first site supervisor
EDC	E. David Cronon, history professor and president of the Board of Curators
HSR	Henry S. Reuss, congressional representative, first major donor
JCJ	John C. Jacques, SHSW assistant director
JEH	John E. Harbour, first on-site director
JMS	James Morton Smith, eighth director of the Society
JWW	John (Jack) W. Winn, first site administrator
LHF	Leslie H. Fishel Jr., seventh director of the Society
MHK	Mark Knipping, first research director
MP	Martin C. Perkins, construction crewmember, researcher
NF	Norman FitzGerald, Milwaukee business executive, first chair of OMC/OWWC
RA	Roger Axtell, Janesville business executive, second chair of OWWC
RAE	Richard A. Erney, associate director, interim director, director of the Society
RP	Richard W. E. Perrin, Milwaukee architect
RSS	Raymond S. Sivesind, Sites and Historic Markers director
RZ	Robert Zigman, Milwaukee business executive, member of Board of Curators
WHA	William H. Applegate, assistant director of SHSW, second site administrator
WT	William H. Tishler, landscape architecture professor

Organizations, Committees, Documents

ARBC	American Revolution Bicentennial Commission
DNR	Department of Natural Resources, formerly the Conservation Department
EIS	Environmental Impact Statement
GPR	General Purpose Revenues
HABS	Historic Architecture Buildings Survey
LRSPC	Long-Range Sites Planning Committee
NPS	National Park Service
OMC	Outdoor Museum Committee
ORAP	Outdoor Recreation Assistance Program
OSV	Old Sturbridge Village
OWW	Old World Wisconsin
OWWC	Old World Wisconsin Committee, formerly OMC
SHSW	State Historical Society of Wisconsin
TASC	Technical Assistance Subcommittee
WARBC	Wisconsin American Revolution Bicentennial Commission
WHF	Wisconsin History Foundation
WHS	Wisconsin Historical Society (current name of State Historical Society of Wisconsin)
WMH	*Wisconsin Magazine of History*

Notes

Introduction

1. The State Historical Society of Wisconsin, which was founded in 1846 as a private organization, became a state agency in 1949. It is now called the Wisconsin Historical Society (WHS). In the text I abbreviate references to it as either SHSW or the Society. The best history of the Society remains Clifford Lord and Carl Ubbelohde, *Clio's Servant: The State Historical Society of Wisconsin, 1846–1954* (Madison: State Historical Society of Wisconsin, 1967), but their work needs to be updated.

2. Attempts to salvage buildings commenced before the Eagle site had been secured. The Society acquired or attempted to acquire five buildings during 1968 and 1969 — the Schultz-Zirbel house (Dodge County), the Pagel house (Green County), the Grosenick house (Dodge County), the Varo house (Crawford County), and the Schuler house (Calumet County). Two had been disassembled and stored, and three were heavily damaged but still at their original locations. In the end, the Society failed to salvage these buildings. John W. Winn (JWW) to Leslie H. Fishel Jr. (LHF), March 6, 1969, SHSW Folder 1980/032, "Heritage Village: List of Inventoried Buildings."

3. Ned Kaufman, *Place, Race, and Story: Essays on the Past and Future of Historic Preservation* (New York: Routledge, 2009), 296. The museum's first "official" name, Heritage Village, demonstrated the visionaries' strong commitment to saving a part of the state's tangible past. Staff frequently linked Wisconsin's heritage (legacy) to its ethnicity. Gary A. Payne, "OWW: Ethnic Research & Acquisitions," January 27, 1974, SHSW Folder 1979/188, "Old World Wisconsin Policy"; William H. Tishler, "Saving Ourselves: Our Rural Heritage," *Museum News* 55, no. 4 (1977): 21–25.

4. David Lowenthal, *Possessed by the Past: The Heritage Crusade and the Spoils of History* (New York: The Free Press, 1966), 102.

5. As late as 2000, Norman Tyler noted that the role of historic preservation in American life "is still being defined." *Historic Preservation: An Introduction to Its History, Principles, and Practice* (New York: W. W. Norton, 2000), 12. William J. Murtagh, *Keeping Time: The History and Theory of Preservation in America*, 3rd ed. (New York: John Wiley & Sons, 2006), 75–76. Richard Longstreth noted that the 1960s and early 1970s were critical years for both the discipline of architectural history and the field of historic preservation. He did not use Old World Wisconsin, which exemplified the melding of architectural history and historic preservation, as an example. "Architectural History and the Practice of Historic Preservation in the United States," *Journal of the Society of Architectural Historians* 58, no. 3 (September 1999): 326.

6. The literature on the history of open-air museums is not vast but it is growing. The two best surveys are Jay Anderson, *Time Machines: The World of Living History* (Nashville: American Association of State and Local History, 1984), and Sten Rentzhog, *Open Air Museums: The History and Future of a Visionary Idea*, trans. Skans Victoria Airey (Stockholm, Sweden: Jamtli Förlag and Carlsson Bokförlag, 2007). Two older studies of great value are Richard W. E. Perrin, *Outdoor Museums* (Milwaukee: Milwaukee Public Museum, 1974), and Edward P. Alexander, *Museums in Motion: An Introduction to the History and Functions of Museums* (Nashville: American Association of State and Local History, 1979), esp. 84–95. Short surveys that treat open-air museums include Candice Tangorra Matelic, "Through the Historical Looking Glass," *Museum News* 58, no. 4 (1980): 35–40; Michael Wallace, "Visiting the Past: History Museums in the United States," in *Presenting the Past: Essays in History and the Public*, ed. Susan Porter Benson et al. (Philadelphia: Temple University Press, 1986), 127–61; Warren Leon and Margaret Piatt, "Living-History Museums," in *History Museums in the United States*, ed. Warren Leon and Roy Rosenzweig (Urbana: University of Illinois Press, 1989), 64–97; and Edward A. Chappell, "Open-Air Museums: Architectural History for the Masses," *Journal of the Society for Architectural Historians* 58, no. 3 (September 1999): 334–41. Other general studies often appear as coffee-table books. Examples include Irvin Haas, *America's Historic Villages & Restorations* (New York: ARCO Publishing Company, Inc., 1974); Ross Bennett, ed., *Visiting Our Past: America's Historylands* (Washington, DC: National Geographic Society, 1977); John Bowen, *America's Living Past: Historic Villages and Restorations* (New York: M & M Books, 1990); and Gerald L. Gutek et al., *Plantations and Outdoor Museums in America's Historic South* (Columbia: University of South Carolina Press, 1996).

7. Emily G. Jackson, *Historic Preservation of U.S. Properties* (New York: Nova Science Publishers, 2011), 1; Perrin, *Outdoor Museums*, 63.

8. See, for example, Murtagh, *Keeping Time*, chapter 10, "Landscape Preservation." The "relationships between buildings and their settings are as important as those among the interior spaces." Chappell, "Open-Air Museums," 336.

9. Another important movement underfoot as the Society planned its museum was an effort to develop a national network of living history farms. As early as 1945, Herbert A. Kellar urged Agricultural History Society members to build "living agricultural museums" across the country. "Living Agricultural Museums," *Agriculture History* 19, no. 3 (July 1945): 186–90. Kellar and his wife were curators of the Cyrus McCormick collection and later curated it after the Society acquired it in the 1950s. Leon and Piatt, "Living-History Museums," 70–72. At a meeting of the Agricultural History Society in September 1970, participants interested in the emerging living history farms explored the formation of a new organization, the Association for Living Historical Farms and Agricultural Museums. John T. Schlebecker, *The Past in Action: Living History Farms* (Washington, DC: Living Historical Farms Project, Smithsonian Institution, 1967), and John T. Schlebecker and Gale E. Peterson, *Living Historical Farms Handbook* (Washington, DC: Smithsonian Institution Press, 1972).

10. Richard White used the term "refugees" to describe native populations that fled the Iroquois. *The Middle Ground: Indians, Empires, and Republics in the Great Lakes Region, 1650–1815* (Cambridge: Cambridge University Press, 1991), chapter 1. Nancy Oestreich Lurie demonstrated the impact that Eastern American migrants and European immigrants had on the native populations in *Wisconsin Indians*, rev. ed. (Madison: Wisconsin Historical Society Press, 2002).

11. Wisconsin's population growth accelerated after 1830. The Territory of Wisconsin achieved the requisite 60,000 inhabitants by 1848. After Congress passed the enabling legislation that year, Wisconsin became a state. Wisconsin Cartographers' Guild, *Wisconsin's Past and Present: A Historical Atlas* (Madison: University of Wisconsin Press, 1998), 4–11.

12. Before William Tishler's class came up with Heritage Village, the museum had a number of names: Ethnic Village or Park, Pioneer Park, and Outdoor Museum. Society staff chose its final name, Old World Wisconsin. I refer to it as OWW or the museum.

13. Perrin, *Outdoor Museums*, 66; Richard W. E. Perrin (RP) to Gaylord Nelson, May 3, 1966, Perrin Papers, "S.H.S.W. 1965, 66, 67, 68."

14. Perrin, *Outdoor Museums*, 66.

15. This data has been culled from OWW publicity material and information supplied by Martin C. Perkins, curator of research at OWW, and Daniel J. Freas, director, OWW. William Cronon wrote that it "is astonishing" that a museum of Old World Wisconsin's "importance and caliber can operate with fewer than a dozen full-time staff members supported by such a small team of seasonal interpreters and volunteers." "Midwestern Landscape History at Old World Wisconsin," Adm Bldg, "OWW Final Report: National Endowment for the Humanities Self Study, Project," GM-25286-94 (1997).

16. *Creating Old World Wisconsin* fits an expanding subfield within museum history. Histories of individual outdoor museums include Geoffrey C. Upward,

Home for Our Heritage: The Building and Growth of Greenfield Village and Henry Ford Museum (Dearborn, MI: Henry Ford Museum Press, 1979); James S. Wamsley, *American Ingenuity: Henry Ford Museum and Greenfield Village* (New York: Harry N. Abrams, 1985); George Humphrey Yetter, *Williamsburg Before and After: The Rebirth of Virginia's Capital* (Williamsburg: Colonial Williamsburg Foundation, 1988); Richard Handler and Eric Gable, *The New History in an Old Museum: Creating the Past at Colonial Williamsburg* (Durham, NC: Duke University Press, 1997); Laura E. Abing, "Old Sturbridge Village: An Institutional History of a Cultural Artifact" (PhD dissertation, Marquette University, 1997); Patricia West, *Domesticating History: The Political Origins of America's House Museums* (Washington, DC: Smithsonian Institution Press, 1999); Phillip Kopper, *Colonial Williamsburg*, 2nd ed. (New York: Abrams, 2001); Thomas Parrish, *Restoring Shakertown: The Struggle to Save the Historic Shaker Village of Pleasant Hill* (Lexington: University Press of Kentucky, 2005); Robert Mazrim, *The Sangamo Frontier: History and Archaeology in the Shadow of Lincoln* (Chicago: University of Chicago Press, 2007); Jessica Swigger, "'History Is Bunk': Historical Memories at Henry Ford's Greenfield Village" (PhD dissertation, University of Texas at Austin, 2008); Carmella Padilla, *El Ranch de las Golondrinas: Living History in New Mexico's La Cienega Valley* (Santa Fe: Museum of New Mexico Press, 2009); Anders Greenspan, *Creating Colonial Williamsburg*, 2nd ed. (Washington, DC: Smithsonian Institution Press, 2009); and Berkley Duck, *Twilight at Conner Prairie: The Creation, Betrayal, and Rescue of a Museum* (Lapham, MD: AltaMira Press, 2011).

17. "The History behind, within, and outside the History Museum," in *Cultural History and Material Culture: Everyday Life, Landscapes, Museums* (Ann Arbor: University of Michigan Press, 1990), 307.

18. Alan Pape, construction supervisor, told Marlin Johnson, a biology teacher who assisted with the reerections: "We are kind of learning as we go along how to do all this." Martin Hintz, "History Yawns, Awakens at Old World Farmstead," *Milwaukee Journal*, May 23, 1974.

19. Rentzhog, *Open Air Museums*, 269–73.

20. "The Prime of Muriel Sparks," *New York Review of Books* 57, no. 13 (August 19, 2010): 59.

21. John S. Tuckey, ed., *Fables of Man* (Berkeley: University of California Press, 1972), 217.

22. Quoted in Handler and Gable, *The New History*, 132. They critiqued the museum's struggles to overcome (unsuccessfully) the Rockefeller past and present a more accurate interpretation of the past.

23. Rentzhog, *Open Air Museums*, 1; Chappell, "Open-Air Museums," 334.

24. "A Pioneer Park for Wisconsin?" *Let's See Magazine*, November 1960, 22.

25. "Proceedings of the . . . SHSW, 1958–1959," *Wisconsin Magazine of History* (hereafter *WMH*) 43, no. 1 (Autumn 1959): 56–78.

Chapter One. Visionaries

1. Richard Homan, "Maryland May Restore First Capital," *Washington Post*, October 3, 1965; Rentzhog, *Open Air Museums*, passim; John Fortier, "Louisbourg: Managing a Moment in Time," *National Museum of Man: Mercury*, Series 32 (1981): 93; Charles B. Hosmer Jr., *Preservation Comes of Age: From Williamsburg to the National Trust, 1926–1949*, 2 vols. (Charlottesville: Preservation Press by the University Press of Virginia, 1981), 1:1–8.

2. Michael Wallace, "Visiting the Past," 137–61; Kerstin Barndt, "Fordist Nostalgia: History and Experience at the Henry Ford," *Rethinking History* 11, no. 3 (September 2007): 379–410.

3. Alexander C. Guth, "Historic American Buildings Survey," *WMH* 22, no. 1 (September 1938): 19, 28; Hosmer, *Preservation Comes of Age*, 2:548–62.

4. Edward P. Alexander, "History Museums: From Curio Cabinets to Cultural Centers," *WMH* 43, no. 3 (Spring 1960): 176.

5. Ibid., 179; Clifford Lord, "In Retrospect and Prospect," *WMH* 30, no. 2 (December 1946): 135.

6. Lord and Ubbelohde, *Clio's Servant*, 402–3, 425; Ubbelohde, "The Threshold of Possibilities: The Society, 1900–1955," *WMH* 39, no. 2 (Winter 1955–1956): 76–84. The state created another foundation in 1959 to fund the operations at Circus World Museum. "Log of Leslie H. Fishel, Jr., 3/25/59–12/23/59 Box 1, Folder 1," Digest of Board Activities, October 31, 1959, SHSW Folder 1997/169; "Proceedings of the . . . SHSW, 1959–1960," *WMH* 44, no. 1 (Autumn 1960): 60; Lord, "In Retrospect and Prospect," 140.

7. Guth, "Historic American Buildings Survey," 15–38.

8. Robert M. Neal, "Pendarvis, Trelawny, and Polperro Shake Rag's Cornish Houses," *WMH* 29, no. 4 (June 1946): 391; Lord and Ubbelohde, *Clio's Servant*, 418–19; Clifford Lord, "Chats with the Editor," *WMH* 31, no. 4 (June 1948): 320.

9. Alexander to RP, June 6, 1969, Perrin Papers, "S.H.S.W. 1969, 70, 71, 72"; Thomas D. Brock, "History of Picnic Point," *FCNA* News 3, no. 2 (Spring 2004): 3–4.

10. Lord and Ubbelohde, *Clio's Servant*, 411, 551.

11. Clifford Lord, "Chats with the Editor," *WMH* 31, no. 2 (December 1947): 138.

12. "Historic Sites as a Part of the State Parks of Wisconsin," *WMH* 31, no. 3 (March 1948): 271–74.

13. Lord to members of SHSW, Series 992, Box 4, Folder 8, "Publicity, Correspondence, 1955–1974."

14. Lord and Ubbelohde, *Clio's Servant*, 412; Raymond Sivesind, "Historic Sites in Our State Park Program," *WMH* 32, no. 4 (June 1949): 436–44; Clifford Lord, "Smoke Rings," *WMH* 34, no. 1 (Autumn 1950): 7. The negotiations to

acquire Villa Louis were well along by the time of Alexander's departure in 1946. Alexander, "History Museums," 179.

15. Raymond S. Sivesind (RSS) to RP, August 17, 1959, SHSW Folder 1986/100, "Old World Wisconsin Background." Stonefield became the state's agricultural museum. Lord and Ubbelohde, *Clio's Servant,* 415–16; Clifford Lord, "Smoke Rings," *WMH* 34, no. 4 (Summer 1951): 200.

16. Alexander, "History Museums," 179–80.

17. Clifford Lord, "Smoke Rings," *WMH* 37, no. 1 (Autumn 1953): 9; Lord and Ubbelohde, *Clio's Servant,* 417, 552.

18. Staff Project Recommendations, Series 678, Box 23, Folder 1, "Plans and Projects 1952–1959, 1969"; Lord to RP, October 27, 1954, Perrin Papers, "S.H.S.W. 1953, 54, 55, 56."

19. Lord to RP, October 27, 1954, Perrin Papers, "S.H.S.W. 1953, 54, 55, 56"; Lord, "Smoke Rings," WMH 37, no. 1 (Autumn 1953): 8.

20. "Wisconsin Historic Sites Project" attached to a memo, Don McNeil to GA [most likely Grace Argall, administrative assistant], October 17, 1958, Series 678, Box 38, Folder 5, "Sites & Markers, Sites, General, 1954–1964"; Lord and Ubbelohde, *Clio's Servant,* 412–13, 416–17, 470.

21. Alexander, "History Museums," 180; Lord, "Smoke Rings," *WMH* 40, no. 1 (Autumn 1956): 9; Justin M. (Chet) Schmiedeke to LHF, October 24, 1960, Series 1762, "SHSW Project files, 1919–1976, Box 2, Ethnic Project-Ethnic Park."

22. Lord, "Smoke Rings," *WMH* 39, no. 4 (Summer 1956): 235.

23. Series 678, Box 23, Folder 3, "Plans and Projects, 1952–1959, 1969." The committee apparently made no connection to outdoor sites as possible attractions for ethnic groups. Series 1910, Box 5, Folder 9, "Ethnic Committee, 1955–56"; undated memo, William J. Schereck, Series 678, Box 23, Folder 3, "Plans and Projects, 1952–1959, 1969."

24. Lord, "Smoke Rings," *WMH* 40, no. 1 (Autumn 1956): 9–10; Lord, "Smoke Rings," *WMH* 40, no. 4 (Summer 1957): 235.

25. "Pioneer Park," 22, 23; RAE to RP, May 21, 1964, Perrin Papers, "S.H.S.W. 1961, 62, 63, 64."

26. "Proceedings of the . . . SHSW, 1958–1959," *WMH* 43, no. 1 (Autumn 1959): 56–78.

27. LHF was aware that all state agencies had suffered from the budget crunch. "Proceedings of the . . . SHSW, 1960–1961," *WMH* 45, no. 1 (Autumn 1961): 44, 45.

28. "Proceedings of the . . . SHSW, 1958–1959," *WMH* 43, no. 1 (Autumn 1959): 56–78.

29. Quoted in Perrin, "Wisconsin's 'Stovewood' Walls: Ingenious Forms of Early Log Construction," *WMH* 46, no. 3 (Spring 1963): 219.

30. Lord to RP, May 23, 1953, Lord to RP, October 27, 1954, RP to Lord, June 1, 1956, Lord to RP, June 5, 1956, Perrin Papers, "S.H.S.W. 1953, 54, 55, 56."

31. Perrin, "A Fachwerk Church in Wisconsin," *WMH* 43, no. 4 (Summer 1960): 239–44; Tishler, "Fachwerk Construction in the German Settlements of Wisconsin," *Winterthur Portfolio* 21, no. 4 (Winter 1986): 275–92; Kuether to RP, November 20, 1958, RP to Kuether, December 15, 1958, and RSS to Kuether, December 26, 1958, included with March 5, 1973, letters from Eichoff to James Morton Smith (JMS), 1986/100, "Old World Wisconsin Background." Kuether "talked and corresponded extensively" with Society staff. *Old World Wisconsin: An Outdoor, Ethnic Museum: A Project in Historic, Cultural, and Environmental Preservation Developed by the State Historical Society of Wisconsin in Cooperation with the Department of Natural Resources* ([Madison], 1973), 17.

32. With memo Don McNeil to GA, October 17, 1958, "Wisconsin Historic Sites Project," Series 678, Box 38, Folder 5, "Sites & Markers, Sites, General, 1954–1964."

33. Ibid.

34. RP, *Historic Wisconsin Architecture* (Milwaukee, 1960), 5; see also RP, *Historic Wisconsin Buildings: A Survey of Pioneer Architecture, 1835–1870* (Milwaukee, 1962), and *The Architecture of Wisconsin* (Madison, 1967); Tishler interview, May 5, 1993; Ed Hinshaw, "WTMJ-TV (Channel 4) Editorial," January 3–4, 1972; William H. Applegate (WHA) to Hinshaw, January 7, 1972, 1993/193, "OWW Public Relations"; Fishel interview.

35. Fishel interview.

36. Ibid.; June 29, 1960, 1997/169, Box 1, Folder 2, "Log of Leslie H. Fishel, Jr. 1/4/60–11/17/60, Jan 3–5, 1961."

37. June 29, 1960, 1997/169, Box 1, Folder 2, "Log of Leslie H. Fishel, Jr. 1/4/60–11/17/60, Jan 3–5, 1961."

38. "Pioneer Park," 22–23.

39. Ibid.

40. LHF to RSS, July 4, 1960, Series 1762, "SHSW Project files, 1919–1976, Box 2, Ethnic Project-Ethnic Park."

41. RSS to LHF, July 13, 1960, RSS to LHF, October 24, 1960, Series 1762, "SHSW Project files, 1919–1976, Box 2, Ethnic Project-Ethnic Park."

42. Tishler interview, May 5, 1993; Russell Austin, "Display of Old Homes Urged in Park Areas," *Milwaukee Journal*, June 21, 1960.

43. The Society's 1973 revision of the master plan gave RP all the credit for the board's decision. *Old World Wisconsin* (1973), 8, 17, 18; Erney interview; Fishel interview.

44. LHF to Executive Committee, September 10, 1964, 1988/222, "Scott M. Cutlip, 1964"; Fishel interview; SHSW, Executive Committee, minutes, September 12, 1964, Series 1910, Executive 1951–1964, Box 6, Folder 7, "Executive Committee 1964"; LHF to Scott M. Cutlip, November 22, 1964, 1988/222, "Scott M. Cutlip, 1964"; LHF to Charles W. Johnson, October 20, 1960, Series 1762, Box 2, "Ethnic Project-Ethnic Park."

45. LHF to Executive Committee, September 9, 1964; RAE to Old World Wisconsin Committee (OWWC), October 6, 1969, Series 1910, Box 10, Folder 3; Fishel interview; Tishler interview, February 21, 1994; LHF to Robert Zigman (RZ), March 19, 1968, Series 958, 1997/078, "Robert S. Zigman 1969-1976."

46. December 17, 1959, 1997/169, Box 1, Folder 1, "Log of Leslie H. Fishel, Jr. 3/25/59-12/23/59."

Chapter Two. Managers

1. Charles van Ravenswaay, Director of Old Sturbridge Village, to RP, September 8, 1964, Perrin Papers, "S.H.S.W. 1961, 62, 63, 64."

2. Richard Doak, "His Goal: A Midwest Showcase," *Des Moines Tribune*, "The Third Page," October 2, 1979.

3. Based on research for the author's work in progress, "Saving Its Past: The State of Maryland and Historic St. Mary's City, 1933-1985."

4. Cutlip to John Geilfuss, July 17, 1964, 1988/222, "Scott M. Cutlip, 1964."

5. Fishel interview; Knipping interview; Erney interview.

6. "Proceedings of the . . . SHSW, 1964-1965," *WMH* 49, no. 1 (Autumn 1965): 58.

7. SHSW, Executive Committee, minutes, September 12, 1964, Series 1910, Box 6, Folder 7, "Executive Committee 1964"; Fishel interview.

8. Fishel, "Suggestions for a Long-Range Historic Sites Program," November 28, 1964, Series 992, Box 4, Folder 6.

9. July 18, 1960, July 21, 1960, 1997/169, Box 1, Folder 2, "Log of Leslie H. Fishel, Jr. 1/4/60-11/17/60, Jan 3-5, 1961."

10. L. P. Voigt, the director of Conservation since 1955, became the first director of the Department of Natural Resources when it was created in 1967; Don Mackie became superintendent of the new State Parks and Recreation Division in 1965; Al Ehly succeeded him as director of the Bureau of Parks and Recreation. SHSW, Ethnic Park Meeting minutes, January 18, 1962, Series 1762, Box 2, "Ethnic Park Project-Ethnic Park"; Mackie to Norman Fitzgerald (NF), February 4, 1966, 1979/202, "OMC, 1966"; LHF to RP and Frederick G. Schmidt, April 9, 1962, Series 1762, 1919-1976, Box 2, "Ethnic Project-Ethnic Park."

11. LHF, "The Society Today and Tomorrow: A Report to the Board of Curators of the State Historical Society of Wisconsin," second draft, 29-31, December 31, 1962, 1988/222, "Scott M. Cutlip, 1957-1963."

12. RP to OMC, December 2, 1964, Series 1910, Box 12, Folder 5, "OMC, 1964," referenced in March 30, 1966, Perrin Papers, Box 14, Bound Folder "Old Sturbridge Village."

13. RP to LHF, January 27, 1965, Perrin Papers, "S.H.S.W. 1961, 62, 63, 64"; Executive Committee, January 16, 1965, Series 1910, Box 6, Folder 8, "Executive Committee 1965."

14. RSS to NF, October 27, 1964, NF to LHF, December 2, 1964, LHF to NF, December 18, 1964, Series 1910, Box 12, Folder 5, "OMC, 1964"; "OMC, minutes," January 29, 1965, 1978/202, "OMC, 1965."

15. RAE to LHF and John Jacques (JCJ), February 1, 1965, 1979/202, "OMC, 1965."

16. RSS to Philip H. Lewis Jr., January 28, 1965, Series 992, Box 5, Folder 4, "Survey, 1956-1972"; Long-Range Sites Planning (LHF, RAE, JCJ, and RSS), February 8, 1965, Series 678, Box 38, Folder 6, "Sites and Markers Sites — General, 1965-1973."

17. [LHF, RAE, JCJ, and RSS], February 22, 1965, Long-Range Sites Planning 1979/202, "OMC, 1965."

18. RP to Gaylord Nelson, May 3, 1966, Perrin Papers, "S.H.S.W. 1965, 66, 67, 68"; Meeting on Bong Air Base Use for the Outdoor Museum, [LHF, RAE, JCJ, and RSS], March 3, 1965, Long-Range Sites Planning 1979/202, "OMC, 1965."

19. LHF to NF, February 10, 1965, Perrin Papers, "S.H.S.W. 1961, 62, 63, 64"; Meeting on Bong Air Base Use for the Outdoor Museum, March 3, 1965, Long-Range Sites Planning 1979/202, "OMC, 1965."

20. LHF to NF, November 3, 1965, November 26, 1965, LHF to L. P. Voigt, November 29, 1965, 1979/202, "OMC, 1965"; NF to Mackie, December 14, 1965, Tishler Papers, "Correspondence Heritage"; "OMC, Report," October 16, 1965, 1979/202, "Outdoor Museum Committee, 1965"; Occasional Paper #11, March 2, 1965, Series 958, Box 1, "Special Communications"; Occasional Paper #12, April 13, 1965, Series 958, SHSW Administration, Board of Curators, Correspondence, Box 1, "Occasional Reports to the Board of Curators 1963-." This report promised a progress report in June. Series 958, Box 1, "Occasional Reports to the Board of Curators 1963-"; 1988/222, "Scott M. Cutlip, 1965" (attached to "A Cooperative Agreement Between the State Conservation Commission and the State Historical Society of Wisconsin," April 7, 1952); 1997/177, Box 1, "OWW Land Acquisitions"; Occasional Report #14 (December 13, 1965), Series 958, Box 1, "Occasional Reports to the Board of Curators 1963-1967"; NF to Mackie, February 11, 1965, December 14, 1965, Tishler Papers, "Correspondence Heritage."

21. Governor Warren P. Knowles, "Remarks to the State Historical Society Founder's Day Banquet," January 9, 1966, Governor Knowles, "Remarks," January 29, 1966, Series 958, "Communications to the Board of Curators, 1966-1968"; Knowles to Cutlip, May 26, 1965, 1988/222, "Scott M. Cutlip, 1966"; Oriol Bohigas et al., *El Poble Espanyol* (Barcelona: Lunwerg Editores, S.A., 1989).

22. LHF to OWWC, May 16, 1969, 1997/177, Box 1, "OWW Land Acquisitions"; "Proceedings of the . . . SHSW, 1965-1966," *WMH* 50, no. 1 (Autumn 1966): 78, 90; LHF to Executive Committee, September 10, 1964, Series 1910, Box 6, Folder 7, "Executive Committee, 1968."

23. RP to William Tishler (WT), January 29, 1968, 1979/202, "OWWC, 1968."

24. "Proceedings of the . . . SHSW, 1965-1966," *WMH* 50, no. 1 (Autumn 1966): 94.

25. Mackie to NF, February 4, 1966, LHF to NF, May 5, 1966, 1979/202, "OMC, 1966."

26. NF to LHF, January 13, 1966, January 26, 1966, February 16, 1966, LHF to NF, February 17, 1966, 1979/202, "OMC, 1966."

27. LHF to NF, March 4, 1966, March 11, 1966, April 13, 1966, May 5, 1966, LHF to RAE, JCJ, and RSS, May 17, 1966, typed on memo of May 17, RSS to LHF, May 18, 1966, 1979/202, "OMC, 1966."

28. RSS to LHF, RAE, and JCJ, June 21, 1966, 1979/202, "OMC, 1966."

29. NF to LHF, June 21, 1966, LHF to Mackie, November 1, 1966, LHF to NF, December 15, 1966, NF to LHF, December 22, 1966, 1979/202, "OMC, 1966"; LHF to NF, December 30, 1967, 1979/202, "OMC, 1967"; Chapter 84, Laws of 1967: The conservation commission may sell lands within the following described area in the Kettle Moraine State Forest to the State Historical Society at fair market value for the purpose of development of an outdoor museum. Series 934, Box 202, "Resh, Warren (Council for the Society), 1968."

30. Hiestand to LHF, January 3, 1968, Series 1048, Box 1, Folder 5, "Administration, Dept of—1968-69."

31. Robert Joslyn, "Location Near I-Road Urged for State Fair," *Wisconsin State Journal*, December 6, 1967.

32. LHF to RAE, January 25, 1968, Series 1048, Box 1, Folder 5, "Administration, Dept of—1968-69."

33. Ibid.

34. Ibid.

35. John A. Beale, Conservation Administrator, by A. E. Ehly, Acting Director Bureau of Parks and Recreation, to RSS, May 23, 1968, Perrin Papers, "S.H.S.W. 1965, 66, 67, 68"; NF to LHF, August 20, 1968, 1979/202, "OWWC, 1968."

36. RAE to LHF and RSS, September 16, 1968, 1979/202, "OWWC, 1968"; RAE, "Memo for the File" regarding conversation with Al Ehly, June 2, 1969, 1997/177, Box 1, "OWW Land Acquisitions."

37. Buchholz to Edgar W. Trecker, October 23, 1968, LHF to NF, December 19, 1968, 1997/177, Box 1, "OWW Land Acquisitions," Perrin Papers, "S.H.S.W. 1965, 66, 67, 68."

38. Assembly Bill 630 Copy with OWWC minutes, January 14, 1969, 1986/097, "Minutes & Staff Reports"; LHF to Warren H. Resh, December 19, 1968, Series 934, Box 202, "Resh, Warren (Council for the Society) 1968."

39. Resh to LHF, December 30, 1968, Series 934, Box 202, "Resh, Warren (Council for the Society) 1968"; LHF to RSS, WHA, RAE, January 3, 1969, RSS to LHF, January 8, 1969, 1997/177, Box 1, "OWW Land Acquisitions."

40. LHF to NF, March 10, 1969, 1997/177, Box 1, "OWW Land Acquisitions"; Fishel to OWWC, May 16, 1969, Perrin Papers, "S.H.S.W. 1969, 70, 71, 72."

41. "Preserving Wisconsin's Heritage," *Wisconsin Agriculturalist*, March 22, 1969; Charlie House, "Germans May Aid State Ethnic Park," *Milwaukee Journal*, April 13, 1969; WT to LHF, April 30, 1969 (with May 8, 1969), 1997/177, Box 1, "OWW Land Acquisitions."

42. LHF to RAE, May 20, 1969, May 22, 1969, 1997/177, Box 1, "OWW Land Acquisitions."

43. LHF to RAE, May 22, 1969, 1997/177, Box 1, "OWW Land Acquisitions."

44. Site Evaluation, July 7, 1969, Tishler Papers.

45. Confidential Meeting of the WHF Board of Directors, May 27, 1969, 1981/160, "WHF Minutes, 1968–1971"; RAE meeting with Al Ehly and Lowell Hanson, September 5, 1969, 1997/177, Box 1, "OWW Land Acquisitions."

46. June 29, 1960, 1997/169, Box 1, Folder 2, "Log of Leslie H. Fishel, Jr. 1/4/60–11/17/60, Jan 3–5, 1961"; SHSW, Executive Committee, minutes, January 6, 1962, Series 1910, Box 6, Folder 5, "Executive Committee 1962"; Series 1762, Box 2, "Ethnic Park Project-Ethnic Park," with Mackie to NF, February 4, 1966, in Tishler papers.

Chapter Three. Master Planners

1. Erney interview.

2. NF to Mackie, December 12, 1965, Series 1762, Box 2, "Ethnic Project-Ethnic Park"; Tishler Papers, "Correspondence Heritage."

3. LHF to RP and Frederick G. Schmidt, April 9, 1962, Series 1762, Box 2, "Ethnic Project-Ethnic Park"; May 29, 1962, Series 678, Box 14, Folder 1, "Field Reports Fishel, 1962."

4. RSS to JCJ, September 10, 1964, Series 992, Box 2, Folder 2, "Historic Sites Committee, 1964–1969"; LHF to Executive Committee, September 10, 1964, 1988/222, "Scott M. Cutlip, 1964."

5. OMC, minutes, October 16, 1964, Series 1910, Box 12, Folder 5, "OMC, 1964."

6. LHF to Scott M. Cutlip, November 22, 1964, 1988/222, "Scott M. Cutlip, 1964"; Fishel interview. Professional planners were expensive. The St. Mary's City Commission employed urban planner Robert L. Plavnick. The commission funded the $50,156 cost, which had to be supplemented locally with $28,083, through a federal grant. *Annual Report of the St. Mary's City Commission to the Governor and to the General Assembly of the State of Maryland, Fiscal Year 1968* (St. Mary's City, Maryland, 1968), 4.

7. Fishel interview.

8. McCarthy interview.

9. Tishler interview, May 5, 1993.

10. Tishler interview, February 21, 1994; LHF to RP, December 30, 1966, Tishler Papers, "Correspondence Heritage."

11. Fishel interview.

12. Tishler interview, February 21, 1994; Tishler interview (Kapler); G. Wm. Longenecker to LHF, October 19, 1966, LHF to Longenecker, October 31, 1966, Summary of meeting with Sivesind, December 14, 1966, WT to LHF, March 7, 1967, Tishler Papers, "Correspondence Heritage."

13. Tishler interview, February 21, 1994; *Heritage Village Wis. A Study by the Department of Landscape Architecture and the State Historical Society of Wisconsin* [Madison, WI, 1967]; LHF to RP, December 30, 1966, Tishler Papers, "Correspondence Heritage."

14. WT to students, ca. December 1966, Tishler Papers.

15. Tishler interview, February 21, 1994.

16. *Heritage Village*, 1–2.

17. Fishel interview.

18. WT to author, April 8, 2009, personal correspondence.

19. Tishler interview, May 5, 1993; *Heritage Village*, 3.

20. Tishler interview, February 21, 1994; WT to students, ca. December 1966, Tishler Papers.

21. Gutzman interview.

22. Tishler interview, May 5, 1993; Tishler interview, February 21, 1994.

23. Tishler interview, May 5, 1993; *Heritage Village*, 4; Gutzman interview.

24. *Heritage Village*, 5–6.

25. Ibid., 7.

26. Ibid., 15–19.

27. Gutzman interview.

28. *Heritage Village*, 9; RSS to WT, April 19, 1967, Tishler Papers; Dean Glenn S. Pound to Cutlip, April 26, 1967, Tishler Papers, "Ethnic Grad Studies"; "Additional Data—Ethnic Village Project," February 14, 1967, Adm Bldg, "Planning and Development."

29. LHF, Opening Remarks (taped), February 14, 1967; WT to LHF, March 7, 1967, Note, Tishler Papers, "Correspondence Heritage"; Tishler interview, February 21, 1994.

30. RSS to WT, March 9, 1967, LHF to WT, April 3, 1967, Tishler Papers.

31. Ethnic Village Park—Phases IIIB & V—Design Proposals F.N. 352Pl06, May 16, 1967, Tishler Papers; Gutzman interview; NF to WT, June 5, 1967, Tishler Papers, "Correspondence Heritage"; LHF, Opening Remarks (taped), February 14, 1967.

32. State Historical Society of Wisconsin Schedule of Meetings, Board of Curators, Eagle Waters Resort, Eagle River, Wisconsin, June 22–24, 1967, Tishler Papers, "Correspondence Heritage"; "Resolution of Appreciation," August 10, 1967, Tishler Papers; "Director's Report, 1966–67," ca. July 1967, Historic Sites and Markers Division, Series 678, Box 4, Folder 4, "Annual Reports 1966–67"; Class Presentation to Landscape Architecture Faculty and OWWC (taped), June 3, 1967.

33. Typed remarks, undated, Tishler Papers.

34. "Director's Report, 1966–67," ca. July 1967, Series 678, Box 4, Folder 4, "Annual Reports 1966–67"; "Proceedings of the . . . SHSW, 1966–1967," *WMH* 51, no. 1 (Autumn 1967): 83, 85; Tishler interview, May 5, 1993.

35. Tishler interview, February 21, 1994.

36. NF, "Outdoor Museum Committee: A Progress Report," October 2, 1967, Tishler Papers, "Correspondence Heritage"; RP to WT, January 29, 1968, WT to Kuether, November 6, 1968, Tishler Papers, "Correspondence Heritage"; LHF to RAE and RSS, February 2, 1968, 1979/202, "OWWC, 1968"; RSS to LHF, February 22, 1968, 1979/202, "Committee Reports, OWW, 1968."

37. LHF to Richard P. Hartung, April 17, 1968, Tishler Papers, "Correspondence Heritage."

38. Tishler interview, May 5, 1993; NF, "Outdoor Museum Committee: A Progress Report," October 2, 1967, Tishler Papers, "Correspondence Heritage"; Tishler interview, February 21, 1994; WT to Robert M. Bock, June 2, 1967, Tishler Papers, "Correspondence Heritage"; Tresch interview.

39. Tishler interview, May 5, 1993; Buchholz interview (Kapler).

40. Tresch interview.

41. LHF to NF, September 28, 1967, Tishler Papers.

42. Robert Sherman, the staff member assigned to do the inventory of historic buildings, had examined about thirty-four of the fifty-three Perrin had previously identified. Meeting OWW (RSS, RAE, JWW, BK [most likely Barbara Keiser, Mass Communication History Center director), "Heritage Village: Inventory List of Buildings," January 11, 1968, 1980/032, "Winn OWW (Culled from other Cartons)"; Tishler interview, February 21, 1994; Tresch interview; RP to WT, January 29, 1968, 2007/135, "OWWC—Heritage"; JWW to RSS, June 20, 1968, 1986/097, "SHSW, Assistant Dir. OWW 68–75, OWW Building Survey."

43. Tishler interview, May 5, 1993; Tishler interview, February 21, 1994.

44. Hiestand to LHF, January 2, 1968, Series 1048, Box 1, Folder 5, "Administration, Dept of—1968–69."

45. LHF to OWWC, May 16, 1969, 1997/177, Box 1, "OWW Land Acquisitions"; Confidential Meeting of the Board of Directors, WHF, minutes, May 27, 1969, 1981/160, "WHF, minutes, 1968–1971."

46. RAE to LHF and RSS, September 16, 1968, 1979/202, "OWWC, 1968."

47. WT to Kuether, November 6, 1968, Tishler Papers; Buchholz interview (Kapler); "Proceedings of the . . . SHSW, 1968–1969," *WMH* 53, no. 1 (Autumn 1969): 71.

48. William H. Tishler, Philip S. Tresch, Richard L. Meyer, and Michael R. Buchholz, *Old World Wisconsin: A Study Prepared for the State Historical Society* (Madison, 1968), 55, 66.

49. Ibid., 67.

50. Ibid., 68.

51. Ibid., 69–70.

52. Ibid., 85.

53. Ibid., chapter 7 (the projections are found on pages 106, 109, and 113); Buchholz interview (Kapler); Joseph E. Kapler, Jr., "Expectations and Reality: The Attendance Issue and Ramifications at Old World Wisconsin" (master's essay, Marquette University, 1995); Buchholz interview (Kapler).

54. Barbara Burlison Mooney, "Lincoln's New Salem: Or, the Trigonometric Theorem of Vernacular Restoration," *Perspectives in Vernacular Architecture* 11 (2004): 22; St. Mary's City Commission, Report, Minutes, First Meeting, August 3, 1966, Historic St. Mary's City, Administration Building, 1.4.2.1 FYs 1969-68-67.

55. Tishler interview, May 5, 1993; *Old World Wisconsin*, 82, 78: The plan called for seven farmsteads, each of which had three buildings. Fishel interview (Kapler); LHF, Some Thoughts for the Long-Range Historic Sites Planning Committee, October 7, 1968, Series 1910, Box 10, Folder 3.

56. RP to WT, January 29, 1968, LHF to NF, May 31, 1968, Tishler Papers, "Correspondence Heritage"; Tishler interview, May 5, 1993.

57. Erney interview; Fishel interview; "Proceedings of the . . . SHSW, 1968-1969," *WMH* 53, no. 1 (Autumn 1969): 68.

58. Board of Curators Meeting, October 25, 1968, as reported in "Proceedings of the . . . SHSW, 1968-1969," *WMH* 53, no. 1 (Autumn 1969): 68; "Briefing Script OWW," December 16, 1971, 1979/188, "Briefing OWW"; 1986/097, "WHA OWW Brief Basic Script"; WT to Kuether, November 6, 1968, Tishler Papers, "Correspondence Heritage."

Chapter Four. Conflict Management

1. Historic Sites Committee, October 3, 1969, Series 1910, Box 8, Folder 10, "Historic Sites Committee, 1969-1971"; LRSPC, minutes, October 3, 1969, Series 1910, Box 10, Folder 3, "LRSPC, 1968-69"; SHSW Staff Newsletter 7:7, October 1969; RAE to Paul Brown, Director of Administration, April 8, 1969, Series 1048, Box 1, Folder 5, "Administration, Dept. of—1968-69"; SHSW budget requests 1969-1971, April 9, 1969, 1981/281, "Special Communications, Curators, 1969-70."

2. Erney interview.

3. Ibid.

4. RZ to LHF, January 17, 1969, Series 958, 1997/078, "Robert S. Zigman, 1969-1976."

5. "On Wisconsin: Leslie Fishel's Useful Part in Preserving State's History," *Milwaukee Journal*, January 17, 1969; LRSPC, minutes, October 3, 1969, Series 1910, Box 10, Folder 3, "Raymond S. Sivesind."

6. RAE to RSS, WHA, TOF (Thomas O. Fox), August 8, 1969, undated draft of Erney letter sent to Thomas H. Barland on September 3, 1969, LRSPC,

minutes, October 3, 1969, Series 1910, Box 10, Folder 3, "LRSPC, 1968–69"; RAE to John C. Geilfuss, September 19, 1969, 1986/097, "SHSW Assistant Dir. OWW 68–75, OWW Correspondence, 1969."

7. RAE to OWWC, October 6, 1969, Series 1910, Box 10, Folder 3, "Raymond S. Sivesind."

8. Ibid.

9. Ibid.

10. Ibid.

11. Ibid.

12. Ibid.

13. Ibid.

14. Ibid.

15. Ibid.

16. Thomas Jefferson to John Holmes, Monticello, April 22, 1820, in Paul Leicester Ford, ed., *The Writings of Thomas Jefferson*, 10 vol. (New York: G. P. Putnam's Sons, 1892–99), 10:159.

17. Cronon interview.

18. Ibid.

19. Erney interview; Tishler interview, February 21, 1994.

20. RZ to NF, October 13, 1969, 1986/097, "SHSW Assistant Dir. OWW 68–75, OWW Correspondence, 1969."

21. RP to NF, October 14, 1969, Perrin Papers, "S.H.S.W. 1969, 70, 71, 72."

22. Ibid.

23. Ibid.

24. Ibid.

25. Ibid.

26. Erney interview.

27. Joint meeting of LRSPC and OWWC, October 16, 1969, Series 1910, Box 10, Folder 3, "Raymond S. Sivesind."

28. Ibid.; John Schroeder, "No Funds for Ethnic Village: Museum Doldrums," *Waukesha Freeman*, April 9, 1970.

29. Tishler interview, February 21, 1994; RP to NF, October 14, 1969, Perrin Papers, "S.H.S.W. 1969, 70, 71, 72"; Joint meeting of LRSPC and OWW, October 16, 1969, Series 1910, Box 10, Folder 3, "Raymond S. Sivesind"; "The Report of the LRSPC 1970 Adopted by the Board of Curators," June 19, 1970, Series 1910, LRSPC, 1970, Box 10, "Final Report."

30. "The Society's New Director," *WMH* 53, no. 3 (Spring 1970): 162; E. David Cronon quoted in "The Society at One Hundred Fifty Years," *WMH* 79, no. 4 (Summer 1996): 321–22.

31. NF to RAE, January 13, 1970, phone conversation, RAE with Al Ehly, January 15, 1970, RAE to NF, January 20, 1970, RSS to RAE, February 11, 1970, 1979/202, "OWWC, 1970"; Cronon interview.

32. RP to Henry S. Reuss (HSR), January 9, 1971, RP to JMS, January 9, 1971, 1993/041, "OWW Financial Contributions"; JMS to Roger Axtell (RA), January 27, 1971, JMS to RP, January 29, 1971, 1979/202, "OWWC, 1971."

33. E. David Cronon (EDC) to HSR, February 3, 1971, 1993/041, "OWW Financial Contributions"; RA to WHA, February 4, 1971, 1979/202, "OWWC, 1971."

34. RA to HSR, February 18, 1971, RA to RZ, April 7, 1971, 1986/097, "(Applegate), OWW Correspondence, 1971."

35. Cronon interview.

36. RA to RZ, April 7, 1971, RA to WT, May 28, 1971, 1979/202, "OWWC, 1971"; WHA to JMS et al., May 12, 1971, 1997/177, Box 1, "OWW Land Acquisitions"; "For File: Meeting on OWW at Representative Reuss's home," May 24, 1971, 1993/041, "OWW Financial Contributions"; Cronon interview.

37. RZ to RA, May 21, 1971, 1986/097, "WHA OWW Correspondence, 1971"; RA to RZ, 1979/188, "Briefing OWW."

38. Bernadette Wilhelm, Adm. Asst. Office of Director, to WHA, RSS, RAE, March 9, 1971, handwritten notes of a meeting between Axtell, Cronon, RAE, RSS, JMS, March 22, 1971, 1979/202, "OWWC, 1971."

39. Gary A. Payne and N. P. Payne to JMS, May 21, 1973, WHA to JMS, May 12, 1973, 1986/097, "WHA Minutes and Staff Reports"; N. P. Payne to Chet Schmiedeke, May 6, 1974, 1979/188, "OWW Current PR."

40. "Plan Commission Study of Old World Wisconsin," June 4, 1973, 1979/188, "OWW PR Post Impact Statement"; quote from Whitney Gould in "Old World Wisconsin—Caught In Between," *Capital Times*, July 12, 1973; *Eagle Town Crier*, July 12, 1973.

41. Jean Loerke to JWW, March 31, 1973, 1986/097, "WHA Minutes and Staff Reports"; John Schroeder, "Look at the Past May Change Site's Future: Old World Wisconsin Shakes up Eagle Town," *Waukesha Freeman*, August 28, 1973.

42. Ann Luke, "Letters," *Eagle Town Crier*, October 13, 1973.

43. Whitney Gould, "Old World Wisconsin—Caught In Between."

44. JMS to William J. Sasko, February 6, 1973, 1986/097, "SHSW Assistant Dir. OWW 68-75, OWW-Eagle Town Board-Litigation."

45. Hauser interview.

46. Thomas A. Day to JMS, March 13, 1973, "Taxpayers!! Beware!!" *Eagle Town Crier*, July 7, 1973, attached to a note dated July 1, 1973, WHA to JWW, who labeled the author of the letter an "unmitigated liar," 1975/239, "OWW Correspondence, 1973."

47. Alan C. Pape (ACP), March 19, 1973, "OWW Display in Eagle," Adm Bldg, "Planning & Development—1973"; "Town Residents Renew Campaign Against the Museum," *Milwaukee Journal*, August 11, 1973.

48. The legislature modeled this law, Sec. 1.11, Chapter 274, Laws of 1971, on the National Environmental Policy Act, which took effect on January 1, 1970.

49. Tishler interview, May 5, 1993.

50. The State Historical Society of Wisconsin *Draft* EIS, March 1973; "General Reply by the State Historical Society to Comments on the Draft Environmental Impact Statement," 1980/032, "JWW OWW Files (loose)."

51. N. P. and G. A. Payne to JMS, June 18, 1973, 1979/188, "OWW PR Post Impact Statement"; John Schroeder, "Seitz Won't Forsake Citizen's Fight," *Waukesha Freeman*, June 30, 1973; "Town Opposes Ethnic Village," *Milwaukee Sentinel*, June 30, 1973; "Eagle Town Undecided on Fighting Museum," *Waukesha Freeman*, August 10, 1973; "Ethnic Village Advances," *Milwaukee Journal*, July 13, 1973.

52. "Eagle Halts Museum, Faces Suit," *Waukesha Freeman*, August 13, 1973.

53. Ibid.; "Too Late to Block Ethnic Museum," *Waukesha Freeman*, August 14, 1973; "Ethnic Village Resumes Building, *Waukesha Freeman*, August 14, 1973; "Judge Says Eagle Can't Stop Project," *Milwaukee Journal*, August 24, 1973.

54. *Eagle Town Crier*, August 18, 1973; *Report on Old World Wisconsin Litigation*, SHSW, Executive Committee, minutes, September 15, 1973, 1975/239, "OWW Correspondence, 1973"; "Eagle Town Sues for $5 Million as Reply," *Waukesha Freeman*, September 27, 1973; SHSW, Board of Curators, minutes, October 20, 1973, 1993/041, "OWW Financial Contributions."

55. SHSW, Board of Curators, minutes, October 20, 1973, 1993/041, "OWW Financial Contributions"; Ann Luke, "Letters," *Eagle Town Crier*, October 13, 1973.

56. JMS Deposition, December 20, 1973, 1986/103, "Eagle Town Board JMS Deposition."

57. OWW Technical Assistance Subcommittee, minutes, February 26, 1974, 2007/135, "OWW Technical Review Committee, 1973-1975."

58. SHSW, Executive Committee, minutes, August 24, 1974, 1980/032, "Winn OWW (Culled from other Cartons)"; JWW to RP, September 12, 1974, Perrin Papers, "S.H.S.W. 1969, 70, 71, 72"; Discussion for settling legal case, September 24, 1974, 1986/097, "SHSW Assistant Dir. OWW 68-75, Eagle Town Board-Litigation"; "Meeting of the Zoning and Planning Commission, September 2, 1974," *Palmyra Enterprise*, September 12, 1974; "On Wisconsin Around the State," *Milwaukee Journal*, November 18, 1974; Bleck to Dempsey, March 10, 1975, 1986/097, "SHSW Assistant Dir. OWW 68-75, Eagle Town Board-Litigation"; JMS for Files Re "Conversation with Mr. Bleck, the Assistant District Attorney General," March 13, 1975, 1986/097, "WHA OWW Correspondence, 1975."

59. SHSW, Budget Review Committee, minutes, June 12, 1975, 1979/173, "Executive Committee 1975"; JMS conservation with Carl Seitz, July 1, 1975, Bleck to Voss, July 22, 1975, Bleck to Smith, October 24, 1975, 1986/097, "SHSW Assistant Dir. OWW 68-75, Eagle Town Board-Litigation"; John Schroeder, "Town May Quit 'Old World Wisconsin' Fight," *Waukesha Freeman*, November 13, 1974; 1975 Press release 550-250080-75, "Old World Wisconsin Legal Dispute Settled."

Chapter Five. Fund-Raisers

1. "Pioneer Park," 22–23; JMS Memo: OWW Committee meeting, La Crosse, June 17, 1971, 1979/202, "OWWC, 1971"; Axtell interview.

2. LHF, "State Support of Historic Sites," October 16, 1964, 1988/222, "Scott M. Cutlip, 1964."

3. Ibid.; Application for Federal Assistance, October 15, 1973, Adm. Bldg., "OWW Grants, 1973"; SHSW, Executive Committee, minutes, June 17, 1976, Budget Review and Finance Committee, 1979/173, "Executive Committee, 1975."

4. Cronon interview.

5. December 17, 1959, 1997/169, Box 1, Folder 1, "Log of Leslie H. Fishel, Jr. 3/25/59–12/23/59"; RZ to Barland, October 13, 1967, 1997/078 (Series 958), "Robert S. Zigman 1967–1976"; SHSW, Board of Curators, minutes, February 20, 1975, 1993/193, "OWW Fundraising Campaign."

6. LHF to Mrs. Robert Friend, July 30, 1963, 1988/222, "Friend, Mrs. Robert, 1951–1972"; NF to LHF, February 10, 1965, LHF to NF, February 17, 1965, 1979/202, "OMC, 1965"; LHF to NF, September 28, 1967, Tishler Papers, "Correspondence Heritage."

7. Occasional Paper #11, March 2, 1965, Series 958, Board of Curators, Correspondence, Box 1, "Special Communications"; OMC, minutes, January 29, 1965; RAE to LHF and JCJ, February 1, 1965, RSS to LHF, RAE, and JCJ, February 22, 1965, 1979/202, "OMC, 1965."

8. RZ to LHF, March 14, 1968, 1997/078 (Series 958), "Robert S. Zigman 1969–1976"; RZ to LHF, April 5, 1968, 1986/097, "WHA OWW Fin Subcmte"; Zigman interview; "Digest of Board of Curators Actions, October 25–26, 1968, "Proceedings of the . . . SHSW, 1968–1969," *WMH* 53, no. 1 (Autumn 1969): 71.

9. RZ to LHF, April 5, 1968, LHF to RZ, April 25, 1968, 1986/097, "WHA OWW Fin Subcmte."

10. LHF to RZ, April 29, 1968, 1986/097, "WHA OWW Fin Subcmte"; OWWC, minutes, January 24, 1969, 1986/097, "WHA OWW Correspondence, 1971"; RZ to LHF, April 5, 1968, LHF to RZ, April 25, 1968, 1986/097, "WHA OWW Fin Subcmte"; Zigman interview.

11. RA to OWWC, January 7, 1971, 1979/202, "OWWC, 1971"; RP to LHF, January 19, 1971, RP to HSR, 1993/041, "OWW Financial Contributions."

12. Investigative reporter Jack Anderson highlighted the ways in which congressional representatives benefited or potentially benefited from federal money deposited in state banks. He noted Reuss and his extensive holdings in M&I Bank. "Reuss' Secret Bank Holdings Bared," reprinted in Madison's *Capital Times*, January 7, 1972. Winn had a copy in his files: 1993/041, "OWW Financial Contributions." For the bank's history, see Ellen D. Langell, *Powered by Our Past: 150 Years of Marshall & Ilsley Bank* (Milwaukee: M & I Corporation, 1997).

13. Axtell interview; Cronon interview; SHSW, Budget Review Committee, minutes, June 12, 1975, 1979/173, "Executive Committee, 1975."

14. HSR to EDC, February 16, 1971, Tishler Papers, "Correspondence Heritage"; WHA, Trip Report Re Old World Wisconsin Conference, February 12, 1971, 1993/041, "OWW Financial Contributions"; Cronon interview; Frank A. Aukoder, "Reuss Holdings Top Half Million," *Milwaukee Journal*, December 23, 1973; Louise Sweeny, "Rep. Henry Reuss: A Rich Paradox," *Christian Science Monitor*, reprinted in *Wisconsin State Journal*, April 7, 1975.

15. RA to HSR, February 18, 1971, 1993/041, "OWW Financial Contributions"; Cronon interview.

16. HSR to author, July 29, 1999, personal correspondence.

17. The sale of stock plus dividends totaled $100,521.67. "Old World Wisconsin July 1, 1971, to December 31, 1972 (18 months)," January 19, 1973, 1986/197, "WHA OWW Fin Subcmte."

18. "Management Review of the State Historical Society Presented by Department of Administration Management Analysis Unit," January 30, 1976, 1981/281, "Special Communications, Curators 1969–70."

19. RA to RZ, June 21, 1971, 1979/202, "OWWC, 1971"; RA to RZ, July 21, 1971, Adm Bldg, "OWW PR—Publicity—Milw Journal"; RAE to JMS, October 1, 1971, 1993/041, "OWW Financial Contributions"; JMS to Mrs. Robert E. Friend, February 22, 1972, WHA to RAE, JMS, May 22, 1972, JMS to WHA et al., June 30, 1972, 1988/222, "Friend, Mrs. Robert, 1951–1972." Neita Friend's indignation did not last too long. At the end of the year, the Society reported that she pledged $22,000. OWW Financial Subcommittee, minutes, November 28, 1973, 1986/097, "WHA OWW Fin Subcmte."

20. JMS comments are from a note by WHA, April 30, 1973, 1986/097, "WHA OWW Fin Subcmte"; Zigman interview.

21. William Penn, *Some Fruits of Solitude, in Reflections and Maximums relating to the Conduct of Human Life*, 5th ed. with additions (London, 1693), A4.

22. RA to RZ, April 7, 1971, 1986/097, "SHSW Assistant Dir. OWW 68–75, OWW Correspondence, 1971"; WHA to JMS, RAE, JWW, October 30, 1972, 1993/041, "OWW Financial Contributions."

23. RA to JMS, May 2, 1973, 1986/097, "WHA OWW Fin Subcmte"; "Funding Old World Wisconsin," undated, possibly end of May 1973, 1986/097, "WHA Assistance Requests and Offers OWW"; JMS to OWW Financial Subcommittee, April 25, 1973; Axtell to JMS, May 2, 1973, clipped with April 30, 1973, with note for JMS only from WHA, 1986/097, "WHA OWW Fin Subcmte."

24. "75 Buildings for Bicentennial Get Support," *Milwaukee Journal*, August 26, 1972; JMS to HSR, September 29, 1972, 1993/041, "OWW Financial Contributions."

25. Briefing Script Old World Wisconsin, December 16, 1971, 1979/188, "Briefing OWW," and 1986/097, WHA, "OWW Brief Basic Script"; "Ethnic Museum Seeks US Aid," *Milwaukee Journal*, December 17, 1971; Wisconsin American Revolution Bi-centennial Commission, meeting, August 25, 1972,

noted in HSR to JMS, September 15, 1972, 1993/041, "OWW Financial Contributions"; "Proceedings of the . . . SHSW, 1971-1972," *WMH* 56, no. 1 (Autumn 1972): 69-76; "US Bicentennial Board Scuttles State Parks Plan," *Milwaukee Journal*, May 16, 1973.

26. JMS to HSR, September 29, 1972, 1993/041, "OWW Financial Contributions"; "Ethnic Museum Park," *Milwaukee Journal*, September 22, 1972; "Old World Wisconsin: Our Bicentennial Park," *Potpourri Junior League of Milwaukee*, January 1973, 14; Loren H. Osman, "New Support for Ethnic Museum," *Milwaukee Journal*, March 1, 1973.

27. Loren H. Osman, "New Support for Ethnic Museum," *Milwaukee Journal*, March 1, 1973; OWWC, minutes, October 20, 1972, 2009/135, "Old World Wisconsin, Technical Review Committee, 1973-1975"; SHSW, Executive Committee, minutes, January 12, 1974, 1979/193, "Executive Committee 1974"; "US Board Scuttles State Parks Plan," *Milwaukee Journal*, May 16, 1973; Peter B. Seymour, "Old World Wisconsin: History or Dreams?," *Capital Times*, June 1, 1973; Knipping interview.

28. RA to Paul E. Hassett, March 20, 1973, JMS to OWW Financial Subcommittee, April 25, 1973, 1986/097, "WHA OWW Fin Subcmte."

29. JMS to OWW Financial Subcommittee, April 25, 1973, 1986/097, "WHA OWW Fin Subcmte"; Mrs. Ervin M. Mueller to WHA, October 20, 1976, 1968/097, "WHA Wisconsin Garden Clubs." Unfortunately, the museum was not ready to use these funds, which led to some hard feelings between Mrs. Mueller and John Harbour.

30. WT to RP, October 31, 1972, RP to WT, November 2, 1972, WT to WHA, November 14, 1972, 1975/239, "WHA Project Files, 1970-1973"; Victor Greene to JMS, April 18, 1973, 1993/193, "OWW Public Relations."

31. *Old World Wisconsin: An Outdoor, Ethnic Museum*, 40; RA to RP, May 24, 1971, 1979/202, "OWWC, 1971"; RAE to Ralph Schaefer, May 6, 1971, 1986/097, "SHSW Assistant Dir. OWW 68-75, UWW Build. Survey"; JMS to HSR, July 13, 1971, 186/097, "WHA Minutes of Staff Reports & Com"; Memorandum of phone call this morning from Congressman Henry Reuss, October 21, 1971, JMS to HSR, January 3, 1972, 1993/041, "OWW Financial Contributions"; RP to JMS, March 23, 1973, 1993/193, "OWW Buildings"; "Old World Wisconsin Construction," October 24, 1973, 1986/097, "WHA OWW Bldg Const & Acquis, 1973-75"; JMS to Wilhelm Hoffman, Director, Pomeranian Society, January 17, 1973, 1986/097, "SHSW Assistant Dir. OWW 68-75, German Proposal for Koepsell"; WHA to RA, ca. February 12 with letter February 14, 1973, RA to WHA, 1986/097, "WHA OWW Fin Subcmte"; SHSW Executive Committee, minutes, May 1, 1976, 1979/173, "Executive Committee, 1975."

32. RA to WHA, ca. February 12 with letter February 14, 1973, WHA to LTC [Lieutenant Commander] Don Green, Commander 2/128 Infantry Battalion, May 24, 1973, R. L. Smith to WHA, June 4, 1973, 1986/097, "WHA

OWW Fin Subcmte"; Green to SHSW, June 30, 1973, WHA to Lt. Schneider, January 12, 1974, 1986/097, "WHA OWW Correspondence, 1973, 1974," 1986/097, "WHA Assistance Requests and Offers OWW."

33. SHSW, Board of Curators, minutes, October 20, 1973, 1993/041, "OWW Financial Contributions"; ACP to JMS, October 27, 1973, Adm Bldg, "Committee—OWW—Corres thru 1979"; OWW Financial Subcommittee, minutes, November 28, 1973, 1986/097, "WHA OWW Fin Subcmte." Fifteen Carroll College students researched Welsh settlements for OWW in the summer of 1974. SHSW, Executive Committee, minutes, January 11, 1975, 1993/193, "OWW Fundraising Campaign."

34. WHA to RA, with letter of January 14, 1973, 1986/097, "WHA OWW Fin Subcmte"; OWWC, minutes, February 27, 1973, 2007/135, "OWW Technical Review Committee, 1973-1975"; Victor Greene to JMS, April 18, 1973, 1993/193, "OWW Public Relations."

35. "Funding Old World Wisconsin," undated, possibly end of May 1973, 1986/097, "WHA Assistance Requests and Offers OWW."

36. OWW Financial Subcommittee, minutes, April 30, 1973, RZ to OWW Financial Subcommittee, May 8, 1973, 1986/097, "WHA OWW Fin Subcmte"; SHSW, Executive Committee, minutes, January 12, 1974, 1979/193, "Executive Committee, 1974."

37. JMS to Board of Curators, November 11, 1974, Adm Bldg, "RES-VB Ramsey Barn Corres 71-74"; JMS to RZ, April 24, 1974, 1986/097, "WHA OWW Fin Subcmte."

38. WHA to Mrs. Henry Baldwin, September 19, 1974, 1986/097, "WHA, Assistance Request and Offer OWW"; JMS to Warner, February 25, 1975, 1986/097, "WHA OWW Correspondence, 1975"; JMS to WT, October 3, 1974, Tishler Papers.

39. SHSW, Executive Committee, minutes, January 11, 1975, JMS to WHA, January 20, 1975, 1993/193, "OWW Fundraising Campaign"; Carlson Presentation List, February 13, 1975, 1993/193, "OWW Fundraising Campaign."

40. Arville Schaleben to Howard W. Mead, January 29, 1975, RZ to Mead, January 30, 1975, Reed Coleman to Mead, February 4, 1975, 1993/193, "OWW Fundraising Campaign."

41. Smith memo to files on William Carlson presentation, February 14, 1975, Smith memo to files on Fund Raising Committee on OWW, February 14, 1975, 1993/193, "OWW Fundraising Campaign."

42. JMS to Members of Joint Finance Committee, February 25, 1975, 1986/097, "WHA OWW Budget Materials."

43. Smith memo to files regarding telephone conversation with Mrs. Hannah Swart, February 14, 1975, 1993/193, "OWW Fundraising Campaign"; RP to Schmidt, February 26, 1975, Perrin Papers, "S.H.S.W. 1969, 70, 71, 72."

44. List of attendees, Carlson presentation with WHA comments, February 13, 1975, 1993/193, "OWW Fundraising Campaign."

45. SHSW, Board of Curators, minutes, February 20, 1975, 1993/193, "OWW Fundraising Campaign."

46. SHSW, Technical Committee, minutes, February 14, 1974, Adm Bldg, "OWW — Meetings thru 1974"; JMS to Chester L. Tolson, May 15, 1975, SHSW, Executive Committee, minutes, May 17, 1975, Fundraising Campaign — Old World Wisconsin, undated but after May 17, 1975, JMS to William Brault, September 11, 1975, 1993/193, "OWW Fundraising Campaign."

47. WHF, Board of Directors, minutes, June 12, 1975, 1993/193, "OWW Fundraising Campaign"; Budget Review Committee, minutes, June 12, 1975, 1979/173, "Executive Committee, 1975"; "Proposed Campaign Plan: Old World Wisconsin," June 12, 1975, 1993/193, "OWW Fundraising Campaign."

48. SHSW, Executive Committee, minutes, May 17, 1975, JMS memo to the files regarding phone conversation with Darlene Hatter, May 22, 1975, 1993/193, "OWW Fundraising Campaign"; "Proceedings of the . . . SHSW, 1974-1975," WMH 59, no. 2 (Winter 1975-1976): 158.

49. "Kohlers to Head Fund Raising for Museum," Milwaukee Journal, December 16, 1975, Tolson to WHA, undated but before August 18, 1975, H. M. Benstead to Mead, August 6, 1975, Murphy to Mead, August 20, 1975, JMS to WHA, October 15, 1975, 1993/193, "OWW Fundraising Campaign."

50. WHA to JMS, February 10, 1976, WHA to JMS and RAE, October 23, 1975, 1993/193, "OWW Fundraising Campaign"; SHSW, Executive Committee, minutes, January 10, 1976, 1979/173, "Executive Committee, 1975"; "Vandals Damaged Ethnic Museum," Milwaukee Journal, January 20, 1976; Old World Wisconsin Fund Drive Area Chairman, minutes, March 17, 1976, 1993/193, "OWW Fundraising Campaign"; Tolson to Kohler, March 19, 1976, SHSW, Executive Committee, minutes, March 29, 1976, 1979/173, "Executive Committee, 1975"; SHSW, Executive Committee, minutes, Murphy to WHF directors, April 21, 1976, 1979/173, "Executive Committee, 1975."

51. SHSW, Executive Committee, minutes, May 1, 1976, 1979/173, "Executive Committee, 1975."

52. OWWC, minutes, October 14, 1977, 1986/097, "WHA OWW Technical Assistance Subcmte."

53. Revision No. 3, May 3, 1972, "The Society and the Seventies: A Case Study," 1981/281, "Special Communications Curators 1969-70"; "Proceedings of the . . . SHSW, 1969-70," WMH 54, no. 1 (Autumn 1970): 66; "Proceedings of the . . . SHSW, 1970-1971," WMH 55, no. 1 (Autumn 1971): 69; "Proceedings of the . . . SHSW, 1974-1975," WMH 59, no. 2 (Winter 1975-1976): 170; JMS to Members of Joint Finance Committee, February 25, 1975, 1980/097, "WHA OWW Budget Materials"; SHSW, Executive Committee, minutes, January 11, 1975, 1993/193, "OWW Fundraising Campaign"; Mead to Board of Curators, April 16, 1975, 1981/281, "Special Communications Curators 1968-70."

54. "Ethnic Museum Needs Commitment," Waukesha Freeman, February 1, 1972.

55. SHSW, Executive Committee, minutes, January 10, 1976, 1979/173, "Executive Committee, 1975"; SHSW, Executive Committee, minutes, September 15, 1973, 1975/239, "OWW Correspondence, 1973"; SHSW, Executive Committee to Board of Curators, February 23, 1974, 1979/193, "Executive Committee, 1974"; SHSW, Executive Committee, minutes, August 24, 1974, 1980/032, "Winn OWW (Culled from other Cartons)."

56. OWW Financial Subcommittee, WHA minutes, September 21, 1972, 1986/097, "WHA OWW Fin Subcmte"; WHA to JMS, RAE, and Kaiser, February 19, 1976, Adm Bldg, "OWW Supporters WI Hist Found"; Milwaukee Cabinet, minutes, February 25, 1976, 1993/041, "OWW Fundraising Cabinet."

57. WHA to Mrs. R. W. Bertran, June 27, 1974, WHA to Nancy Scherr, June 27, 1974, 1986/097, "WHA Assn of Univ. Women & Coll Women"; WHA for acting director RAE to Joseph H. Sisk, Legislative Assistant to Reuss, December 3, 1976, 1993/041, "OWW Financial Contributions"; RA to OWWC, October 19, 1976, Tishler Papers.

Chapter Six. Builders

1. William H. Tishler, Mark H. Knipping, Alan C. Pape, Martin C. Perkins, Conference on Building OWW, OWW, December 2, 2009.

2. RP to LHF, RP, and JWW, August 2, 1968, 1993/193, "OWW Buildings."

3. OWW Conference, December 2, 2009; LHF to NF, September 28, 1967, Tishler Papers, "Correspondence Heritage"; Knipping interview; Fishel interview.

4. "Over $100,000 in Grants for Old World Wisconsin," *Staff Report* (10:8), July 1974, 1981/281, "Special Communications Curators, 1969–70"; Ralph Schaefer, *Index Reconstruction of Koepsell Half Timber House Job No. OWW #5*, April 1974, 1980/032, "Winn OWW (Culled from other Cartons)."

5. OWW Conference, December 2, 2009; RP to OMC, December 2, 1964, Series 1910, Box 12, Folder 5, "OMC, 1964," referenced in March 30, 1966, Perrin Papers, Box 14, Bound Folder "Old Sturbridge Village"; LHF to Executive Committee, September 10, 1964, 1988/222, "Scott M. Cutlip, 1964"; Pape interview, October 25, 2007. The term "Scandinavia," or "Scandinavian," has two meanings. Scandinavia is a region centered on the Scandinavia Peninsula. Since Finland was once a part of Sweden, it is sometimes included with Denmark, Norway, and Sweden. The term also has a broader cultural meaning that includes both Finland and Iceland. Users did not always distinguish between a stricter geographical definition and the broader cultural one. On this list, Perrin listed Norway and Finland as Scandinavian.

6. OMC, minutes, January 29, 1965, 1979/202, "OMC, 1965."

7. Meeting on Bong Air Base Use for the Outdoor Museum, March 3, 1965, 1979/202, "OMC, 1965." Some ethnic groups did not make this list: Finnish and Swiss. Fred Sammond to LHF, March 26, 1965, 1979/202, "OMC, 1965."

8. LHF to RAE and RSS, February 22, 1965, Series 678, Box 38, Folder 6, "Sites & Markers—Sites—General, 1965-1973"; RP to LHF, March 30, 1966, 1979/202, "OMC, 1966."

9. RSS to LHF, RAE, and JCJ, April 5, 1966, 1979/202, "OMC, 1966."

10. Robert Sherman to Krugler, July 31, 2009, personal correspondence. The survey of historic buildings in Wisconsin continues. In compliance with the National Historic Preservation Act in 1966, the State of Wisconsin created the State Historic Preservation Office (SHPO) in 1973. That year SHPO began a systematic survey of historic buildings and added nearly six hundred buildings to its inventory. Michael E. Stevens to Krugler, February 22, 2012, personal correspondence.

11. RAE memo for the file, February 8, 1974, 1997/177, Box 1, "OWW Land Acquisitions."

12. Loren H. Osman, "Historical Society Raps Zoning Request," *Milwaukee Sentinel*, February 16, 1973; Executive Committee, minutes, May 4, 1974, 1979/173, "Executive Committee, 1974"; N. P. Payne to Chet Schmiedeke, May 6, 1974, 1979/188, "OWW Current PR"; February 23, 1974, Executive Committee to Board of Curators, 1979/193, "Executive Committee, 1974."

13. OWWC, minutes, April 3, 1971, 1986/097, "WHA Minutes & Staff Reports"; HSR to JMS, September 15, 1972, JMS to HSR, September 29, 1972, 1993/041, "OWW Financial Contributions."

14. Consultants Tishler and Schaefer, meeting with OWW staff, January 7, 1974, Pape Collection; Development Schedule Alternative I, Jan 1974-July 1976, Adm Bldg, "OWW—Meetings thru 1974."

15. ACP, "Development of Old World Wisconsin," December 1979, Adm Bldg, "Planning and Development"; ACP to RP, May 26, 1976, Adm Bldg, "Correspondence—Misc"; Bargren, "Queenly Visit," *Waukesha Freeman*, May 15, 1976.

16. WHA draft, meeting with HSR, January 6, 1972, JWW, "List of buildings (based on review of Reuss-Smith December 1, 1971) updated and refined," January 6, 1972, 1980/132, "OWW Winn."

17. "Contributors," *WMH* 46, no. 4 (Summer 1963): 320; Ralph Schaefer to the Jury of Fellows, American Institute of Architects, December 30, 1959, Schaefer Papers, "Richard W. E. Perrin"; *Historic Wisconsin Buildings*, foreword, 5; McNeil to RP, June 17, 1958, RP to McNeil, July 16, 1958, Perrin Papers, "S.H.S.W. 1957, 58, 59, 60"; RP to John M. Kahlert, March 16, 1976, Perrin Papers, "Historical Correspondence, Miscellaneous 1976"; Schaefer interview, January 12, 2010.

18. The state created the Jackson Marsh as a state wildlife area in 1952. It preserves 2,312 acres. A dendrochronological analysis concluded that the timbers were cut in the winter of 1858. Martin C. Perkins concluded that Koepsell built the house in 1859. The 1860 census listed the family as being property owners, an indication that they had moved into the house by that time. An examination

of the records at the David Star Evangelical Church revealed a child was born on August 21, 1859. The newborn's father at that time was listed as "carpenter." "The Friedrich Koepsell Farm: A Pomeranian Carpenter's Farmstead of Washington County (Circa 1880)," August 31, 1978, Perkins Papers, 53; Richard W. E. Perrin, *The Architecture of Wisconsin* (Madison, 1967), 6; "Dedication: Richard W. E. Perrin Cultural History Trail Panels," Perkins Papers.

19. Schaefer interview, January 12, 2010.

20. OWW Conference, December 2, 2009. Jim Schaefer has a photo of himself and perhaps Mrs. Butt standing outside the house. He dated the photo as circa 1960. Schaefer interview, January 28, 2010; Perrin, *Wisconsin's Historic Buildings*, 18; Tishler, "Fachwerk Construction," 277, 279–82.

21. Perrin, "Wisconsin's Heritage Park: A Legacy of Many Nations," typescript of an article, 21 pages, March 19, 1969, Perrin Papers, "Wisconsin's Heritage Park: A Legacy of Many Nations, *Nord Nytt* [Denmark] (Spring 1969)."

22. On October 30, 1961, Perrin's secretary sent Butt's letter to Fishel with a sense of "urgency." Butt had written the letter on October 5 but did not send it to Perrin until October 27 because he did not know Perrin's address. Perrin Papers, "S.H.S.W. 1961, 62, 63, 64"; Ethnic Park Meeting, minutes, January 18, 1962, Series 1762, Box 2, "Ethnic Park Project-Ethnic Park."

23. Notes on meeting, RSS, RAE, JWW, and Barber J. Kaiser, January 11, 1968, 1980/132, "Winn, Heritage Village Inventory List of Buildings."

24. "Wisconsin's Circus World Museum," *WMH* 45, no. 4 (Summer 1962): 271; LHF, "Annual Report, 1968 Old World Wisconsin Committee," July 1968 [?], Series 678, Box 4, Folder 6; RSS, RAE, JWW, and Kaiser, meeting, January 11, 1968, 1980/032, "Winn, Heritage Village Inventory List of Buildings"; Jack C. Schuette, "Moving Evaluation of Heritage Village Project," undated 1968, 1993/193, "OWW Buildings." Fishel went into the hospital with a urinary tract infection before Christmas and did not get out until mid-January. John Jacques suffered a heart attack and was out indefinitely. Erney, who was in charge, characterized the situation as "kind of rag, tag, and bobtail, and a little battered around the ears." RAE to Robert Sherman, January 17, 1968, 1979/202, "OWWC, 1968"; RP to LHF, August 2, 1968, 1993/193, "OWW Buildings."

25. JWW to LHF, July 8, 1968, 1993/193, "OWW Buildings."

26. RP to LHF, August 2, 1968, 1993/193, "OWW Buildings."

27. The Society did not publicize the resignation until January 1969. "Proceedings of the . . . SHSW, 1968–1969," *WMH* 53, no. 1 (Autumn 1969): 68, 71; WT to Kuether, November 6, 1968, Tishler Papers; LHF to William Hoffman, December 23, 1968, 1997/202, "OWWC, 1968."

28. RZ to LHF, January 17, 1969, 1997/078 (Series 958), "Robert A. Zigman, 1967–1976"; LHF to RSS, RAE, et al., January 14, 1969, Series 678, Box 14, Folder 8, "Field Reports, Fishel, 1969"; "SHSW budget requests 1969–1971," April 9, 1969, 1981/281, "Special Communications, Curators, 1969–70."

29. RP to LHF, April 14, 1969, 1986/097, "WHA OWW Correspondence, 1971"; LHF to RP, April 17, 1969, 1993/193, "OWW Buildings."

30. JWW listed the disassembled Koepsell house, now at Eagle, as the top priority, January 6, 1972, "List of buildings (based on review of Reuss-Smith December 1, 1971) updated and refined," 1993/041, "OWW Financial Contributions."

31. OWW Conference, December 2, 2009.

32. Erney interview; JWW and JMS, re OWW, July 16, 1971, 1979/2022, "OWW Jack Winn Reports."

33. RSS to LHF, December 18, 1959, 1997/169, Box 1, Folder 1, 1960, "Log of Leslie H. Fishel, Jr. 3/25/59–12/23/59"; "Briefing Script OWW," December 16, 1971, 1979/188, "Briefing OWW."

34. "For File: Meeting on OWW at Representative Reuss's Home," May 24, 1971, 1986/097, "WHA Minutes & Staff Reports."

35. RAE to HSR, August 7, 1972, 1993/041, "OWW Financial Contributions."

36. JWW, "Old World Wisconsin Report for the Period 1/12–2/3/74," February 3, 1974, 1979/188, "OWW Current PR."

37. "Old World Wisconsin construction," October 24, 1973, 1980/032, "OWW Winn (stationery box)"; Schaefer, *Koepsell Half Timber House*, April 1974, 1980/032, "Winn OWW (Culled from other Cartons)"; RAE to RSS, May 6, 1971, 1986/097, "SHSW Assistant Dir. OWW, Build Survey"; Robert H. Irrmann to Technical Assistance Sub-committee, June 25, 1974, 2007/135, "OWW Technical Review Committee, 1970–1974."

38. Pape to RAE, RP, RSS, WT, JWW, and JMS, January 30, 1974, 1979/188, "OWW Current PR"; Murtagh, *Keeping Time*, 101–5; Morton W. Brown III and Gary L. Hume's *The Secretary of Interior: Standard for Historic Preservation Projects with Guidelines for Applying the Standards*, Technical Preservation Services, U.S. Department of the Interior (Washington, D.C.: GPO, 1979), became the standard by which historic rehabilitations informed Harbour's later conclusions.

39. ACP to Bjarne O. Breilid (BOB), October 29, 1975, BOB to WHA, November Report, 1975, 1986/097, "SHSW Assistant Dir. 71–79, OWW Monthly Reports."

40. Tyler, *Historic Preservation*, 217, Pape interview, October 25, 2007.

41. Restoration involved dismantling or moving intact an existing historic building and relocating it on a new site. Reconstruction involved the creation of a building that was no longer extant or too damaged to move; essentially it was a new construction.

42. Perkins, "The Friedrich Koepsell Farm," August 31, 1978, Perkins Papers; Gary A. Payne described the *Vierkanthof* as a four-sided farm plan that had four major buildings located on the sides of an open square to form the barnyard. "Interpretive Proposal North German Farm Exhibit, OWW," February 13, 1975, 1980/132, "Winn OWW Slide Show."

43. Meeting Notes (with 2/3 [Feb. 3]), January 24, 1974, 1979/188, "OWW Current PR"; Perkins interview, October 5, 2007; Mark Knipping and Alan Pape, "Report on Friedrich Koepsel House Site at Old World Wisconsin," March 16, 1972, 1986/097, "SHSW Assistant Dir. OWW 68-75, OWW—Eagle Town Board—Litigation."

44. Chet Schmiedeke to JMS, May 30, 1974, 1979/188, "OWW Current PR."

45. Pape interview, October 25, 2007; Schaefer, *Koepsell Half Timber House*; SHSW, Executive Committee, minutes, August 24, 1974, 1980/032, "Winn OWW (Culled from other Cartons)"; Meeting Notes (with 2/3), January 24, 1974, 1979/188, "OWW Current PR."

46. Pape interview, October 25, 2007.

47. Ibid.

48. ACP to Robert M. Lotz (Chippewa Valley Historical Museum), December 31, 1975, 1980/032, "Winn OWW (Culled from other Cartons), Correspondence with Other Museums"; Knipping interview.

49. OWW Technical Assistance Subcommittee, Report, October 10, 1974, 1986/097, "SHSW Assistant Dir. OWW 71-79, OWW Technical Assistance Subcommittee"; ACP Productivity Report, December 31, 1975, 1986/097, "SHSW Assistant Dir. 71-79, OWW Monthly Reports."

50. John Harbour (JEH) to RP, August 17, 1976, Perrin Papers, "S.H.S.W. 1973, 74, 75, 76"; ACP, "Two year Report," 1986/097, "SHSW Assistant Dir. 71-79, OWW Monthly Reports."

51. WHA to RP, November 26, 1974, 1986/097, "SHSW Assistant Dir. OWW 71-79, OWW Correspondence, 1973-1974"; Breilid Report, November 17 to December 6, 1974, APC Work report, week of November 18, 1974, ACP report, January 20-31, 1975, 1986/097, "SHSW Assistant Dir. 71-79, OWW Monthly Reports"; Perkins interview, October 5, 2005; Pape interview, October 25, 2007; ACP, March 14 to April 11, 1975, April 28 to May 9, 1975, Breilid report, August 17-30, 1975, 1986/097, "SHSW Assistant Dir. 71-79, OWW Monthly Reports"; Adm Bldg, "Purchase contract, RES—Building leads—Minett, William."

Chapter Seven. Toward an Insecure Future

1. Niels Bohr, quoted in *The University: An Owner's Manual* by Henry Rosovsky (New York: W.W. Norton & Company, 1990), 147.

2. Early in the acquisition process, the Society had acquired five buildings that, mainly because of continued deterioration, were never reerected. See introduction, note 2. Staff chose the five buildings or sets of buildings discussed in this chapter to fill specific site needs.

3. William Shakespeare, *Richard III*, Act 1, Scene 1.

4. Harbour interview; OWW Conference, December 2, 2009; Zigman interview.

5. Barbara Dembski, "Church to Regain Its Ethnic Focus," *Milwaukee Journal*, October 27, 1974; JWW to JMS, February 13, 1976, WHA to ACP, March 29, 1976, Adm Bldg, "Pape, Alan Carl"; OWW Conference, December 2, 2009; Knipping interview; "Report on Field Trip to Inspect the Harmony Town Hall and Kansasville Depot," July 28, 1976, Adm Bldg, "RES—Building Leads—Kansasville Depot."

6. Pape interview, October 25, 2007; Knipping interview.

7. "Old World Wisconsin: A Case Study in Funding Perplexity," October 31, 1977, 1993/041, "OWW Fundraising Cabinet"; RA to William F. Stark, June 2, 1971, 1979/202, "OWW, 1971"; Robert H. Irrman to RP, September 10, 1974, Perrin Papers, "S.H.S.W. 1969, 70, 71, 72"; O. W. Martin, Director of Administrative Services, to Dr. Earle William Newton, April 13, 1976, 1986/097, "WHA OWW Correspondence, 1976"; APC Report, April 1976, 1986/097, "SHSW Assistant Dir. OWW 71–79, OWW Monthly Reports."

8. Harbour interview.

9. WT and Schaefer meeting with OWW staff, January 7, 1974, Adm Bldg, "Planning and Development"; SHSW, Executive Committee, minutes, May 17, 1975, 1993/193, "OWW Fundraising Campaign"; JWW to WHA, August 21, 1975, 1980/032, "OWW Winn"; ACP, "Elapsed Time to Dismantle and Restore a Five Building with Eight Men," 1979/202, "Board of Curators, Committee Reports, OWW—Ethnic Research, 1975," and Perrin Papers, "Letter Box File: OWWC, Report, November, through January 31, 1977"; Technical Assistance Subcommittee, Minutes, September 4, 1975, Adm Bldg, "OWWC—Meetings, Misc"; Ralph Schaefer to Rudolp Rechle, September 6, 1975, Adm Bldg, "OWW—WI—St Building Comm, 1977."

10. Steven L. Stearns, "Interpretation Policy Proposal," May 27, 1975, Adm Bldg, "OWW—Interpretation, 1975–1980"; Breilid Report, September 28 to October 25, 1975, 1986/097, "SHSW Assistant Dir. OWW 71–79, OWW Monthly Reports."

11. WHA to JMS, RAE, October 23, 1975, Tolson to WHA, December 22, 1975, 1993/193, "OWW Fundraising Campaign"; Lucey to JMS, January 5, 1976, 1986/97, "SHSW Assistant Dir. OWW 71–79, OWW Correspondence, 1976." Tolson informed WHA that consultation follow-up meetings had been pushed back to January: Tolson to WHA, December 22, 1975, 1993/041, "OWW Financial Contributions."

12. APC to James Severa, April 29, 1975, Adm Bldg, "Pape, Alan Carl"; ACP, "Two year Report," July 1975 to June 1977, 1986/097, "SHSW Assistant Dir. OWW 71–79, OWW Monthly Reports."

13. JEH, Monthly Report, May 1976, 1986/097, "SHSW Assistant Dir. OWW 71–79, OWW Progress Reports."

14. Steven L. Stearns, "Interpretation Section Biennial Report 1975–1977," Adm Bldg, "OWW—Reports, 1977 & 1978"; Loren H. Osman, "State Showpiece Taking Shape," *Milwaukee Journal*, October 20, 1975; OWWC meeting,

minutes, September 10, 1976, 2007/135, OWW Technical Review Committee, 1975–1977.

15. WHA to JMS, RAE, October 23, 1975, Tolson to WHA, December 22, 1975, 1993/193, "OWW Fundraising Campaign"; Lucey to JMS, January 5, 1976, 1986/097, "SHSW Assistant Dir. OWW 71–79, OWW Correspondence, 1976."

16. "Vandals Damaged Ethnic Museum," *Milwaukee Journal*, January 20, 1976.

17. Loren H. Osman, "An Old World Look," *Milwaukee Journal*, July 1, 1976; Harbour, Monthly Report, July 1976, 1986/097, "SHSW Assistant Dir. OWW 71–79, OWW Monthly Reports"; Barland to JMS, July 6, 1976, Adm Bldg, "OWW PR—Complaints 1976-77."

18. Loren H. Osman, "State Showpiece Taking Shape," *Milwaukee Journal*, October 20, 1975.

19. Richard Zeitlin, OWW Research Section Monthly Report, July 30, 1976, Adm Bldg, "OWW—Meetings, 7-12/76"; JMS to Barland, July 13, 1976, Adm Bldg, "OWW PR—Complaints 1976-77."

20. Quincy Dadisman, "New Crowds Jam Old World," *Milwaukee Sentinel*, July 1, 1976. For the failure of success, see Bernard Rosenthal, *Salem Story: Reading the Witch Trials of 1692* (Cambridge, UK, 1993), 151.

21. JMS to Barland, July 13, 1976, Adm Bldg, "OWW PR—Complaints 1976-77."

22. WHA to Robert C. Schmidt, July 19, 1976, WHA to Mrs. E. Putnam Sr., August 9, 1976, JEH to Mrs. Ida Wettstein, August 19, 1976, JEH to Mrs. Robert Winkelman, August 19, 1976, WHA to Mrs. Amanda Ross, September 28, 1976, Victor Greene to RAE, August 30, 1976, JEH to Victor Greene, September 28, 1976, Adm Bldg, "OWW PR—Complaints 1976-77"; Gerda Mueller to RP, February 21, 1977, Perrin Papers, "S.H.S.W. 1977, 78, 79, 80."

23. JEH, Monthly Report, July 1976, 1986/097, "SHSW Assistant Dir. OWW 71–79, OWW Monthly Reports"; Harbour interview.

24. Osman, "State Showpiece," *Milwaukee Journal*, October 20, 1975; JEH, Monthly Report, June 1976, Adm Bldg, "OWW Reports, 1976 Jan-June"; JMS to files RE conversation with John Harbour about start-up costs for OWW, June 17, 1976, Adm Bldg, "OWW Meetings Planning & Development, 1976"; SHSW, Executive Committee, minutes, June 17, 1976, Budget Review and Finance Committee, 1979/173, "Executive Committee, 1975"; OWWC minutes, September 10, 1976, 2007/135, "OWW Technical Review Committee, 1975–1977."

25. "Costly Old World Wisconsin," *Waukesha Freeman*, January 25, 1977.

26. "Aid Plea Issued For 'Old World,'" *Milwaukee Sentinel*, February 23, 1977; BOB to JEH, January 10, 1977, OWW Budgeting, Operating, 1976, March 16, 1977, Adm Bldg, "OWW—Meetings Jan.-June 1977"; OWW, Monthly Report, January 26, 1977, Adm Bldg, "OWW Reports, 1977 & 1978"; RAE to Henry Dorman and Gary K. Johnson, March 17, 1977, 1986/097,

"WHA OWW Ten Year Plan"; Governor Lucey's and Senator Fred Risser's comments before the Joint Finance Committee attached to Paul L. Brown to RAE, April 12, 1977, Adm Bldg, "OWW—WI—St Building Comm, 1977"; RP to JEH, February 27, 1977, 1986/097, "WHA OWW Correspondence, 1977-78."

27. "Erney: Good Selection," *Capital Times*, August 27, 1977; Government Funding, 1971-March 1977, 1993/041, "OWW Fundraising Cabinet"; "Major Prospects—Evaluations & Assignment," March 1, 1977, 1993/041, "OWW Fundraising Cabinet"; OWWC Report, November 1, 1976, through January 1, 1977, Adm Bldg, "OWW—Committee Reports"; OWWC minutes, January 14, 1977, Adm Bldg, "OWW—Committee Meeting 10/14/77"; "Staff Meeting," November 10, 1977, Adm Bldg, "OWW—Meetings July-Dec. 1977"; RAE conference with John Torphy, December 21, 1977, 1986/103, "OWW Budget, 1969-1979."

28. OWWC, Report, November 11, 1976, to January 31, [1977], OWWC, Report, June 23, 1977, 1986/97, "SHSW Assistant Dir. OWW 71-79, OWW Progress Reports."

29. WT and Schaefer meeting with OWW staff, ACP, January 7, 1974, Scrapbook Collection; Knipping interview; OWWC minutes, October 14, 1977, Adm Bldg, "OWW—Committee Meeting 10/14/77."

30. ACP, "Preliminary Architectural Review," June 12, 1976, Adm Bldg, "RES-FINN-Rankinson House-Research to 1977."

31. RA to EDC, April 15, 1971, 1979/202, "OWWC, 1971"; Meeting Notes (with 2/3), January 24, 1974, 1979/188, "OWW Current PR"; Howard Mead to Dr. Jean M. Helliesen, September 20, 1973, 1979/188, "OWW Policy."

32. Perkins interview, August 28, 1992; Knipping interview; Zack Cooper, "Proposal for a Black Exhibit at OWW," September 4, 1975, 1986/097, "WHA OWW Technical Assistance Subcomte"; JEH to RP, August 17, 1976, Perrin Papers, "S.H.S.W. 1973, 74, 75, 76"; Knipping to JEH, June 28, 1977, Adm Bldg, "OWW African American Advisory Committee, Background Materials, 1993."

33. WHA to BOB, ACP, GP, October 18, 1974, Adm Bldg, "RES—Louis Breen Farm"; SHSW Fall Board Meeting, October 14, 1977, 1986/097, "WHA OWW Technical Assistance Subcmte."

34. OWWC, minutes, September 10, 1976, 2007/135, "OWW, Technical Review Committee, 1975-1977"; Staff Report, November 1976, 1981/281, "Special Communications Curators 1969-70"; OWWC minutes, October 14, 1977, Adm Bldg, "OWW—Committee Meeting 10/14/77"; RAE meeting with John Torphy, December 21, 1977, 1986/103, "OWW Budget, 1969-1979"; Pape interview, October 25, 2007.

35. ACP, "Visitor Center, Plan Proposal," November 1974, Adm Bldg, "Planning and Development"; ACP to RP, May 26, 1976, Perrin Papers, "S.H.S.W. 1973, 74, 75, 76." A nonprofit organization preserved and restored the Saxonia house on its original location.

36. Meeting Notes (with 2/3), January 24, 1974, 1979/188, "OWW Current PR"; Pape interview, August 18, 2008; file notes, April 5, 1976, Adm Bldg, "OWW and Kenosha-Racine FS Cooperative"; ACP to RP, May 26, 1976, Perrin Papers, "S.H.S.W. 1973, 74, 75, 76"; JEH to RAE, Development of the Old World Wisconsin "Operable Nucleus," November 29, 1977, Tishler Papers, "Committee, OWW."

37. Staff meeting, June 13, 1976, Adm Bldg, "OWW—Meetings 1-6/76."

38. Knipping Presentation, ca. 1976, 1979/202, "Board of Curators, Committee Reports, OWW—Ethnic Research, 1975"; Breilid Report, November 17 to December 6, 1974, 1986/097, "SHSW Assistant Dir. OWW 71-79, OWW Monthly Reports."

39. Knipping Presentation, ca. 1976, 1979/202, "Board of Curators, Committee Reports, OWW—Ethnic Research, 1975."

40. Marty Perkins, "Yankee Research Report," September 4, 1975, Perrin Papers, "S.H.S.W. 1973, 74, 75, 76"; Richard Fapso, Mark Knipping, Richard Zeitlin, "Town Hall Report," July 24, 1975, 1979/202, "Board of Curators, Committee Reports, OWW—Ethnic Research, 1975"; Knipping Presentation, ca. 1976, 1979/202, "Board of Curators, Committee Reports, OWW—Ethnic Research, 1975."

41. Knipping, Research Department Report, May 17, 1976, Adm Bldg, "OWW—Meetings 1-6/76"; files notes, April 27, 1977, OWW Adm Bldg, "RES-GER-Koepsell Hse-Arch"; Jay Joslen, "New Growth Keeps History Alive," *Milwaukee Sentinel*, April 28, 1977; OWWC minutes, October 14, 1977, 1986/097, "WHA OWW Technical Assistance Subcmte."

42. Budget Review Committee, minutes, June 12, 1975, 1979/173, "Executive Committee 1975"; Breilid Report, September 14-27, 1975, OWW Monthly Report, June 1976, Adm Bldg, "OWW Reports, 1976 Jan-June"; JWW to WHA and JMS on April 24 visit by HSR to site, April 28, 1976, 1980/032, "J. W. Winn's OWW Files Applegate, Wm A."

43. OWWC Report, November 1, 1976, to January 31, 1977, 1986/097, "SHSW Assistant Dir. OWW 71-79, OWW Progress Reports," 4. Two of these were adaptive use buildings in the visitor's center complex. OWWC Report, June 23, 1977, 1986/097, "SHSW Assistant Dir. OWW 71-79, OWW Progress Reports," 2, 4; WHA, "One Year at OWW—A Progress Report," ca. July 1, 1977, 1986/097, "SHSW Assistant Dir. OWW 71-79, OWW Progress Reports."

44. "Interpretation Section Report," June 20 to July 13, 1977, Adm Bldg, "OWW—Meetings July-Dec. 1977"; dictated by JEH, August 3, 1977, Adm Bldg, "Plan & Des 1977." In November, Harbour reiterated many of his concerns from August and added more to the list that now totaled 147. "Work Necessary to be accomplished on the site of Old World Wisconsin," November 8, 1977, Adm Bldg, "Plan & Des 1977."

45. OWWC Report, June 23, 1977, 1986/097, "SHSW Assistant Dir. OWW 71-79, OWW Progress Reports"; OWW Technical Committee,

December 6, 1977, Adm Bldg "OWW Committee (sub)—Mtg. 12-6-77," 3;
OWW Technical Assistance Subcommittee, December 19, 1977, Adm Bldg,
"Committee (sub) meeting 12-19-77," 5; OWWC, minutes, October 17, 1978,
Adm Bldg, "OWW—Committee Meeting 10/14/77," 5.

46. OWWC Report, June 23, 1977, 1986/097, "SHSW Assistant Dir.
OWW 71-79, OWW Progress Reports," 2. Staff intended the Clausing barn as
another adaptive restoration for the visitor's center. The intended restaurant
fell victim to endless delays that pushed its opening date from October 1977 to
early 1979. Reerection of this barn "can only be described as a nightmare."
OWW Quarterly Report, July 1 to September 30, 1977, 1986/097, "SHSW
Assistant Dir. OWW 71-79, OWW Progress Reports," 6; John W. Reilly,
Annual Report, 1978, November 18, 1978, Adm Bldg, "OWW Reports, 1977 &
1978." OWW had eighteen buildings open by September 1979. OWWC,
minutes, October 14, 1977, Adm Bldg, "OWW—Committee Meeting 10/14/77,"
2. OWW Quarterly Report, July 1 to September 30, 1977, 1986/097, "SHSW
Assistant Dir. OWW 71-79, OWW Progress Reports," 6; Bill Hibbard,
"Old World Wisconsin's Spell," *Milwaukee Journal*, June 26, 1977.

47. Hibbard, "Old World Wisconsin's Spell"; WHA, "One Year at OWW—
A Progress Report," ca. July 1, 1977, 1986/097, "SHSW Assistant Dir. OWW
71-79, OWW Progress Reports." Harbour noted the need to cut the grass that
had grown unwieldy around the orchard trees. Some members of the Kettle
Moraine Garden Club, who spent many hours and dollars to create the garden
and orchard, thought the orchard to be "ill-kept." "Work Necessary to be
accomplished on the site of Old World Wisconsin," November 8, 1977, Adm
Bldg, "Plan & Dev 1977."

48. "Status of Preparations for Opening," February 1977, Adm Bldg,
"OWW—Meetings Jan.-June 1977"; OWWC, minutes, October 14, 1977, Adm
Bldg, "OWW—Committee Meeting 10/14/77"; OWW Technical Committee,
December 6, 1977, Adm Bldg "OWW—Committee (sub) meeting 12-6-77,"
5. The state imposed limits on both the gift shop and the food service. All
merchandise sold at the shop "must be limited to appropriate items consistent"
with the site's mission in order to limit competition with private enterprise.
Likewise, food service was leased to private companies on the assumption that
private enterprise could provide services cheaper than the state. Karl Rajani
(Budget Analysis) to O. W. Martin (Director of Administrative Services,
SHSW), December 16, 1977, 1993/041, "OWW Fundraising Cabinet," 5.

49. OWWC Report, June 23, 1977, 1986/097, "SHSW Assistant Dir.
OWW 71-79, OWW Progress Reports," 6.

50. Joan L. Nemitz to JWW, July 21, 1977, 1980/032, "Winn OWW (Culled
from other Cartons)."

51. OWWC, minutes, October 14, 1977, Adm Bldg, "OWW—Committee
Meeting 10/14/77," 6; Hibbard, "Old World Wisconsin's Spell." As 1977 drew
to a close, planning envisioned seventy-eight buildings on site by 1983, a number

that has eluded OWW staff. OWW Technical Subcommittee, December 19, 1977, Adm Bldg, "Committee (sub) meeting 12-19-77," 3; Staff meeting, November 10, 1977, Adm Bldg, "OWW—Meetings July-Dec. 1977," 7; OWW Technical Subcommittee, December 6, 1977, Adm Bldg, "OWW—Committee Meeting 10/14/77."

52. RAE meeting with John Torphy, December 21, 1977, 1986/103, "OWW Budget, 1969-1979."

Epilogue

1. Rentzhog, *Open Air Museums*, chapters 4 and 8. He speculated that Vesterheim, which dated to 1913, "was the oldest American outdoor museum." Wallace, "Visiting the Past," 137–61; *Heritage Integrity Statement Crysler Park (Upper Canada Village) Morrisburg, Ontario: Final Report* (Commonwealth Historic Resource Management Limited, March 1998).

2. "Pioneer Park," 22, 23.

3. LHF, introduction of the OMC to Tishler's students (taped), February 14, 1967.

4. John J. Appel (Cooperstown Graduate Programs) to JWW, May 12, 1974, 1980/032, "Winn OWW (Culled from other Cartons), Correspondence with Other Museums."

5. Staff Meeting, January 10, 1977, Adm Bldg, "OWW—Meetings July-Dec. 1977"; RAE meeting with John Torphy, December 21, 1977, 1986/103, "OWW Budget, 1969-1979."

6. Richard L. Pifer, "Planning for Preservation: Two Case Studies," 2-18, May 18, 1978, 2007/193, "Controversy—OWW"; European Outdoor Museum Tour Observations, August 11-September 18, 1975, 2007/193, "European Outdoor Museum Tour"; Knipping interview.

7. Technical Subcommittee, minutes, December 6, 1977, and December 19, 1977, Adm Bldg, "Committee (sub) meetings 12-6-77, 12-19-77."

8. RA to OWWC, October 19, 1976, Tishler Papers.

9. Untitled report, after August 3, 1977, Adm Bldg, "Planning & Development—1977."

10. Kaufman, *Place, Race, and Story*, 296.

11. Leon and Piatt, *History Museums*, passim.

12. Acton to Michael Creighton (April 3 or 5, 1887), John Emerich Edward Dalberg, Lord Acton, Acton-Creighton Correspondence (1887), *The Online Library of Liberty: A Project of the Liberty Fund, Inc.*, http://oll.libertyfund.org /?option=com_staticxt&staticfile=show.php%3Ftitle=2254&chapter= 212810&layout=html#a_3436346.

13. Department of Administration, Bureau of Facilities Management, "1977-79 Building Program Recommendations for the State Historical Society," February 1977, E-10.

14. "Proceedings of the . . . SHSW, 1958–1959," *WMH* 43, no. 1 (Autumn 1959): 56–78.

15. Chappell, "Open-Air Museums," 336.

16. Christina G. Rossetti, *Time Flies: A Reading Diary* (Boston: Roberts Brothers, 1886), 11.

Sources

Wisconsin Historical Society Archives, Madison

Archival sources for WHS/OWW are plentiful. The WHS Archives houses most of them; some of the documents have been processed but many have not been. This means some of the documents may be moved or reclassified as the archivists process them. Fuller descriptions of these collections may be accessed online at Wisconsin Historical Society, Archives, ArCat, http://arcat.library.wisc.edu/.

Series 678 Administration, Divisional Files, 1954–1979
Series 684 Tape-recorded ceremonies, June 30, 1976
Series 932 Minutes of Proceedings, 1849–1978
Series 934 General Administrative Correspondence
Series 958 Board of Curators, Correspondence
Series 992 Division of Historic Sites Correspondence, 1947–1976
Series 1048 State Agency Correspondence, 1940–1967
Series 1762 SHSW Project files, 1919–1976
Series 1820 Office of Public Information, 1942–1985, 1988
Series 1910 SHSW, Board of Curators Committee Records, 1940–1972
Series 1940 Wisconsin Legislature, Joint Committee Records, 1959–1991
Series 2110 Interviews for "Columns" (interview with John Harbour)
Series 2550 Dept. of Natural Resources, Subject files, 1971–1987
1975/239 Bill Applegate's development project files, ca. 1970–1973
1976/082 Bill Applegate's development files, ca. 1969–1973
1978/229 Board of Curators committees, ca. 1967–1974
1979/019 Material on the Wis. American Revolution Bicentennial Commission
1979/020 Selection of materials of the Director and Assistant Director
1979/076 Files of Harva Hatchen and Chet Schmiedeke
1979/173 Non-current Board of Curators committee files, 1971–1975

1979/188 Subject files regarding Old World Wisconsin, 1971–1976
1979/202 Records, 1966–1974; includes files of committee lists, minutes, correspondence, reports, and recommendations relating to Old World Wisconsin Committee
1980/003 Records relating to Old World Wisconsin
1980/004 Review Board records, 1974–1975
1980/032 Files regarding Old World Wisconsin, ca. 1960–1999
1981/160 Wisconsin History Foundation
1981/245 Subject files regarding Old World Wisconsin, ca. 1977–1980
1981/281 Special Communications, Curators 1969–70
1981/282 Board of Curators committee records, 1976–77
1982/067 Public information subject files, 1968–1991
1983/189 Fund-raising material, 1971–1980
1983/311 Board of Curators committee material, 1976–1978
1985/242 1975–1979 files
1984/001 Historic preservation files, 1976–1980
1986/097 Subject files, 1968–1980, re Old World Wisconsin, fund-raising, and state/federal grants
1986/099 Promotional photographs and related material, 1971–1984
1986/100 Subject files on the Society's historic sites
1986/103 Files on Old World Wisconsin, 1970–1981
1988/222 Records, 1950–1964, Retired Board Members, 1950–1967
1989/215 Divisional files, 1975–1985
1989/266 SHS Directors Administrative Correspondence, 1972–1981
1991/157 Files, 1976–1987
1993/010 Files re projects at OWW, Stonefield, Villa Louis, and Pendarvis, ca. 1976–1987
1993/041 Division monthly reports, Development files, and files
1993/193 Additions, 1969–1989; includes early material on Old World Wisconsin
1993/206 Press clippings, press releases, photographs, 1976
1996/096 Committee records, 1968–1998
1997/078 Correspondence, 1967–1994
1997/169 Fishel logs, March 1959–January 5, 1961
1997/177 Divisional files, 1967–1996
1997/180 Board of Curators committee records, 1965–1996
1997/211 Divisional Files, 1971–1996
1999/096 Committee records, 1968–1998
2003/130 Survey Report, compiled by Robert Sherman
2007/135 Organizational Files (1967–1999)
2010/157 Additions, 1968–1969 (Phillip S. Tresch)
MSS 4 Papers of C. L. Harrington
MSS 943 Fishel, Leslie H. Jr., Papers, 1939–1999
MSS 1029 Papers of David E. Clarenbach

Old World Wisconsin

Documents at OWW have not been processed and are listed by their folder designation. Since I consulted these files, they have been moved from the administrative building basement to more environmentally safe locations. Generally, folder names do not include OWW, which may be assumed.

Carroll College/Clayville
Committee Meeting 10/14/77
Committee Meetings 1976–1979
Committee Meetings — Misc
Committee — OWW — Corres thru 1979
Committee Reports
Committee (sub) meetings 12–6–77, 12–19–77
Grants 1973
Grants 1973–1979
Grants 1974
Interpretation thru 1974
Interpretation 1975–80
Meetings 1–6/76
Meetings 7–12/76
Meetings 1975–1976
Meetings 1976
Meetings July–Dec. 1977
Meetings thru 1974
Miscellaneous thru 1973
Newspaper clippings
OWW and Kenosha-Racine FS Cooperative
OWW — WI — St Building Comm, 1977
Pape, Alan Carl
Richard W. E. Perrin Papers
 Bound Folder Old Sturbridge Village
 Carl F. Schmidt
 Historical Correspondence, Miscellaneous — 1976
 Letter Box Old World Wisconsin Committee, Report, November, through January 31, 1977
 National Correspondence, Miscellaneous, 1968–1971
 "Old World Wisconsin: A New Concept for an Outdoor Museum" Marc Balticim 1968
OWW, 1977–78
S.H.S.W. 1953, 54, 55, 56
S.H.S.W. 1957, 58, 59, 60
S.H.S.W. 1961, 62, 63, 64
S.H.S.W. 1965, 66, 67, 68
S.H.S.W. 1969, 70, 71, 72

S.H.S.W. 1973, 74, 75, 76
S.H.S.W. 1977, 78, 79, 80
State Correspondence, Miscellaneous, 1967–1970
Unmarked File Folder, Box 8
Unmarked Folder c. 1963
"Wisconsin's Heritage Park: A Legacy of Many Nations," Nord Nytt
 (Denmark) Spring, 1969
Planning and Development
Planning & Development—1971–1972
Planning & Development—1973
Planning & Development—1974
Planning & Development—1977
PR—Complaints 1976–77
PR Dedication June 8, 1974
PR—Publicity—Milw Journal
PR—Publicity Newspaper Corres.
Reports 1977 & 1978
RES—Building leads—Kansasville Depot
RES—Building leads—Minett, William
RES-GER-Koepsell Hse-Arch
RES-Louis Breen Farm
RES-VB Ramsey Barn Corres 71–74
RES-FINN-Rankinson House Research to 1977
Supporters Axtell, Roger E
Supporters Johnson's Wax Found.
Supporters—Stark, Wm (Mr. & Mrs.)
Supporters Tishler William H
Supporters WI Fed—Women's Clubs
Supporters WI History Found.
Unmarked

Perkins Files

Papers and files located in the office of Martin C. Perkins at OWW.

Tishler Papers

Tishler housed his OWW files in his office at UW–Madison. He allowed me to copy his papers in 1994. He has subsequently donated his papers to the WHS archives, where they are housed in 2007/135, Organizational files, 1967–1999.

Album with newspaper clippings
Articles on OWW
Brochure OWW

Clippings Misc
Clippings — Opening of OWW
Clippings — Planning of OWW
Clippings — Progress of OWW
Committee OWW
Concept — for OWW
Controversy — OWW
Correspondence Heritage
Correspondence Misc
Eagle, WI, related to
Ethnic Grad Studies
Ethnic Village Park
Ethnic Village Press
Folklore
Geology — OWW
Journal Series — House
Keuther Mtl — Misc
Landscape OWW
Master Plan
Old World Wis Program
Outdoor Museums Genl Info
OWW Class Project
Plng Infmn — Misc
Publications Misc OWW
Unmarked
Vegetarian Studies OWW
Village Plan

Pape Collection

Three scrapbooks of newspaper clippings, large notebook, and loose documents
from Alan C. Pape in author's possession (to be housed at OWW).

Personal Correspondence

This includes letters or e-mails from Alan Pape, Marty Perkins, Henry S. Reuss,
Robert Sherman, James Schaefer, Michael Stevens, and William Tishler.

Interviews

Unless otherwise noted, the author conducted the interview.
 Roger Axtell, September 20, 2006
 Michael Buchholz, March 25, 1995 (conducted by Joseph E. Kapler Jr.)

E. David Cronon, September 13, 2006
Richard A. Erney, April 23, 1999
Leslie H. Fishel Jr., August 17, 1998
Leslie H. Fishel Jr., March 9, 1995 (conducted by Joseph E. Kapler Jr.)
Robert Gutzman, March 9, 1999
John E. Harbour, March 31, 1995
Steven Hauser, May 3, 2007
Jack Holzhueter, August 24, 1998
Mark H. Knipping, April 1, 2009
Michael McCarthy, March 9, 1999
Alan C. Pape, October 25, 2007, August 18, 2008, October 19, 2010
Martin C. Perkins, August 28, 1992, September 25, 1992, May 11, 1994,
 October 5, 2007, November 1, 2007, June 25, 2008, April 22, 2009
James Schaefer, January 12, 2010, January 28, 2010
Robert Sherman, June 12, 2009
William H. Tishler, May 5, 1993, February 21, 1994
William Tishler, March 9, 1995 (conducted by Joseph E. Kapler Jr.)
William H. Tishler, Mark H. Knipping, Alan C. Pape, Martin C. Perkins,
 December 2, 2009
Philip Tresch, June 9, 2010
Robert Zigman, September 3, 1998

Taped Presentations

Three reel-to-reel tapes made by William H. Tishler. Marquette University archives staff digitally reformatted them. The originals and a digital copy are now in the Wisconsin State Archives.

Index

Page references in italics indicate illustrations. "OWW" refers to Old World Wisconsin.
"Society" refers to the State Historical Society of Wisconsin.

WISCONSIN LAND AND LIFE

Spirits of Earth: The Effigy Mound Landscape of Madison and the Four Lakes
Robert A. Birmingham

*Pioneers of Ecological Restoration: The People and Legacy of the University of Wisconsin
 Arboretum*
Franklin E. Court

A Thousand Pieces of Paradise: Landscape and Property in the Kickapoo Valley
Lynne Heasley

*Environmental Politics and the Creation of a Dream: Establishing the Apostle Islands
 National Lakeshore*
Harold C. Jordahl Jr., with Annie L. Booth

*Creating Old World Wisconsin: The Struggle to Build an Outdoor History Museum of
 Ethnic Architecture*
John D. Krugler

A Mind of Her Own: Helen Connor Laird and Family, 1888–1982
Helen L. Laird

When Horses Pulled the Plow: Life of a Wisconsin Farm Boy, 1910–1929
Olaf F. Larson

North Woods River: The St. Croix River in Upper Midwest History
Eileen M. McMahon and Theodore J. Karamanski

Buried Indians: Digging Up the Past in a Midwestern Town
Laurie Hovell McMillin

Wisconsin My Home
Thurine Oleson, as told to her daughter Erna Oleson Xan

Wisconsin Land and Life: A Portrait of the State
Edited by Robert C. Ostergren and Thomas R. Vale

*Condos in the Woods: The Growth of Seasonal and Retirement Homes in Northern
 Wisconsin*
Rebecca L. Schewe, Donald R. Field, Deborah J. Frosch, Gregory Clendenning,
 and Dana Jensen

Door County's Emerald Treasure: A History of Peninsula State Park
William H. Tishler